MANCHESTER MEDIEVAL LITERATURE AND CULTURE

NONHUMAN VOICES IN ANGLO-SAXON LITERATURE AND MATERIAL CULTURE

MANCHESTER
1824

Manchester University Press

Series editors: Anke Bernau and David Matthews

Series founded by: J. J. Anderson and Gail Ashton

Advisory board: Ruth Evans, Nicola McDonald, Andrew James Johnston, Sarah Salih, Larry Scanlon and Stephanie Trigg

MANCHESTER
MEDIEVAL
LITERATURE
AND CULTURE

The Manchester Medieval Literature and Culture series publishes new research, informed by current critical methodologies, on the literary cultures of medieval Britain (including Anglo-Norman, Anglo-Latin and Celtic writings), including post-medieval engagements with and representations of the Middle Ages (medievalism). 'Literature' is viewed in a broad and inclusive sense, embracing imaginative, historical, political, scientific, dramatic and religious writings. The series offers monographs and essay collections, as well as editions and translations of texts.

Titles Available in the Series

The Parlement of Foulys (by Geoffrey Chaucer)
D. S. Brewer (ed.)
Language and imagination in the Gawain-poems
J. J. Anderson
Water and fire:The myth of the Flood in Anglo-Saxon England
Daniel Anlezark
Greenery: Ecocritical readings of late medieval English literature
Gillian Rudd
Sanctity and pornography in medieval culture:On the verge
Bill Burgwinkle and Cary Howie
In strange countries: Middle English literature and its afterlife: Essays in Memory of J. J. Anderson
David Matthews (ed.)
A knight's legacy: Mandeville and Mandevillian lore in early modern England
Ladan Niayesh (ed.)
Rethinking the South English legendaries
Heather Blurton and Jocelyn Wogan-Browne (eds)
Between earth and heaven: Liminality and the Ascension of Christ in Anglo-Saxon literature
Johanna Kramer
Transporting Chaucer
Helen Barr
Sanctity as literature in late medieval Britain
Eva von Contzen and Anke Bernau (eds)
Reading Robin Hood: Content, form and reception in the outlaw myth
Stephen Knight
Annotated Chaucer bibliography: 1997–2010
Mark Allen and Stephanie Amsel
Roadworks: Medieval Britain, medieval roads
Valerie Allen and Ruth Evans (eds)
Love, history and emotion in Chaucer and Shakespeare: Troilus and Criseyde *and* Troilus and Cressida
Andrew James Johnston, Russell West-Pavlov and Elisabeth Kempf (eds)
Gesta Romanorum: A new translation
Christopher Stace
The Scottish Legendary: *Towards a poetics of hagiographic narration*
Eva von Contzen

Nonhuman voices in Anglo-Saxon literature and material culture

JAMES PAZ

Manchester University Press

Published by Manchester University Press
Altrincham Street, Manchester M1 7JA
www.manchesteruniversitypress.co.uk

British Library Cataloguing-in-Publication Data
A catalogue record for this book is available from the British Library

ISBN 978 1 5261 0110 5 hardback
ISBN 978 1 5261 1599 7 Open Access

First published 2017

Typeset by Out of House Publishing
Printed and bound by CPI Group (UK) Ltd, Croydon, CR0 4YY

For my parents

Contents

List of figures viii

Acknowledgements ix

Introduction: On Anglo-Saxon things 1

1 Æschere's head, Grendel's mother and the sword
that isn't a sword: Unreadable things in *Beowulf* 34

2 The 'thingness' of time in the Old English riddles of
the Exeter Book and Aldhelm's Latin *enigmata* 59

3 The riddles of the Franks Casket: Enigmas, agency
and assemblage 98

4 Assembling and reshaping Christianity in the Lives
of St Cuthbert and Lindisfarne Gospels 139

5 *The Dream of the Rood* and the Ruthwell
monument: Fragility, brokenness and failure 175

Afterword: Old things with new things to say 216

Bibliography 221

Index 233

Figures

1 Gold hilt plate from the Staffordshire Hoard
 (© Birmingham Museums Trust) 51
2 Franks Casket, front panel (© The Trustees of the
 British Museum) 99
3 Franks Casket, right panel (© The Trustees of the
 British Museum) 111
4 Franks Casket, left panel (© The Trustees of the
 British Museum) 115
5 The Ruthwell monument, north (now east) side, upper
 and lower stones: vine scroll and runic inscription
 (© Corpus of Anglo-Saxon Stone Sculpture,
 photographer T. Middlemass) 199
6 The Ruthwell monument, north (now east) side, lower
 stone: vine scroll and runic inscription (© Corpus
 of Anglo-Saxon Stone Sculpture, photographer
 T. Middlemass) 200

The author and publishers are grateful to all of the institutions and individuals listed above for permission to reproduce the images for which they hold the copyright.

Acknowledgements

My initial ideas for this book took root in 2008, when I was still based at King's College London. I was extremely fortunate to find an excellent mentor in Clare Lees: her support and enthusiasm for imaginative research, balanced with insightful criticism and commitment to high scholarly standards, have played no small part in the successes of this book. I acknowledge any of its shortcomings as my own. Sarah Salih and Robert Mills (now at UCL) also deserve thanks for providing helpful insights and suggestions on work in progress, and I am very grateful to Catherine Karkov (Leeds) for reading and commenting on an earlier version of this book.

The Centre for Late Antique and Medieval Studies (CLAMS) provided me with an intellectual home for over four years, as well as with a warm and friendly testing ground for new ideas. Our Old English reading group kept me focused on the language and poetry of my primary texts. I would like to thank the tight-knit cluster of Anglo-Saxonist postgraduate students who participated in this group, some of whom are now lecturers and tutors at King's or other institutions: especially (but not exclusively) Carl Kears, Hana Videen, Josh Davies, Kathryn Maude, Rebecca Hardie and Victoria Walker.

I acknowledge my alma mater, Aberystwyth University. Special thanks are due to Diane Watt, now at the University of Surrey, whose classes in Old English first stimulated my interest in this field and whose advice was crucial in making the step from undergraduate to postgraduate study. My spell as a lecturer at the University of Leeds (January to July 2014) was brief but I shared fruitful conversations with Alaric Hall and his (former) doctoral student, Helen Price, whose own work on ecomaterialism and Old English poetry I found very illuminating. Since September 2014, I have been lecturing full-time at the University of Manchester. The collegiality and support of my new colleagues have enabled

me to balance teaching and research duties and helped me to settle into my role as an early career academic while completing my first book. I am especially thankful to my fellow medievalists, Anke Bernau and David Matthews, for their welcoming attitude and sound mentorship. Of course, research is not separate from but always informed by teaching. Therefore, I acknowledge the many undergraduate students who have studied Old English under me at Manchester to date: particularly those who signed up for my third-year, research-led course on Anglo-Saxon 'Things that Talk'. Their thoughtful responses in class and often exciting written work prompted me to rethink certain aspects of this book in productive ways.

I am indebted to the anonymous peer reviewers for Manchester University Press, whose observations, queries and criticisms of the first draft of this book have helped me to refine its structure and writing style and to tighten and refresh its theoretical framework.

The most important thanks of all are owed to my family, particularly my parents, who steered me through many moments of academic and personal self-doubt. I hope that I have repaid your faith in me.

Introduction: On Anglo-Saxon things

> How many things,
> Files, doorsills, atlases, wine glasses, nails,
> Serve us like slaves who never say a word,
> Blind and so mysteriously reserved.
>
> (Jorge Luis Borges, 'Things')[1]

> Næfre hio heofonum hran, ne to helle mot,
> ac hio sceal wideferh wuldorcyninges
> larum lifgan. Long is to secganne
> hu hyre ealdorgesceaft æfter gongeð,
> woh wyrda gesceapu; þæt is wrætlic þing
> to gesecganne.

[It never reaches heaven, nor to hell, but it must always live within the king of glory's laws. Long it is to say how its life-shape spins on afterwards, the twisted pattern of fate; that is a wondrous thing to speak.]

(Exeter Book Riddle 39)[2]

Anglo-Saxon things and theory

Things could talk in Anglo-Saxon literature and material culture. Many of these Anglo-Saxon things are still with us today and are still talkative. Nonhuman voices leap out from the Exeter Book riddles, telling us where they came from, how they were made, how they do or do not act. In *The Husband's Message*, runic letters are borne and a first-person speech is delivered by some kind of wooden artefact. Readers of *The Dream of the Rood* in the Vercelli Book will come across a tree possessing the voice of a dreaming human in order to talk about its own history as a gallows and a rood. In *Andreas*, in the same manuscript, we read about stone angels, emerging from the wall into which they have been carved, speaking and walking and raising the dead. Beyond the manuscript

page, we have artefacts that use their voices to remind us of their makers and owners. 'Beagnoþ', says the rune-marked *seax* found in the River Thames and now kept in the British Museum. But who was Beagnoþ anyway? A warrior who liked hunting and combat? Someone interested in runic literacy or mysterious magic? A skilled smith? 'Beagnoþ' has become synonymous with the blade itself and so might as well belong to the blade. The *seax* now owns Beagnoþ as much as Beagnoþ ever owned the *seax*. Other Anglo-Saxon artefacts are more outspoken still. They want to speak about themselves instead of the humans who crafted them. The eighth-century Franks Casket is a box of bone that enigmatically alludes to its former fate as a whale that swam aground onto the shingle. Monuments such as that in Ruthwell, Dumfriesshire, can talk and act as other things. This stone column speaks as if it were living wood, or a wounded body.

We may like to believe that we are seeing, hearing, touching the voices of long-lost men and women through these things, but why did these humans so often feel the need to talk with the things around them – giving voice to, and receiving voice from, a sword, a shield, a tree, a bone, a cross, a casket? Their words are not whispered or shouted to us from across the centuries but cut or carved or scratched or inked. These early medieval voices are embodied but the 'bodies' that bear them are not fleshy human ones; they are calfskin, whalebone, sculpted stone, twisted gold.

Can we even begin to imagine the Anglo-Saxon world without things? Lacking carved monuments or inscribed brooches or illuminated manuscripts, that world would seem a lot more muted if not silent altogether. Should we not take the things themselves seriously, then? Instead of looking *through* these things, as if they are windows onto a distant age, we should start to look at and into them, listen to them, touch and feel them, recognise them for what they are, what they once were, what they may yet be. We can increase our understanding of both Anglo-Saxon culture and the objects that bring that culture before us by seeking to grasp how such things mesh meaning with matter and with acts of making and breaking. Things do not merely carry early medieval human voices across time but change them, sometimes reshaping or even subverting the messages intended by their original patrons, makers, possessors.

This book seeks, therefore, to recognise the voice and agency that nonhuman things have across Anglo-Saxon literature and material culture. Drawing on a variety of sources (from riddles and dream

visions to stone sculpture and gospel books), it examines the rela-
tionship between inscribed speech, bodies and early medieval arte-
facts, looking at how nonhumans might be as active and talkative
as humans are assumed to be. In arguing for the agency of things,
this work is informed by what has become known as 'thing theory'
and as such it rethinks conventional divisions between 'animate'
human subjects and 'inanimate' nonhuman objects. Throughout
the course of the book, the Anglo-Saxon thing will be shown to
resist such categorisation. The active role that things have in the
early medieval world can also be linked to the Germanic origins
of the word, where a *þing* is a kind of assembly, with the ability to
gather other elements – material goods, bodies, words, ideas – to
it. It is in this way that a thing might be said to speak. By mould-
ing meaning and matter together into a distinct whole, a cross, a
casket, a book, a relic, becomes talkative. Such talking things can
exist across boundaries of time and space in ways that embodied
humans cannot, carrying our voices from the past into the present
and future.

Over the past fifteen years an intense interest has arisen in the
lives of ostensibly inanimate objects. Some of the foundations
for 'thing theory' were laid by Arjun Appaduri, who did much to
illuminate the 'social life of things' by focusing on how the com-
modities exchanged and circulated within communities can shape
human subjects, rather than the other way around.[3] But in his essay
'Thing Theory' (2001) and his book *A Sense of Things* (2003), Bill
Brown developed a more nuanced definition of 'thingness' as that
which is excessive in objects, beyond their mere materialisation
or utilisation.[4] Brown seeks at once to problematise and promote
the task of connecting 'things' with 'theory'. The form of criti-
cism he sets out moves previous work on materialism forward by
drawing on a Heideggerian account of the way in which humans
share agency with their tools and by borrowing from Heidegger
a distinction between objects and things.[5] Brown claims that we
cannot remain content with things, cannot leave them alone and
apart from theory, since 'even the most coarse and commonsensi-
cal things, mere things, perpetually pose a problem because of the
specific unspecificity that "things" denotes'.[6] This characteristic of
being specific yet unspecific, present yet elusive, is what differenti-
ates things from objects.[7]

This way of thinking about thingness has much in common
with other strains of materialism that have emerged since 2010. In
The Speculative Turn (2011), editors Levi Bryant, Nick Srnicek

and Graham Harman identify a renewed attention to materialist and realist options in philosophy, with thinkers 'speculating once more about the nature of reality independently of thought and of humanity more generally'.[8] Meanwhile, in *New Materialisms* (2010), Diana Coole and Samantha Frost argue that contemporary thinkers should question prevailing presumptions about agency and causation and 'reorient ourselves profoundly in relation to the world, to one another, and to ourselves'.[9] This call has been taken up by political theorists such as Jane Bennett, whose concept of 'thing-power' in *Vibrant Matter* (2010) seeks to 'acknowledge that which refuses to dissolve completely into the milieu of human knowledge' while aiming to 'attend to the it as actant'.[10] Even more recently, Ian Bogost's *Alien Phenomenology* (2012) situates things at the centre of being and advocates the use of metaphor in philosophy as a means of glimpsing things as they exist outside of human consciousness.[11] The work of Levi Bryant (2011) puts entities at all levels of scale on equal ontological footing and Timothy Morton has questioned whether sensory experience allows direct access to reality, employing the term 'hyperobjects' (2013) to describe entities of such vast temporal and spatial dimensions that they defeat traditional ideas about what a thing actually is.[12] In *Entangled* (2012), archaeologist Ian Hodder has questioned the human-centred perspective in studies of material culture, discussing human 'entanglements' with material things and demonstrating how things have always directed us, defined us and driven our supposed progress through history.[13] Anthropologist Tim Ingold, in his essay collection *Being Alive* (2011) and book *Making* (2013), has refined the distinctions we make between 'materials' and 'materiality' and has argued for ways of thinking through making in which sentient craftsmen and active materials continually correspond with one another in the generation of form.[14]

As this short summary indicates, thing theory is a very recent branch of critical theory, surfacing with vigour in the twenty-first century and still developing as we speak.[15] Medievalists have not been slow to take up the challenges presented by this theoretical work and an object-oriented medieval studies has started to take shape. In 2008, Kellie Robertson published an article in *Literature Compass* contending that medieval things were endowed with an autonomy and agency that was largely misrecognised in the wake of Enlightenment empiricism, concluding with a reading of Chaucer's Merchant's hat.[16] Robertson also contributed to a special issue of *Exemplaria*, edited by Patricia Clare Ingham in 2010,

which was devoted to premodern culture and the material object.[17] In *Animal, Vegetable, Mineral* (2012), Jeffrey Jerome Cohen and the contributors treat a range of medieval and early modern texts and artefacts, from Old Norse to the English Renaissance, and argue against ecological anthropocentricity by ceasing to assume that only humans exert agency.[18]

The 'material turn' has started to manifest itself in companions and handbooks to medieval literary studies, too. The 2013 *Handbook of Middle English Studies* features a chapter, by Jessica Brantley, on material culture, which is specifically interested in the ways in which the boundaries between the 'material' and 'immaterial' break down in late medieval dream visions.[19] Martin Foys demonstrates that early medieval media were native, consciously referenced, temporally thick and vitally interrelated to each other in *A Handbook to Anglo-Saxon Studies* (2012).[20] This renewed attention to material 'things' has also addressed the physical and sensory experience of manuscripts. Articles by Bruce Holsinger and Sarah Kay, for example, have explored the impact on readers of the fact that medieval books were produced in a context involving the slaughter and transformation of animals and written on parchment that is made from animal skins.[21] A theoretically informed discussion of specifically Anglo-Saxon 'speaking objects' which intersects with my own work in some illuminating ways may be found in Catherine Karkov's chapter 'Object and Voice' in *The Art of Anglo-Saxon England*.[22] A 2014 article by Benjamin C. Tilghman also shares some strong affinities with the arguments I make in my own work.[23] However, Tilghman limits himself to initial readings only and calls for each of the things discussed to be puzzled out more thoroughly.[24]

Nonhuman voices in Anglo-Saxon literature and material culture builds upon this dynamic body of scholarship that reads premodern culture from a new materialist perspective in order to demonstrate that the culture of early medieval England offers fertile ground for theoretical work of this kind. It will differentiate itself from current scholarship that connects thing theory and medieval studies and take that scholarship forward in three, interrelated ways: first, this book concentrates on the early, rather than late, medieval period in detail and moves across literature and material culture, from manuscript poems to epigraphic artefacts and monuments; second, it recognises the significance and relevance of Old English riddles and riddling culture to the role that things play in this early period; third, it acknowledges and engages with the fact

that the Old English *þing* was an assembly in the etymological, as well as material, sense.

The argument that I draw from these areas of focus is that, although things are endowed with voices in Anglo-Saxon literature and material culture, they also have an agency apart from humans. This agency is linked to: one, their enigmatic resistance, their refusal to submit to human ways of knowing and categorising the world; and, two, their ability to gather, to draw together, other kinds of things, to create assemblages in which human and nonhuman forces combine. Anglo-Saxon things speak yet they can be stubbornly silent. They can communicate with humans but, like riddles, they also elude, defy, withdraw, from us. Things collaborate with humans but they are also entangled with other materials, animals, plants, natural phenomena, images, sounds and words. Therefore, Anglo-Saxon things can teach us to rethink the concept of voice as a quality that is not simply imposed upon or attributed to nonhumans but which inheres in nonhuman ways of existing and being in the world; they can teach us to rethink the concept of agency as arising within heterogeneous groupings of diverse elements, rather than always emerging from human actors alone.

Old English words for things

Both aspects of this argument – enigmatic resistance and assemblage – are rooted in an understanding of the word 'thing' and its etymological predecessor in Old English: the *þing*. Evidently, some important theoretical claims have now accrued around this word in literary and cultural studies. Those of us who engage with such theory can no longer use the word 'thing' without thinking about it, perhaps tripping over it. Throughout his seminal essay, Bill Brown plays with the modern English word, remarking that it designates the concrete yet ambiguous in the everyday, an amorphous characteristic or a frankly irresolvable enigma, a latency (the not yet formed or the not yet formable) and an excess (what remains physically or metaphysically irreducible to objects). 'Things' is a word that tends, especially at its most banal, to 'hover over the threshold between the nameable and unnameable'.[25] As well as designating the enigmatic in the everyday, the word 'thing' may also allude to a drawing together.[26] Ian Hodder has made use of the word's original meaning of 'assembly' in Old English and Old High German to challenge a human-centred understanding of things as separate, bounded entities. This is how they may naively appear to us as

humans, but an awareness of the thing-as-assembly reveals that all things depend on other things along chains of interdependence in which many other actors are involved.[27] Of course, this approach owes a debt to the philosopher of science Bruno Latour, who imagined a Parliament of Things in which silent objects speak, in which passive matter exerts power; an assembly in which participants rediscover their connectedness to nature by acting out the voices of other beings.[28]

If the word 'thing' carries such weight in contemporary thing theory, then it is worth taking the time to examine the Germanic origins of the word *þing* and its various uses within the Old English lexicon. Very broadly, a number of dictionaries are in agreement that ModE 'thing' developed in the following way: it originates from the Proto-Germanic word *thengan*, meaning 'time', before developing semantically via 'allotted time' to the day or time for an 'assembly'; in the English language, however, the meaning moved on to 'subject for discussion in such an assembly' and then 'subject, affair, matter' and finally 'entity or object'.[29]

But this brief overview does not fully illustrate the fact that the word, or words, for things have always hinted at their ability to both exist and act in a variety of ways. Even if we look back at the (necessarily hypothetical) roots of the word in Indo-European and then Proto-Germanic, we find terms indicating a concept that is at once fixed and flexible. Some philologists suggest that the original Germanic sense of *thing* as a 'day of assembly' is ultimately connected to a base meaning 'stretch or extent of time'; this is derived from the Indo-European root *tenk-*, meaning 'stretch, draw out or draw together'. The *Chambers Dictionary of Etymology* goes on to state that this base meaning is related to the source of Old English *þennan* (or *þenian*) meaning to 'stretch out'.[30] Any assembly needs to be fixed, its time and location settled upon for practical purposes. Yet this early linguistic evidence indicates that, although such assemblies gathered bodies, ideas, arguments, animals and artefacts together on an allotted day in an appointed space and time, these *things* could also draw or stretch time out; they could interrupt the everyday rhythms of human life, extend conventional time frames, stretch out the pattern of events, in order to insert themselves into the world.

Historically, most Germanic languages associated the *thing* with the assembly. The Old English *þing* was originally a meeting or assembly and only later an entity, being, matter, and then also an act, deed or event. This is cognate with Old Frisian and Old

Saxon *thing*, again meaning assembly, as well as action, matter; and Middle Dutch *dinc*, lawsuit, matter, thing; Old High German *ding*; assembly, lawsuit, thing; Old Icelandic *thing*, assembly, meeting, parliament, council. The latter is especially interesting since the Icelandic national parliament is still called the Althing (literally, the 'all-thing'). Founded in 930 at Thingvellir, the Althing is the oldest extant parliamentary institution in the world. Representatives of Iceland's various districts would gather together each midsummer to hear the laws of the land recited, debate legal cases and elect rulers. In a less formal sense, the Althing was the social event of the year: an occasion for exchanging news and gossip, for negotiating marriages and business deals. Since all free men were eligible to attend, the Althing attracted farmers and their families, parties involved in legal disputes, traders, craftsmen and storytellers. This annual meeting therefore amassed a multitude of voices, with a variety of things to say, about a wide range of issues. In the Icelandic sagas, it is predominantly powerful men such as the *goðar* who speak at this outdoor assembly.[31] However, in a general assembly, a gathering of all things, surely a variety of voices should be raised. Who gets to talk and who does not? Who gets heard and who or what does not? What role do 'things' play in mediating or silencing or subverting a cacophony of competing voices? And what about the mysterious voice of the thing itself in all of this? It is noteworthy here that many of these assemblies carry legal connotations, too: etymologically, the early medieval thing was an assembly at which law cases were decided; or, in some Germanic languages, a thing could be the name for the lawsuit itself. This linguistic connection suggests that things have the ability to fix, link or bind human codes of behaviour. Again, the thing shapes the human world.

The Old English word *þing* covered a wide semantic range, encompassing action and inaction, power, passivity and possession, the physical and metaphysical. Alas, the Toronto Dictionary of Old English has not yet reached the letter *þ* (thorn) but for OE *þing* Bosworth-Toller gives us (I) 'a thing': including 'a single object, material or immaterial', 'a thing that is done, an action', 'an event', 'a state of condition', a 'matter' or a 'concern, affair', etc. But Bosworth-Toller also gives us (II) 'a meeting, court'.[32]

There is more than one instance in Old English where a *þing* designates an assembly, gathering or meeting. This sense is attested to in *Beowulf*, when the hero 'nu wið Grendel sceal, / wið þam aglæcan, ana gehegan / ðing wið þyrse' [must now with Grendel, hold a

thing (i.e. meeting) alone with the fighter, with the giant] (424–6).[33] In the same text *þing* is given the prefix *ge-* to indicate that is the outcome or issue of that meeting, where Beowulf 'bad bolgenmod beadwa geþinges' [awaited, bulging-minded, the battle's outcome] (709). *Maxims I* uses the word in this same way when it states, 'þing sceal gehegan / frod wiþ frodne; biþ hyra ferð gelic' [the wise must hold meetings with the wise; their minds are alike] (18–19). Whereas in *Beowulf*, the meeting is a violent physical clash, in the *Maxims* it is what we might nowadays call a meeting of minds. Things, in Old English, can designate material *or* immaterial, embodied *or* spiritual, encounters.

There is some overlap between the usages of the word for things in modern English and Old English, inasmuch as the *þing* could also denote material possessions, in the sense that is most common to speakers of modern English. Yet it is safe to say that in the earlier stages of the language the term *þing* encompassed a wider range of meanings than the inanimate objects to which the modern word usually refers.

Of course, this reminds us that one of the key distinctions made by thing theory is that between the thing and the object. We evidently have things in Old English literature, but where are the objects? Modern English 'object' is borrowed from Old French *object*, and directly from Medieval Latin *objectum*: that which is put before the senses, neuter of Latin *objectus*, past participle of *obicere*: to present, oppose, cast in the way of. For Lorraine Daston, this implies that objects are solid, obvious, sharply outlined and self-evident, that they 'throw themselves in front of us, smite the senses, thrust themselves into our consciousness'.[34] The term 'object' conjures up a history that opposes subject and object, mind and matter, self and other, and can connote 'an objectifying approach in which material matter is analysed, codified and caught in disciplinary discourse'.[35] As much as the subject may move and control and organise the object, the object, that which is *thrown before*, may, in turn, have the ability to humble or even form the subject, that which is *thrown under* to receive an impression. However we conceive of the dynamics, the subject and object remain related to each other. Yet this relation derives ultimately from their Latin word histories. What kinds of 'objects' are there in the Old English lexicon and how do they relate to the human subjects who see, hear, make, own, handle or exchange them?

If an object is that which is put before the eyes or other senses, then we find an interesting parallel in the OE *wiht*. These creatures

or created things are most often associated with the Exeter Book riddles, where they are strange entities to be seen, heard or talked about. The sword of Riddle 20 says 'Ic eom wunderlicu wiht' [I am a wondrous creature] and the same self-description is used by the magpie of Riddle 24 and the onion of Riddle 25, while the speaker of Riddle 29 claims that 'Ic wiht geseah' [I saw a creature] to describe the moon. In the riddles, then, *wiht* is used for a wide variety of things: weapons, animals, food, drink, instruments, celestial bodies. But *wiht* or *wihte* is also used as an adverb, as in Riddle 47, which says: 'Stælgiest ne wæs wihte þy gleawra' [The thieving guest was not in any way the wiser] (5–6). In this adverbial sense, *wihte* usually means 'in any way' or 'at all'. Kevin Crossley-Holland translates the line in Riddle 47 as 'The thievish stranger was not a whit the wiser',[36] attesting to the continued usage of 'whit' in this way in modern English, although the OED describes such usage as now 'archaic or literary'. In addition, the modern use of 'whit' most often expresses or implies the negative, as in the phrases 'never a whit' or 'not a whit'. OE had the related word *nawiht* or *nanwiht* (cf. ModE 'naught') which could function as an adverb ('not' or 'not at all') but also as a noun or indefinite pronoun. Bosworth-Toller defines *nawiht* as (I) 'nothing, naught, a thing of no value, an evil thing' or (II) 'as an adverb, not'. It appears in the accusative singular in Riddle 11, where the speaking cup claims, 'Ic þæs nowiht wat' [I in no way know] (5). From this evidence it is clear that *wiht* and its connected terms not only described a multitude of material things, but could also be used in a more abstract sense to relate a lack of wisdom, for instance, and even carried moral connotations, as in a worthless or evil thing. So, the word *wiht* straddles the bounds between the abstract and tangible, immaterial and material, manmade and natural, living creature and dead artefact. The reoccurring use of *wiht* in the riddles further identifies these things as lively, resistant and elusive.

The related term *awiht*, *awyht*, *awuht* or *aht* is another indefinite pronoun meaning 'aught' or 'anything'. Although this is a somewhat vague usage, the OE term *æht*, which also gives us ModE 'aught', has the more specific sense of 'possession, especially property, goods, wealth, treasure'.[37] In contrast to *wiht*, an entity to be perceived by human senses, *æht* refers to goods of value, things defined by ownership. These objects therefore stand in a different kind of relationship with human subjects. The word is used in this sense in *Beowulf*: 'Heald þu nu, hruse, nu hæleð ne moston, / eorla æhte!' [Now, earth, hold what heroes can no longer keep, the

property of earls] (2247–8). The preterite-present verb *agan* simi-
larly means 'to own, possess, have' and could be used in relation
to wealth, treasure, gold, silver, gems or other material items, as
well as in relation to land, domestic animals or slaves. The word is
found not only in literary texts but inscribed on material artefacts.
A ninth-century gold ring discovered in Manchester, inscribed
with both Roman and runic characters, claims in a first-person
voice that 'æDRED MEC AH EAnRED MEC agROf' [Ædred
owns me, Eanred engraved me]. A more complex variant of this
formula is found on the eleventh-century, Anglo-Scandinavian,
Isle of Ely disc brooch, which displays a verse inscription around
its rim that reads:

+AEDWEN ME AGE HYO DRIHTEN
DRIHTEN HINE AWERIE ÐE ME HIRE ÆTFERIE
BUTON HYO ME SELLE HIRE AGENES WILLES

[+Ædwen owns me, may the Lord own her. May the Lord curse him
who takes me from her, unless she gives me of her own free will.]

Even though this speaking object has a voice of its own, we may
assume that the OE verb *age* puts the brooch into a subservient
position as a material possession that has no independence apart
from its human owner. It may be significant, though, that the
inscription is on the back of the brooch, the part worn against the
body, where it would have been seen only by Ædwen herself – or
by the potential thief who had taken it from her. While the inti-
mate, owner–property relationship between Ædwen and her disc
brooch is undeniable, Karkov has observed that the power of the
curse that follows the statement of ownership 'relies to a certain
extent on her person not being present (otherwise the curse could
not have been seen), and to a degree of agency being transferred
to the object' for the brooch 'must be understood as having the
power to convey threat if the inscription was to be at all effective'.[38]
Thus, the balance of power between human owner and thing pos-
sessed was not always as hierarchical in Anglo-Saxon England as
one might imagine.

Maðum or *maþm* is another OE word used to denote treasure.
What is more, it is often used as a compound noun with the verb
giefan to evoke the ritual of exchange: a *maþþumgyfa* is a treasure-
giver, a king or warlord who deals out goods to his followers in
exchange for loyalty, so that the thing given and taken binds two
human beings together. But objects did not only accrue value via

ownership or exchange; the skill or craft that went into the creation of an artefact, and the display of that workmanship in the complex beauty of the item itself, also made a thing worth seeing, handling, owning or exchanging. *Searu* is an OE word denoting a device, design or artifice. It is an ambiguous word, and Bosworth-Toller lists a number of glosses where it is uncertain whether the word is used with a good or bad meaning. *Searu-* is used in a variety of compounds to refer to the skill or cunning invested in a crafted object. In *Beowulf, searu-* draws our attention to the highly wrought, aesthetic value of artefacts yet often carries dubious connotations. Grendel's glove is described as 'sid ond syllic, searobendum fæst' [roomy and rare, fixed with cunning bonds] but also 'eall gegyrwed / deofles cræftum ond dracan fellum' [all adorned with devil's craft and dragon's skin] (2085–8). *Searu-* did not refer exclusively to handmade, artificial items, for *searowundor* is the term used for Grendel's arm once it has been torn away by Beowulf and hung as a trophy in Heorot (920). OE *wræt* likewise describes a highly ornamented work of art, and *wrætlic* is an adjective applied to something that is artfully made, often used to invoke a sense of awe, as in the opening lines of *The Ruin*: 'Wrætlic is þes wealstan' [Wondrous is this wall-stone] (1). Once again, body parts can also be described as *wrætlic*. Grendel's severed head, this time, is referred to as 'wliteseon wrætlic' [a curious, beautiful sight] (1650) when Beowulf carries it into the mead hall for everyone to gaze upon. The Exeter Book riddles play on this overlap between adorned artefacts and curious or intriguing body parts which attract our attention with their unusual appearance. Riddle 44, for instance, describes something *wrætlic* that hangs beside a man's thigh. Stiff and hard, it enters a hole it has often filled before. The explicit solution is, of course, a key, but the implication is that this 'thing' is a curious sight that we cannot help but stare at in wonderment.

Finally, what about Old English words for signs and symbols? A *beacen* is a sign or portent. The TDOE states that the word can be used to designate a multitude of different 'signs' from the physical to the abstract, natural to manmade: miracles performed by Christ, the sign of the cross (with OE *beacen rodes* glossing Latin *signum crucis*), outward marks or gestures, standards, banners or monuments, idols, natural phenomena like the sun or fire, audible signals such as the sound of a bell. *Tacen* is another word for a sign, as well as a token or evidence of something. In *Daniel*, the writing on the wall to be interpreted by the eponymous prophet is

described as a *tacen*, showing or prefiguring imminent doom (717). Both OE terms – *beacan* and *tacen* – encompass a diversity of material items, but equally actions, events and phenomena that point to some referent beyond themselves, summoning up a metaphysical dimension that exceeds the mundane usefulness or functionality of objects. At the same time, however, many of these symbols retain the fragility and breakability of mere, everyday things; their hard, defining edges can shape the human self and body but those edges still blur and bleed into other things. As we shall see in Chapter 5, the so-called cross in *The Dream of the Rood* is not a fixed sign like a crucifix but a shifting thing, not yet formed or formable, losing its shape before it has the chance to take one.

To summarise this section, one might say that the range of Old English words for things reveals that they could play different roles in Anglo-Saxon culture: material or immaterial, animate or inanimate, elusive or owned, crafted and valuable, gifted or exchanged, but also autonomous, sometimes unknowable. The nuances of these Old English terms suggest that early medieval things resist being fixed in one form, function or ontological category. Words often try to capture certain aspects of a *þing* (or a *wiht* or *maðum* or a *searowundor* or a *beacan* or *tacen*) yet those words are also flexible and polysemous enough to reflect the entities they attach themselves to: words do not only define things; things can define their words.

Riddles, riddling and the enigmatic power of things

I have contended that the very word 'thing' and its Old English origins has played, and can continue to play, a central part in thing theory; but Anglo-Saxon culture has another claim on this ascendant area of study through the genre of the riddle. Literary scholar Daniel Tiffany contributed to the inauguration of thing theory by asking what poetic riddles may be able to tell us about the material substance of things. For Tiffany, when a thing speaks and takes on a verbal identity in riddles, it reveals its true 'substance'.[39] Tim Ingold has built upon some of Tiffany's ideas by arguing that materials are ineffable; they cannot be pinned down in terms of established concepts or categories. Therefore, to 'describe any material is to pose a riddle, whose answer can be discovered only through observation and engagement with what is there'. For Ingold, the riddle 'gives the material a voice and allows it to tell its own story: it is up to us, then, to listen, and from the clues it

offers, to discover what is speaking'.[40] Thus, the power and agency possessed by things has much in common with the way that the riddle works as a genre in Old English literature: riddles engage yet resist those who try to read them; riddles talk to us but also make us speak in response.

How does a riddle speak and how does a riddle make us, as readers, speak? The literary riddles of the Exeter Book use a variety of methods to disguise and defamiliarise things that were common in the Anglo-Saxon world: butter churn, bellows, key, mead, onion, anchor, fish, magpie, swan, cock and hen, sun and moon. An everyday item or phenomenon could be made mysterious by concealing its name, sometimes challenging us to 'say what I am called' or sometimes putting the name in runes to be decoded and rearranged or sometimes stating very obviously what the thing is but revelling in the curious nature of the creature or creation described anyway. Metaphor could also be utilised to take the familiar thing apart and put it back together, a means of temporarily representing things as other than they actually are, whereby each riddle-creature takes on the guise of another: a sword can be a chaste and celibate retainer, while an onion can pose as a penis or vice versa. Paronomasia is a form of word play often arising from the metaphorical language used in the riddles, deploying puns or punning to exploit the multiple meanings of words and cause deliberate ambiguity. Prosopopoeia is another frequently used technique in the Old English riddles, where the riddler communicates with the reader by speaking as another being or thing. In many of the riddles, the device of prosopopoeia is connected to the use of the first-person voice to create an element of surprise or wonder when a thing that one would not normally expect to speak describes its own creation, lifespan and behaviours. Other riddles adopt the more detached, inquisitive viewpoint of an observer who has seen or heard about some strange thing described in the third person. The tension between these third-person and first-person modes raises questions about the relationship between how we make meaning (hermeneutics) and how we define being (ontology): our recognition of nonhuman others that can speak ('I am') and be spoken about ('it is') helps us to 'enlarge both our sense of human perception and our understanding of alternate ways of being in the world'.[41] But riddling speech relies on the skilful deployment of silence for its effect. Silence can conceal key clues which, if spoken, would demystify the riddles and make the thing familiar again. Additionally, silence is as crucial as the incitement to 'say what

I am called' in making the reader talk. Those wordless gaps, those difficult silences, in which we are prompted to speak but fear that we cannot, or cannot speak correctly, problematise the assumption that humans always possess the power of speech and expose the limits of our ability to capture or pin down the nonhuman world by means of language.

These generic 'literary' devices are not exclusive to the manuscript page; they are commonly found on or across or around other material artefacts. For instance, the eighth-century Franks Casket features a riddle on its front panel that alludes to the former life of the whale from whose bone the box is made. The casket may also be using metaphor by describing this whale as *gasric* or the 'king of terror'. Not only does this riddle leave a number of ambiguous silences regarding the fate of *gasric* but the riddle itself (and what might be its answer) is encoded in runes. The Ruthwell monument likewise presents us with riddle-like runic texts on its north and south sides, in which a *galga* and a *rod* seem to speak in both the first and third person alternately. Prosopopoeia is utilised and the 'inert' monument imbued with sight, memory and voice. At the same time, the many silences left unfilled by the monument invite the viewer to bring their own sight, memory and voice into play. But the riddles and riddling devices used by whalebone casket and stone column alike cannot be divorced from their material context and they engage the viewer or handler in a tactile and mobile manner. Riddling was not a matter of purely intellectual gameplaying in Anglo-Saxon culture. On the contrary, there was something very visible, audible, tangible and kinetic about this trickery.

Indeed, reading (OE *rædan*) and riddling (OE *rædels*) are etymologically connected in Old English.[42] Riddling is a form of reading that does not look through or skim over words, or flick through pages, in the way that someone might read a popular modern novel. Rather, riddling asks for a reader who will engage with the words on the page or other surface in a sensuous way, drawing on a combination of sight, sound, speech, even touch. The recurring phrases that run throughout the Exeter Book riddles support this claim: *ic seah*, *ic gefrægn*, *saga hwæt ic hatte* (see, hear, say). The riddles of this collection produce responsiveness in their audience, who must be able to voice solutions orally and decode tricky sets of letters or runes visually.[43] The use of runes in manuscripts and elsewhere may combine the visual element of reading with touch, too; not only are runes incised into or carved out of artefacts in a three-dimensional manner that invites touch, but the shapes of

certain manuscript runes may also have been manipulated by successive writers and readers interacting with the page.[44] Reading riddles in Anglo-Saxon culture is a multisensory and multidimensional endeavour where words combine with images, sounds and materiality to simultaneously yield and defy solutions. It is a perceptual, as well as mental, exercise, and an exercise that discourages us from looking *through* textual objects.

The etymological link between 'riddle' and 'read' suggests that riddling is essentially a form of close reading. In fact, riddling can be seen as the *closest* form of reading. Riddles invite us to attend to the object thrown before us so closely, so carefully, that we glimpse beyond the veil of the material world, promising to reveal the hidden nature of things. Riddles insist on obscurity while revealing underlying links in the fabric of creation. Each descriptive component within a riddle can be applied to more than one animal, artefact, vegetable, weather phenomena or heavenly body; but in attempting to draw these elements together into one solution, the reader tries to make them cohere into a single named thing. In this way, riddles have much in common with 'things that talk' as defined by Lorraine Daston. For Daston, talkative things are often chimeras, 'composites of different species' that threaten to overflow their outlines. At the same time, there is a tension between 'their chimerical composition and their unified gestalt that distinguishes the talkative thing from the speechless sort'. Such things can circumscribe and concretise previously unthinkable combinations and thus become a 'paradox incarnate'.[45]

This description equally applies to the various *wihtu* depicted in the Exeter Book poems. Riddles and things share the ability to gather other things to them, embodying a tension between disparate parts and circumscribed whole. In addition to the agency of assemblage, another way in which the power of things resembles the riddle is in their enigmatic resistance and elusiveness. Brown defines thingness as the ambiguity that coalesces around the other side of the obscured object.[46] Or, as Harman puts it, 'like the moon, one face of the tool is darkened in the silence of its orbit, while another face illuminates and compels us with dazzling surface-effects'.[47] This warrants further comparison with the riddle, especially those of the Exeter Book which seem to lack clear and definitive solutions.[48] Even when we settle on one answer, we can never be sure that it is *the* answer. As a result, these riddles can never be objectified; they, too, are always partially obscured. As we say one name (shield, swan, wine, anchor, plough, moth, oyster,

creation) a myriad of other names hover on the periphery of our vision, dance on the tip of our tongue. Riddles, like things, have the power to resist human knowledge, human mastery. The efforts of the reader to try and fail, try and fail, to solve a riddle are not unlike the processes of making and breaking that things embody and enact. As John D. Niles says of the Old English riddles, many of them can be read perfectly well in several different ways and in any case 'finding the solution to a riddling text is scarcely the end of the experience of reading it'.[49] Similarly, one of the aims of this book is to complicate the notion of a completed artefact and to contend that the 'solid' or 'finished' object is not the be all and end all of our encounter with things. Just as a riddle may thwart our efforts to answer it once and for all, so too do things make, break and remake themselves in an ongoing process of becoming.

These initial observations on the affinities between riddles and things are the starting point for a theme that will run throughout this book. Each chapter will feature a thing that is also a riddle or at least riddle-like: in the first chapter, I look at the giants' sword in *Beowulf*, which shifts its shape and function from cutting blade to sword hilt to runic text to something else; in the second chapter, I focus on Old English and Anglo-Latin riddles and the way that the things they describe reshape conceptions of time; in the third chapter, I ask how the three-dimensional riddles of the Franks Casket have the power to move us; in the fourth chapter, I consider the mystery of the Word as embodied by the enigmatic, labyrinthine design of the Lindisfarne Gospels; and in the fifth and final chapter, I reflect on the unanswerable riddle that is *The Dream of the Rood* and the related silences and paradoxes of the ever-altering Ruthwell monument.

Speaking subjects, speaking objects and other things that talk

New materialists continue to wrestle with the fluid relationship, the back and forth, between the 'human subject' and 'nonhuman objects'. When exploring the intersections between modern thing theory and an early medieval culture, it is important to historicise this relationship and thereby question the apparently immutable boundaries that are drawn between human and nonhuman. What is deemed an object, or a speaking object, and who or what is deemed a speaking subject in Old English literature? How might the shifting boundaries between these two categories reveal shifting ideas about the location of selfhood and subjectivity, objecthood and

objectivity? It certainly appears that the power of speech could be ascribed across the subject–object boundary in Old English texts, as well as material culture. In fact, the OE concept of a *reordber-end* (literally translated as 'speech-bearer') features prominently in such poems as *The Dream of the Rood*, *The Husband's Message*, the Exeter Book riddles and the inscriptions on the Ruthwell and Brussels Crosses, where both 'animate' human subjects and 'inanimate' nonhuman objects can talk.

Old English texts display an awareness that voice can be seen as well as heard, deciphered as well as spoken, inscribed as well as chanted; that it can be borne by or within a body as well as performed by one. Extant Anglo-Saxon culture provides ample evidence for an oral tradition in which poems (and laws, maxims and gnomic wisdom) were composed, recited, memorised and passed on. At the same time, Anglo-Saxon readers needed to decode complex combinations of letters, scripts and languages both on the manuscript page and on the surfaces of other artefacts. Most scholars now recognise that a sharp divide between 'oral' and 'literate' modes of communication does not reflect the realities of Anglo-Saxon England, and that oral poetry can involve and interact with writing and reading – encompassing everything from live verbal performance, to texts composed in writing but recited aloud, and texts written for the page but composed in a traditional oral style.[50] The interrelatedness of orality and literacy in this 'transitional' age may be glimpsed in the surviving literature.[51]

Beowulf famously opens with a reference to the courage of the Danes in days of old which 'we' have heard or learnt about through asking – strongly evoking an oral community that shares ancient stories by remembering, speaking and listening (1–3). However, the opening of *Beowulf* does not truly take place in any such environment, for the poem is written down in a manuscript, MS Cotton Vitellius A. xv, very much a literary codex that includes prose works and a number of illustrations, making this an artefact to be viewed as much as heard. Elsewhere, Bede's story of Cædmon summons up a seventh-century world where it was customary for a cowherd to recite poems he had learnt by heart (IV.24).[52] And yet, after being graced with the gift of song by God, memorising, ruminating on and reciting fitting Christian verse in front of an audience throughout his lifetime, Cædmon's poetic voice was preserved on parchment and endured across the Anglo-Saxon period because it was borne by the (transformed) bodies of the beasts he once watched over in the cattle byre when too embarrassed to sing.

In an atmosphere where 'orality' and 'literacy' coexisted and were interdependent, voice could, quite literally, move across the divide between human subject and nonhuman object. Anglo-Saxon poets, composers, compilers, scribes and other craftsmen must have been highly conscious of this, a consciousness reflected in many Old English texts.

Many of these texts feature the voices of what might nowadays be referred to as speaking subjects. A number of Old English elegies express individuality and perhaps even introspection. *The Wanderer* introduces us in its opening lines to an *anhaga*, suggesting both one who is alone and one who thinks intently, before speaking in the first person about hardships endured in a state of loneliness, bemoaning his inability to say what is in his heart even while doing exactly that in a personal speech-poem: 'Oft ic sceolde ana uhtna gehwylce / mine ceare cwiþan; nis nu cwicra nan / þe ic him mod-sefan minne durre / sweotule asecgan' [Often I must sing about my sorrow, alone each dawn; there is no one left alive to whom I dare speak my heart] (8–11). *The Wanderer* provokes our sympathy for the plight of a fellow human yet also offers wisdom and consolation, its anonymous voice still reaching out to us across the ages. *The Seafarer*, too, explores the nature of suffering in the poetic voice of a speaking subject: 'Mæg ic be me sylfum soðgied wrecan' [I can recite a true song about myself] (1). *The Wife's Lament* shares many features with both *The Wanderer* and *Seafarer*, but has the distinction of being spoken or sung in a female voice: 'Ic þis giedd wrece bi me ful geomorre, / minre sylfre sið' [I speak this poem full of sorrow about my own fate] (1–2).

Yet this kind of personal expression, the ability and desire to relate one's own life experiences, is not, by any means, unique to humans in the corpus of Old English literature. One immediately thinks of the speaking objects of the Exeter Book riddles, which sit alongside *The Wanderer*, *Seafarer* and *Wife's Lament* in the same poetic anthology. John Miles Foley has shown that, because the same alliterative verse form serves as the vehicle for all Anglo-Saxon poetic genres, the phenomenon of 'generic leakage' can be extremely common: that is, the diction and motifs associated with one genre migrate to another.[53] If we can detect generic leakage between the elegiac and riddling verse of the Exeter Book, then this overlap has implications for identity: as genres leak into each other, ontological boundaries become fluid or 'leaky' too. Critics tend to associate elegies such as *The Wanderer* or *Wife's Lament* with human speakers (men and women) and the riddles with

nonhuman speakers (animals and artefacts). However, if diction, motifs and narrative patterns can leak from one genre to the next, then it must be true that the experiences and emotions expressed in these poems can also criss-cross between human subjects and nonhuman objects.[54]

In Riddle 5, for instance, a thing that may be a shield (or a chopping board) also describes itself as an *anhaga*. Speaking in the first person, this solitary and thoughtful artefact goes on to relate the loneliness and suffering it has endured throughout its lifetime in a way that is reminiscent of *The Wanderer*.[55] Riddle 26 has a first-person speaker recounting the process of book-making from its own, personal perspective. Much like the human speakers in the aforementioned poems, the animal-turned-parchment recalls the hardships it underwent as 'Mec feonda sum feore besnyþede' [An enemy ended my life] (1). From the slaughtering of the beast, to the removing of hairs, the folding of the page and the act of marking skin with inky words, this poetic voice expresses the torment and torture it has known but then offers comfort, wisdom and consolation, revealing that 'Gif min bearn wera brucan willað, / hy beoð þy gesundran ond þy sigefæstran' [If the children of men make use of me, they will be the safer and the more sure of victory] (18–19). In both cases, the speaking object shows itself to be as capable of reflecting on its personal experience, arousing pathos and conveying hope to us as the speaking subjects of the previous poems. Even if literary works such as *The Wanderer* present us with 'a single complex persona', the equally complex beings that talk to us in the riddles question the notion that *The Wanderer* and other elegies offer a 'profoundly moving view of the human condition'.[56] For Anglo-Saxon writers, this 'condition' may well have been profoundly moving but it was not always exclusive to humans.

A lot of Old English poetry appears to offer a personal, heartfelt reflection on life, but these poetic words do not necessarily come from 'within' the speaker. It is important not to imbue this poetry with the Romantic aura of a later period. These are not unique expressions summoned up by a private individual; rather, they are often attributed to divine inspiration. Cædmon's poetic skill is depicted by Bede as a gift from God rather than a skill learnt from men and his 'hymn' is not the result of 'the spontaneous overflow of powerful feelings'.[57] It is not individualistic human emotion or sensibility but an angelic visitation in the midst of a dream that catalyses a dramatic transformation in Cædmon, from shy cowherd who would flee at the sight of the harp to a skilled *scop* capable of

captivating an audience. In *The Dream of the Rood*, likewise, it is clear that the dreamer is relating something that comes not from within but outside of him. He says he will tell the best of dreams, 'hwæt me gemætte' [what (it) dreamed to me] (2).[58] The use of the impersonal verb implies that the dreamer did not dream his vision; it dreamed him or it dreamed to him. In both instances, poetic inspiration comes from an external authority instead of being something original to the 'poet'.

When God is not invoked as the inspiration for Old English poetry, a shared tradition is called upon. As Carol Braun Pasternack points out, the 'Hwæt' and then 'I have heard/I have found/we have heard' formula has a mnemonic value, linking memory and tradition to 'suggest that the following text is a commencement and that it has origins in a tradition circulating orally within the community or found in books'.[59] If it has been heard or found, then the poem or song cannot be said to belong to its 'author' in the same way that a modern text does; it is something out there already. If this poetry is inspired by God in a dream, or found in tradition, that is, if it comes from external, shared sources rather than internal, original sources, then objects should be able to talk as well as subjects. In this way, an animal or artefact can receive a poem upon or within its body as easily as a human can. Humans and nonhumans alike may perform as *reordberend*: speech-bearers. Moreover, the staged 'I' in *The Wanderer, Seafarer, Dream of the Rood*, and other poems, has 'not yet fully become a fictional narrator: the language remains formulaic rather than shaped to imply a particular subjectivity'.[60] This lack of individualised subjectivity allows objects to lay claim to speech and carry a voice across time and space, presenting a challenge to the modern day 'common-sense' view that only human subjects can truly speak whereas speaking objects must always be ventriloquised.

It may be counter-argued that there is no thing 'there' behind those literary texts in which an object talks. But this is not so different to the way that there is no human body there behind texts in which a subject talks. In his study of the Old English enigmatic poems, Niles makes the point that these texts 'put on display certain imagined actors (or voices) who are embroiled in certain imagined circumstances' so that it is 'up to the members of the audience to infer who these people are, what their stories have been, what makes the speakers "sing", what may ensue after the poem stops, and what wisdom one can gain by reading these things'. Niles warns against mistaking these imagined voices for

real human beings, even in those instances where we think we are
dealing with a named author. For example, when analysing those
poems in which the CYNEWULF runes are embedded, we should
not pursue the question of individual identity too far, 'for then we
would not so obviously risk mistaking for flesh-and-blood reality
what is really no more than a rhetorical effect'.[61] A good deal of
Old English poetry involves these (often riddle-like) performances,
whereby a rich variety of roles are assumed and a multiplicity of
voices are thrown. One might assume that an onion is not 'really'
doing the talking in Riddle 25, or that a drinking horn is not actu-
ally speaking to us in Riddle 14, but neither can we know for sure
that an authentic female voice utters *The Wife's Lament*, or that
the speaker of *The Seafarer* ever fared out to sea. When I confront
issues of prosopopoeia in this book, I will refute the notion that
distinctly human attributes are simply imposed upon nonhuman
others; instead, we encounter collaborative performances between
human and nonhuman actors in which the nature of things (their
materiality, lifespan, tendencies, movements) can shape ideas about
the human self and the human world.

The aesthetics of prosopopoeia that we find in the Old English
riddle genre, and in poems that draw upon that genre, can be
encountered in Anglo-Saxon epigraphic 'speaking objects' as well.
For Peter Ramey, these inscriptions demonstrate a vernacular
concept of writing as a curiously material form of speech, and it
is 'precisely this vernacular notion of writing as a voice that mys-
teriously inheres within the object, yet also stands apart and com-
ments upon its own materiality, that informs the more concrete
prosopopoeia of the Exeter Book Riddles'.[62] As such, the prosopo-
poeic voice is generated by the interplay of material and text. This
interplay means that epigraphic speaking objects present us with
a slightly different interpretive challenge to their counterparts in
Old English poetic manuscripts. With the exception of riddles
like number 26, in which parchment speaks, the formula 'say what
I am called' is often uttered by an object that is absent and which
must be summoned forth by the imagination and responding
voice of the reader. Conversely, with epigraphic speaking objects
like Ædwen's brooch (mentioned above) there is no riddle to be
solved because the 'solution' is physically present, in the hand or
before the eye of the reader. And yet, as we will see, these voices
often play on their own materiality in ways that ask their human
viewers or handlers to meditate upon the enigmatic relationship
between words and the things that carry those words: sometimes

by connecting the inscribed voice to the material or materials into which it has been carved (e.g. the Franks Casket) or sometimes by creating a disconnect between speech and object (e.g. the Ruthwell monument).

Voices from Anglo-Saxon England are therefore shaped and altered by the material things onto which they have been inscribed. These voices are not found in manuscripts alone, but can be borne by weapons, helmets, rings, brooches, caskets, crosses, columns, sundials, even buildings. Nor do these voices always represent poetry in the purest sense; early medieval artefacts may be marked with poetic fragments, riddles, charms, curses, threats, names, claims of ownership and other forms of verbal address. What is more, they communicate across languages (Old English and Latin) and play with different scripts (Roman alphabet and runic fuþorc). Sometimes they speak in the first person and sometimes in the third person, and other times they display a complex interaction of both first- and third-person inscriptions. With a number of arte-facts, it can be near impossible to tell what kind of inscribed voice is speaking – or even whether that voice is attempting to commu-nicate with us at all.

The gilded silver fitting discovered in the River Thames near Westminster Bridge displays a prominent runic inscription that has defied interpretation to date. This is a thing that seems as if it *should* be talking but which fails to make straightforward mean-ing. It features a striking animal head, with blue glass eyes which, whilst fearsome, almost lend an air of intelligence. Its open mouth and sharp fangs hover between feral snarl and playful grimace, while its long tongue implies eloquence even as it loops round and ties itself to the back of the beast's throat. Archaeologists can only speculate that this artefact might have been part of the binding for a *seax* sheath, the rivets along its length probably holding it to the leather or wood of a scabbard. Another possibility is that it is a fragment of the ridge-piece of a gabled shrine. It has been broken, loosened, freed from whatever function it once served and now stands apart – curious, singular. Those remarkable runes promise to reveal more – what was this thing for, who made it, who owned it, why was it discarded? But the runologists are as stumped as the archaeologists. R. I. Page notes, approvingly, that the runes are 'clearly cut, finely shaped and elegantly seriffed' but unfortunately 'they make no obvious sense'.[63] Transliterated, they read:

|| s b e r æ d h t e o b c a i || e r h a d æ b s ||

Each inscribed object speaks in a unique way, not simply due to the idiosyncrasies of the words, languages or scripts used, but because the voice of each object interacts with its materiality differently. The famous Alfred Jewel, dating from the late ninth century, reveals in a first-person inscription that 'AELFRED MEC HEHT GEWYRCAN' [Alfred ordered me to be made]. This inscription implies obedience and subservience and yet this humble voice cannot be divorced from its material setting: the reused Roman polished crystal from which the Jewel is made imbues this speaking object with both worldly and spiritual power, with rarity and purity, value and faith, opulence and innocence. This materiality is bound up with the purpose of the Jewel, for if this artefact was indeed once an *æstel*, used to skim the manuscript page and follow words when reading a book, then the light-reflecting, light-bearing crystal enhances its power as a pointer towards wisdom. The servile Jewel possesses a voice, but the servant can also turn master, teaching its human makers and owners how to see, hear and speak. The Jewel that was ordered to be made can, in turn, make us into readers.[64] Thomas Bredehoft examined the first-person inscriptions on Anglo-Saxon speaking objects and made a case for them extending knowledge of literacy through textual communities. Bredehoft claims that many inscribed objects were meant to be read aloud within literate circles by interpreters who did not necessarily have to be the owner of the object but who would lend their voice to it.[65] However, Karkov has questioned whether 'communal access to the texts via the spoken word was what gave them their efficacy and power' and whether 'it was actually necessary for the inscription to be read out loud by someone lending his or her voice to the object'. Instead, the power inherent in the inscribed statement or curse might have been increased 'if the object itself was seen as having its own voice, even if the words it "spoke" might not have been comprehensible to all'.[66]

Inscribed Anglo-Saxon artefacts could form and extend literacy within human communities. At the same time, the thingness of these things creates, alters or subverts inscribed voices in surprising ways. The materiality of an artefact can mould or remould linguistic meaning while the enigmatic latency and excess of things often resists human efforts to read, name, know and control. Talking things can even disrupt literate communities by bringing alien, partly incomprehensible, voices from distant times or places into their midst. What a thing refuses to say – the

manner by which it cannot be read – is as significant as what it does have to say.

If indeed many literate Anglo-Saxons were accustomed to seeing epigraphic inscriptions and knowing that they 'said' something and that the texts could be given voice, then it is tempting to speculate about how these speaking objects would have functioned in performance, tempting to reconstruct the moment in which these objects would have been vocalised, enacted upon a listener or group of listeners, as part of a social ritual.[67] Yet this assumes that all speaking objects will yield to interpretation. What about a thing like the Thames silver fitting? How would it have been possible to 'read' and perform an object that speaks nonsense? Lending voice to an object can animate it, enabling it to speak to its human users; but, when that voice speaks incoherently, then the thing once again resists and retreats from us. It is vaguely possible that the obscure and fragmentary inscription borne by the silver fitting represents runic magic.[68] But even this depends upon an extensive knowledge of runes and a belief in their magical powers. What happens when the rune-knower is absent from a social setting?

At some stage in its life history, the Thames silver fitting might have assembled together human beings (whoever owned it, whoever could read its runes), animals (its head evokes the appearance and power of a wolf), other artefacts (whatever it was attached to, whether a leather scabbard or gabled shrine) and maybe even gods or other supernatural beings. Somehow, though, the fitting found its way to the bottom of the River Thames – discarded, torn apart from the context which would have imbued it with meaning. This shift from object to thing alerts us to the difficulties of 'knowing' an entity that has been broken, or spoiled, or dispersed, or abandoned. Yet, as Ian Hodder reminds us, it is only because we take things for granted that they become invisible to us, that we fail to notice their characteristics, forgetting that they are connected to and dependent on other things, that they are not necessarily inert, but may have temporalities different from our own.[69] When humans can no longer use objects as we find them, we are forced to look at, rather than through, *things*, and our relationship with them is changed. We might look more closely and carefully at the blue glass eyes (looking back at us) of the Thames silver fitting or question why it has been tongue-tied. The obscurity of its inscription might encourage us to retrace relationships we had overlooked before, such as that between smith and warrior. Or we may

involve the silver fitting in different social and material contexts, linking it to other extant Anglo-Saxon artefacts and increasing its lifespan by recovering it from a watery grave and housing it in a museum. From the point of view of the Thames silver fitting it has (as Jane Bennett would put it) refused to dissolve completely into the milieu of human knowledge, but has endured across a stretch of time unimagined by its original human makers, breaking free from the social rituals it was intended for and entering into unanticipated relationships, forming new assemblages of humans and nonhumans. It has asserted its thing-power.

Talking with things

This introduction has established some of the key features of early medieval 'thingness' that I will be paying attention to throughout this book. Voice will be a central part of my discussion: how do things talk and how does their talkativeness shape or reshape the human voice? Time is another focal point: how do things resist being frozen in one form or function; how do they change across temporal spans and how do they carry words, ideas, bodies or technological processes from the past into the present and the future? Space is a third important factor: how do books or relics or monuments have the power to move human bodies in space; how do things assemble other things into a solid yet composite, unified yet paradoxical whole?

Chapter 1 starts with a discussion of the different ways in which human bodies and nonhuman things carry and communicate – or fail to communicate – knowledge. It engages with thing theory to demonstrate that both Grendel's mother and the giants' sword found in her underwater hall are riddle-like things that resist the kinds of reading that Æschere, a rune-knower and advice-bearer, was meant to provide for King Hrothgar. By killing and decapitating Hrothgar's reader, Grendel's mother highlights an anxiety within *Beowulf* about 'things' that defy human interpretation and convey monstrous, marginal or unknowable messages instead. Although *Beowulf* acknowledges that a wide range of artefacts can be read, the text also reveals that certain enigmatic things exceed their role as readable objects. Liminal things like the giants' sword carry alien stories and histories into the safety of the mead hall, disrupting a longstanding human reliance upon legibility and altering the way that literate communities interpret that which has come before them.

Those who wish to take the claims of thing theory seriously should slow down and 'try to linger in those moments during which they find themselves fascinated by objects'.[70] Anglo-Saxon culture invites us to cultivate a lingering fascination with the blade that melts like ice at the turning of the seasons, the candle clock that burns too swiftly, the stone monument that crumbles and fades, the bone that endures as a relic, human and animal skin that does or does not display the corruption of death. The second chapter of this book is therefore concerned with the 'thingness' of time. By refusing to remain fixed within one form, the speaking creatures in Old English and Anglo-Latin riddles invite human readers to rethink how our own bodies, as things among other things, may cross categories of age, role and gender over different stretches of time.

As the book reaches is midway point, I place emphasis on space as well as time; in particular, how a three-dimensional object uses its own shape, size and material substance to interact with us kinetically. Chapter 3 considers how the interpretation of the Franks Casket is bound up with movement. It opens with a brief overview of previous criticism on the casket in order to look at how different scholars have read it, but especially how they have moved around the box as they endeavour to solve its riddles. Is there a correct order in which we might read the casket? Can the reader finally solve it? The casket could instead be seen as a 'thing' that itself has the ability to move those who encounter it. In doing so, it actively forms human identities. The second part of this chapter explores the Franks Casket as an assembly. To address this issue, I draw on Daston's definition of things that talk, in which she identifies a tension between their chimerical composition and their unified gestalt. The Franks Casket is a thing that can be seen to circumscribe and concretise previously unthinkable combinations, becoming a 'paradox incarnate'.

Chapter 4 continues to pursue the theme of assemblage. This chapter looks at how the books, relics and other material things associated with the cult of St Cuthbert reshaped 'universal' Christianity within a distinctly Northumbrian environment in the seventh and early eighth centuries. I begin by moving the focus from an animal body (whalebone) to a human (saintly) body, thinking about how the saint – both as text, in the hagiographical evidence, and as relic, in the case of the incorrupt corpse – assembles and performs differing elements of Christianity through his body. But as well as acting as an assembly, the saintly body is also

a thing that crosses the boundaries between life and death, animate and inanimate, organic and artefactual. The second part of the chapter homes in on the Lindisfarne Gospels, dedicated to God and St Cuthbert. Like the Lives of St Cuthbert, the gospel book reshapes a universal sign (the body of Christ as Cross) into a perceptible thing.

The fifth and final chapter turns its attention to the other side of assemblage – that is, the way that things break up and break away. The poem usually referred to as *The Dream of the Rood* is a fragile thing that has been broken apart and pieced back together time and again. It is not a sound or coherent whole, in any of its forms (manuscript poem, runic inscriptions, etc.) but an elusive assortment – at once breakage and assemblage – that invites us to participate in its ongoing process of becoming.

With regards to the ordering of these chapters, I have opted not to treat these Anglo-Saxon texts and artefacts in a strictly chronological sequence. Rather, the main principles informing the chapter organisation are provided by theoretical and thematic concerns. Broadly, I start by restricting my analysis to the role played by nonhuman things within Old English literary texts, and then change tack to examine an extant artefact inscribed with texts and images, before combining these two approaches in the final two chapters to consider how things can be represented within texts while, in return, texts can be altered by the things into or onto which they have been inscribed. In doing so, we confront the limits of textual evidence for grasping materiality, but also the problems presented by actually existing artefacts that may have changed, moved or broken since the early Middle Ages. Another thematic organisational principle is the progression from issues of time, temporalities and change; to space, movement and assemblage; to fragility, breakage and failure. These issues spring from the central concerns of thing theory and inform one another, and, as such, I have selected case studies that best exemplify the points raised and situated them in a sequence that links one point to the next. I have primarily, but not exclusively, chosen Anglo-Saxon texts (*Beowulf*, *The Dream of the Rood*) and artefacts (Franks Casket, Ruthwell monument) that have long and vexed critical histories in order to see how early medieval things, when loosened from overly familiar discourses, can disrupt the disciplinary divisions that have been imposed upon them; I am interested in the before and after, the latency and excess, of the literary and material object of study.

The five chapters outlined here will establish that, in the period of English history we call Anglo-Saxon, humans at once used and relied on things to carry their voices. Early medieval patrons, makers, owners, handlers and viewers did not talk over or about or for things, but talked *with* things. This was a human–nonhuman dialogue, a dialogue that did not end with the Norman Conquest but has continued in the afterlives of Anglo-Saxon texts and artefacts and in the scholarship that has circled those lives. At the same time, this is not a conversation that can be easily contained by human discourse, the present study included. When we talk with things, something always has and always will elude us. This way of thinking is encompassed by the two quotes which opened this introduction. Both the Argentinean poet and the Anglo-Saxon riddler recognised that mere things shape our memories (the memories we hold and the memories others hold of us) in a way we cannot quite comprehend; they may seem like silent slaves while we are alive and animate and active, but as time stretches out we are the ones who are at the service of these entities, these strange beings with the ability to elongate our lives and prolong our voices, these things wrought by us and yet still wondrous to us.

Notes

1 Translation by Stephen Kessler, in Jorge Luis Borges, *Selected Poems*, ed. Alexander Coleman (London: Penguin, 1999), p. 277.
2 This text, and all further references to the Exeter Book, taken from Bernard J. Muir (ed.), *The Exeter Anthology of Old English Poetry: An Edition of Exeter Dean and Chapter MS 3501* (Exeter: University of Exeter Press, 1994). Translations are my own.
3 Arjun Appadurai (ed.), *The Social Life of Things: Commodities in Cultural Perspective* (Cambridge: Cambridge University Press, 1986).
4 Bill Brown, 'Thing Theory', *Critical Inquiry*, 28:1 (Autumn 2001), 1–22; Bill Brown, *A Sense of Things: The Object Matter of American Literature* (Chicago: University of Chicago Press, 2003).
5 See Martin Heidegger, *What is a Thing?*, trans. W. B. Barton Jr. and Vera Deutsch (Chicago: Henry Regnery, 1970); Graham Harman, *Tool-Being: Heidegger and the Metaphysics of Objects* (Chicago: Open Court, 2002).
6 Brown, 'Thing Theory', p. 3.
7 Another big influence on a burgeoning 'thing theory' in the early 2000s was Lorraine Daston (ed.), *Things That Talk: Object Lessons from Art and Science* (New York: Zone Books, 2004). I draw on Daston's ideas in more detail below and in subsequent chapters.

8 Levi Bryant, Nick Srnicek and Graham Harman (eds), *The Speculative Turn: Continental Materialism and Realism* (Melbourne: re.press, 2011), p. 3.

9 Diana Coole and Samantha Frost (eds), *New Materialisms: Ontology, Agency and Politics* (Durham: Duke University Press, 2010), p. 6.

10 Jane Bennett, *Vibrant Matter: A Political Ecology of Things* (Durham: Duke University Press, 2010), p. 3.

11 Ian Bogost, *Alien Phenomenology, or, What It's Like to Be a Thing* (Minneapolis: University of Minnesota Press, 2012).

12 Levi Bryant, *The Democracy of Objects* (Ann Arbor: Open Humanities Press, 2011); Timothy Morton, *Hyperobjects: Philosophy and Ecology after the End of the World* (Minneapolis: University of Minnesota Press, 2013).

13 Ian Hodder, *Entangled: An Archaeology of the Relationships between Humans and Things* (Oxford: Wiley-Blackwell, 2012).

14 Tim Ingold, *Being Alive: Essays on Movement, Knowledge and Description* (London: Routledge, 2011); Tim Ingold, *Making: Anthropology, Archaelogy, Art and Architecture* (London: Routledge, 2013).

15 I have touched only on those studies that are most pertinent to my aims; however, the literature on 'thing theory' is ever-expanding: see also Bill Brown (ed.), *Things* (Chicago: University of Chicago Press, 2004); Daniel Miller (ed.), *Materiality* (Durham: Duke University Press, 2005); Daniel Miller, *The Comfort of Things* (Cambridge: Polity Press, 2008); and the 'Object Bibliography' in Fiona Candlin and Raiford Guins (eds), *The Object Reader* (London: Routledge, 2009). Relevant works by other authors will be cited as needed below.

16 Kellie Robertson, 'Medieval Things: Materiality, Historicism, and the Premodern Object', *Literature Compass*, 5:6 (2008), 1060–80. Cf. Bruno Latour, *We Have Never Been Modern*, trans. Catherine Porter (Cambridge, MA: Harvard University Press, 1993). Latour argues that the dividing line between the human subject and the nonhuman object was more porous prior to the seventeenth century. He states that 'modernity' is based on this false binary, this ontological distinction between inanimate objects and human subjects, whereas in fact the world is full of quasi-objects and quasi-subjects.

17 Kellie Robertson, 'Medieval Materialism: A Manifesto', *Exemplaria*, 22:2 (2010), 99–118.

18 Jeffrey Jerome Cohen (ed.), *Animal, Vegetable, Mineral: Ethics and Objects* (Washington, DC: Oliphaunt Books, 2012). See also Jeffrey Jerome Cohen and Julian Yates (eds), *Object Oriented Environs* (Earth: Punctum Books, 2016), which explores the critical confluence between the environmental turn and thing theory.

19 Jessica Brantley, 'Material Culture', in Marion Turner (ed.), *A Handbook of Middle English Studies* (Oxford: Wiley-Blackwell), pp. 187–206.

20 Martin K. Foys, 'Media', in Jacqueline A. Stodnick and Renée R. Trilling (eds), *A Handbook to Anglo-Saxon Studies* (Oxford: Wiley-Blackwell, 2012), pp. 133–48.

21 Bruce Holsinger, 'Of Pigs and Parchment: Medieval Studies and the Coming of the Animal', *PMLA*, 124 (2009), 616–23; Sarah Kay, 'Legible Skins: Animals and the Ethics of Medieval Reading', *Postmedieval: A Journal of Medieval Cultural Studies*, 2:1 (2011), 13–32.

22 Catherine E. Karkov, *The Art of Anglo-Saxon England* (Woodbridge: Boydell Press, 2011), pp. 135–78.

23 Benjamin C. Tilghman, 'On the Enigmatic Nature of Things in Anglo-Saxon Art', *Different Visions: A Journal of New Perspectives on Medieval Art*, 4 (January 2014), http://differentvisions.org/on-the-enigmatic-nature-of-things-in-anglo-saxon-art.

24 There is, moreover, an ever-increasing interest in the intersections between Old English literature, thing theory and ecocriticism among postgraduate and postdoctoral scholars. See, for example, Helen Price, 'Human and NonHuman in Anglo-Saxon and British Postwar Poetry: Reshaping Literary Ecology' (unpublished doctoral thesis, University of Leeds, September 2013); Corinne Dale, 'Suffering, Servitude, Power: Eco-Critical and Eco-Theological Readings of the Exeter Book Riddles' (unpublished doctoral thesis, Royal Holloway, University of London, September 2015).

25 Brown, 'Thing Theory', pp. 4–5.

26 See Martin Heidegger, *Poetry, Language, Thought*, trans. A. Hofstadter (London: Harper, 1971).

27 Ian Hodder, 'Human–Thing Entanglement: Towards an Integrated Archaeological Perspective', *Journal of the Royal Anthropological Institute*, 17 (2011), 154–77, at 157. See also Hodder, *Entangled*.

28 Latour, *We Have Never Been Modern*.

29 See, primarily, the OED entry for 'thing' online at www.oed.com; see also C. T. Onions et al. (eds), *The Oxford Dictionary of English Etymology* (Oxford: Oxford University Press, 1966); and Robert K. Barnhart et al. (eds), *The Chambers Dictionary of Etymology* (London: Chambers, 1999).

30 *Chambers Dictionary of Etymology*, p. 1134.

31 See, for instance, *Njal's Saga*, ed. and trans. Robert Cook (London: Penguin Classics, 2001).

32 Thomas Northcote Toller, *An Anglo-Saxon Dictionary: Based on the Manuscript Collections of Joseph Bosworth Supplement, by T. Northcote Toller* (Oxford: Clarendon Press, 1972). Also available online at http://bosworth.ff.cuni.cz/. Henceforth abbreviated as Bosworth-Toller.

33 This and all further references to *Beowulf* are taken from R. D. Fulk, Robert E. Bjork and John D. Niles (eds), *Klaeber's Beowulf and the Fight and Finnsburg* (Toronto: University of Toronto Press, 4th edn, 2008). Translations are my own.

34 Lorraine Daston, *Biographies of Scientific Objects* (Chicago: University of Chicago Press, 2000), p. 2.
35 Hodder, *Entangled*, pp. 7–8.
36 Kevin Crossley-Holland (trans.), *The Exeter Book Riddles* (London: Enitharmon, 1978), p. 50.
37 See *The Toronto Dictionary of Old English Corpus in Electronic Form*, ed. Angus Cameron, Ashley Crandell Amos, Antonette diPaolo Healey et al. (Toronto: 1981–). Henceforth abbreviated as the TDOE.
38 Karkov, *Art of Anglo-Saxon England*, p. 158.
39 Daniel Tiffany, 'Lyric Substance: On Riddles, Materialism, and Poetic Obscurity', *Critical Inquiry*, 28:1 (Autumn 2001), 72–98, at 75. I return to Tiffany's essay in Chapter 2.
40 Ingold, *Making*, p. 31.
41 Craig Williamson (ed. and trans.), *Beowulf and Other Old English Poems* (Philadelphia, PA: University of Pennsylvania Press, 2011), p. 162.
42 For discussion, see Nicholas Howe, 'The Cultural Construction of Reading in Anglo-Saxon England', in Jonathan Boyarin (ed.), *The Ethnography of Reading* (Berkley, CA: University of California Press, 1993), pp. 58–79. I examine the connection between reading and riddles in more depth in Chapter 1.
43 Cf. Patricia Dailey, 'Riddles, Wonder and Responsiveness in Anglo-Saxon Literature', in Clare A. Lees (ed.), *The Cambridge History of Early Medieval English Literature* (Cambridge: Cambridge University Press, 2012), pp. 451–72.
44 See, for instance, John D. Niles, *Old English Enigmatic Poems and the Play of the Texts* (Turnhout: Brepolis, 2006), pp. 96–100.
45 Daston, *Things That Talk*, pp. 9–24.
46 Brown, 'Thing Theory', pp. 4–5.
47 Graham Harman, 'The Theory of Objects in Heidegger and Whitehead', in *Towards Speculative Realism: Essays and Lectures* (Winchester: Zero Books, 2010), p. 33.
48 Whether this is intentional or due to lost folios is a moot point: for a summary of lost gatherings in the Exeter Book, see Muir, *The Exeter Anthology of Old English Poetry*, pp. 12–13.
49 Niles, *Old English Enigmatic Poems*, p. 308.
50 See John Miles Foley, 'How Genres Leak in Traditional Verse', in Mark C. Amodio and Katherine O'Brien O'Keeffe (eds), *Unlocking the Wordhord: Anglo-Saxon Studies in Memory of Edward B. Irving Jr.* (Toronto: University of Toronto Press, 2003), pp. 79–80.
51 Katherine O' Brien O' Keeffe, *Visible Song: Transitional Literacy in Old English Verse* (Cambridge: Cambridge University Press, 1990); see also Mark C. Amodio, *Writing the Oral Tradition: Oral Poetics and Literate Culture in Medieval England* (Notre Dame: University of Notre Dame Press, 2004).

52 Bede, *Ecclesiastical History of the English People*, ed. Bertram Colgrave and R. A. B. Mynors (Oxford: Oxford University Press, 1969).

53 Foley, 'How Genres Leak', p. 97.

54 *The Husband's Message* is an example of an Exeter Book poem in which the difficulty of interpreting the identity of the speaker – human or nonhuman? – is intricately linked to the difficulty of defining its genre – elegy or riddle? For discussion, see Niles, *Old English Enigmatic Poems*, pp. 225–34.

55 Of course, if this riddle is solved as 'chopping board' rather than 'shield' then it reads more like a parody of heroic values than a tragic treatment of them. The OE word *bord* is polysemous enough to cover both possibilities.

56 Michael Swanton, *English Poetry before Chaucer* (Exeter: University of Exeter Press, 2002), p. 112.

57 William Wordsworth, 'Preface to *Lyrical Ballads*', in *William Wordsworth: The Major Works*, ed. Stephen Gill (Oxford: Oxford University Press, 2008), pp. 595–615.

58 References to the Vercelli Book are taken from George P. Krapp (ed.), *The Vercelli Book*, ASPR 2 (London: Routledge, 1932). Translations are my own.

59 Carol Braun Pasternack, *The Textuality of Old English Poetry* (Cambridge: Cambridge University Press, 1995), p. 151.

60 Ibid., p. 14.

61 Niles, *Old English Enigmatic Poems*, pp. 309–10.

62 Peter Ramey, 'Writing Speaks: Oral Poetics and Writing Technology in the Exeter Book Riddles', *Philological Quarterly*, 92:3 (2013), 335–56, at 336, 341.

63 R. I. Page, *An Introduction to English Runes* (Woodbridge: Boydell Press, 2nd edn, 1999), p. 182.

64 For a study of the Alfred Jewel, see Leslie Webster, '*Aedificia Nova*: Treasures of Alfred's Reign', in Timothy Reuter (ed.), *Alfred the Great* (Aldershot: Ashgate Publishing, 2003), pp. 79–103; see also Karkov, *Art of Anglo-Saxon England*, pp. 212–18.

65 Thomas A. Bredehoft, 'First-Person Inscriptions and Literacy in Anglo-Saxon England', *ASSAH*, 9 (1996), 103–10.

66 Karkov, *Art of Anglo-Saxon England*, p. 153.

67 Ramey, 'Writing Speaks', p. 344. Ramey looks to Exeter Book Riddles 48 and 59 to give us a glimpse of speaking objects in performance.

68 See further R. I. Page, *Runes and Runic Inscriptions* (Woodbridge: Boydell Press, 1995), pp. 120–1.

69 See Hodder, *Entangled*, pp. 6, 101–3.

70 Bennett, *Vibrant Matter*, p. 17.

Æschere's head, Grendel's mother and the sword that isn't a sword: Unreadable things in *Beowulf*

When Grendel's mother attacks Heorot, her victim, Æschere, is described by Hrothgar as 'min runwita ond min rædbora' [my rune-knower and advice-bearer] (1325).[1] Later, when Beowulf returns to Heorot, having slain Grendel's mother, he hands the hilt from the giants' sword he used to kill her over to Hrothgar, who looks at the artefact before issuing a warning to Beowulf about becoming monstrous and foreshadowing the hero's later encounter with the *wyrm* (1677–784). By examining this passage in *Beowulf*, this chapter highlights connections between Grendel's mother and the giants' sword found in her underwater hall, arguing that they are both riddle-like things that resist the kind of reading that Æschere was meant to offer King Hrothgar. Indeed, Æschere's death provokes an anxiety in the text about 'things' that defy human interpretation and convey monstrous, marginal or altogether unknowable messages instead. While *Beowulf* is sensitive to the fact that a range of artefacts, including swords, have always been legible, the text also reveals that certain enigmatic things exceed the community of readable objects. Through their liminal status, these things carry alien stories and histories into the safety of the mead hall, unsettling the shared body of knowledge held within reading communities.

The first part of this chapter reconsiders Grendel's mother's slaying of the counsellor Æschere, examining the significance of both figures. The poem refers to Grendel's mother in a variety of ways: she is both a noble lady (OE *ides*) and a monstrous or warrior woman (OE *aglæcwif*); she is of the kin of Cain and linked to a race of giants but is still in the likeness of a woman (*idese onlicnes*) and dwells in a roofed hall (*hrofsele*). Well known, also, are the critical debates about who or what Grendel's mother is: from Klaeber's glossing of *aglæcwif* and its influence on later translators to arguments that she is a warrior woman or a valkyrie figure.[2] Since

Grendel's mother ultimately eludes efforts to name and identify her, it is significant that, unlike her son who randomly grabs thirty men, young and old, in his raids, her one victim is the counsellor Æschere. He has been carefully selected, for he is a rune-knower and advice-bearer, and Grendel's mother is therefore killing Hrothgar's reader. Nicholas Howe traces the etymology of the Old English *rædan* to show that it gives the meanings 'to give advice or counsel' and 'to explain something obscure' but also 'to exercise control over something'.[3] Therefore, even though Grendel's mother says no words in the text, in her slaying of Æschere she is making a clear statement that she will be neither explained nor controlled by the community of Heorot.

What is more, acts of reading – giving advice and solving riddles – were a means of 'creating and then enlarging the bounds of a textual community'.[4] While not literate in the modern sense, the community of Heorot is nonetheless bound together by 'reading' in this way. The second part of this chapter focuses on the giants' sword to argue that, even as Grendel's mother threatens a community through her refusal to be read, the sword hilt also enters Heorot from the outside and has the ability to destabilise its set of beliefs and knowledge. In both cases, this power is linked to the elusive or riddle-like nature of a 'thing' that exists on the margins of a human community. As Grendel's mother refuses to be named, identified and objectified, we can similarly see the giants' sword transforming from a functioning blade into *something* else.

In the absence of his *runwita* and *rædbora*, Hrothgar is confronted by the thing that the giants' sword has become and must try to read its runes himself. But when he looks at the rune-engraved hilt he cannot entirely make sense of it and what he does see is a historical narrative of giants, which is more closely connected to the Grendelkin than to the Danes. Hrothgar 'reads' that hilt all the same and, urged by an alien history, warns Beowulf through the figure of Heremod against becoming monstrous to future generations. Thus, the hilt might be seen as a self-reflexive literary device; it asks whether *Beowulf* itself is the story of an alien, monstrous past. The hilt embodies a concern over how stories of the present are conveyed to future audiences and, specifically, how histories may be transformed by the kinds of artefacts that carry them. Unreadable things can disrupt a longstanding human reliance upon legibility, altering the way we interpret that which has come before us.

Killing the reader

Readers of *Beowulf* do not really encounter Æschere (he is not singled out as a recognisable individual, nor is he named) until he is dead. In line 1251, there is this allusion to him: 'Sum sare angeald / æfenræste' [one paid sorely for his evening-rest]. Here, Æschere is merely 'a certain one' among the retainers who has been chosen to pay a penalty. Although not mentioned by name, we are given the sense that this 'one' has been marked out for death beforehand, at least by the narrator. And yet a mere eighteen lines earlier we are told that the sleepy hall-thegns 'Wyrd ne cuþon, / geosceaft grimme' [did not know the grim shape of formerly-fixed fate] (1233–4). Tricky to translate in this line, *geosceaft* essentially means 'that which has been shaped of old', thus adding to the notion that Æschere has been chosen for death from the start. The other brief reference to Æschere, before his name is mentioned, tells us that 'Se wæs Hroþgare hæleþa leofost / on gesiðes had be sæm tweonum' [He was to Hrothgar the most beloved of men among the retainers he had between the two seas] (1296–7). It is telling that, after ravaging Heorot for twelve years, seizing thirty men at a time, night after night, Grendel somehow misses the king's most beloved thegn; but in her one attack, Grendel's mother's single victim is this trusted counsellor, Æschere. This is no coincidence: Æschere's death is a very deliberate statement.

Why Æschere? Perhaps his name will provide a clue, or perhaps Æschere is not a name at all. The narrative context would suggest that it is, or at least it is used as a name when Hrothgar tells Beowulf that 'Sorh is geniwod / Denigea leodum: dead is Æschere, Yrmenlafes yldra broþor' [Sorrow is renewed for the Danes: Æschere is dead, Yrmenlaf's older brother] (1322–4). Yet it is not commonly used as a name elsewhere in Old English. The online Prosopography of Anglo-Saxon England (PASE) informs us that there is only one Æschere (male) recorded in Domesday Book m xi.[5] In the poetry, 'æschere' appears not as a name but as a noun in *The Battle of Maldon*, meaning a (Viking) army in ships. In this instance, *æsc* is used as a metonym for ships in the same manner as it is often used as a poetic metonym for spears, both being made from ash wood.

This takes us to the two elements that comprise the name: *æsc* and *here*. As well as referring to warships and battle-spears, *æsc* also carries connotations of obscure, or runic, knowledge. For example, the TDOE gives us (1) ash tree; (2) a light, swift ship, especially

a Viking ship; (3) in poetry: a spear; but then (4) ash, the name of
the runic letter (cf. *æ*). An example of *æsc* being utilised in this
latter capacity can be found in Exeter Book Riddle 42, where the
riddler claims that he can reveal the names of the creatures through
runstafas: 'þær sceal Nyd wesan / twega oþer ond se torhta Æsc / an
an linan' (8–10). It is also interesting to note that, as a noun, *æ* has
the meaning (1) law (divine and secular), statement of law (writ-
ten or customary), code of behaviour.[6] This could well be signifi-
cant when we consider that, in her slaying of Æschere, Grendel's
mother adhered to the heroic ethic of the blood feud.[7] And yet, as
an *aglæca*, she is also one who violates some natural or moral law.[8]
Evidently, the first element of Æschere's name identifies him as
a fitting victim for her. The second element of the name, *here*, is
glossed by Klaeber as 'army' and is used many times in *Beowulf*
to form compound words such as *here-grima* (war-mask or helm),
here-net (war-net or mail shirt) and *here-sceaft* (battle-shaft or
spear).[9] It is apparent that in the name 'Æschere' there is the sim-
ultaneous combining and opposing of knowledge (both lore and
law) and violence (warfare).

This is also the case when one considers Æschere's role in the
narrative. At around line 1320, Beowulf asks if Hrothgar is well
rested, and the king tells him about Grendel's mother's attack. He
describes Æschere as follows:

'Ne frin þu æfter sælum! Sorh is geniwod
Denigea leodum: dead is Æschere,
Yrmenlafes yldra broþor,
min runwita ond min rædbora,
eaxlgestealla ðonne we on orlege
hafelan weredon, þonne hniton feþan,
eoferas cnysedan. Swylc scolde eorl wesan,
æþeling ærgod, swylc Æschere wæs. (1322–29)

[Don't you ask after well-being! Sorrow is renewed for the
Danes: Æschere is dead, Yrmenlaf's elder brother, my rune-knower
and advice-bearer, my shoulder-companion when we guarded heads
in war, when in battle the troops clashed, the boars crashed together.
So should a nobleman, a good prince, be, so Æschere was.]

Here, then, Hrothgar describes Æschere as 'min runwita ond
min rædbora' (1325). *Runwita* is glossed by Klaeber as 'confi-
dant, trusted adviser' and *rædbora* as 'counsellor'.[10] Translators
of the poem usually opt for similar terms: Michael Alexander has
Hrothgar describe Æschere as his 'closest counsellor' and 'keeper

of my thoughts'; Heaney has him as a 'soul-mate' and a 'true mentor'; Dick Ringler, in a more recent translation, still has 'counsellor, confidant, and closest friend'.[11] Although 'counsellor', 'adviser' and 'confidant' are all acceptable modern translations, more is revealed about Æschere's role in Heorot if we look back at the Old English: in particular, the pairing of *run* and *ræd*.

Run carries the sense of secret consultation, of words that must not be overheard. It is used early on in *Beowulf* (again paired with *ræd*) when Grendel is ravaging the hall and 'Monig oft gesæt, / rice to rune; ræd eahtedon' [Many powerful ones often sat at secret counsel; they deliberated advice] (171–2). The word *run* also, of course, carries the related meaning of 'mystery' or 'a secret', as well as 'that which is written, with the idea of mystery or magic'.[12] As a noun, *wita* primarily means 'wise man' or, more literally, 'one who knows'. Yet the word also carries legal connotations. The plural form, *witan*, 'remained the technical term for the national assembly from the seventh to the twelfth century' and so a *wita* was a member of the national assembly, or *witan*. In most cases and 'as far back as the seventh century' the *witan* 'are king's counsellors'.[13]

The first aspect of Æschere's role is thus 'rune-knower'. He is one who knows mysteries and can keep secret counsel. Yet he is also a *rædbora*. Howe usefully explains that 'most uses of *ræd* and related forms in Old English texts refer to the giving of advice', while a 'significant number of others denote the more specific act of explaining something obscure or solving a riddle'. Howe links these (interconnected) uses of *ræd* to a 'culture unaccustomed to the written text' in which an 'oral dimension' remains and whereby something obscure becomes meaningful 'when read aloud by those initiated in the solution of such enigma'.[14] Æschere's role as *run-wita* appears to be bound up with his role as *rædbora*: he knows mysteries and keeps secrets but also has a duty to share and explain those secrets aloud to a community. This side of his role is reinforced by the second element of the compound *rædbora*. *Bora* (from the Old English *beran*) implies that Æschere bears or carries his advice, therefore embodying that knowledge. But at the same time his body is vulnerable, underscored by the association of knowledge with violence that we get from his name and description. Indeed, as soon as Hrothgar has referred to Æschere as his *runwita* and *rædbora*, he goes on to refer to his other duty as *eaxlgestealla* in battle 'ðonne we on orlege / hafelan weredon' [when we guarded heads in war] (1326–7). It is not in battle, though, that Æschere is slain, but in the safety of the hall: 'Wearð him on Heorote to hand-banan

wæl-gæst wæfre' [He was hand-slain in Heorot by a wandering slaughter-guest] (1330–1).

Why does Grendel's mother kill Hrothgar's reader and, by extension, Heorot's as well? And why is it the mother who does so and not her son, despite Grendel's more prolonged raids and reckless killings? Although there is undoubtedly an ambiguity about Grendel, who straddles the boundary between man and monster,[15] he has generated less critical confusion over his status and role in the text than his mother has. For a start, we at least have a name for him. 'Grendel' was a name bestowed on the monster by humans (1354–5). The same humans seem to have been unable to name the mother, or any name she might have had has been forgotten by Hrothgar and his men and is not communicated to the audience of *Beowulf*. In addition to not having a name, Grendel's mother has a history of not being 'read' by critics of the poem.[16] Jane Chance points out that the episode involving Grendel's mother 'has been viewed as largely extraneous, a blot upon the thematic and structural unity of the poem'.[17] But herein lies her agency – an agency that is linked to her killing of Æschere. In her namelessness and in her disappearances from the poem, Grendel's mother eludes our efforts at reading her. Thus in early *Beowulf* criticism, she is not so much glossed as glossed over.[18] Even in more recent attempts to read and explain her, however, we are left with a variety of contradictory views.

Klaeber's glossing of the term *aglæcwif* in line 1259 as 'wretch, or monster of a woman' has influenced many translations of Grendel's mother, so that Michael Alexander, for example, has her as a 'monstrous ogress' while Chickering opts for 'monster-woman' and Heaney has 'monstrous hell-bride'.[19] Yet the revised fourth edition of Klaeber's *Beowulf* has *aglæcwif* as 'troublemaker, female adversary', and similarly, in 1994 the TDOE updated the same noun to 'female warrior, fearsome woman'. In the criticism, Grendel's mother likewise hovers between monster, woman and warrior. That she should be interpreted as 'monstrous' is unsurprising given that she is associated with the kin of Cain as soon as she comes on the scene (1258–65). There is, therefore, a case for seeing Grendel's mother as monstrous on account of family ties. Moreover, as Andy Orchard points out, Grendel's mother is linked both structurally and thematically to the other two monsters in the poem. Grendel and his mother are 'closely connected not simply by the family relationship between the monsters, but by their human shape, their cannibalistic acts, their shared dwelling,

and their decapitation' while narrative parallels also 'connect the episode of Grendel's mother and the dragon'.[20]

On the other hand, one should be wary of reading the mother through the son who 'owns' her. Christine Alfano warns us against this, claiming that 'a large part of her reputed monstrosity lies not in Grendel's mother, but in Grendel himself' so that she 'finds herself implicated in her child's monstrosity, as unchallenged assumptions subsume her maternal role within a son's identity'.[21] According to Alfano, the numerous monstrous translations of Grendel's mother, such as those based on Klaeber's early glossary, have diminished her claim on humanity. As such, Alfano attempts a more human reading of this enigmatic figure. In doing so, she tends to side with Kuhn's earlier reading of her as a 'female warrior' with the conclusion that it 'is time to relieve Grendel's mother from her burden of monstrosity and reinstate her in her deserved position as *ides, aglæcwif*: "lady, warrior-woman"'.[22] Gillian R. Overing comments on the very 'complication' of Grendel's mother to the extent that she 'is not quite human, or, rather, she has her own particular brand of otherness; her inhuman affiliation and propensities make it hard to distinguish between what is monstrous and what is female'.[23]

In addition, Grendel's mother hovers on the threshold between human and animal in a number of critical readings. An instance of this can be found in what Orchard refers to as her 'lupine' aspect. Orchard remarks on the description of her as a 'she-wolf of the depths' (*grundwyrgen*) and as a 'sea-wolf' (*brimwylf*).[24] But Alfano again steers such descriptions towards the human, and especially the warrior-woman, contending that *brimwylf* 'does not imply Grendel's mother's literal resemblance to a female water-wolf; it could function as an epithet such as those applied to warriors and figures in battle'.[25]

These arguments demonstrate the enigmatic or riddle-like nature of Grendel's mother.[26] Through her ability to signify as more than one thing, Grendel's mother generates a variety of contradictory readings – and the contradictory character of such readings means that she is not, in the end, read at all. She remains unsolved. As Shari Horner argues, 'we will probably never come to a definitive understanding of such fundamental characteristics as her gender and species' so we should consider instead the effect of not defining them.[27] Similarly, Overing reassesses the significance of Grendel's mother and asserts that the 'complication' that she brings to the narrative, 'this line-crossing, this cross-identification,

this identity flux as it is imbricated with bodies and genders, this depth-charge of uncertainty that is Grendel's mother, this omission, my omission, I have come to believe, is the "argument"'. That is to say, she produces an uncertainty and indeterminacy that 'explodes preconceived categories of gendered identity, and is a means to imagine the poem's shifting and fragmented situating of the self, male or female, human or otherwise'.[28] Renée R. Trilling likewise takes up the issue of the critical silence and confusion surrounding Grendel's mother, concluding that, although she is far from the only ambiguous figure in *Beowulf*, she is 'unique in that the poem embodies so many of these tensions in one character, and she is defined by her ability to transgress the boundaries that ultimately limit the agency of other characters'. Grendel's mother 'stands in for that which exceeds representation – and hence exceeds the totalizing grasp of criticism as well'.[29]

In this manner, Grendel's mother is not unlike one of the Exeter Book riddles for which we have no solution. A crucial difference, however, is that whereas many (but not all) of those riddles invite the reader to 'say what I am called' Grendel's mother makes no such invitation. Her very silence is her power. She is unwilling to participate in verbal play, and yet does engage in a different kind of play – the battle play. Although a number of the Old English riddles make a challenge to 'wise' or 'thoughtful' (*þoncol*) men, to those shrewd or 'crafty' in mind (*hygecræftig*), and especially to rune-knowers (*rynemenn*),[30] the riddle that is Grendel's mother comes out of the dark, snatches Heorot's 'rune-man' away, and severs his head, silencing him. Again, we should see this not as reckless but as deliberate violence.

As with a number of the riddles, however, we need to be alert to visual as well as verbal signs. In the aftermath of her raid, Beowulf, Hrothgar and his retainers continue to try and read Grendel's mother by following the tracks and trails she has left behind:

> Lastas wæron
> æfter waldswaþum wide gesyne,
> gang ofer grundas, heo gegnum for
> ofer myrcan mor, magoþegna bær
> þone selestan sawolleasne
> þara þe mid Hroðgare ham eahtode. (1402b–7)

[The tracks were widely seen along the forest trails where, going over ground, she fared onwards over the murky moor, bearing away the lifeless body of the best thegn in Hrothgar's household.]

I connect this passage to the process of reading because the terms *lastas* (tracks) and *swaþu* (tracks or trails) are also found in Riddle 51 of the Exeter Book to describe the black marks left behind by the pen: 'swearte wæran lastas, / swaþu swiþe blacu' (2–3). Moreover, in his Preface to the Pastoral Care, Alfred speaks in similar terms:

> Ure ieldran, ða ðe ðas stowa ær hioldon, hie lufodon wisdom, ond ðurh ðone hie begeaton welan, ond us læfdon. Her mon mæg giet gesion hiora swæð, ac we him ne cunnon æfter spyrigean, ond for ðæm we habbað nu ægðer forlæten ge ðone welcan ge ðone wisdom, for ðæm ðe we noldon to ðæm spore mid ure mode onlutan.[31]

> [Our ancestors, who formerly held these places, they loved wisdom, and through it they obtained wealth and left it to us. Here one may yet see their tracks, but we cannot follow after them, and therefore we have now lost both the wealth and the wisdom, for we would not bend down to their tracks with our minds.]

Hrothgar and his men follow Grendel's mother's tracks across the moors as a reader might follow lines of ink across parchment. Those tracks do not lead the men of Heorot to wisdom but to further sorrow, as they meet Æschere's head on the cliff by the water (1417–21). More than a heartbreaking sight for Hrothgar, the severed head is also another visual statement left by Grendel's mother. First, it is a sign of payback in the escalating and deadly swapping game between the Grendelkin and the Danes, where one body part is (both literally and symbolically) exchanged for another: Hondscioh (glove) for Grendel's hand; Grendel's hand for Æschere's head; Æschere's head for Grendel's head.[32] As the poet says, 'Ne wæs þæt gewrixle til' [That was not a good exchange] (1304). Wordless though she may be, Grendel's mother is nevertheless demonstrating that she knows the rules of this game. According to Leslie Lockett, extant Anglo-Saxon law codes 'do not prescribe the display of corpses, but they do preserve the distinction between the legitimate killing of an offender and secret murder'. Lockett notes that whereas Grendel's killings are without just cause and are therefore kept concealed, his mother's 'slaying of Æschere is – at least from her perspective – a legitimate requital of her own son's death, for which reason she prominently displays the head at the entrance of her own home, on high ground at the edge of the mere'.[33] Earlier, I noted that the Æsc- element of Æschere's name links him to law or a code of behaviour. In her beheading of him, Grendel's mother is making the statement that she recognises the laws of the feud, and is capable of participating in them, and

yet by slaying the namer, knower and reader, she is also showing
that she stands outside those laws and defies the men who devise
and recall them.

Even beyond the tit for tat feud, the severing and displaying of
Æschere's head is noteworthy in itself. Bill Griffiths, for instance,
finds evidence for a cult of the head in Anglo-Saxon tradition, and
what lies behind this cult (and similar ones elsewhere in time and
place) is the 'importance of voice, as messenger between different
levels of existence, in combination with a practical recognition of
the head as the source of hearing, speech and sight (and perhaps
intelligence)'.[34] A beheading episode also occurs in Ælfric's *Life of
St Edmund*.[35] Here, the Vikings attempt to sever the dead king's
head from his body in an act of control:

> Hwæt ða se flot-here ferde eft to scipe and behyddon þæt heafod þæs
> halgan eadmundes on þam þiccum bremelum þæt hit bebyrged ne
> wurde.[36]

> [So then the floating-army fared back to their ship and hid the head
> of the holy Edmund in the thick brambles so that it might not be
> buried.]

But when the folk of the region go searching for that head, so that
they may reunite it with the body, the head itself continues to
function as a source of hearing and speaking beyond decapitation
and death:

> Hi eodon þa secende, and symle clypigende, swa swa hit gewunelic
> is þam ðe on wuda gað oft, 'Hwær eart þu nu, gefera?' and him
> andwyrde þæt heafod, 'Her! Her! Her!' and swa gelome clypode,
> andswarigende him eallum swa oft swa heora ænig clypode, oþþæt
> hi ealle becomen þurh ða clypunga him to.

> [They went on seeking and always calling out, as is usual with those
> who often go to the woods, 'Where are you now, friend?' and the
> head answered them, 'Here! Here! Here!' and so it continually
> called, answering them all, as often as any of them called, until they
> all came to it through the calling.]

Of all the body parts that Grendel's mother could have chosen
to display, therefore, the head is most closely associated with the
human ability to perceive and to make sense of the world. Grendel's
mother does leave tracks and trails behind for Hrothgar's men
to follow and read, and yet what these tracks lead to is a warn-
ing against the very act of reading. Unlike those who go searching
throughout the forest in the *Life of St Edmund*, Hrothgar's men do

not find a speaking head but a silent object now unable to perceive, interpret or explain anything.

I want to take a moment to clarify what the term 'reading' means in an Anglo-Saxon context and so gain a sounder understanding of why Grendel's mother refuses to be read by the community of Heorot. The Old English usage of *ræd* refers generally to the giving of counsel and, more specifically, to the explaining or solving of something obscure, like a riddle. This, in turn, is connected to controlling that obscure or elusive *something*. Howe looks to the store of conventional sayings and knowledge collected in *Maxims I* to show that reading in the sense of offering counsel is a public act that, in an oral culture, is 'of necessity to speak and thereby to create community'. Old English gloss writers used *ræd* and its derivatives to translate the various forms of the Latin *consulere*, 'to consider, take counsel, consult'. This means that the Old English word could often have the same sense of counsel as a public act as did the Latin word. One such instance is the use of the Old English *rædbora* to gloss the Latin *consiliarius* (counsellor) and also *jurisperitus* (one skilled in law).[37] A *rædbora* such as Æschere held a key role as an individual that 'reads' publically on behalf of his community and indeed creates that very community by so doing.

Seth Lerer points out that the word 'literacy' can be 'invoked to determine an individual's place in society and to assess the social norms against those distant in geography or time'. In these terms, the power of the literate 'is the power to include and exclude: to distinguish the self from the other, the civil from the savage, the mainstream from the subversive'.[38] The community of Heorot is evidently 'literate' in its ability to exclude and control that something that does not belong within its bounds; and it is this kind of control that Grendel's mother resists.

The power of unreadable things

Although the giants' sword is strongly associated with Grendel's mother and her function within *Beowulf*, it is too often read as the weapon that brings an end to any threat she might have held for the community of Heorot – for not only does Beowulf use the sword to slay her, but he is also able to bring it, bladeless, safely back into the hall where it can be read and thus contained and controlled by Hrothgar. However, I want to consider exactly why and how

Hrothgar 'reads' the hilt and so ask what his reading of it tells us about the power that a sword-becoming-something-else can have in shaping the way a literate community reads itself across time. The power of the giants' sword can be linked to that of Grendel's mother inasmuch as they both defy interpretation and threaten to destabilise Heorot's shared body of knowledge.

Traditional Western ontological systems would categorise Grendel's mother and the giants' sword as distinct entities. Grendel's mother is a living being whereas the sword is an inanimate artefact. While Grendel's mother and the sword hilt are not necessarily ontologically equivalent, we cannot say for certain what the nature of their existence is. The point is that they both deny the readers within the world of *Beowulf* and us, as readers of the *Beowulf* manuscript, the ability to know what kinds of entities they really are, recalling Graham Harman's proposition that 'things' infinitely withdraw.[39] Grendel's mother seems to be humanoid (a mother, in the shape of a woman, capable of emotion, who seeks revenge) but cannot be pinned down as such (a monstrous mother, dwelling beyond the bounds of civilisation, who does not speak). The hilt is like an ordinary weapon (it has a cutting edge, brings victory in battle) but it is also unlike the other swords in the heroic world (it is unnamed, is too big for any man to wield, its blade melts).

Grendel's mother's very namelessness and indescribability give her an agency, allowing her to stand out from other female figures in the text. In this poem we also have an instance of an object breaking out of a passive, background role and asserting its thingness. Brown describes how we look through objects, as they circulate through our lives, whereas we begin to confront the 'thingness' of an object when it does not behave how it is meant to behave, does not carry out the role it was made and intended for, and suddenly exerts its own power – a power to disrupt human activity, custom or ritual and to assert its own presence.[40] Bennett similarly expresses 'thing-power' as the refusal to dissolve completely into the milieu of human knowledge, a moment of independence from human subjectivity.[41]

Such thing-power can be identified in a sword that melts, failing to fulfil its function as a weapon yet transforming into some other kind of thing. It is no coincidence that this thing should be found in the underwater hall of the text's least controllable female. Even as Grendel's mother refuses to be contained by the customs

of Heorot, the hilt that emerges from her dwelling likewise enters the mead hall as an irresolvable enigma.

At first glance, it may not be obvious why the giants' sword should be a thing alien to the community of Heorot. After all, swords are conspicuous in the poem. Some of them are even named and given their own histories. The sword Hrunting is one such instance, but of course Hrunting fails Beowulf in his battle against Grendel's mother: 'Ða se gist onfand / þæt se beadoleoma bitan nolde, / aldre sceþðan, ac seo ecg geswac / ðeodne æt þearfe' [Then the guest found that the battle-light would not bite, nor harm her life, but the edge let down its lord in his need] (1522–5). Although Hrunting gets its own name and history, it is bound up with the social rituals of Heorot, a gift exchanged between warriors, an artefact that remains within circulation, binding one man to another. It is very much the sort of powerless object that cannot claim independence from the human subject.

Considering Grendel's mother's power of resistance, it is perhaps unsurprising that this named and circulated weapon should fail to cut her out of the narrative. Allen J. Frantzen's work on the relationship between writing instruments and their carving action examines the key words *writan* and *forwritan*, 'words which pun on "to write" and "to carve" and represent analogues for "to interpret"'. He notes that in *Beowulf* both words are 'linked to weapons' and that the acts of hewing and carving 'align these weapons with instruments for engraving and writing, in the sense of inscribing'.[42] Hrunting's failure against Grendel's mother is therefore further evidence of her ability to disrupt the literate community of Heorot: the sword that cannot cut or carve her is also the pen that cannot write her. As the poet says, 'Ða wæs forma sið / deorum madme, þæt his dom alæg' [That was the first time for the fine treasure that it failed in its destiny] (1527–8). As an heirloom circulated from man to man, the sword is a sort of story-bearer; but this time it fails to fulfil its destiny and thus the accumulated narrative it carries is broken off by Grendel's mother.

Despite this moment of resistance, she is soon thereafter cut through and killed by Beowulf. In order to slay Grendel's mother, the hero cannot use any circulated, named heirloom from Heorot but must instead turn to an unknown, unnamed blade that he finds within his enemy's dwelling:

Geseah ða on searwum sigeeadig bil,
ealdsweord eotenisc ecgum þyhtig,
wigena weorðmynd; þæt wæs wæpna cyst,

buton hit wæs mare ðonne ænig mon oðer
to beadulace ætberan meahte,
god ond geatolic, giganta geweorc. (1557–62)

[He saw there among the armour a victory-blessed blade, an old
sword of giants, strong in edges, worthy to warriors; that was the
choicest of weapons, but it was more than any other man might bear
into battle-play, good and glimmering, the work of giants.]

This initial description of the giants' sword immediately sets up
its ambivalent qualities. It is, on the one hand, a praiseworthy
weapon. It is 'sigeeadig bil' (a victory-blessed blade) and 'wæpna
cyst' (the choicest of weapons). On the other hand, it is an 'eald
sweord eotenisc' (old sword of giants) and 'giganta geweorc' (the
work of giants). The sword's ornate visual aesthetic and the skill
or craft involved in its making are thereby linked to a distant
time and an alien race. The beauty and power of the sword is
such that the poet can praise it and the audience can, by exten-
sion, perceive and appreciate it. And yet it is still the work of an
older age and as such remains at a remove from both poet and
audience.

The description of the sword also sheds a strange light on our
hero, Beowulf, for we are told that 'hit wæs mare ðonne ænig mon
oðer / to beadulace ætberan meahte' [it was more than any other
man might bear into battle-play] (1560–1). Beowulf's feat of doing
what no other man can do may set him above other men in the
heroic sense, but at the same time such superhuman strength aligns
him with the giants who made the sword and distances him from his
fellows in the mead hall. Even from this initial description of the
sword, we can see that it is a self-reflexive literary device, intended
to remind the audience that we are reading a highly crafted text
about (and maybe from) a different time, featuring a hero who is
'not one of us'.

Then again, it is not Beowulf's superhuman power alone that
allows him to wield the giants' sword and defeat Grendel's mother.
When the outcome of battle looks most dire for the hero, the narra-
tor intervenes to tell us that God has intervened on Beowulf's behalf
(1553–6). It is only after this statement that Beowulf sees the *sigee-
adig bil* hanging among the other armour. And then, once Beowulf
has swung the deadly blow and Grendel's mother lies defeated on
the floor, we are told, 'Lixte se leoma, leoht inne stod, / efne swa of
hefene hadre scineð / rodores candel' [The light gleamed, a radi-
ance stood within, even as heaven's candle clearly shines from the

sky] (1570–2). Beowulf himself brings God even more forcefully into his victory when he retells the battle to Hrothgar:

> Ic þæt unsofte ealdre gedigde
> wigge under wætere, weorc geneþde
> earfoðlice; ætrihte wæs
> guð getwæfed, nymðe mec God scylde. (1655–8)

[I did not easily endure that underwater battle, but did the deed with difficulty; the fight would have ended right away, had God not saved me.]

Particularly, Beowulf credits God with granting him the sight of the sword (1661–4). How are we to read this? Why did he need God to intervene here and highlight this weapon? The giants' sword is an artefact from an age beyond human memory, an unnamed thing that has survived across an inhuman stretch of time – *giganta geweorc*. A known and named sword like Hrunting does not need divine intervention in order to be seen and used, since it has remained within circulation, exchanged between the warriors of Heorot who have said its name time and again. Yet the giants' sword defies this mnemonic way of knowing, and its history cannot be measured through the generations of men who have owned it. Therefore, God – as a transcendent and extratemporal entity – is the only agent with the ability to bring this sword to light.

In order to reveal the sword, though, God too must enter from the outside. So can the killing of Grendel's mother really be read as a victory for Heorot over the monsters lurking beyond its bounds? I think, rather, that it undermines the control that that community has over the unknown and unknowable. That is, it undermines their ability to read the obscure. For God's entrance into the poem is not invoked by the community of Heorot as a way of dealing with the threats they are under. On the contrary, the poet explicitly told us early on that the community did not know God and so turned to heathen shrines for help:

> Monig oft gesæt,
> rice to rune; ræd eahtedon,
> hwæt swiðferhðum selest wære
> wið færgryrum to gefremmanne.
> Hwilum hie geheton æt hærgtrafum
> wigweorþunga, wordum bædon
> þæt him gastbona geoce gefremede
> wið þeodþreaum. (171b–78)

[Many powerful ones often sat at secret counsel, deliberated advice, what it might be best for the strong-minded Danes to do against these sudden attacks. Sometimes they made sacrifices at heathen shrines, prayed with words that the soul-slayer would send help to them for the pain of their people.]

This passage in fact demonstrates the failure of Heorot's reading – it is as a result of secret counsel (*rune*) but bad advice (*ræd*) that they seek aid from the Devil, or soul-slayer (*gast-bona*). In seeming contradiction to this passage, there are moments when Beowulf and Hrothgar do recognise that a higher power has helped them, as when Beowulf says that the *ylda waldend* (lord of men) granted him the sight of the sword (1661–4) or when Hrothgar claims that God favours mankind with the gift of wisdom (1725–8). God hovers between the known and unknown from Heorot's perspective, and his power is not summoned by Hrothgar and his men; rather, God's movements into and out of their world are beyond their ken. From their standpoint, the role of God is not so different from that of Grendel's mother. As lines 171–8 show, God is at times forgotten, much like Grendel's mother. Also like Grendel's mother, God's absence actually empowers his presences, his intrusions, into the poem. The eternal lord can see and reveal those things that dwell outside of Heorot in time and space, things like the giants' sword that would otherwise elude that community.

Yet the narrator is at pains to cite God when the sword blade melts. For the *Beowulf* poet, the melting of the blade indicates God's presence, not God's disappearance:

> þæt wæs wundra sum
> þæt hit eal gemealt ise gelicost,
> ðonne forstes bend fæder onlæteð,
> onwindeð wælrapas, se geweald hafað
> sæla ond mæla; þæt is soð metod. (1607b–11)

[That was a wonder, how it all melted like ice when the father loosens frost's bonds, unwinds the water-fetters, he who watches over the time and seasons. That is the true ruler.]

The poet's perception of God as an ever-present father, watching over time and seasons, stands in contrast to Heorot's more limited perspective, whereby God shifts in and out of view. Much like Grendel's mother stealing into the hall, killing and then fleeing again before she is found, the community of Heorot's partial

knowledge of God sees him making his entrance into the under-water lair before going out again. As well as revealing the sword, God also has the ability to destroy, or, more accurately, transform it into some other thing; and the ancient sword illuminated by divine intervention can no longer function as a weapon.

It is this 'weapon' revealed by God that, unlike its named coun-terparts, has the power to slay Grendel's mother. However, while the giants' sword may put an end to her physical threat in the poem, it does not extinguish the anxieties Grendel's mother brought into the narrative in her slaying of Æschere: anxieties about 'things' that resist human interpretation and the way they unsettle human reliance upon legibility. On the contrary, the bladeless hilt actu-ally continues this threat in her absence and connects it even more clearly to the acts of reading and writing.

Seeing many treasures around him in Grendel's mother's hall, Beowulf nevertheless elects to take nothing away with him 'buton þone hafelan ond þa hilt somod / since fage' [but for the head and also the hilt, the shining treasure] (1614–15). What does Beowulf think he is taking back to Heorot, and why would he take such a thing back with him anyway? The retrieving of Grendel's head makes sense in the context of the swapping game. But the giants' sword is no longer a sword. Even before it melted, the blade was too great for anyone but Beowulf to wield, and now that it has with-ered away it is surely useless as a weapon. It must be its status as decorated or 'shining treasure' (since fage) that appeals to Beowulf. Archaeological evidence has long shown that richly decorated sword hilts, not unlike the one described here, with twisting and serpentine patterns, complex motifs and sometimes runic inscrip-tions displaying personal names, would be buried in early English and Scandinavian graves – the blades themselves kept for another generation, perhaps.[43] The Staffordshire Hoard similarly turned up an extraordinary quantity of pommel caps and hilt plates – but no blades (see Figure 1). These highly decorated artefacts, featur-ing beautiful garnet inlays, detailed scrolls, animals executed in fili-gree or geometric and zoomorphic interlace, were no doubt prized and taken as treasure – yet there is little, if any, evidence that blades were valued in the same way.

In the poem, however, the blade is not simply discarded or even kept and reused; it vanishes from sight. The poet here reiterates that 'sweord ær gemealt, / forbarn brodenmæl; wæs þæt blod to þæs hat, / ættren ellorgæst se þær inne swealt' [the sword had melted, the patterned blade burnt up; the blood of the

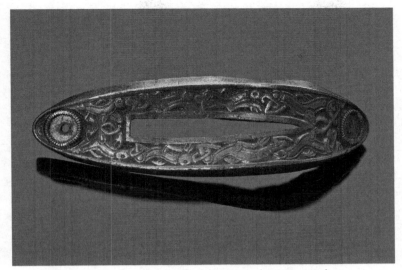

1 Gold hilt plate from the Staffordshire Hoard (© Birmingham
Museums Trust).

venomous fiend, the one who died therein, was too hot] (1615–
17). Although there is some ambiguity as to which *ellorgæst*
(Grendel or his mother) has destroyed the blade with their
hot blood, the fact that it is the one who died therein (*se þær
inne swealt*) suggests that it was the blood of the recently slain
Grendel's mother that melted the weapon. A transferral of power
has taken place. The riddle-like resistance that made Grendel's
mother so hard to read and control can now be seen in the sword
that can no longer be classified as a sword. Overing remarks that,
notwithstanding her lack of definition, Grendel's mother is very
much on the scene: 'when Hrothgar famously expounds upon
the remaining sword hilt, this dismembered object so present in
the text remains a function of, and testament to, her capacity to
rend asunder'.[44]

 This takes us to the presentation of the hilt to Hrothgar. In his
speech, Beowulf first introduces the hilt as a sword. Immediately
after relating how well it worked *as a sword*, though, Beowulf reveals
how the battle-blade burned up (1666–7). When Hrothgar receives
the hilt from Beowulf, then, what is it he thinks he is receiving, and
why? It is true that the familiar treasure-giving ritual is invoked

here, but the enigmatic, thing-like element to the artefact (is it a sword to be wielded, a decorated hilt to be admired, or a text to be read?) means that Hrothgar's reaction to this gift is anything but straightforward. The thing itself seems to communicate a variety of somewhat contradictory functions to the king, and the king reacts in a variety of ways, looking at the hilt and recognising its intricate decoration, seeing a history of violence consistent with its former role as a battle-blade, and yet also endeavoring to 'read' what he sees and say what he reads:

> Hroðgar maðelode; hylt sceawode,
> ealde lafe. On ðæm wæs or writen
> fyrngewinnes; syðþan flod ofsloh,
> gifen geotende giganta cyn,
> frecne geferdon; Þæt wæs fremde þeod
> ecean dryhtne; him þæs endelean
> þurh wæteres wylm waldend sealde.
> Swa wæs on ðæm scennum sciran goldes
> þurh runstafas rihte gemearcod,
> geseted ond gesæd, hwam þæt sweord geworht,
> irena cyst ærest wære,
> wreoþenhilt ond wyrmfah. (1687–98a)

[Hrothgar made a speech; he looked at the hilt, the old remnant, on which was written the origin of ancient strife, when the flood, the surging sea, slew the race of giants, a dreadful event. That race was estranged from the eternal lord: the wielder rewarded them through the water's welling. So too it was stated on the bright gold cross-guard, through rune-letters rightly marked, set down and sealed, for whom that sword was first made, the finest of iron, spiral-hilted and serpent-stained.]

This scene has been much discussed by critics in recent times. For example, Lerer is keen to highlight the 'vagueness' of the hilt which renders it 'all the more ambiguous and alien'. He points out that the 'maker of the sword is unnamed, and the sword and patron remain equally anonymous'; nor is the sword 'christened with a meaningful identity like Hrunting or Nægling'. This leads Lerer to describe this scene as 'a kind of riddle whose expected solution now rests not with Hrothgar and his men, but with the reader of *Beowulf*.[45] The hilt itself, and the scene it produces, is indeed a kind of riddle, making this a self-conscious literary passage that extends the role of reader to those who are outside of the text. Lerer goes on to state:

The text is made accessible, in part, to Hrothgar and to us so that we may together try to understand the mythic origins of the terror we have seen and to realize that, in the end, we can only live with monsters and their kin in writings: works that are as impotent as a bladeless sword or a bodiless head. Those monsters now are like the hilt itself. Both come as a written tale, able to enter the hall and hurt no one, to sit silently like a souvenir of an alien kingdom.[46]

Yet the 'impotence' and 'silence' of the hilt and the monsters it shows us are no less a threat than the silent resistance, the elusive agency, of Grendel's mother. For a start, Hrothgar has been *forced* into the role of reader due to the absence of Æschere. Let us not forget this, for the hilt is said to be incised with runic letters (OE *runstafas*): Æschere was both *runwita* and *rædbora* within Heorot; now that these runes have been brought into the hall, his absence is felt even more strongly, as the cryptic signs on the thing that was once a sword challenge Hrothgar to stand in for the deceased rune-knower and to interpret and explain them himself. Even though Beowulf has killed Grendel's mother and 'avenged' Æschere's death, the threat that the unreadable outsider carried has not been removed. The dissolving of the gigantic blade after it cut through her body does not, therefore, signify the impotence of the thing itself so much as the impotence of the community of Heorot, their inability to resolve that which is mysterious and elusive now that their reader has gone.

Hrothgar's verbal response to the rune-marked hilt demonstrates not only that he cannot readily interpret what he sees there, but also that he does perceive the power of the thing he holds in his hand. The runic letters on the hilt tell us for whom that sword was made without actually relating a name. Thus Hrothgar does not have all the knowledge he needs to make sense of the thing and neither do we, the audience. We might imagine that if he still lived, Æschere would be able to read the runes on our behalf. But that is only a fantasy. As such, the hilt must remain a mysterious thing and the story it tells must remain alien to us.

What Hrothgar – and we – do see is a historical narrative of giants, more closely connected to the Grendelkin than to the Danes (1688–91). This sight incites Hrothgar to make a speech in which he offers counsel (*ræd*) to Beowulf. The counsel both is and is not a reading of what is borne on the hilt. The poet uses the Old English verb *sceawian* to describe Hrothgar's interaction with the hilt, but this merely means that the king 'looked at' or

'inspected' the thing. Beyond this, there is no evidence to suggest
that he reads anything that we, as readers of *Beowulf*, do not read;
no evidence that he gathers any extra or hidden knowledge that we
do not have access to. The hilt, I would argue, does not actually
grant Hrothgar any knowledge to withhold (beyond what is made
clear to us, reading along with him). He looks at its surface, but
cannot penetrate it.

And yet in another sense Hrothgar does read the hilt, or at least
tries to. It is an act of reading in its communal, counsel-offering
form. It is reading in the sense of giving advice to those listen-
ing. It cannot, however, be a true act of reading in the way that
the Anglo-Saxons conceived of the term, for in the absence of the
rune-knower Hrothgar is unable to decode the runic text borne
on the hilt. There is no evidence that Hrothgar has the skill (as
Æschere may have had) to solve the riddle posed by the hilt; but
in his speech he intends to offer counsel anyway. Therefore what
the king expounds upon is the very impenetrability, the otherness,
of the thing he is gazing upon. From this, he constructs advice
and gives warning to the hero Beowulf. Particularly interesting is
Hrothgar's invocation of the 'bad' king Heremod. Immediately
following a passage of praise for Beowulf, Hrothgar says:

> Ne wearð Heremod swa
> eaforum Ecgwelan, Ar-Scyldingum;
> ne geweox he him to willan ac to wælfealle
> ond to deaðcwalum Deniga leodum;
> breat bolgenmod beodgeneatas,
> eaxlgesteallan, oþ þæt he ana hwearf,
> mære þeoden mondreamum from.
> Ðeah þe hine mihtig God mægenes wynnum,
> eafeþum stepte ofer ealle men,
> forð gefremede, hwæþere him on ferhþe greow
> breosthord blodreow, nallas beagas geaf
> Denum æfter dome; dreamleas gebad
> þæt he þæs gewinnes weorc þrowade,
> leodbealo longsum. Ðu þe lær be þon,
> gumcyste ongit; ic þis gid be þe
> awræc wintrum frod. (1709b–24a)

[Heremod was not so to the sons of Ecgwela, the noble Scyldings: he
did not bring gladness but gloom to them, destruction and death to
the Danes. Swollen-minded, he would slaughter friends at the table
and allies at his shoulder, until that mighty lord, alone, turned away
from the joys of men – even though almighty God had furthered him,
exalted him in strength above all other men. Yet bloodthirstiness

grew in his breast-hoard. He did not in his judgement deal out rings
to the Danes. Joyless he dwelt, endured this distress, for the long-
lasting hurt he'd inflicted. You must learn from this, recognise the
right way! I, wise in winters, have recited this speech about you.]

Having examined the hilt and seen an alien history that he can-
not rightly read or resolve, Hrothgar is warning Beowulf against
becoming monstrous to future generations who will read his story.
It is no coincidence that 'Heremod's fate, to turn away in lonely
exile from the joys of men, recalls that of Grendel himself, the more
so since his exile takes place among giants'.[47] The warning looks
forward in time, as well as back, since Heremod's refusal to deal
out rings to Danes foreshadows the *wyrm* Beowulf will encounter,
which likewise hoards gold and other things to the benefit of no
one (2275–7). This is not the only way in which the speech seems
to stand outside of time, for the very thing that Hrothgar is advis-
ing Beowulf against has, in fact, already occurred. Beowulf has
already become excessively monstrous to those who read him, as
exemplified by the numerous 'intimate links' between the hero and
his inhuman foes.[48] Perhaps this is what Hrothgar means when he
says that he makes the speech 'for' or even 'about' him (*ic þis gid be
þe awræc*). Thus Hrothgar is warning Beowulf against becoming
monstrous to future readers within a text that has already carried
out this work.

Of course, this speech was itself provoked by a thing that is
out of time and place within the community of Heorot. In a simi-
lar vein, Brown comments on how inanimate objects, released
from their functionality, can make us rethink the temporality of
the animate world. An example he uses is that of Oldenburg's
Typewriter Eraser, and in particular the 'pleasure of listening
to the child who, befuddled by an anachronistic object she never
knew, pleads: "What is that thing supposed to be?" What is this
disk with the brush sticking out of it? What was a typewriter?
How did that form ever function?' This plea 'expresses the power
of this particular work to dramatize a generational divide and to
stage (to melodramatize, even) the question of obsolescence'. In
a time when the typewriter eraser has disappeared into the delete
function, Oldenburg's objects seem to ask how 'the future of your
present' will ever 'understand our rhetoric of inscription, erasure,
and the trace?'[49] The hilt in *Beowulf* carries with it a similar sort
of power. The sword that has lost its blade, its cutting edge, com-
ments on the anachronism and obsolescence of a bygone 'heroic'
age: we may well ask how that form ever functioned.

But more than this, its very inscrutability (what is that thing meant to be, and what is it trying to say?) embodies a concern over how stories of the present are conveyed to future audiences and, specifically, how histories may be transformed by the kinds of artefacts that carry them. The suggestion here is that unreadable, irresolvable things can disrupt a longstanding human reliance upon legibility, altering the way we interpret that which has come before us. By killing the 'reader' in the form of Æschere, Grendel's mother provoked an anxiety about things that resist human interpretation. The giants' sword found in her underwater hall prolongs this anxiety. Its presence makes Æschere's absence even more conspicuous. As an unnamed artefact, found outside of the circle of song and light, the hilt is a thing that dwells on the margins of a human community and fails to fulfil its role as either a weapon of war or a readable object. Instead, the hilt breaks out of the poem to work as a self-conscious literary device, inviting the reader of *Beowulf* to ask how the future of their own present will read and make sense of them. An answer may be detected in Hrothgar's reading of the hilt: the future will look at the things we leave behind and read us, too, as alien, monstrous, other or even unknowable altogether.

Notes

1 An earlier version of this chapter appeared as James Paz, 'Æschere's Head, Grendel's Mother and the Sword That Isn't a Sword: Unreadable Things in *Beowulf*, *Exemplaria*, 25:3 (2013), 231–51.

2 See Sherman M. Kuhn, 'Old English Aglæca–Middle Irish Oclach', in Irmengard Rauch and Gerald F. Carr (eds), *Linguistic Method: Essays in Honour of Herbert Penzl* (The Hague: Mouton, 1979), pp. 213–30; Helen Damico, 'The Valkyrie Reflex in Old English Literature', in Helen Damico and Alexandra Hennessey Olsen (eds), *New Readings on Women in Old English Literature* (Bloomington: Indiana University Press, 1990), pp. 176–89.

3 Howe, 'Cultural Construction', p. 61.

4 Ibid., p. 62; see also Brian Stock, *Listening for the Text: On the Uses of the Past* (Baltimore: Johns Hopkins University Press, 1990).

5 'Æschere', in Prosopography of Anglo-Saxon England, www.pase. ac.uk.

6 According to the TDOE.

7 Kevin Kiernan, 'Grendel's Heroic Mother', *In Geardagum*, 6 (1984), 13–33, at 24–5.

8 Alexandra Olsen, 'The Aglæca and the Law', *American Notes and Queries*, 20 (1982), 66–8.

9 See *Klaeber's Beowulf*, p. 395.

10 Ibid., pp. 423, 425.

11 Michael Alexander (trans.), *Beowulf: A Verse Translation* (Harmondsworth: Penguin, 1973); Seamus Heaney (trans.), *Beowulf: A Bilingual Edition* (London: Faber and Faber, 1999); Dick Ringler (trans.), *Beowulf: A New Translation for Oral Delivery* (Indianapolis: Hackett, 2007).

12 Bosworth-Toller.

13 Felix Liebermann, *The National Assembly in the Anglo-Saxon Period* (New York: Franklin, 1961), p. 7.

14 Howe, 'Cultural Construction', pp. 63–4.

15 See, for example, Andy Orchard, *Pride and Prodigies: Studies in the Monsters of the Beowulf-Manuscript* (Cambridge: D. S. Brewer, 1995), pp. 30–1.

16 Notably, J. R. R. Tolkien in '*Beowulf*: The Monsters and the Critics', in Lewis E. Nicholson (ed.), *An Anthology of Beowulf Criticism* (Notre Dame: University of Notre Dame Press, 1963).

17 Jane Chance, 'The Structural Unity of *Beowulf*: The Problem of Grendel's Mother', in Helen Damico and Alexandra Hennessey Olsen (eds), *New Readings on Women in Old English Literature* (Bloomington: Indiana University Press, 1990), pp. 248–61, at 248.

18 In addition to Tolkien, see Adrien Bonjour, 'Grendel's Dam and the Composition of *Beowulf*', *English Studies*, 30 (1949), 113–24.

19 Alexander (trans.), *Beowulf*, p. 90; Howell D. Chickering (trans.), *Beowulf: A Dual-Language Edition* (New York: Anchor, 2006), p. 121; Heaney (trans.), *Beowulf*, p. 89.

20 Orchard, *Pride and Prodigies*, p. 29.

21 Christine Alfano, 'The Issue of Feminine Monstrosity: A Reevaluation of Grendel's Mother', *Comitatus*, 23 (1992), 1–16, at 12.

22 Ibid.

23 Gillian R. Overing, *Language, Sign, and Gender in "Beowulf"* (Carbondale: Southern Illinois University Press, 1990), p. 81.

24 Orchard, *Pride and Prodigies*, p. 75.

25 Alfano, 'Feminine Monstrosity', p. 8.

26 On the importance of Grendel's mother, see also John D. Niles, 'Ring Composition and the Structure of *Beowulf*', *PMLA*, 94:5 (1979), 924–35; Jacqueline Vaught, '*Beowulf*: The Fight at the Centre', *Allegorica*, 5 (1980), 125–37; and, more recently, Paul Acker, 'Horror and the Maternal in *Beowulf*', *PMLA*, 121 (2006), 702–16.

27 Shari Horner, *The Discourse of Enclosure: Representing Women in Old English Literature* (New York: SUNY Press, 2001), pp. 81–2.

28 Gillian R. Overing, '*Beowulf* on Gender', *New Medieval Literatures*, 12 (2010), 1–22, at 3–4.

29 Renée R. Trilling, 'Beyond Abjection: The Problem with Grendel's Mother Again', *Parergon*, 24:1 (2007), 1–20, at 20.

30 See Exeter Book Riddles 1, 2 and 42 for examples.
31 Text is taken from Dorothy Whitelock (ed.), *Sweet's Anglo-Saxon Reader* (Oxford: Oxford University Press, 1967), p. 5.
32 Ringler usefully summarises these exchanges in the introduction to his translation, p. xxxix.
33 Leslie Lockett, 'The Role of Grendel's Arm in Feud, Law, and the Narrative Strategy of *Beowulf*', in Katherine O'Brien O'Keeffe and Andy Orchard (eds), *Latin Learning and English Lore: Studies in Anglo-Saxon Literature for Michael Lapidge*, vol. 1 (Toronto: University of Toronto Press, 2005), pp. 368–88, at 372.
34 Bill Griffiths, *Aspects of Anglo-Saxon Magic* (Frithgarth: Anglo-Saxon Books, 1996), p. 41.
35 For an excellent discussion of the symbolic and political implications of the king's severed (and later restored) head, see James W. Earl, 'Violence and Non-Violence in Anglo-Saxon England: Ælfric's "Passion of St. Edmund"', *Philological Quarterly*, 78 (1999), 125–49.
36 Ælfric of Eynsham, 'Life of St Edmund', in *Ælfric's Lives of Saints*, ed. W. W. Skeat, vol. 2 (Oxford: Oxford University Press, 1966), pp. 318–20.
37 Howe, 'Cultural Construction', pp. 63–4.
38 Seth Lerer, *Literacy and Power in Anglo-Saxon Literature* (Lincoln: University of Nebraska Press, 1991), p. 22.
39 Harman, *Tool-Being*, pp. 126–7.
40 Brown, 'Thing Theory', p. 4.
41 Bennett, *Vibrant Matter*, p. 3.
42 Allen J. Frantzen, 'Writing the Unreadable *Beowulf*', in Eileen A. Joy and Mary K. Ramsey (eds), *The Postmodern Beowulf: A Critical Casebook* (Morgantown: West Virginia University Press, 2006), pp. 91–129, at 107–9.
43 Cf. Leslie Webster, 'Archaeology and *Beowulf*', in Bruce Mitchell and Fred C. Robinson (eds), *Beowulf: An Edition* (Oxford: Blackwell, 1998), pp. 183–94.
44 Overing, '*Beowulf* on Gender', p. 20.
45 Lerer, *Literacy and Power*, p. 177.
46 Ibid., p. 179.
47 Orchard, *Pride and Prodigies*, p. 48.
48 Ibid., pp. 32–3.
49 Brown, 'Thing Theory', pp. 15–16.

The 'thingness' of time in the Old English riddles of the Exeter Book and Aldhelm's Latin *enigmata*

What do we make of the transformation of things over time? Maybe one also ought to ask what things make of us over time: how are human beings transformed by the things that carry the traces of our voices and our bodies when we are gone? The Old English and Anglo-Latin riddling traditions give voice to things, as if they could answer such a question. Yet, for the most part, criticism has focused on the rhetorical device of prosopopoeia, whereby the human voice is attributed to or imposed upon a nonhuman and so the things themselves are thought to be mute, or silenced, through a process of anthropomorphism.[1] Recent trends in thing theory, however, have fought against the ingrained idea that anthropomorphism is always a simplistic and childish habit to be avoided. As Benjamin C. Tilghman has suggested, it might instead be recognised as a useful tool for making sense of the alterity of nonhuman things. Rather than reinforcing anthropocentrism, early medieval riddles can 'highlight the agency of things and the human inability to gain complete mastery over them'.[2] A significant obstacle to recognising the agency of things is the common-sense assumption that they are inert: the assumption that a 'thing' must be an inanimate material object. This too has been rethought by modern thing theorists, who have shown that all matter has a vibrant materiality.[3] Gases and liquids flow, take new forms, vanish into air. Organic solids breathe, eat, create energy, rot, decay. Even hard inorganic solids like rocks erode into sands that are sorted and carried in water down to the seas. To acknowledge the flux and fluidity of things is to acknowledge that they endure over different temporalities to human beings, sometimes radically different timescales: from the ever-transforming raincloud to the gradual decay of a stone wall.[4]

As a literary form built upon metaphor, the riddle is perfectly placed to show how all things shift shape (from ice to water, fire to

smoke, honey to mead, ox to leather, sheep to book, ore to gold) as time unfolds. In this chapter, I will listen to the voices granted to the riddle-creatures in order to uncover the impressions these animals or artefacts (or animals becoming artefacts) have left on their human counterparts. This will enable me to look at how the Anglo-Saxons interacted with the nonhuman 'things' with which they shared their world, but in particular how these interactions affected their cognizance of time and change. In keeping with the aims outlined by thing theory, I intend to recognise the agency things have as they affect the lives of humans, focusing especially on their ability to shape the temporalities of Anglo-Saxon men and women. By refusing to remain fixed within one form, the elusive riddle-creatures often invite human readers to rethink how our own bodies, as things among other things, may cross categories of age, role and gender over different stretches of time. From the outward transformation of bodies, the latter part of this chapter moves on to explore how voice can be ascribed across the human/ nonhuman divide in early medieval textual and material culture. When other animals or artefacts take on our voices in riddles and enigmas, humans start to exist differently within the temporal world. These poems reveal how we may find human temporality altered when voice-bearing things talk back to us. It is the 'thing-ness' of these nonhuman voice-bearers that ultimately determines how human identities will endure or fade with the gradual passing of time.

Nonhuman time

When thing theory emerged in the late 1990s and early 2000s, literary scholars started to publish books about early modern objects and eighteenth-century it-narratives.[5] But it is worth remembering that a fascination with how things speak, and how to speak with things, stretches into the more distant past. Accordingly, the 2001 special issue of *Critical Inquiry* on 'Things' featured an essay that discussed Old English riddles at length. In 'Lyric Substance: On Riddles, Materialism, and Poetic Obscurity', Daniel Tiffany draws our attention to what the early medieval riddling tradition tells us about the materiality of things. For Tiffany, the inscrutability of things in riddles betrays 'the inescapable role of language in depicting the nonempirical qualities – the invisible aspect – of material phenomena'.[6] Tiffany undertakes this analysis in order to

make available to literary and cultural studies a more productive sense of the ambiguity of material substance. As such, the Anglo-Saxon riddling tradition offers some key insights that can lead to the formation of a theory of things. Central to Tiffany's thesis is the notion that these riddles are essentially 'materialist allegories' as well as allegories of materialism. Unlike conventional allegory, the 'phenomenon veiled by the dark or enigmatical description is not a metaphysical entity (an abstract concept or a divinity), but a physical object or being'.[7] The weird creature (the OE *wiht*) we encounter at the outset of the poem, and veiled by its obscure speech, turns out to be a familiar phenomenon, a part of every-day experience. By taking on board the lessons of the riddles, and incorporating their approach to the material world into our critical practice, Tiffany's essay aims to encourage the humanities to abandon uncritical assumptions about the nature of material substance, for 'the reality of matter must always remain uncertain, always a problem that needs to be taken into consideration'. Therefore, the study of material culture 'should never take for granted the material existence of its objects'.[8]

I aim to extend the work that Tiffany started, by considering how riddles offer us a unique glimpse into the temporality of material things: a nonhuman temporality that we would otherwise fail to perceive, were it not captured by the playful language of the Anglo-Saxon riddles. By granting a voice to mere things, and coaxing them to talk about their former origins as well as their current and future uses, riddles do not allow us to take for granted the inertia of objects. Material artefacts that seem to be unmoving are lyrically transformed into other kinds of things as time enacts change and as processes of creation, exchange, use, decay, suffering and shape-shifting unfold. Time itself is not usually defined as an object but its movements can nevertheless be observed through the lifespan of various material bodies, a lifespan that riddles are capable of unfurling before our eyes. How, then, do early medieval riddles and enigmas play with the phenomenon of time? How do these riddles make nonhuman temporalities visible, audible and perceptible through the language of poetry?

Paradoxically, my discussion of the 'thingness' of time begins with the nothingness of time. In many senses, nothing could be less thinglike than time, so intangible, unseen, unheard, fleeting. If indeed the solution to Riddle 39 of the Exeter Book is 'time', as critics such as Trautmann have suggested,[9] then it would seem that

the Anglo-Saxons had arrived at a similar conclusion. Riddles 39 opens with the teasing proposition that:

> Gewritu secgað þæt seo wiht sy
> mid moncynne miclum tidum
> sweotol ond gesyne. Sundorcræft hafað
> maran micle, þonne hit men witen. (1–4)

[Writings say that this creature is amid mankind at many times, clear and seen. It has a special power, far greater when men know it.][10]

The *wiht* we are dealing with in this riddle has neither 'fot ne folme' [foot nor hand] (10). It 'ne eagena hafað ægþer twega' [has no two eyes either] (11) and 'ne muð hafaþ' [has no mouth] (12). With no feet or hands, eyes or mouth, this entity does not have the bodily senses to see us, or touch us, or taste us. From further descriptions, we may ask how we are meant to perceive it, in turn: handless and footless, it 'ne æfre foldan hran' [never leaves its touch on the earth] (10) and with neither 'blod ne ban' [blood nor bone] (18) there is no body there for us to make sense of. And yet the opening of Riddle 39 tells us something different. Far from being invisible the *wiht* is 'mid moncynne miclum tidum sweotol ond gesyne' [amid mankind at many times, clear and seen] (2–3). Insubstantial as it may seem, the riddling entity has a 'wile' [will or desire] (5) which is to 'gese-can sundor æghwylcne feorhberendra' [to seek out separately each one of the life-bearers] (5–6). What is this nothingness that has a desire to seek us out, that moves in our midst, both known and strange, seen and unseen, dwelling with us individually, intimately, and yet never being the same – or the same being – 'niht þær oþre' [one night as another] (7)?

The phenomenon described in Riddle 39 sounds very much like one of Timothy Morton's 'hyperobjects'. Hyperobjects are so massively distributed across time and space that they appear to be everywhere and nowhere; they can be experienced partially yet any particular materialisation never reveals the totality of the hyperobject: raindrops are a local manifestation of climate but do not enable us to encounter climate itself, and a single word might allow us to speak a language but it cannot reveal the entirety of that language to us. 'Time' could be understood as the ultimate hyperobject: humans are continuously experiencing its effects but we will never be able to grasp it as a solid entity. Hyperobjects create 'a sense of the *asymmetry* between the infinite powers of cognition and the infinite being of things'.[11] Similarly, Riddle 39

posits a *wiht* at once so present and so evasive that it troubles the subject–object, self–other, interior–exterior binaries that ordinarily allow us to divide the world into the human that sees, touches, names and organises and the nonhuman that is seen, touched, named, organised.

This is a resolutely disembodied riddle. On the one hand, the insistent negation tells us what we are not dealing with: having no eyes, ears, mouth, no soul or life, leaving no mark, the entity cannot be an animal and is unlikely to be an artefact. On the other hand, via its repetition of the phrase 'ne hafað ... ne hafað ...' the riddle also robs us of our ability to make sense of things. As we are taken through the negative statements, we are able to eliminate solutions, to say what it is *not* called; but the affirmation that it 'leofaþ efne seþeah' [lives even so] (27) or is 'bearnum wearð geond þisne middangeard mongum to frofre' [for the children of men around this middle-earth a comfort to many] (18–19) keeps the riddling game alive, keeps us guessing. As the *wiht* oscillates between being and not being we also oscillate between sensing and not sensing, knowing and not knowing. There is no firm ground for the riddle reader to stand on. We are neither subjects who see, scrutinise and organise time nor objects on the receiving end of its action. Riddle 39 denies us our usual mode of sensory apprehension via which we act as subjects. It also denies us a solid object to scrutinise. Riddle 39 forces us into a liminal zone, an area of 'thingness'. Yet Riddle 39 does at least give us a name, for in the Old English 'time' is here described as a *wiht*. As I have demonstrated, the OE word *wiht* straddles the bounds between the abstract and tangible, immaterial and material, manmade and natural, living creature and dead artefact, and therefore shares many affinities with the 'thing' described by Brown and others.

Following the lead of Riddle 39 itself, I have so far been speaking in negative terms, relating what is taken away from us as sentient humans, unable to make sense of the bodiless entity, the *wiht* we are somehow meant to resolve: 'reselan recene gesecgan' (28). Yet if time is neither an artefact organised by us nor a being that organises us, we are granted the flexibility to exist fluidly within time. We are invited to stretch out our embodied boundedness, to expand our temporal frame.

Fluidity and flexibility, instability, stretching and expanding, flowing across thresholds, across boundaries: what better way to understand such a state of being than through water? For this

reason, I want to read Riddle 39 alongside Riddle 85 of the Exeter
Book, conventionally solved as 'fish and river':

> Nis min sele swige ne ic sylfa hlud
> ymb [* * *]; unc dryhten scop
> siþ ætsomne. Ic eom swiftre þonne he,
> þragum strengra, he þreohtigra.
> Hwilum ic me reste; he sceal rinnan forð.
> Ic him in wunige a þenden ic lifge;
> gif wit unc gedælað, me bið deað witod.

[My hall is not silent, myself am not loud around [* * *]; the lord
shaped our course together. I am swifter than he, at times stronger,
he more enduring. Sometimes I rest myself; he must run forth.
I dwell in him while I live; if we are divided, my death is ordained.]

Andy Orchard has argued that, if we allow ourselves to look beyond
similar Latin *enigmata* by Alcuin and Symphosius, and the con-
ventional 'fish and river' solution they offer us, then we might well
understand this as a 'soul and body' riddle.[12] Patrick J. Murphy
concurs, arguing that, while the correct solution must be a fish
in the river, the 'descriptive proposition is shaped by something
more – the unspoken metaphor of the soul and body' so that the
emphasis 'is on exploring the contrasting relationship of guest
with hall'.[13]

I, too, wish to shift the focus away from the simple 'fish and
river' solution and run with this contrasting guest and hall relation-
ship, exploring what it might have to say about temporality. Here,
we are invited to apprehend our life course, our movement through
time, from a split perspective. Unlike the probable source of this
riddle, Symphosius's Riddle 12, *Flumen et Piscis*, the Exeter Book
reworking does not give its answer away. More than that, Riddle
85 does not even open and close with the usual riddling formulae,
the conventional 'Ic seah' or the final 'Saga hwæt ic hatte'. With
no immediately identifiable perspective, the reader must dive into
a voice in the first person. The initial statements, as with much of
Riddle 39, are negative: 'Nis min sele swige, ne ic sylfa hlud ymb
...' [My hall is not silent, myself am not loud around ...] (1–2).
Speaker and environment are contrasted in a way that would have
run counter to Anglo-Saxon expectations of how voice-bearing
creatures behave. For instance, in *Beowulf* the din of the hall that
so troubles Grendel is not made by the hall itself but by the men
and women within the hall, their singing and harping and story-
telling. In Riddle 85, though, it is the speaker who is not loud and

the hall (*sele*) that is not silent, reversing the sense of vocality and agency. Ostensibly, the substance around or about (*ymb*) which the speaker in Riddle 85 moves seems quite different to that which moves around us in Riddle 39, where the latter 'ne muð hafaþ, ne wiþ monnum spræc' [has no mouth, nor does it speak with men] (12). However, the *fisc ond flod* are entwined in their course, bound together by the lord: 'unc dryhten scop siþ ætsomne' [the lord shaped our course/fate together] (2–3). Similarly, the entity or substance in Riddle 39 has a will, a desire to seek out each of the life-bearers (*feorhberendra*) and, not unlike the exiled speakers in *The Wanderer* and *Seafarer*, it must 'wideferh wreccan laste ham-leas hweorfan' [widely roam the road of exiles, homeless] (8–9). It never 'heofonum hran, ne to helle mot, ac hio sceal wideferh wul-dorcyninges larum lifgan' [reaches heaven, or to hell, but it must always live within the king of glory's laws] (20–2). Time is thus depicted as a fellow wanderer in this world, bound by God's laws and teachings as we are. Even while this entity is in many senses unknowable to us, there are ways by which we *can* know our fellow traveller. According to Augustine we must know this fellow travel-ler (that is, time) if we are to make sense of our journey at all:

> A temporum autem delectatione, dum in temporibus vivimus, prop-ter aeternitatem in qua vivere volumus abstinendum et ieiunandum est, quamvis temporum cursibus ipsa nobis insinuetur doctrina con-temnendorum temporum et appetendorum aeternorum.

> [While we live in the temporal order, we must fast and abstain from the enjoyment of what is temporal, for the sake of the eternity in which we desire to live, but it is actually the passage of time by which the lesson of despising the temporal and seeking the eternal is brought home to us.][14]

Human perspective is inextricably shaped by the movements of time and the alterations it enacts on temporal things even as the perspective of the 'I' in Riddle 85 is shaped by its watery envi-ronment. The *fisc* can only comprehend its life course in relation to the *flod*. As with the first line of the riddle, the speaker ('Ic') continues to contrast itself with its home ('he'): 'Ic eom swiftre þonne he, þragum strengra, he þreohtigra' [I am swifter than he, at times stronger, he more enduring] (3–4). It is in this way that Riddle 85 presents us with a split perspective. As readers we can only comprehend the speaker in relation to its hall, the 'I' in rela-tion to 'he'. As a result, we not only read or speak the 'I' of the fish but enter into the body of water, the watery body, it inhabits,

seeing and hearing the fish as silent, insignificant, scarcely animate in contrast to the long endurance of the river, its continuation as it 'sceal rinnan forð' [must run forth] (5) while the fish rests, still flowing on well beyond the fish's lifespan, stretching back into a history and forward into a future that the piscine speaker can neither conceive nor express: 'Ic him in wunige a þenden ic lifge; gif wit unc gedælað, me bið dead witod' [I dwell in him while I live; if we are divided, my death is ordained] (6–7). We are invited, then, to comprehend our life course in a nonhuman, expanded temporal frame. By way of comparison, consider Bede's famous sparrow:

> 'Talis,' inquiens, 'mihi uidetur, rex, uita hominum praesens in terris, ad conparationem eius, quod nobis incertum est, temporis, quale cum te residente ad caenam cum ducibus ac ministris tuis tempore brumali, accenso quidem foco in medio, et calido effecto caenaculo, furentibus autem foris per omnia turbinibus hiemalium pluuiarum uel niuium, adueniens unus passeium domum citissime peruolauerit; qui cum per unum ostium ingrediens, mox per aliud exierit. Ipso quidem tempore, quo intus est, hiemis tempestate non tangitur, sed tamen paruissimo spatio serenitatis ad momentum excurso, mox de hieme in hiemem regrediens, tuis oculis elabitur. Ita haec uita hominum ad modicum apparet; quid autem sequatur, quidue praecesserit, prorsus ignoramus.'

> ['This is how the present life of man on earth, O King, appears to me in comparison with that time which is unknown to us. You are sitting feasting with your ealdormen and thegns in winter time; the fire is burning on the hearth in the middle of the hall and all inside is warm, while outside the wintry storms of rain and snow are raging; and a sparrow flies swiftly through the hall. It enters in at one door and quickly flies out through the other. For the few moments it is inside, the storm and wintry tempest cannot touch it, but after the briefest moment of calm, it flits from your sight, out of the wintry storm and into it again. So this life of man appears but for a moment; what follows or indeed what went before, we know not at all.']¹⁵

Separated from the hall, our bodies die. Yet what Riddle 85 reminds us is that the hall itself endures beyond our passing. In the riddle, the *sele* is fluid, and is stretched, and in turn we shrink almost to nothingness, and the sound and fury of our brief life is not loud. *Fisc* and *flod* are bound up in their course, and yet the *siþ* (fate or movement) shaped for them unfolds differently, or, rather, they unfold differently along their course: one swift, the other slow; one stronger, the other more enduring; one always running forth, while the other rests.

In Riddle 39, we are likewise being asked to read and unriddle something that humankind is entwined with in this world. Nevertheless, this substance exists or unfolds differently to us. As the fish seems silent, small and fleeting to long-enduring water, the *wiht* of Riddle 39 seems almost unknowable to embodied humans. As the 'earmost ealra wihta þara þe æfter gecyndum cenned wære' [swiftest of all creatures after its kind ever conceived] (14–15), its movements through this world – always faring forth on its way, never staying still, never the same being one night after another, never leaving its mark on the earth – mean that there is no temporal moment in which we might make sense of its blood or bone, hear its words or see its eyes. This encourages us to shed our finite form, for the duration of the riddling game, and start to see ourselves as things among other things, and to see time *through* other things. An important contradiction within Riddle 39 is that, while it emphasises the unknowable character of time, it also teases us with the notion that, in fact, we can and do know time. Intangible and inaudible to us, the way to know this substance, the riddle suggests, is through the insubstantial: mind and words. Its 'special power' or *sundorcræft* is far greater 'þonne hit men witen' [when men know it] (3–4). It is a *wiht* that is 'cenned': from *cennan*, to conceive. Moreover, 'Soð is æghwylc þara þe ymb þas wiht wordum becneð' [true is each and every one of those things signified by words about this being] (25–6). We can know the 'truth' about this *wiht* through words. The poetic language of the riddle, in particular, can render the obscurity of time, its nonempirical qualities, visible. But, like Augustine in his *Confessions*, we must still mentally wrestle with the elusive concept of time: 'inde mihi visum est nihil esse aliud tempus quam distentionem; sed cuius rei, nescio, et mirum, si non ipsius animi' [it seems to me that time is nothing other than a stretching-apart; but of what, I do not know, and I would marvel if it is not a stretching-apart of consciousness itself].[16]

The paradox of time is that of a non-physical entity which presents itself to our consciousness through physical change. For all the 'immaterial' interaction we may have with this entity, we cannot get away from the bodily images summoned forth by Riddle 39's negative statements: blood, bone, limb, touch, foot, hand, eyes, mouth. What this poem seems to be telling us is that, although we may shed our human skins, we can still only think through tangible things. In the riddling game, human subjects are always becoming some other thing. Even the 'nothingness' of time must be accessed

through interactions with other bodies, other animals, other material objects.

Time, then, can only be conceived through things. Time, in turn, influences how we comprehend the 'thingness' of any given creature or artefact — for this thingness is relative to their existence within time, their transience or endurance. Time determines the manner in which we divide the world — into animate and inanimate, alive and dead, still and active, silent and loud. In relation to a long-lasting body of water, the fish of Riddle 85 is fleeting and not loud. What would the *wiht* of Riddle 39, the swiftest of all creatures, make of us, with voices too slow, or not slow enough, to be heard, and with bodies too brittle to endure, as it seeks us out and goes again on its way?

Time and change in material things

In her discussion of the premodern object, Kellie Robertson reminds us that it is post-Enlightenment 'common sense' that 'encourages us to view things as inert, mute witnesses to the life of active agents, to train our attention on the human subjects who look at, move around, and organize nonhuman things'.[17] As a result, we have become accustomed to clocks acting as objects rather than things, as windows onto the human whose sole existence is to tell us the time that we have imposed upon them, rarely impressing their own temporal existence upon us. However, Anglo-Saxon notions of time could often be enmeshed with the very 'thingness' of the artefact being used as a measuring or recording device. This is not to say that the Anglo-Saxons had no way of organising and segmenting the days or months or years apart from the rhythms of the external world. What will be seen in the section to follow, for instance, is a tension between 'natural' and 'social' time. Yet this tension is exactly that: a two-way tussle, a to and fro between what humankind wants and needs time to be and do, and the resistance of nonhuman things with their own, often contradictory, being-in-the-world. Candles and stones do not act as mute witnesses but might be understood as asserting a kind of agency. They have their own say in what time is and does.

Before turning my attention to what such things have to say, though, I will first consider the human take on determining time, the methods and meanings behind Anglo-Saxon divisions of the day, seasons and year. Frederick Tupper offered a detailed study of this matter, which shall be useful for my purposes here.[18] First

of all, Tupper deals with the Anglo-Saxon day, how it was divided
and the significance of these divisions. Without the use of artificial
time-keepers, the 'interval between sunrise and sunset was divided
into twelve equal parts called hours, and, as this interval varied
with the season, the length of the hour varied also'. Variable hours
like these were called 'temporary hours' whereas at the time of the
equinoxes 'both the day and night hours were of the same length
as those we use' and were therefore called 'equinoctial hours'.[19]
Tupper asks whether this was true of Anglo-Saxon times, whether
there is also a distinction evident between temporary and equi-
noctial hours. In addition to Bede and Ælfric, he cites Byrhtferð's
Enchiridion as evidence that there was a distinction between 'natu-
ral' and 'artificial' day, and that the Anglo-Saxon day began at sun-
rise. Byrhtferð says the following:

> On twam wisum ys se dæg gecweden: naturaliter et uulgariter, þæt
> ys gecyndelice and ceorlice. Þæt ys þæs dæges gecynd þæt he hæbbe
> feower and twentig tida fram þære sunnan upspringe þæt he eft up
> hyre leoman ætywe. Vulgaris uel artificialis dies est (þæt byð ceorlisc
> dæg oððe cræftlic) from þære sunnan anginne þæt heo to setle ga
> and eft cume mancynne to blisse.

> [Day is spoken of in two ways: *naturaliter* and *vulgariter*, natural and
> vulgar. It is the nature of the day to have twenty-four hours from
> the rising of the sun until it again displays its rising radiance. The
> *vulgaris* or *artificalis* (vulgar or artificial) day lasts from the sun's
> rising until it goes to its seat, and then it comes again as a joy to
> mankind.][20]

For Tupper, the evidence that unequal hours were employed by
the Anglo-Saxons is 'very conclusive' and refers to Bede in *De tem-
porum ratione*, who 'shows that the twelve hours of the Artifical
day – the time from sunrise to sunset – are necessarily unequal'.[21]
Further, in Anglo-Saxon England, 'unequal hours had their sup-
port in the Hours of the Canons' and while these were strictly for
monks 'there can be but little doubt that with them the laity were
perfectly familiar'. It is only with the introduction of clocks into
England during the thirteenth and fourteenth centuries that 'equi-
noctial hours' are established, causing old temporary divisions to
lose their meaning.[22]

What kind of time markers did the Anglo-Saxons have? They
were not as privileged as some of their neighbours, did not have
great clocks or a golden horologe or other mechanical inventions.
Of water clocks and sandglasses they 'probably knew little' and

'many passages in prose and poetry show how entirely the monks
and people relied upon the heavens as their guide'.[23] An intrigu-
ing case study, however, is that of Alfred the Great's candle clock,
as recounted in Asser's Life of the king. Initially, the account fits
well with the familiar story of the human subject's mastery of the
world of objects around him. Unable to accurately estimate the
lengths of the nocturnal hours, because of darkness, or of the day-
time hours because of the regular density of the rain and cloud,
Alfred finds a useful and intelligent solution (*invento utili et discreto
consilio*).[24] The king instructs his chaplains to make six candles (*sex
candelas*) out of wax, each of equal size, 'ut unaquaeque candela
duodecim uncias pollicis in se signatas in longitudine haberet' [so
that each candle would have twelve divisions marked longitudi-
nally on it]. Man creates the artefact and marks its body so that it
might tell him what he already knows about time: 'sex illae cande-
lae per viginti quatuor horas die nocteque sine defectu coram sanc-
tis multorum electorum Dei reliquiis ... ardentes lucescebant' [the
six candles were lit so as to burn through the twenty-four hours of
each day and night, without fail, before the sacred relics of many
of God's elect]. Stevenson, in the notes to his edition of the *Life of
Alfred*, remarks of this passage that 'the author refers to a division
of the day and night taken together into twenty-four equal hours,
and not to the division of the day, the time between sunrise and
sunset, and the night, the time between sunset and sunrise, into
twelve hours each, the length of which, strictly speaking, varied
from day to day'. For Stevenson, Alfred is 'pictured as using the
equinoctial hours' in this instance and, if this is so, he has 'the
credit of anticipating by several centuries the use of this, the mod-
ern, system, which is so largely the result of the introduction of
the wheel-clock'.[25]

As Exeter Book Riddle 39 demonstrates, humans can know time
by conceiving it, but what we conceive with the mind must also be
seen and touched in material form. Alfred thinks the candle clock
into being so that what he already knows about time (that each day
and night is segmented into twenty-four hours) may be tangibly
confirmed through a waxen body. According to Asser's account,
though, the candles do not behave as Alfred intends them to, for
the violence of the wind (*ventorum violentia*) blowing through
doors and cracks into the churches causes the candles to burn up
more quickly than they should, so that they had finished their
course before their appointed hour (*exardescere citius plus debito
ante eandem horam finiendo cursum suum*). Wax and wind interact

to tell Alfred something different about time, challenging the neat twenty-four hour division of day and night. It is in this manner that the candles cease acting like objects and start to assert their thingness. In this moment of resistance, Alfred's invention is sliding between candle clock and waxy amorphousness, neither formed nor unformed, neither working as intended nor idle. The candles are meant to melt – but the fact that they are doing so more swiftly than their design dictated exhibits the tension between human and nonhuman time.

While Alfred's candle clock is a means of measuring time in this world, it is also a way of creating space within the course of the day in which the king might reflect on the timelessness of the next world. Asser tells us that the reason behind the construction of the clock is so that Alfred can render to God 'dimidiam partem servitii mentis et corporis' [one half of his mental and bodily service] both by day and night. Yet the rendering of this time to God is connected to Alfred's somatic existence in this life, for the king can only offer to God 'in quantam infirmitas et possibilitas atque suppetentia permitteret' [as much as his health and means would allow] and when he thinks to increase the half of his service, he can only do so as far as his means and abilities and of course his health (*immo etiam infirmitas*) would permit. Even when intending to think on eternal bliss, while waiting to be fetched from this transitory life, Alfred remains conscious of his own body in time, its temporal limitations, its change and decay.[26]

But the candles themselves are key to how Alfred understands his bodily alterations and movement through time. He is devoting time to his Maker through the artefact he himself has made or commanded to be made. In *De civitate Dei*, St Augustine lists the many technological inventions of humankind, from weaving and building to agriculture and navigation, pottery, painting and sculpture, weapons, musical instruments and ornaments. For Augustine, such inventions merely adorn our mortal lives and would not have been necessary were it not for original sin and the resulting miseries.[27] However, in the Augustinian Christian view of technology, as the world declined into the future, the enfeebled body of postlapsarian mankind could 'improve through artifice' whereby the artefactual serves as 'a prosthesis to supplement the fallen body of mankind'.[28] The human body and the body of the artefact are bound together, a continuousness between the two formed in the act of making. Some artefacts (swords, shields, cups, books) may outlive their human makers but others, like the candle, have a shorter life course; they

deteriorate and die before human eyes, while we watch. There is an ambivalence about Alfred's candle clock. On the one hand, we witness human mastery over nature, the construction of an artefact to tell us the time, an invention that allows Alfred to take time out of this world and devote himself to what is morally and spiritually important. On the other hand, the ever-melting candles, which melt even faster when their nakedness is not covered by a wood and ox-horn lantern, a covering devised by Alfred to shelter the candles from draughts of wind, call to mind the ever-deteriorating fallen body of man, itself hastening towards the grave as the twenty-four hours of each day go by. In the Old English *Genesis A*, the naked bodies of Adam and Eve are suddenly exposed to 'wind' and 'hægles' and 'forst' and the 'beorhte sunne' (806–11) after the Fall.[29] Similarly, the candles in Asser's *Life of Alfred* are vulnerable to the wind and rain in their nakedness, and must be clothed in wood and horn. Partly due, no doubt, to the Life's debt to hagiographical conventions, Alfred's body comes down to us through Asser as a sickly one and his 'illness' is often discussed in visceral terms, relating to the king's insides.[30] Just as the candle clock that the king makes allows him to devote time to his Maker, the vulnerability and visible decay of this manmade artefact also says something about Alfred's own existence in time.

In his Latin *enigmata*, compiled before the age of Alfred, at the end of the seventh century, Aldhelm describes a candle in similarly visceral terms. Enigma LII opens with the candle's manual construction: 'Materia duplici palmis plasmabar apertis' [I was created from two materials by open hands] (1).[31] Man shapes his artefacts with his hands, but so too does God the Creator when shaping the earth and humankind in *Genesis B*.[32] In the next lines, the candle crosses between human and nature, god-made body and manmade artefact: 'Interiora mihi candescunt' [My insides shine hot] (2). *Candescere* is a verb that has connotations of both heat (like the warm human interior) and radiance. This thing also has entrails (*viscera*) but they are taken from the natural world, from flax (*lino*) and the slender rush (*gracili iunco*) (2–3). The candle's interior seems human, and yet has been formed from what is exterior to the body. Likewise, the outer surface of its body, its skin, is yellowish gold and produced from flowers: 'Sed nunc exterius flavescunt corpora flore' (4).

Having constructed the candle, enfolding outer and inner, body and nature, in the first half of the riddle, Aldhelm then describes its deterioration, again in both human and nonhuman terms. The

candle vomits or belches out fire: 'Quae flammasque focosque laremque vomentia fundunt' (5), which causes it to both melt and weep: 'Et crebro lacrimae stillant de frontibus udae' (6). In Juster's poetic translation, 'And maudlin tears keep dripping down my brow'. Once the candle has cried itself to death, its insides, shaped from nature by the hands of a maker, once radiant with life, are now scorched (*viscera tosta*) and leave only remnants of ash (*reliquias cinerum*) (8). Or, as Juster renders the final line, 'They leave ash smudges where my guts were seared'. Unsettling the divide between the body that makes and the body that is made, between that which lives and breathes and vomits and weeps, and that which shines and burns and melts, Aldhelm's riddle sheds light on what a candle can tell us about time and change. When viewed in such visceral terms, the melting candle seems to hasten somatic decay and death, serving to underscore the deterioration of the fallen human body.

What a waxen candle has to say about time and change is very different to what stone tells us. It is hard to imagine stone telling us much at all. Whereas a candle melts before human eyes, visibly returning to its waxy formlessness as it burns down, always becoming something else, its deterioration registering the passage of time faster than the human body can, stone seems to remain inert, immutable, constant. At least, that is how humans tend to make sense of stone. Jane Hawkes has commented on the Anglo-Saxon utilisation of stone as a powerful and permanent material, and shown how Roman forts could provide a backdrop for Christian monuments – such as those of Ruthwell and Bewcastle – as a 'physical manifestation of the old *imperium*' which the Church 'appropriated and redefined' for its own purpose.[33] Stone's power was bound up with its ability to endure across multiple human lifespans, to outlive the men and women who shaped it into a monument or fortress and to carry the power of the past into the present, its stony life vaster than empires, and more slow.[34] So while stone does seem to stand solid and silent before the human, we have always been aware that its stillness through time is itself a kind of movement that renders us ephemeral in comparison.[35] As such, stone has not only been utilised as a symbol of power, but as a means to measure time in a way that other materials cannot.

One instance of stone's role in reckoning time is to be found in the Bewcastle monument, which has a sundial on its south side. This feature is significant as 'probably our earliest surviving English instrument for calculating the passage of time'.[36] For

the Anglo-Saxons, the sundial was the 'chief chronometer'[37] and is described by Byrhtferð in his *Enchiridion* in the section immediately following his discussion of the 'natural' and 'artificial' day:

> Se dæg þe hæfð feower and twentig tida, he hæfð syx and hundnigontig punctos. Feower puncti (þæt synt prican) wyrcað ane tid on þære sunnan ryne; and forþan ys se prica gecweden forþan seo sunne astihð pricmælum stihð on þam dægmæle. Me ys neod þæt ic menge þæt Lyden amang þissum Englisce. Punctus a pungendo dicitur. Forþan ys se prica gecweden forþan he pingð oððe pricað. Hawa, la cleric, hu seo sunne pricmælum stihð on þam dægmæle; þonne miht þu gleawlice ascrutnian þas prican þe we ymbe sprecað * * *

> [The day that has twenty-four hours has ninety-six points. Four *puncti* (points) make one hour in the sun's course; and the point is so called because the sun advances point by point on the sundial. It is necessary for me to mix some Latin in with this English. *Punctus a pungendo dicitur.* The point is so called because it pricks or stings. Observe, O clerk, how the sun advances point by point on the sundial; you may then wisely scrutinize those points that we speak of * * *][38]

A sundial thus functions instrumentally, as a tool for recording the passing of time. But a closer consideration of the Bewcastle sundial reveals how a thing of stone might not always comply with manmade temporalities.

Éamonn Ó Carragáin has noted that the sundial was likely to have had both practical and symbolic functions. On the practical side, each day it would have 'reminded ecclesiastics of their duty to celebrate the liturgical hours, and reminded all onlookers, religious or secular, that other tasks needed to be done'. Its symbolic function was to show that the 'sun was an image of Christ, the Bridegroom' and to indicate 'the logic behind the sequence on the west side, from Christ to John the Baptist' whereby Christ's conception and birth were celebrated on the 'growing days' when the sun began to overcome the winter darkness, while John's conception and birth were celebrated on the 'lessening days' when the darkness began to triumph over the sun's light. In this way, the Bewcastle sundial binds the practical with the symbolic, even as power and permanence are bound within the medium of stone. The Bewcastle monument stands and has always stood 'out of doors, within the massive vallum of a Roman fort'.[39] Its sundial means that it could not have been enclosed within a church if it was to function as intended, but its stoniness means that it could have endured the

weather as a candle clock could not have. This endurance allowed
the monument and sundial to be seen by onlookers as it reminded
them of their duties within the divisions of the day; and its endur-
ance and monumental visibility is connected to power. Its presence
within a Roman fort would have communicated the appropriated
imperium of the Christian Church but this is also linked, via the
sundial, to the sun's triumph over darkness and Christ's triumph
over death. Lithic solidity and stability thus enables time – the
daily and seasonal division of time – and power to visibly intercon-
nect across and around the Bewcastle monument. While a candle
clock measures twenty-four hours by burning and melting away
far faster than the human body deteriorates within time, the stone-
carved sundial witnesses and stands witness to equinox after equi-
nox, solstice after solstice, long since its human onlookers have
ceased looking.

For Orton, Wood and Lees in *Fragments of History*, Ó Carragáin
is on uncertain ground when he talks about the 'symbolic reasons'
for the Bewcastle sundial which, as 'an instrument that represents
the sun's ordered progress, seems a strange device with which to
represent the "powers of heaven ... shaken", driven from their
courses'.[40] However, they do note that the sundial 'must be seen
and understood as an aspect of the monument's Romanness' and
also remind us that the monument was erected within the remains
of the Roman fort of *Fanum Cocidii*. The 'Romanness' of the
monument is linked not only to power but to knowledge, given
that its sundial is best understood as 'resourced' by a familiar-
ity with Roman dials and dialling.[41] But what I want to stress
here is that stone as a material, in its very stillness and solid-
ity, substantiates this Roman-resourced knowledge and enables
an artificial division of time to be observed in a way other things
cannot. That is to say, no thing but stone would have sufficed in
reckoning time and regularising the days and years in the ordered
manner necessary for the Bewcastle community. Orton, Wood
and Lees comment on how early medieval Northumbrian time
would have been mainly natural time, determined by the rhythms
of nature, without imaginary divisions of time, without hours –
mainly natural time, but not entirely, for Northumbrian monastic
society was starting to inaugurate a different kind of time: social
time, the time of calendars and clocks.[42] But the beginnings of
this search for social time may have depended upon stone, or at
least upon a certain sort of materiality which only stone can offer.

Early Northumbrian monastic societies increasingly needed a time that was removed from nature. Stone stands in a still and stark contrast to the apparent movement of the sun across the sky, to growing and harvesting, the changing seasons, the tides, the swaying of grass in the wind, the heartbeats of animals. It would, for this reason, seem the ideal material to facilitate the move from natural to social time, registering movement while itself remaining unchanged.

Stone is nevertheless part of the natural world, even if it can be used to record the time of society, and to say that stone is still and solid is to speak only from the limited perspective of the human lifespan. Stone could outlast a hundred generations of human beings, kingdom after kingdom, but it would not remain unchanged forever. The Exeter Book poem *The Ruin* takes a broader perspective and describes how 'Wrætlic is þes wealstan, wyrde gebræcon; / burgstede burston, brosnað enta geweorc' [Wondrous is this wall-stone, broken by fate; the fortresses fell to bits, the work of giants decays] (1–2). While stone might stand for the redefined *imperium* of the Christian Church, it could simultaneously convey the crumbled *imperium* of empire. From different perspectives, a stone monument could be a solid monument or a material in flux. In his discussion of 'materials against materiality' Tim Ingold encourages us to switch our attention from stone as a material object to what happens to stone *as a material* in the course of exchanges of substance across its surface with the surrounding medium of air. Ingold demonstrates – by way of a wet stone becoming dry – that stoniness is not in the stone's nature or materiality, as such, but emerges through the stone's involvement in its total surroundings (including the human observer) and from the manifold ways in which it is engaged in the currents of the lifeworld. In place of the material world, populated by solid objects, our eyes are opened to a world of materials, in which 'all is in flux and transformation'.[43]

This may not be an exclusively modern insight. In a number of his early medieval *enigmata*, Aldhelm toys with the boundary between the inert and the active, the dead and the living. Minerals and gemstones react and interact with the life and death cycles of animate creatures. Enigma IX begins with the seeming hardness, the unyielding nature, of the 'diamond' (*adamas*): 'En ego non vereor rigidi discrimina ferri, / Flammarum neu torre cremor' [See! I do not fear the cutting of rigid iron, nor am I burned in a

furnace of flames] (1–2). In the next moment, we learn that the blood of a goat (*sanguine capri*) can affect the indomitable strength (*virtus indomiti*) of the diamond in a way that neither flame nor the sword can, causing it to undergo elemental change: 'Sic cruor exsuperat quem ferrea massa pavescit' [Thus blood overcomes that which frightens an iron mass] (4). In Enigma XXIV, a speaking stone relates how the head of a dragon generates or gives birth to it: 'Me caput horrentis fertur genuisse draconis' (1). This 'dragon-stone' interacts with gemstones and enriches their luminance. But its own rigidness, its hard stoniness, is reliant on the life force of an animate creature, for no strength will be given to this stone 'Si prius occumbat squamoso corpore natrix / Quam summo spolier capitis de vertice rubra' [If the scaly serpent should meet its death before I have been plundered, red, from the crown of its head] (4–5). Aldhelm challenges the seeming indifference of stone to the rest of the natural world, highlighting its active and reactive role in a chain or web of being. But we must be careful, while recognising the livingness of stone, not to think that it can be made to yield utterly to human whims. In his distinction between materials and materiality, Ingold attempts to escape an oscillation between the brute materiality of stone and its simple incorporation into human affairs. Rather, in the world of materials 'humans figure as much within the context for stones as do stones within the context for humans' – both belonging within an ever-unfolding continuum of organic life.[44] Our desire for stone to work for us, to be more malleable, for its life rhythms to match human life rhythms, silences the subaltern thing no less than an insistence on its deadness.

To state the obvious, a sundial only works well when the sun is shining. Orton et al. imagine that some members of the Bewcastle community, mesmerised by its novelty, 'wondered whether the dial controlled the movement of the sun rather than the sun the movement of the gnomon's shadow across the dial'.[45] Yet, unlike a modern clock, the Bewcastle sundial was not so in synch with the manmade fragmentation of life. While humans may at times wish for stone to be more flexible, more responsive, more aware of us and our time, its silence and stubborn lack of movement is its agency, even its voice, reminding us that our tiny segmentations of day and night, our divisions of light from dark, this year from that, one age or era from another, mean little when viewed from the longevity of the lithic.

The body in flux

The thing described in Exeter Book Riddle 74 has continuously shifted its shape in the minds of critics, who have sought but struggled time and again to say what it is called:

> Ic wæs fæmne geong, feaxhar cwene,
> ond ænlic rinc on ane tid;
> fleah mid fuglum ond on flode swom,
> deaf under yþe dead mid fiscum,
> ond on foldan stop, hæfde ferð cwicu.

> [I was a young girl, a grey-haired woman, and a singular warrior at one time; I flew with the birds and swam in the water, dove under the waves, dead with the fish, and stepped on land – I held a living spirit.]

This has been identified as everything from swan to quill pen, figurehead to barnacle goose.[46] Franz Dietrich in 1859 and then John Walz in 1896 sought a name for the entity and found a fitting one in the Latin *luligo* (squid or cuttlefish), making a connection with Aldhelm's Enigma XVI.[47] In Juster's recent translation of the Latin enigma we read:

> Nunc cernenda placent nostrae spectacula vitae;
> Cum grege piscoso scrutor maris aequora squamis.
> Cum volucrum turma quoque scando per aethera pennis,
> Et tamen aethereo non possum vivere flatu.

> [Seeing life's spectacles now entertains;
> With fishy, scaly flocks, I search sea plains.
> With mobs of birds I also rise through sky,
> And yet I can't survive in breeze that's high.]

In Aldhelm, the enigmatic speaker searches the waters of the sea with fish (*Cum grege piscoso scrutor maris aequora squamis*) and also ascends through the air with the birds (*Cum volucrum turma quoque scando per aethera pennis*) (2–3). The wonder of the cuttlefish is that, even so, it cannot live by breathing air (*Et tamen aethereo non possum vivere flatu*) (4) and its life is therefore a 'spectacle'. An ability to change age and sex, and to walk on land as well as swim and fly, is found in the Exeter Book riddle but not accounted for by Aldhelm's cuttlefish and so this answer cannot be deemed completely satisfactory.

Tupper offered the solution of 'Siren', claiming that this answer 'easily meets every demand of the text' since 'the Siren is both aged and young, centuries old and yet with the face of a girl. It

is not only a woman but sometimes a man.'[48] The allusiveness of this entity provokes Tupper to not only opt for a hybrid creature as his solution but to situate her/him at the intersection of two discourses: 'at an early period of the Middle Ages ... the Teutonic conception of a fish-woman or mermaid met and mingled with the classical idea of a bird-maiden'.[49] In order to satisfy 'every demand of the text' the siren must cross boundaries of historical as well as corporeal time: young girl and old woman; at once classical and medieval. For Tupper, the combined bird and fish aspects of this classical–medieval creature explain line 3 of the riddle: 'fleah mid fuglum ond on flode swom' [I flew with the birds and swam in the water]. To meet the demands of line 4 – 'deaf under yþe dead mid fiscum' [I dove under the waves, dead with the fish] – Tupper leans more towards its classical characteristics, or rather what 'every student of myths' knows; namely, that the sirens threw themselves into the sea and were transformed into rocks when Ulysses or the Argonauts had passed by in safety.[50] For Niles, writing in 2006, it is Tupper's classical learning that has 'led him into the realm of fancy' since the 'very peripheral place of the siren in Anglo-Saxon lore' means that we cannot take this solution seriously.[51]

To my mind, Trautmann's solution of 'water in its various forms' gets closer to the thingness of this riddle creature: the young girl (*fæmne geong*) may be seen as a spring and the grey-haired woman (*feaxhar cwene*) as an ice floe, while the singular warrior (*ænlic rinc*) is snow.[52] As such, Trautmann's solution relates both a continuity across time and a continuous shifting in form, whereby the thing offers different sorts of interactions to the creatures or elements that encounter it: floating on water as ice at one time, then melting and mingling into the sea, and serving as a home or hall to fish in another stage of its life course. Thus the speaker of Riddle 74 is the same being but is never 'being' the same as time enacts alterations on it. Niles likewise deems this one of the better solutions offered, but has some doubt about whether ice, 'when it melts away into its matrix and alter ego of water, can legitimately be called "dead" '.[53] Nonetheless, it is worth keeping in mind that these riddles are designed to deliberately mislead, to say one thing and mean another, to force the reader or listener to question the conceptual categories they take for granted, to force us to ask what we mean when we say something is dead, especially when that thing is nonhuman. The trick lies not in making us see life where 'really' there is death, but in testing and stretching human categorisation itself, our ostensibly neat divisions of living being from dead thing.

As Mercedes Salvador-Bello has shown, a number of Old English as well as Anglo-Latin riddles lack transitional clues that would help distinguish living animals from the lifeless objects fashioned from them.[54] Death, indeed, is not the final word for the entity of Riddle 74, which is 'dead mid fiscum, / ond on foldan stop' [dead with the fish, and stepped on land] (3–4) so that its 'death' beneath the waves is only part of cycle in which it flies, dives and walks in air, water and earth.

Niles offers his own ingenious solution, in which the 'elusive speaking object is an *ac*, or oak-tree, which has been cut down and made into a *bat*, or boat'. The tree changes from sapling to a hoary, old oak before it is turned into a strong, warrior-like ship. This answer relies on us taking the oak tree as feminine and the boat as masculine, based on the fact that in Old English *ac* is a feminine noun, whereas *bat* is a masculine noun. Niles claims that such a reading is 'consistent with gender biases that were firmly entrenched in Anglo-Saxon society' so that trees are rooted to one spot in the same way that 'women are traditionally associated with hearth and home' whereas ships are 'daring rovers, as men have been known to be'. However, one phrase in the riddle remains as an obstacle to this solution: 'on ane tid' (2). Niles's reading is unsettled if the speaker is understood as having been a sapling (young girl) and old tree (grey-haired woman) and ship (warrior) 'at one time'. His way out is to punctuate the riddle differently from modern convention, so that it is 'the ship's motion that is single and undivided, not the speaker's identity as maiden, matron, and man'.[55]

As when the riddle tells us that a thing is 'dead', though, we ought to be alert to the riddling game and aware of those instances where the reader and would-be solver is being deliberately misled or deceived. 'On ane tid' is intentionally ambiguous, and modern punctuation, whatever choice is made, one way or another, often closes down – or perhaps falls for – the trick of the riddle. The reader wants to name, identify, solve, close; the riddle desires uncertainty, ambiguity, misdirection. The solver wants to win the game; the riddling voice wants to keep playing. This is not to say that efforts at solving the Exeter Book riddles have been futile. But what happens when we let the riddle have its own way? This starts to illuminate the distinction between objects and *things*, as formulated by Brown and other theorists. The thing always exceeds the named object; there is more to a riddle than its solution.

Where Niles, for instance, wants to name and identify the girl, woman and warrior as sapling, oak and ship, dividing one from the

other, fixing them within their own stage in time, the riddle itself wants us to ask and keep asking how these three, ostensibly discrete bodies can still be the same being at the same time. Thing theory highlights 'an amorphous characteristic or a frankly irresolvable enigma'.[56] So the thing of Riddle 74 is always sliding, always eluding us as we try to fix and name its form, and as such remains an enigma that we can only encircle again and again, which generations of critics name only to rename, time and time over. In its stubborn refusal to yield up its solution, its reluctance to be finally named, Riddle 74 simultaneously communicates wholeness and transformation, form and formlessness. It has lured critics into identifying it as a manmade, finished, solid artefact (boat or quill pen) but also as something not yet formed (sapling) or not yet formable (water). Niles himself acknowledges that OE *tid* is a 'vague term' in the Anglo-Saxon lexicon, which can mean anything from an hour to a season to an entire age. Thus the ambiguity of the phrase 'on ane tid' forces the reader to not only ask whether it is the thing's identity or motion that occurs at one time but to ask, furthermore, what sort of time these changes, these movements, unfold through. Are we dealing with a substance that changes before human eyes, in the course of a single day, like the waxen candle? Or is it something whose movements can hardly be conceived within a human timeframe, something like stone for which even an age is fleeting? By refusing to strive for a definite answer here, by resisting the need to solve the riddle, to close down its ambiguities, I am not fixing the thing within time and space, and so it retains in its being both latency and excess, its before and after all at once. That is, the thing can be this *and* that – sapling *and* oak, ice *and* water, fish *and* bird – in one time, because by not naming it, or by naming it only as a 'thing', I am not containing it within a human timeframe.

It is in this way that the unsolved thing forces the human reader to hover over a threshold, within the liminal zone in which we can start to understand what it means to be both subject and object, human and nonhuman. Bestowing a name on Riddle 74 would make it into an object, solved and named, but also reinforce the status of the reader as the human subject who solves and names. Our inability to solve this riddle may be irritating at first, but before long we might start to wonder. Wonder, according to Ian Bogost, destabilises and unhinges us from familiar systems of interpretation. Wonder is an event that detaches us from 'ordinary logics, of which human logics are but one example'.[57] Only if we know for certain that the thing in Riddle 74 is, say, a boat or ice or siren or

cuttlefish can we say that it is anthropomorphised – that the hoary oak or the ice floe is 'like' an old woman or that snow or a ship is 'like' a warrior. Yet unlike Aldhelm's Enigma XVI, Exeter Book Riddle 74 offers us no name or title and so there is no stable reference from which the human reader may enter and exit the riddling game. Instead, the human who gives voice to the riddle merges with the thing describing itself. As well as seeing and naming both form and formlessness, critics have seen and named both human and nonhuman, man, woman and animal (siren, for instance, or figurehead in the form of a girl, man or beast). This is because the riddle describes neither an animal nor an artefact that is 'like' a man or woman, nor a human that is 'like' some other creature. Rather, it merely gives us a body in flux, a thing that is what it is but is always becoming some other thing. The riddle troubles both the artificial categories that divide human from nonhuman and the categories that subdivide the human itself, by gender, age or role, revealing in addition the way that time is artificially segmented and organised to fit such categorisation. That is, *fæmne geong*, *feaxhar cwene* and *ænlic rinc* are identified as discrete roles because they are to a degree understood as different stages within time, whether in human terms or in nonhuman terms as spring, ice and snow, or as sapling, oak and ship.

This shifting exterior, though, is contrasted with a living continuity across time. Not only is this suggested by the all-at-onceness of 'on ane tid' but also by the final line of the riddle: 'hæfde ferð cwicu' (4). The usual translation of this statement is 'I had a living spirit', though Niles has also offered 'I contained living spirits', connecting Riddle 74 with Taylor riddle-type 828, 'The Dead Bears the Living', which in his reading would mean a ship carrying human cargo.[58] Either way, the *ferð cwicu* runs like a thread or a river through the shape-shifting exterior of the enigmatic thing. If we acknowledge the 'Dead Bears the Living' theme, then the changing external form might be seen as a kind of *banhus*, an outer surface or shell on which time enacts its alterations, safeguarding an inner treasure. Situated in the last line, where often the riddle reader might be asked to 'say what I am called', the statement invites us to ask what it means for a thing to be alive, or dead, and, if change is the only constant, as it is in this riddle, when does something shift from being an animal to an artefact, creature to tool, or from human to nonhuman? As the voice declares its former livingness, the final statement turns inside out so that rather than having or 'holding' a living spirit within it at one time, this

continuously mutating and mobile thing seems to have been held together over time by its own interiority. It is almost an inversion of Riddle 85, where the fluid but enduring river holds the swifter but more fleeting fish, where the hall flows on well before and far beyond the life of its inhabitant. In Exeter Book Riddle 74, it is a body in flux that can ultimately only express its multifaceted life course in relation to the force that ran through it.

Sound, speech and temporal movement

For Patrick J. Murphy, the Old English riddles 'glory not only in their variety of solutions but also in the intricacy of the links they reveal in the fabric of creation'.[59] Within that fabric we glimpse human faces and bodies among the fish and birds, stones and candles, trees and boats, rivers and skies. The human, or the category of the human, itself emerges as a riddle, something known only in relation to other things. Do we move through time like candles or like stone? Is that movement swift, like a fish, or long and slow, like a river? At what stage does a body in flux change from old woman to young warrior? When the oak tree becomes a boat, when snow turns to ice? Through the readings I have offered of the various riddles, we begin to see the nonhuman nature of the human body and so to understand what things make of us over time. But I opened this chapter with the issue of voice, and the rhetorical device of prosopopoeia. Is it possible to escape the idea that the animals and artefacts presented to us in these riddles speak in a human voice that has been imposed upon them? In this final section, I will look at those riddles that deal with sound, speech and the written word in order to question the idea of 'imposition' and reframe it as a human–nonhuman collaboration. The Exeter Book 'swan' riddle, along with Latin and Old English 'quill pen' riddles, show how voice flies and, furthermore, reveal how human speech and its spatio-temporal movement is bound up with nonhuman sound. By throwing our winged voices in this manner, human identity is able to endure in ways that our mortal bodies alone cannot. Yet our identity depends upon and is sustained by nonhuman bodies. When sound flies from one thing to be inscribed onto another, words become visible and tangible and, as such, become enmeshed with the thingness of the voice-bearing artefact.

For the modern reader, there is a significant obstacle in the way of the notion that nonhuman, and especially artefactual, things can talk in any other sense than a metaphorical one: men and women

have mouths with which to speak whereas inanimate objects do not. However, in 1990 Eric Jager wrote an article that examined the important role of the chest in relation to speech in Old English, where he uses the term 'pectorality' as a corrective to the tendency of 'orality' to deflect attention from the chest's significant verbal role. Jager notes that although 'Old English poetry sometimes mentions the mouth in connection with speech, many contexts instead specify the chest as the source of utterance and as the centre of verbal activity, usually without any mention of the mouth'.[60] Perversely, the two main examples Jager provides in his footnotes of 'oral' speech in Old English are Riddles 8 and 60 of the Exeter Book where the mouths in fact belong to nonhuman creatures: the nightingale in the former and the mouthless reed or rune staff in the latter.[61] In keeping with some of the claims I made in the introduction to this book, Jager demonstrates that speech does not always originate from 'within' the embodied self, nor is it necessarily controlled by human volition, by our individual consciousness, but enters and exits the body through the chest, often bypassing the mouth altogether.

The chest is widely treated, in OE poetry, as the spiritual, intellectual and verbal 'centre of action' in humans.[62] Words and thoughts do not always originate within us, but often enter the chest from an external source, such as when the 'living waters' of divine teaching come into human breasts from heaven, through holy books.[63] When speech does exit our bodies, into the external world, it leaves as sound, and in the case of poetic performance the sound is a blend of human and nonhuman noise. Indeed, Jager draws our attention to the Anglo-Saxon practice of holding the harp or lyre near the chest. Positioned thus, 'the harp's sound would have come from near the pectoral region traditionally considered the source of physical words and the repository of verbal art'.[64] A combination of words and music, song and sound, thereby centres on the chest, issued from and received by it. Moreover, as a container that both receives and releases, locks and unlocks, the poetic image of the *wordhord* or *breosthord* configures words as treasure as well as potential weapons. When released from the breast-coffer, they may fly or be thrown forth, as in the ritual flyting that is a feature of *Beowulf* and other poems. In this way, speech becomes 'an object carrying its significance over distance'.[65]

Exeter Book Riddle 7, usually solved as 'swan', exemplifies and extends some of the points made above. This riddle is concerned with how sound moves through time and space, and links the flight

of nonhuman sound with human speech. The first lines of the riddle, though, deal with silence, and associate this soundlessness with earth and water: 'Hrægl min swigað, þonne ic hrusan trede, / oþþe þa wic buge, oþþe wado drefe' [My dress is silent when I tread the ground, or dwell in the village, or drive the waters] (1–2). In these lines, the speaking 'I' could easily be a human among other humans. It refers to its *hrægl* (dress or garment) and walks on land, as we walk, dwells in the *wic* where men dwell, and stirs or drives the waters, as the speakers in *The Wanderer* and *Seafarer* describe themselves doing. Silent as the speaker may be, no mention is made of voice or mouth. Rather, it is its 'dress' that makes no sound. From dwelling among men, its *hyrste* (trappings or ornament) then lifts it 'ofer hæleþa byht' [over the dwellings of men] (4). *Hyrst* is used elsewhere in the Exeter Book riddles (11 and 14) to describe a gem-studded cup and a drinking horn. Riddle 11 also uses the noun *hrægl* in relation to the decorated drinking vessel. Like cups or horns or other adorned items, the entity of Riddle 7 can dwell among men, but it can also carry its significance beyond that earthbound time or place. The visual is bound up with the verbal, for even as it is the *hrægl* that remains silent on land and water, it is the *frætwe* (adornments) of the creature that start to sing when it is above the *flode and foldan*. The creature tells us that it 'torhte singað' [brightly sings] (8) when in flight, so that it is again the visual element, the brightness, being highlighted. The riddler is suggesting that this is a song to be seen, and it is this that entwines the swan's sound with human speech.

It is worth looking at what Isidore of Seville has to say about the swan (Latin: *cygnus*) in his *Etymologies* for the way that it differs from the Old English riddle creature:

> Cygnus autem a canendo est appellatus, eo quod carminis dulcedinem modulatis vocibus fundit. Ideo autem suaviter eum canere, quia collum longum et inflexum habet, et necesse est eluctantem vocem per longum et flexosum iter varias reddere modulationes.

> [Indeed the swan (*cygnus*) is named from its singing (*canendo*) because it pours out sweet song with modulated sounds. It sings so sweetly because it had a long and curved neck, and the voice, forcing its way through the long and winding route, necessarily utters varied modulations.][66]

For Isidore, the swan sings so sweetly because it has a long and curved neck (*quia collum longum et inflexum habet*) which its voice winds through to give out varied *modulationes*. The sound and

soundlessness of the OE swan, on the other hand, comes about through its coat and musical wings, with no mention made of throat or mouth or voice. The swan wears its song more than it vocalises it. Rather than being oral or even vocal, the swan's song is visible. It thus has more in common with pectorality than orality, where in the former human speech is presented in visual terms as treasure stored in the breast, the *wordhord*, and where silence and sound is held or released rather than voiced or not voiced. That is, in pectorality the emphasis is on a sort of visual stillness or movement where speech is either stored or worn within the body, or thrown forth like a weapon.

For Katherine O'Brien O'Keeffe, to make a song visible is to kill it. Speaking is in essence a 'temporal act' whereas 'writing is language made spatial'. The 'metaphors of loss' used in Anglo-Latin and Old English riddles on the technology of writing 'reflect an Anglo-Saxon understanding that speech itself is not a *thing*, but that writing, as it alienates speech from speaker, transforms living words into things'.[67] However, Riddle 7 challenges the living word versus dead thing dichotomy, in which sound and sight are kept apart, by presenting us a with a visible song in flight, a song borne on a body, like clothing or ornament, instead of mouthed. Further to this, the riddle demonstrates that human speech can be entwined with and shaped by nonhuman sound, so that speech does not always originate from a human voice in the first instance.

Dieter Bitterli points out that the solution to this riddle lies in the *sw-* sound made by the three onomatopoeic words *swigað*, *swogað* and *swinsiað*. The OE *swan* or *swon* is 'so named because it is silent (*swigað*) when it rests or swims, yet loudly sings with its feathers (*swogað* ... *swinsiað*) when it flies'. The riddler therefore 'exhibits what may be called the latent etymology of the bird's vernacular name'.[68] But the key to the riddle depends not only on recognising the vernacular *name* but also the actual *sound* made by the swan's wingbeats, so that the *sw-sw-sw* noise that the human voice makes when reading this riddle imitates the *vaou-vaou-vaou* noise of the mute swan in flight, as described by ornithologists.[69] A sound from the nonhuman 'natural' world therefore enters into human language as the riddler asks the reader to mimic the sound of the swan. In this riddling game there is a criss-crossing of categories in which the swan, absent in body, enters the realm of human language, identified by the *sw-* sounds its body makes when visible; in turn, the human reader sees the words of the riddle but

only 'sees' those words *as* the flying swan when he or she speaks the sounds they make, using their voice to say the *words* which will allow them to cross into the nonhuman realm of *things*.

From the outset Riddle 7 alerts us to the fact that we will have to hear what we see, and see what we speak, if we are to make sense of it, for the first *sw-* sound comes from the word *swigað*. Seeing and reading 'silence' is tied to saying and hearing a sound, and so the riddle highlights the interrelation between seeing words (*swigað*) and hearing sounds (*vaou-vaou-vaou*) and seeing sounds (the feathers of a swan in flight) and hearing words (*swogað, swinsiað*). In the final line of the poem, the swan is described as 'ferende gæst' [a travelling spirit] (9). At times visibly in this world, as a clothed and ornamented body, the swan is audibly on its way out of this world in that closing line, where the successive alliteration on 'flode ond foldan, ferende ...' means that the final 'gæst' is breathed out softly by the reader, a word that takes wing before vanishing into the air. Asking us to see its flight while mimicking its sounds, the swan finally draws us out of our earthbound bodies, invoking our voices in order to take us with it over the earth and sea. It invites us to see and say, sing and fly.

That which flies, though, must also land again. So it is with voice. In both the Old English and Latin riddles about writing tools, images of flight and landing, feathers and tracks dominate. The swan's song in Riddle 7 is both seen and heard, but it is nonetheless fleeting: a *ferende gæst*. The 'writing technology' riddles are, in a way, a continuation of the course of speech as it moves in space and alters across time, from airborne to earthbound once more, from feathers to tracks, white to black. In Aldhelm's Enigma LIX (*penna*) it is not the swan but the 'candens onocrotalus' [bright pelican] that produces the speaker as 'albam' [white] (1). Bitterli notes that, according to Pliny, the pelican resembles the swan, and so even to Aldhelm, *onocrotalus* 'was perhaps no more than an exotic name for the more familiar swan'.[70] The white feather then moves through whitened fields, but the whiteness of feather and field is contrasted with the dark tracks left by the speaker: 'Pergo per albentes directo tramite campos / Candentique viae vestigia caerula linquo' (3–4). Similarly, in Exeter Book Riddle 51 the 'wrætlice wuhte feower' [four wondrous creatures] (1) seen by the speaker 'fleag on lyfte, / deaf under yþe' [flew in the air, dived under the wave] (4–5) and yet here it is not musical wingbeats that the riddler draws our attention to, but the black tracks left behind: 'swearte wæran lastas, / swaþu swiþe blacu' (2–3).

So voice moves through space and in doing so changes over time; it endures through continuous transformation. It leaves a body and flies through the air and lands again, leaving tracks and trails on scrapped skin, shapeshifting between human, animal and artefact. A human voice can mimic the wingbeats of the swan, while the speech-sound that issues forth from our breast-coffers may blend with the music of a harp. Anglo-Saxon riddlers played with the idea that nonhuman sound can enter human language and reshape it. And the scribes who copied these riddles down did so by using the relics of once living creatures: goose feathers, ink horns, oak gall, sheepskins. Even the letters of the alphabet, which formed the syllables and words and sentences of these poems, were described by Aldhelm in Enigma XXX as *elementa*, the smallest component and source element of speech, whose very existence depends not upon the human mouth or hand but upon the iron of the metal stylus and the feathers of the writing quill: 'Nascimur ex ferro rursus ferro moribundae / Necnon et volucris penna volitantis ad aethram' [We are born from iron and by iron die, or from the feather of a bird flying through the sky] (3–4).[71] It becomes difficult to determine at which stage 'speech' and 'writing' is clearly human or clearly nonhuman, or at which stage it goes from living to dead. Hence it is not so straightforward as to say that speech originates with the human and 'dies' as soon as it is alienated from the speaker and transferred onto a nonhuman artefact.

How, then, do we find human temporality altered when voice-bearing things talk back to us? Riddle 60 of the Exeter Book presents us with such a voice-bearer. The speaker itself tells the reader that it carries a message: 'ic wiþ þe sceolde / for unc anum twam ærendspræce / abeodan bealdlice' [I can boldly announce an errand-speech to you, for us two alone] (14–16). What is less certain is whether this speaker is a tool that inscribes or is an artefact inscribed upon – specifically, whether it is a reed pen or rune staff. Williamson weighs the arguments for both of these solutions. Line 13, he says, where 'eorles ingeþonc ond ord somod' [the man's inner-thought and the point together] leads to a resulting message 'would tend to support "rune staff" since the activity that requires the thinking (and thus presumably the making of the message) is the cutting itself'. On the other hand, 'the habitat of the creature (in or near the water) certainly favours "reed"'. That 'the creature itself speaks in the hearer's presence' could favour 'rune staff' and yet 'by extension the pen as well as the author might be said to "speak" through the medium of the written word'.[72] Balanced as

these arguments are, it is hard to rule out either answer. I, however, lean more towards the 'reed' solution and am particularly convinced by Niles's recent take on this as the OE neuter noun *hreod*. For Niles, with this one word 'all the conditions of the riddle are met'. Pointing to the Bosworth-Toller definition of *hreod* as both a 'collective or generic term' for a reed or reeds and also 'a reed for writing' as well as the occurrence of *hreod-pipere* as a gloss for the Latin *auledus*, Niles takes us through the transformation of the single 'reed' from one thing to another during its life course.[73] First of all, the reed grows in silence by the shore: 'Ic wæs be sonde sæwealle neah / æt merefaroþe' [I was by the sand, near the sea-wall, on the shore] (1–2). Later, it becomes a flute and speaks (makes music) in the mead hall: 'Lyt ic wende / þæt ic ær oþþe sið æfre sceolde / ofer meodubence muðleas sprecan, / wordum wrixlan' [Little did I expect that I before or afterwards ever should speak, mouthless, over the mead-bench, exchanging words] (7–10). Additionally, it is shaped by 'seaxes ord ond seo swiþre hond' [the knife's point and the right hand] (12) so that it can announce its message (*ærendspræce*). As such, the reed is the source of both a flute and pen.

If one were to solve the riddle as 'rune staff' it would be easy to see the speaker as an inert object onto which the human subject visibly imposes his or her voice. It is easier still to see the reed (especially in the form of a pen) as the passive conveyer of human words, whereby Williamson, for instance, claims that it is only 'by extension' that the pen as well as the 'author' might be said to speak. In doing so, however, the active role of the reed in conveying its message would be missed, for under closer consideration the message is less human and more nonhuman than expected. The fact that Riddle 60 is followed in the Exeter Book manuscript by *The Husband's Message* has complicated its critical history and led some readers to view the two poems as one. While I do not wish to enter this particular debate here, I am interested in Williamson's assertion that the 'relationship between the personified speaker of the riddle and the intended reader is an impersonal one' whereby the 'references to *unc* and *þe* facilitate the riddlic game'. In contrast, the *ic* and *þe* of *The Husband's Message* 'both have past histories, present personalities, and contemplated future actions' and so have a 'psychological reality that the personae of the riddle do not'.[74] I do not wholly disagree with what Williamson says here, but think that he misses the nonhuman autobiography in the riddle. He is correct to say that, despite some similarities between

the speakers, the relationship between the *ic* and *þe* of the riddle is different to that in *The Husband's Message*. The *þe* in the riddle is not so actively involved in the events being narrated, whereas in *The Husband's Message* the second person is invited and instructed to recall and respond, and to travel. What leads Williamson to refer to the relationship between the *ic* and *þe* of the riddle as an 'impersonal' one, I believe, is a reversal of the subject–object roles. The human reader takes an inactive role, usually associated with the silent, inert artefact onto or via which the speaker inscribes their story. That Williamson, like other critics, should posit a human 'author' behind the words of Riddle 60 takes away much of the agency the talking thing has in delivering the message. In *The Husband's Message* we are given information about a 'lord' (*dryhten, frean, þeoden*) who has given commands beforehand to the messenger: 'Hwæt, þec þonne biddan het se þisne beam agrof ...' [Listen, he who carved this beam ordered me to ask you ...] (13). Yet in the riddle, very little information is given to us about any 'author' who dictates or commands the message being delivered. The closest we get is in lines 10–14 when the thing describes its own making or, rather, refashioning. Here, though, it is not human control but the collaboration between human and nonhuman in fashioning a message that is stressed, the hand and the artefact working in tandem:

> Þæt is wundres dæl,
> on sefan searolic þam þe swylc ne conn,
> hu mec seaxes ord ond seo swiþre hond,
> eorles ingeþonc ond ord somod,
> þingum geþydan (10b–14a)

[That is the wondrous part, crafty in mind to those who know not how the knife's edge and the right hand, the man's inner-thought and the point together, pressed me for the purpose]

In the crafting of this tool or instrument, the human maker thinks both with and through the changing artefact, the thing becoming some other thing. Knife and hand and inner-thought work together, pressing the speaker for a purpose which is also a meeting and a thing (*þingum*). For the ignorant observer, lacking the advanced technological knowledge of the craftsman, such art brings skill or cunning into the mind (*on sefan searolic*). Yet the craftsman himself remains half-concealed in this riddling passage, only partially represented by his right hand (*seo swiþre hond*), a body part intimately associated with the materials it is working

with. This passage demonstrates, then, how mind and craft, hand and tool and transforming thing become enmeshed in the act of making and delivering a message, an act of collaboration rather than dictation.[75] It represents the way in which 'in the act of making the artisan couples his own movements and gestures – indeed his very life – with the becoming of his materials, joining with and following the forces and flows that bring his work to fruition'.[76]

What about the message itself? While the absence of a human author and the impersonality of the addressee may indicate a lack of 'psychological reality' in Riddle 60, the past history, present personality and future actions Williamson attributes to the personal pronouns in *The Husband's Message* are likewise features of the preceding riddle. Only, in the riddle, these do not allude to a supposedly human relationship but instead relate the transformation over time of the reed. This is not to say that the speaker is 'personified' and we need not look for a psychological 'interiority'. Its story, its autobiography, is distinctly nonhuman, even if we as humans recognise its voice as our own. The role of the human in this riddle is to serve as witness to the life and story of a thing, which talks to us, moves among us and organises or reorganises us.

The reed is closest to a 'living' being in the first few lines of the riddle, but its livingness is unseen and unheard by mankind: 'Fea ænig wæs / monna cynnes þæt minne þær / on anæde eard beheolde' [There were but few among mankind who beheld me alone in the wilderness] (3–5). Can something scarcely if ever seen, heard, touched, smelled or tasted by human beings still be said to be alive? The reed springs into action once it turns into a 'dead' thing. In the form of a flute or pipe, it is said to 'exchange words' (*wordum wrixlan*) over the mead-bench. For the verb *wrixlan*, Bosworth-Toller gives us (I) 'to change, vary, alter'; but also (III) 'of reciprocal, mutual action, to exchange, deal'; and (IIIa) 'with dat. of what is exchanged, fig. of conversation, intercourse'. The term has two senses, then. It could indicate a 'varying' or 'alternating' musical sound so that Crossley-Holland, for instance, translates *wordum wrixlan* as 'varying my pitch'.[77] Like the harp held close to the chest, this enigmatic instrument emits a blend of voice and music. Yet it also indicates a trading of words. As Jager demonstrates, in verbal transactions speech enters and exits the chest and so we can imagine a physical movement of speech-sound from one body to another, from nonhuman to human. Thus the contrast between the silent isolation of the reed during its 'life' and its more active role during its afterlife makes us rethink how we categorise the living

and the dead. What the riddle stresses above all is interaction, where it is circulation or exchange, involving both the human and nonhuman, that maintains life.

In the final lines, as the reed transforms once more from flute or pipe to pen, the more open interaction in which it partook in the mead hall narrows down to include only two (*for unc anum twam*). Having been reshaped by mind, hand and knife, the reed can now announce a private message. The speaker announces its *ærendspræce* in such a way that 'hit beorna ma / uncre wordcwidas widdor ne mænden' [no other men may spread our speech more widely] (16–17). Here, the speaker personally addresses a certain individual but at the same time reminds that 'individual' that their identity is bound up with the 'I' that has spoken this riddle. If we take the *ic* to be the reed pen and the *þe* to be the reader or even writer of this riddling message, then this talking thing seems to be reminding us that human identity, and the continuation of that identity, is always entwined with nonhuman narratives, the stories things tell – about us, but also about themselves. For whenever we read this riddle, any human 'author' we might imagine to have been behind it will necessarily be absent in body. Only a voice remains, and that voice tells of the transformation of reed to flute to pen, silent in life, noisy in death, the tracks and traces of its body present while ink and parchment lasts, even as those physical remains sustain the words of an absent other.

Human temporality is reordered by the nonhuman voice-bearer, and the relation between living and speaking and dying and not speaking is changed. And so if human voices are still to be heard when our bodies are absent in space or time, due to distance or death, then this nonhuman autobiography is also how we, as things that talk, will be read and unriddled through time. Always some other thing will say what we are called.

Notes

1 Margaret Schlauch provides a useful definition of prosopopoeia in Old English literature as being a first-person monologue by an animal or object that feels and speaks like a person in her classic article 'The "Dream of the Rood" as Prosopopoeia', in P. W. Long (ed.), *Essays and Studies in Honour of Carleton Brown* (New York: New York University Press, 1940), pp. 23–34.

2 Tilghman, 'On the Enigmatic Nature of Things', p. 5. Tilghman is drawing on arguments made by Bennett in *Vibrant Matter*, pp. 119–20.

For a lively re-examination of anthropomorphism, see also Lorraine Daston and Greg Mitman (eds), *Thinking with Animals: New Perspectives on Anthropomorphism* (New York: Columbia University Press, 2005).

3 See especially Bennett, *Vibrant Matter*.

4 I draw upon Hodder, *Entangled*, pp. 4–5. Cf. Gilles Deleuze and Félix Guattari, *A Thousand Plateaus*, trans. B. Massumi (London: Continuum, 2004).

5 See, for example, Margreta De Grazia, Maureen Quilligan and Peter Stallybrass (eds), *Subject and Object in Renaissance Culture* (Cambridge: Cambridge University Press, 1996); Mark Blackwell (ed.), *The Secret Life of Things: Animals, Objects and It-Narratives in Eighteenth Century England* (Lewisburg, PA: Bucknell University Press, 2007).

6 Tiffany, 'Lyric Substance', p. 75.

7 Ibid., p. 79.

8 Ibid., p. 97.

9 Moritz Trautmann (ed.), *Die altenglischen Ratsel (die Ratsel des Exeterbuchs)* (Heidelberg: C. Winter, 1915). Alternative solutions have included 'day': Franz Eduard Dietrich, 'Die Rathsel des Exeterbuchs: Wurdigung, Losung und Herstellung', *ZfdA*, 11 (1859), 448–90; 'cloud': Christopher B. Kennedy, 'Old English Riddle No. 39', *ELN*, 13 (1975), 81–5; 'speech': Craig Williamson (ed.), *The Old English Riddles of the Exeter Book* (Chapel Hill: University of North Carolina Press, 1977), pp. 258–65; 'dream': Antonina Harbus, '*Exeter Book Riddle 39* Reconsidered', *SN*, 70 (1998), 139–48.

10 References to the Old English riddles are taken from Muir's *Exeter Anthology of Old English Poetry*. Unless indicated otherwise, translations are my own.

11 Morton, *Hyperobjects*, p. 22.

12 Andy Orchard, 'Enigma Variations: The Anglo-Saxon Riddle-Tradition', in Katherine O'Brien O'Keeffe and Andy Orchard (eds), *Latin Learning and English Lore: Studies in Anglo-Saxon Literature for Michael Lapidge*, vol. 1 (Toronto: University of Toronto Press, 2005), pp. 284–304, at 294.

13 Patrick J. Murphy, *Unriddling the Exeter Riddles* (University Park, PA: Pennsylvania State University Press, 2011), pp. 19–20.

14 St Augustine, *De doctrina Christiana*, 2.16, ed. and trans. R.P.H. Green (Oxford: Clarendon Press, 1995), pp. 86–7.

15 Bede, *Ecclesiastical History*, II.13, ed. Colgrave and Mynors. Translation from Judith McClure and Roger Collins (eds), *The Ecclesiastical History of the English People* (Oxford: Oxford University Press, 1994).

16 St Augustine, *Confessions*, 11.26, ed. James J. O'Donnell (Oxford: Oxford University Press, 1992).

17 Robertson, 'Medieval Things', p. 1063.
18 Frederick Tupper, Jr., 'Anglo-Saxon Dæg-Mæl', *PMLA*, 10:2 (1885), 111–241.
19 Ibid., p. 118.
20 Byrhtferth's *Enchiridion*, II.3, ed. and trans. Peter S. Baker and Michael Lapidge (Oxford: Oxford University Press, 1995), pp. 104–5.
21 Tupper, 'Anglo-Saxon Dæg-Mæl', p. 121.
22 Ibid., pp. 121, 165.
23 See Tupper, p. 129.
24 Asser, *De rebus gestis Ælfredi*, chs 103–4, in *Asser's Life of King Alfred*, ed. William Henry Stevenson (Oxford: Clarendon Press, 1959), pp. 89–91. Translations from the Latin are my own.
25 Ibid., p. 339.
26 Cf. David Pratt, 'Persuasion and Invention at the Court of King Alfred the Great', in Catherine Cubitt (ed.), *Court Culture in the Early Middle Ages* (Turnhout: Brepols, 2003), pp. 189–222. Pratt suggests that further candle clocks may have been manufactured for King Alfred's noble readers as a means of gaining wisdom. Pratt notes Alfred's use of the expression *modes eagan* in his translations, whereby the eyes of the mind are associated with divine gifts such as wisdom through which minds share immortality even as men's bodies grow old.
27 St Augustine, *De civitate Dei*, 24, *The City of God against the Pagans*, trans. William H. Green (Cambridge, MA: Harvard University Press, 1972), pp. 330–1.
28 Scott Lightsey, *Manmade Marvels in Medieval Culture and Literature* (New York: Palgrave, 2007), pp. 13–14. Lightsey is discussing *De civitate Dei* here.
29 See A. N. Doane (ed.), *Genesis A: A New Edition* (Madison: University of Wisconsin Press, 1978).
30 For instance, G. Craig offers a modern medical assessment of his symptoms in, 'Alfred the Great: A Diagnosis', *Journal of the Royal Society of Medicine*, 84 (May 1991), 303–5. Craig claims that 'the evidence available points to inflammatory bowel disease with a particular inclination towards Crohn's disease', at 305.
31 All references to Aldhelm are taken from A. M. Juster (trans.), *Saint Aldhelm's Riddles* (Toronto: University of Toronto Press, 2015). Translations are my own, though I have drawn on Juster's excellent new translations for guidance. I have also consulted Aldhelm, *The Poetic Works*, ed. and trans. Michael Lapidge and James L. Rosier (Cambridge: D. S. Brewer, 1985).
32 See for instance lines 247, 251 in A. N. Doane (ed.), *The Saxon Genesis: An Edition of the West Saxon Genesis B and the Old Saxon Vatican Genesis* (Madison: University of Wisconsin Press, 1991).
33 Jane Hawkes, 'Sacraments in Stone: The Mysteries of Christ in Anglo-Saxon Sculpture', in Martin Carver (ed.), *The Cross Goes*

North: Processes of Conversion in Northern Europe, AD 300–1300 (Suffolk: York Medieval Press, 2003), pp. 351–70, at 352.

34 Andrew Marvell, 'To His Coy Mistress', in *The Complete Poems*, ed. Jonathan Bate (Harmondsworth: Penguin, 2005), p. 50.

35 Here and below I echo some of the thoughts of Jeffrey Jerome Cohen, 'Stories of Stone', *Postmedieval*, 1:2 (Spring/Summer 2010), 56–63. His recent book *Stone: An Ecology of the Inhuman* (Minneapolis: University of Minnesota Press, 2015) also investigates the power and abiding companionship of this seemingly inert substance. I will return to some of these ideas in Chapter 5.

36 Fred Orton and Ian Wood with Clare A. Lees, *Fragments of History: Rethinking the Ruthwell and Bewcastle Monuments* (Manchester: Manchester University Press, 2007), p. 131.

37 Tupper, 'Anglo-Saxon Dæg-Mæl', p. 129.

38 Byrhtferth's *Enchiridion*, pp. 104–5.

39 Éamonn Ó Carragáin, *Ritual and the Rood: Liturgical Images and the Old English Poems of the Dream of the Rood Tradition* (London: British Library, 2005), p. 46.

40 Orton and Wood with Lees, *Fragments of History*, p. 132.

41 Ibid., pp. 137–40.

42 Ibid., p. 134.

43 Ingold, *Being Alive*, pp. 15–32.

44 Ingold, *Being Alive*, pp. 30–1. In this section, Ingold is critiquing Christopher Tilley's *The Materiality of Stone: Explorations in Landscape Phenomenology* (Oxford: Berghahn, 2004).

45 Orton and Wood with Lees, *Fragments of History*, p. 142.

46 'Swan': Ferdinand Holthausen, 'Anglosaxonica Minora', *Beiblatt zur Anglia*, 36 (1925), 219–20; 'quill pen': F. H. Whitman, *Old English Riddles* (Ottawa: Canadian Federation for the Humanities, 1982), pp. 144–8; 'figurehead': see Williamson, *Old English Riddles of the Exeter Book*, pp. 349–52; 'barnacle goose': Daniel Donoghue, 'An Anser for Exeter Book Riddle 74', in Peter S. Baker and Nicholas Howe (eds), *Words and Works: Studies in Medieval English Language and Literature in Honour of Fred C. Robinson* (Toronto: University of Toronto Press, 1998), pp. 45–58.

47 Franz Eduard Dietrich, 'Die Rathsel des Exeterbuchs: Wurdigung, Losung und Herstellung', *ZfdA*, 2 (1859), 448–90; John A. Walz, 'Notes on the Anglo-Saxon Riddles', *Harvard Studies and Notes in Philology and Literature*, 5 (1896), 261–8.

48 Frederick Tupper, Jr., 'Solutions of the Exeter Book Riddles', *Modern Language Notes*, 21:4 (1906), 97–105, at 103.

49 Ibid, pp. 103–4.

50 Ibid, p. 104.

51 Niles, *Old English Enigmatic Poems*, p. 19.

52 Trautmann, *Die altenglischen Ratsel*, p. 128. This solution has been taken up more recently by Thomas Klein, 'Of Water and the

Spirit: Metaphorical Focus in Exeter Book Riddle 74', *Review of English Studies*, 66:273 (2014), 1–19. Building upon the work of Patrick J. Murphy, Klein nuances the argument by proposing that the spoken solution of 'water' is also shaped by an unnamed metaphorical focus alluding to the 'Holy Spirit'.

53 Niles, *Old English Enigmatic Poems*, p. 19.

54 Mercedes Salvador-Bello, *Isidorean Perceptions of Order: The Exeter Book Riddles and Medieval Latin Enigmata* (Morgantown: West Virginia University Press, 2015), p. 317. Specific examples are Exeter Book Riddle 12 (ox/leather) and 14 (auroch/horn) and Aldhelm's Enigma LXXXVI (ram/battering ram) and XCVI (elephant/ivory).

55 See Niles, *Old English Enigmatic Poems*, pp. 35–9. Niles's solution has been supported but refined by Mark Griffith, 'Exeter Book Riddle 74 *Ac* "Oak" and *Bat* "Boat"', *Notes and Queries*, 55 (2008), 393–6.

56 Brown, 'Thing Theory', p. 4.

57 Bogost, *Alien Phenomenology*, p. 124.

58 Niles, *Old English Enigmatic Poems*, pp. 42–3.

59 Murphy, *Unriddling the Exeter Riddles*, pp. 236–7. The Roman grammarian Donatus, well known in Anglo-Saxon England, made the similar observation that 'Aenigma est obscura sententia per occultam similitudinem rerum'. Taken from Donatus, *Ars maior*, in *Grammatici latini*, ed. Heinrich Keil, vol. 4 (Leipzig, 1850–80), 402.

60 Eric Jager, 'Speech and the Chest in Old English Poetry: Orality or Pectorality?', *Speculum*, 65:4 (1990), 845–59, at 845.

61 See ibid.

62 Ibid., pp. 847–8.

63 See, for instance, the metrical epilogue to *The Pastoral Care*, in N. R. Ker (ed.), *The Pastoral Care*, EEMF 6 (Copenhagen: Rosenkilde and Bagger, 1956).

64 Jager, 'Speech and the Chest', p. 848.

65 Ibid., p. 852.

66 Isidore, *Etymologies*, 12.7, ed. W. M. Lindsay (Oxford: Oxford University Press, 1911).

67 O'Brien O'Keeffe, *Visible Song*, pp. 4, 54.

68 Dieter Bitterli, *Say What I Am Called: The Old English Riddles of the Exeter Book and the Anglo-Latin Riddle Tradition* (Toronto: University of Toronto Press, 2009), p. 45. Cf. Roberta Frank, 'The Unbearable Lightness of Being a Philologist', *JEGP*, 96 (1997), 486–513.

69 See Stanley Cramp et al. (eds), *Handbook of the Birds of Europe, the Middle East and North Africa: The Birds of the Western Palearctic*, 9 vols (Oxford: Oxford University Press, 1977–94), 1:372, 377.

70 Bitterli, *Say What I Am Called*, p. 143.

71 For further discussion, see Salvador-Bello, *Isidorean Perceptions of Order*, pp. 192–3.

72 Williamson, *Old English Riddles*, p. 318.

73 See Niles, *Old English Enigmatic Poems*, pp. 131–2.
74 Williamson, *Old English Riddles*, pp. 316–17.
75 For a discussion of the ways in which Anglo-Saxon poetic texts (particularly riddles) actively and self-consciously explore the interaction between intellectual creativity and material processes, see the first and second chapters of Helen Price's doctoral thesis, 'Human and NonHuman'. Price also conducts a very useful linguistic case study on the etymology of the Old English word *cræft* and its semantic relation to the modern term and concept of *technology*.
76 Ingold, *Making*, p. 31; cf. Bennett, *Vibrant Matter*, p. 60.
77 Crossley-Holland (trans.), *The Exeter Book Riddles*, p. 63.

3
The riddles of the Franks Casket:
Enigmas, agency and assemblage

Since its recovery from Auzon, France, in 1859 by English anti-
quary Sir Augustus Franks, the whalebone chest known as the
Franks or Auzon Casket has been a 'fascinating enigma' to those
who have studied it and among the most 'intriguing and irritat-
ing' of Anglo-Saxon artefacts to have survived.[1] Now held in the
British Museum, it has been dated to the early eighth century and
is likely to be of Northumbrian craftsmanship, though more exact
details of its original context are unknown. The casket has tra-
ditionally been assigned to a highly learned milieu and to a syn-
cretistic era, as its imagery draws on diverse sources, including
Germanic and Roman legends, as well as Jewish and Christian
stories. The images work in tandem with texts that are mostly dis-
played in Anglo-Saxon runes and written in the Old English lan-
guage, but which also make use of Latin and the Roman alphabet.
Not only do these inscriptions shift between different types of let-
tering and languages; they also run backwards, read upside down
and even use cryptic runes.

The verbal play represented by these complex inscriptions is
reinforced by the visual riddles of the casket. The rectangular,
lidded box features intricate yet deeply puzzling carvings on each
of its five panels. The lid appears to show the archer Egil from
Germanic legend defending a fortress from attack. The back panel,
meanwhile, shows the Romans, led by Titus, sacking Jerusalem.
The left end panel presents us with the Roman legend of Romulus
and Remus, while the right end panel displays an unidentified
Germanic legend. The front panel differs slightly from the oth-
ers inasmuch as it features two clearly contrasting scenes from
Germanic legend and Christian biblical history (see Figure 2). The
former alludes to Wayland the Smith at his forge as he is about to
take revenge upon the children of his captor while another figure,

possibly his brother Egil again, strangles birds to manufacture wings for escape. The biblical scene is a visual representation of the Three Magi paying homage to the Virgin Mary and the infant Christ. These two scenes are framed by an Old English runic riddle about the whale from whose bone the box has been fashioned. The front panel originally carried the now-missing lock, implying that it holds the key to unlocking the physical and perhaps intellectual contents of the casket.[2]

This chapter explores the Franks Casket as a three-dimensional series of riddles, whereby the interpretation of this artefact is bound up with movement. I open with a brief overview of previous criticism on the casket in order to look at how different scholars have read it, but especially how they have moved around the box as they try to solve its riddles, so that different movements result in different readings. Is there a correct order in which we might read the Franks Casket? Can the reader finally solve its riddles and 'unlock' the box? Or does it read, move and make sense of us? I contend that the casket can be seen as a 'thing' that has the ability to move those who encounter it. In doing so, it actively forms human identities. Although some scholars have tried to divide the Franks Casket into discrete 'scenes' and categorise

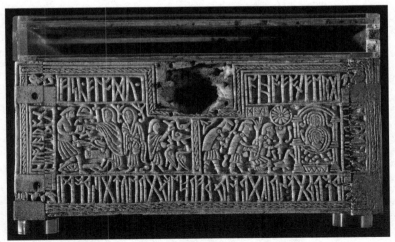

2 Franks Casket, front panel (© The Trustees of the British Museum).

these as Christian or pagan, Roman or Germanic, and so have seen the artefact as either a hoard box or reliquary, belonging to a warlord or an ecclesiastical context, the thing itself resists being fixed in this way. That is, it does not allow us to impose our manmade categories onto it, but instead makes us rethink how we categorise ourselves. It resists human mastery through continuous movements: back and forth transformations, repetition, misdirection, the concealment of space and assemblage.

The second section of this chapter examines, in more detail, the ways in which the Franks Casket is able to transform Anglo-Saxon identities. For instance, the casket depicts its various figures in more than one role (pagan and Christian, Roman and Germanic, human and animal, shepherd and spearman) within space and time. The various movements the casket forces us to make mean that we cannot read a single 'figure' and the 'scene' they inhabit the same way twice. There is, therefore, no hierarchy in terms of reading one side in light of another (whether pagan/ Christian or secular/spiritual or magic/religion) but how each side is read transforms and is transformed by the others. This manner of reading the casket is as much about concealment as revelation and our constant awareness of what we are *not* seeing defies resolution. Even the text (on the back panel) slides from Old English to Latin, from Anglo-Saxon runes to the Roman alphabet and back. Again, this transformation is not fixed but rectangular and continuously on the move. Via its use of different languages as well as writing systems, the casket is both informed by and able to form varied levels of interpretive competency. If its text is read by some and not by others, or only partially read by still others, we must ask how the casket identifies each one of its makers, handlers and owners differently in terms of role, status and authority. These identities can also be transformed over time as interpretive power waxes or wanes. Thus, the casket is telling its Anglo-Saxon observers who and what they are (literate/illiterate, secular/ecclesiastical, Germanic/Roman) while at the same time suggesting that these roles are always liable to change.

By directing us around and around its whalebone body, or dictating that we hold it and turn it this way and that, the Franks Casket keeps us guessing at its inner mystery (OE *run*). The casket *insists* on its basic function and materiality (it openly declares that it is a whalebone box) but *resists* human mastery (we cannot claim ownership of it or know what was kept inside it). Such resistance

involves repetition and misdirection. It tests our mental agility, exercising our intellect by moving us around and around, back and forth, asking us to look and look again. Such movements induce tiredness and frustration. Indeed, the casket rewards our efforts only by sending us towards dead ends (the right side) and empty holes (the back). Even if we do reach what can be taken both literally and metaphorically as the start and close of the casket (that is, the lid) we are confronted by a confusing warning: here, both the image and the runic label (*ægili*) suggest that trouble waits for those who try and break in.

The final section explores the Franks Casket as an assembly. Here, I will relate my analysis of the casket to seventh- and eighth-century Northumbria which undergoes its formation through movement and assemblage. My intention is not to try to name and identify an owner or contents for the Franks Casket – an endeavour it resists – but to understand how this *þing* might have the autonomous ability to gather other elements to it. What kinds of ideas, texts, images, material goods, and human and animal bodies, were available to Anglo-Saxons in this time and place and how does the casket draw them into itself? Ian Wood makes a strong case for linking the Franks Casket to the milieu of Wilfrid of York's monasteries.[3] As such, I take into account figures such as Wilfrid and Benedict Biscop, who travelled back and forth to the Continent, gathering cultural goods such as books and relics, as well as ideas and customs, as they moved about, both within and beyond Northumbria. It is within this environment that the Franks Casket moulds the identities of its observers and handlers, assuming the role of an 'assembly' in the Germanic etymological sense. Is something like the Franks Casket similar, therefore, to an assembly such as the seventh-century Synod of Whitby, in which different elements are brought together and remade? I connect this notion of assemblage with Daston's thing-making whereby the 'tension' between chimerical composition and unified whole means that talkative things 'instantiate novel, previously unthinkable combinations'.[4] Even though a casket may be like a meeting in its ability to gather, the very thingness of a whalebone chest differentiates it from meetings of the less material kind. How does the bone of a once-living creature not only mould meaning into a distinct whole but hold it together over time?

Moving, reading, riddling

> [The subject is] that which lies under that which lies before it, holds itself back: attentive, concentrated, humble, silent. Subject. This word retains the trace of an act of humility. The subject subjects itself to the dominion of that which forms and loses it. Yes, kills it. Only the object exists and I am nothing: it lies before me and I disappear beneath it.[5]

When I encountered the Franks Casket in the British Museum for the very first time, I could not read Anglo-Saxon runes and my visual literacy, with regards to Anglo-Saxon art, was poorer than it is now. But even then, I was struck by how, the more that I moved around the box, the more that its mysteries deepened; and yet the more I moved around it, the closer I felt to it: it was telling me what I knew about it already, but also what I needed to do and to know to move closer to it still ...

The runes on this side look different to the ones before. Are they upside down? Back to front? If only I knew what they meant. But that script is not runic. Is that a horse? Is that a horse, too? Those look like spear-carriers. Did I not see them a moment ago? Another bird here. Why is it flying in that direction? Am I moving the wrong way? Maybe I should have started round the other side (I had entered from 47: Europe 1800–1900; maybe I should have come from 49: Roman Britain). Is it broken? It is broken. What did that bit do? What is missing? Is something missing? I can see inside. Nothing. Something *is* missing.

I am misremembering a lot of the above, but other visitors might have had similar thoughts and asked similar questions. Some of them might have moved around the casket in the same way; many will have moved differently, or started reading it from a different end, or started and not finished, bored, frustrated, humbled, some not reading it at all but merely looking at it, or glancing at it, or ignoring it altogether. Others still will have moved around it and read its riddles with considerably superior interpretive skill. A few have been fortunate enough to read it by feeling it. It is said that, blind and approaching death, Jorge Luis Borges made a special trip to the British Museum in 1986 to fulfil a longstanding desire to touch the Franks Casket and trace its riddles with his fingers, hoping that the relief carvings and inscriptions would magically bring to life the Anglo-Saxon language and literature that otherwise seemed so far away in time and place.[6] Despite its promise to provide immediate, physical access to a distant world, however,

many of the Franks Casket's mysteries remain unsolved. Are we really any closer to this enigmatic artefact? Many scholars have moved around and around and around the whalebone box, trying to solve its myriad riddles while also engaging with it as a single, three-dimensional enigma. Different movements result in different readings. But is there a correct order in which one might read the casket? Can the reader finally solve and unlock it?

R. I. Page's treatment of the Franks Casket in *An Introduction to English Runes* focuses primarily on the runic material found on all fours sides and the lid. According to Page, the complexity of the texts makes it impossible to go beyond a summary account. Page finds his starting point in the materiality and design of the casket as a whole and opens with the information that each 'side of the Auzon casket is a plate of whale's bone, intricately carved' before relating how the 'plates were fixed to corner posts and were clamped by metal mounts, now missing' and then moving on to convey what else is lost and unknown about the artefact: much of the plain bone base has been lost, how the lid originally fitted is unknown, the front has a hole for a lock or hasp, etc.[7] Mystery and unknowing seems, to an extent, to dictate Page's movement around the casket. Broadly, he starts with what is conventionally described as the front panel, which he divides in two, moves around to the left side, around once more to the back, then up onto the lid, leaving the right side till last. Why finish here? Page claims that he has left the casket's right side until last 'because of its difficulty'. The cryptic vowel runes, in particular, are 'very hard to interpret' and the inscription refers to a carving that is both 'unknown and unusual'. Page dismisses the 'unconvincing' readings of 'excited and imaginative scholars' since the 'story' illustrated on this side has probably been 'lost in the course of years'.[8] And yet leaving this elusive, enigmatic side until last is itself a tantalising move, hinting at a future resolution (which will not only solve this one side but, maybe, unlock the casket as a whole) and thereby provoking further excitement and imagination. But this, in any case, is what the casket wants from us.

Page's fascination with the right side, and especially its cryptic runes, is partly determined by his role as a runologist. In her 1972 article, Amy L. Vandersall makes disciplinarity an issue in relation to the Franks Casket. At the time of writing, Vandersall remarks that the critical studies to date had had two primary concerns: linguistic on the one hand and literary on the other. But there had been 'no comprehensive examination of the date and provenance of the

casket in light of art-historical evidence'.[9] Vandersall encourages us to look again at the casket: it is a visual, as well as a verbal, arte-fact. Ostensibly, the article seeks to fix the casket within its con-text. Its purpose, claims Vandersall, is to 'present a body of visual material that had not generally been considered in relation to the Franks Casket' and which 'indicates that both the traditional date and provenance of the casket are questionable on art-historical grounds'. Although the ultimate aim may be to assign the casket to a new milieu, however, the thing is also liberated in the course of Vandersall's writing. Early on, for instance, she reminds us that the 'lack of critical art-historical attention can be accounted for by the *singularity* of the casket in early medieval English art' (empha-sis added). Moreover, the style of carving and conventions of the representations are 'not directly comparable to Northumbrian art of ca. 700 unless the casket is regarded as a unique surviving exam-ple of folk art of the period'. A page later, our attention is drawn to the 'striking' variety of visual sources suggested for the casket, ranging from 'Oriental, Coptic, Merovingian, Celtic, and Viking to Northumbrian'. From here, Vandersall works through previous criticism on the casket, noting the deprecation of its artistic merit, the doubts over whether it is 'English' work at all, and its resistance to the 'great art' of the Northumbrian renaissance, reaching the conclusion that the casket is, by consensus, 'unusual, even unique in the context of Northumbrian art of about 700'.[10] In the pro-cess of finding the casket a new context, then, Vandersall succeeds in evoking some of its *thingness*: a refusal to be named and neatly categorised. At the same time, the casket will not be made into an art object. We see from Vandersall's article that there is still a lot of text to be read (she provides us with translations and descrip-tions of the runic inscriptions) and stories to be retold (the leg-end of Wayland the Smith is recounted for us). Indeed, strangely enough, Vandersall's movement around the casket is dictated as much by the verbal as by the visual. She moves from the front, round to the right, to the back, the left, and onto the lid. At first glance, the fragment of the lid might seem the least talkative side, identified 'only by a single rune word in the pictorial field'.[11] And yet the silences of this lid encourage Vandersall to return to the Wayland legend – where she began, on the front – and discuss what the written sources have to say about Wayland's brother Egil. Even as the Franks Casket lends itself to art historical study, then, it also refuses to be wrested away from linguistic and literary concerns. It insists on hovering between disciplines, perhaps superseding (or

preceding) them. And with this move, the thing resists disciplinary ownership.

Like Borges, Alfred Becker's engagement with the Franks Casket begins with touch:

> Exactly 30 years ago I could actually touch it in the rooms of the *Department of British and Medieval Antiquities* at the British Museum. And I did. It must have been at that moment that it cast its spell on me.[12]

The past and the present of this artefact – and the related question of obscolescence – spellbind and frustrate Becker in turns. Is it too distant for us to utilise in some practical way? Is it merely an object to be studied from afar? Why can we not still touch it (maybe even open it, turn it, carry it, too) if we could a mere thirty years ago (so that, in this sense, thirty years may as well be one thousand and thirty years)? Becker takes issue with previous scholarship; but, rather than disciplinarity, his concern is that no convincing answer has been offered 'as to the nature and the purpose of the box'. Evidently, he wants to know how this thing (now an artefact out of its time, inaccessible within a glass case) ever functioned. For Becker, the key to unlocking such an answer lies in a careful consideration of time and motion. Time, because 'the assumption that it *must* be a piece of Christian art' obstructs our understanding of the way in which a Germanic pagan past has influenced the casket as much as a Christian present. Motion, because too often critics isolate and treat a single panel or 'sometimes only picture or inscription' and 'from such approaches we cannot expect clues as to the concept of the casket'.[13] For Becker, in order to fully grasp the functionality, the usefulness, of the casket, we have to move around it.

It is, nevertheless, worth noting that Becker identifies purpose and ownership from the outset, before the analysis of each side. He is keen to point out that the casket 'was not meant to be a religious piece of art' and that, as none of the carvings apart from the Magi scene would have suited religious purposes, it is 'very likely' that the casket 'had been meant for some noble layman, for a king, an *æðeling* or a thane'. Becker acknowledges that such statements must remain 'hypothetical' but still wants us to 'assume' that the casket 'once used to contain the hoard of some noble warrior, king or thane' and that the carvings and the runes were meant to 'augment his fortune (from all aspects of this word) and fate by means of magic'. Becker wants us to establish a 'logical, even chronological

program' for the casket. And, indeed, his movements around the chest are nothing if not ordered and logical. We start with the front panel, and move round to the left, to the back, the right, and finish with the lid; but the discussion of each side is subdivided as follows: *the inscription, the picture* and, finally, *magic and how it is worked*, where the last provides not a mere description but an ingenious explanation of how each particular charm or spell operated. As to whether the overall magical programme of the Franks Casket actually worked for 'our' thane, Becker can only conclude that the 'records of Valhalla will know the answer; – surely kept in runes'.[14] We end, once more, with unknowing.

Two of the more recent studies of the Franks Casket, by Marijane Osborn and Leslie Webster, are similarly concerned with identifying a logical and coherent programme for this artefact. Osborn's reading of the casket deals with its 'syncretism'. In her essay 'The Lid as Conclusion of the Syncretic Theme of the Franks Casket' Osborn claims that a syncretism 'directed at promoting a Christian idea appears to inform the four sides and the lid of the Franks Casket', which she describes as 'an ivory box carved with rune-framed pictures illustrating stories from both Germanic and Mediterranean sources'.[15] This syncretism 'finds a thematic unity in the idea of exile' on the casket, and this theme 'culminates' on the lid. Osborn's ensuing movements around the chest are clever and intriguing: unlike many scholars, who deal with the front panel in one spatio-temporal moment, she divides it into two, starting with the Wayland scene on the left, moving clockwise (or sunwise) around the box, before returning to the Magi scene on the right-hand side of the front panel. Via this movement, Osborn identifies both a 'secular story' and an 'eschatological history' running from scene to scene: starting with Wayland, then Romulus and Remus, the exile of the Jews on the back, the riddling 'Harmberga' scene and then the approach of the Magi; but the real conclusion and spiritual 'homecoming' is on the lid, where *ægili* 'defends the soul in her Christian homeland against those hostile forces that eternally attack ... from exile'.[16]

Webster's movement around the Franks Casket differs to Osborn's because she is less concerned with 'story' or 'history' and instead reads the artefact as a 'three-dimensional riddle'. It should be approached with the awareness that the Anglo-Saxons 'had a long, preliterate tradition of non-verbal messages, often structured in a complex and riddling manner'.[17] For Webster, the learned mindset behind the Franks Casket 'ingeniously combines verbal

and visual riddles to deliver a serious message'. Yet this combination of riddles serves a 'contrapuntal' overall programme. Thus, the casket may be read 'as three pairs of opposed scenes in each of which a Christian topos offers a commentary on a pagan Germanic one'.[18] Indeed, Webster is keen to assert that behind the riddling there is a message to be decoded. We see this in her treatment of the front panel, which is her starting point, and which she identifies as 'literally' the 'key to the casket'. And it is the 'heart, the content, that matters' for 'in the case of our three-dimensional riddle, there is a precious three-dimensional content' which is accessed both physically and intellectually. In contrast to Osborn, who splits the two scenes on the front panel, Webster contends that these 'twin scenes' are to be read together and so introduce the idea that 'the four other panels are also organized in contrapuntal pairs'.[19] Thus, the lid and the back panel should be read in tandem, as should the two side panels. And so Webster moves as follows: front, lid, back, left, right. This is different to other movements we have encountered, in some ways awkward or counter-intuitive. It is, perhaps, dictated by intellectual rather than practical or functional concerns: to read the left, then skip to the right side, is to defy the form of the box (the two are not adjacent); to finish not with the lid but with the right side is to defy its function (it is the lid, not the right side, that allows us physical access to the three-dimensional content). Similarly, Webster started by stating that it is the heart, the content, that matters, and yet finishes by asking where we have arrived, what we have learnt about the casket's function and context. For Webster, this 'learned and complex' artefact 'has to have been made in a monastic context, and for a royal patron' and served an instructional purpose 'as a container for a gospel book, perhaps'. But, even as she finishes with the riddling right side, Webster, like so many others, concludes her essay with the enigmatic: in the end, 'this casket is *sui generis*; this extraordinary object will never cease to excite speculation and debate'.[20]

What can be deduced, then, from this selection of Franks Casket criticism? What similarities arise from these movements and the readings they generate? What differences may be observed? First, and most obviously, it is worth noting that the readings are carefully ordered, with a clear start and finish. While this may seem sensible, it is worth reminding ourselves that a casket is not a book: it offers no definite beginning and end; we do not open and close covers, or turn pages. Why could one not move around and around the thing infinitely? Why not return to the same side

twice, or three, or four, times? Why not oscillate between one side and another? Admittedly, the casket does offer clues as to where one ought to begin and end with it, though these have less to do with reading and more to do with function: that is, the casket has a (missing) lock and a lid. Scholars such as Vandersall, Becker and Osborn organise their readings accordingly. They start with the front, finish with the lid. On the other hand, both Page and Webster have elected to start with the front but finish on the right side – an odd choice, if one thinks in terms of functionality. In both cases, however, this choice has something to do with mystery, with unknowing (the right side being acknowledged as the most difficult to unravel). While this may seem an issue of readability, it is not unrelated to form and function, either; for a box, by virtue of being a box, tempts us to try and unlock its inner secrets in a way that a book cannot.

Another point to make is that most of the readings are dictated by the three-dimensionality of the artefact itself. Commonly, the order in which the panels are treated follows the manner in which the casket has been constructed (or reconstructed). That is to say, from the front panel to the lid, or from the right side to the back to the left, or from the front to the left and round to the back. The adjacency of the sides is held intact. Such scholarship continuously rejoins the left side with the back panel, the back with the right, and so on. There is, moreover, an awareness of spatial existence here, a refusal to violate the way in which embodied humans can or cannot interact with a casket. We cannot, for instance, skip from the left side to right without moving over the lid or across the back or front. We are forced to engage, however fleetingly, with an intermediary panel. As noted, the one reading that does contradict this tendency is Webster's reading, which moves from the front to the lid to the back, but then leaps from the left side to the right side. The photographic reproductions of the four panels and the lid in Webster's essay also follow the order of this reading – so that the casket has been disassembled and rearranged in a way that suits Webster's intellectual aims but is at odds with the three-dimensional form of the artefact.[21]

This leads to my final observation, which concerns the practicalities of the casket *as a casket*. The lock and lid predetermine a reading order for a number of scholars. As these readings usually start with the front and finish with the lid, the implication – in terms of practical usage – is that one would take the key to the casket (imagining that we have a key) and insert it into the lock,

and thus encounter the scenes on the front panel (Wayland and the Magi) first. But then what? Surely, if we continue to think in terms of practicality, the next logical move is to open the lid. Only Webster moves from front to lid, but does not finish there, continuing over to the back, then left and right. Vandersall, Becker and Osborn all decide that interaction with the lid must be delayed and move round to the left side or the right instead. Other practicalities are almost ignored. The extant panel on the lid has a fixing for a (now missing) handle. Who carried this casket and how did they interact with it? If one carries the box before unlocking it, does the lid not come first in order of reading? How is the casket lifted, turned, tilted, opened and closed? Does this not encourage a kind of tactile engagement? Are we not meant to read with hands as well as eyes? And what about the bottom of the casket? Does it have nothing at all to say to us? Like the inside of the box, the bottom of it becomes an inscrutable space.

My conclusion must be that there is no single, correct way of reading the Franks Casket. There is not a fixed, logical order in which the panels or scenes must be dealt with. Despite the familiar scholarly insistence that 'I' have discovered the right programme, an ingenious thematic unity that will 'unlock' the many riddles of this three-dimensional riddle, the casket ultimately frustrates us. More than that, it humbles us. This object subjects us to continuous interpretive failure and defeat. What to do in the face of such defeat? What is there to say? We could begin to acknowledge its agency. We ought to understand it as a 'thing' that has the ability to move those who encounter it. Rather than form our own movements, we submit ourselves to its movements: the back and forth transformations, the misdirection, the repetitions, which work to resist human mastery.

The agency of the casket

One mode of resistance exhibited by the Franks Casket is its refusal to allow us to impose manmade categories onto it. Instead, it makes us rethink how we categorise ourselves. For instance, a number of scholars have tried to divide the casket into discrete 'scenes' and categorise these as Christian or pagan, Roman or Germanic, Mediterranean or northern European. This often leads them to hypothesise about the context and/or contents of the casket. Becker remarks that none of the four runic inscriptions refers to a Christian item, and among the carvings there is only one

biblical scene, the adoration of Jesus by the Magi. The fact that
'none of the other carvings would have suited religious purposes'
encourages Becker to identify the casket as a royal or aristocratic
'hoard box' rather than a reliquary.[22] To the contrary, Webster
acknowledges that while the 'unambiguously pagan content' of the
scenes has cast doubt over the casket's ecclesiastical character, the
'assimilation of a Germanic past to a Christian message is by no
means unusual' and therefore it remains likely that the artefact had
some 'religious intent'.[23] But the casket eludes easy identification.
Like a riddle, it delights in wrong guesses. Any attempt to work out
intent/content from a straightforward ratio of pagan to Christian
scenes is fraught with danger.

A look at the right side of the casket (see Figure 3) soon reveals
why this is the case. What do we see here? My initial impression is
one of disorder (compare this with the relative neatness of the front
or the back). My eyes are drawn first to the horse, which is almost
floating in the midst of things. The horse faces to the right, and yet
I cannot help but glimpse the strange hybrid creature sitting on a
mound, being guarded (or confronted?) by what looks like a hel-
meted warrior. There are three figures on the far right, though, and
they also grab my attention. The horse is looking at them, so they
must be significant. But what have I missed in glancing so casually
from left to right? Look carefully among the foliage and you might
see runes. This is an image that asks to be disentangled; but it is also
an image, or congregation of images, so busy that the observer finds
it difficult to focus on any one thing at any one time. The lack of any
neat division invites the observer to take everything in at once, and
yet as soon as I try to do so, I swiftly find myself lost in a dense wood.

It is this sense of bewilderment that leads several scholars to
categorise this side as 'the impenetrable world of an unknown
Germanic story'.[24] Lack of scholarly access to earlier 'pagan'
sources is hereby linked to the knotty, tangled density of the carv-
ing. Some attempts have been made to penetrate this impenetrable
paganity by linking the scene with elements of the Sigurd Saga,
though the texts detailing this story are much later.[25] In any case,
the casket is misleading us here. The difficulty of this side cannot
be attributed to lost stories. It is deliberately unclear. The runic
inscription that frames the picture only adds to this impression.
What is puzzling about it? For a start, the runes read upside down
on the lower border. Second, the carver uses arbitrary or cryptic
runes to replace vowels, a provocative trick. Third, the alliterative

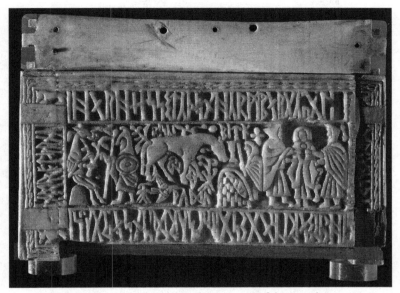

3 Franks Casket, right panel (© The Trustees of the British Museum).

verse, even when decoded, is linguistically ambiguous. R. I. Page
gave the following reading:

> 'Here Hos sits on the sorrow-mound; she suffers distress as Ertae
> had imposed it upon her, a wretched den (?wood) of sorrows and of
> torments of mind' or, with different punctuation, 'Here Hos sits on
> the sorrow-mound; she suffers distress in that Ertae had decreed for
> her a wretched den (?wood) of sorrows and of torments of mind.'[26]

Is this verse related to the carved images it surrounds? If so, how?
Does it comment on them, illuminate them or add another riddle?
It would not be surprising if the text were unrelated to the images,
since the other instance of riddling alliterative verse on the cas-
ket – the front – is usually assumed to be unrelated to the images it
frames, referring instead to the whalebone from which the artefact
is made. In fact, Karkov suggests that the inscription on the right
side may provide 'an echo of the inscription on the front of the
casket in its tone of sadness and change in fortune, and imagery
of death'.[27]

Yet, ambiguous as it may be, the verse on the right side does seem to direct or redirect our attention to the carving it frames. 'Hos' sits on a sorrow-mound and, fittingly, the carving shows someone or something sitting on a mound. Our gaze is directed towards the leftmost side of the carving. As we continue reading the runes, our gaze moves slowly to the right. So this is one way of untangling the tangled wood; we read the image as we would read a sentence, from left to right. But this only takes us partway through the verse. The upper border tells us only of 'Hos' and the sorrow-mound:

| | herhossitæþonhærmbergaagl | |

If we wish to read on, we must tilt the box – even turn it upside down if we wish to read the lower border of runes. Not only are we gaining further linguistic knowledge ('she suffers distress as Ertae had imposed it upon her, a wretched den of sorrows and of torments of mind') but our view of the image is literally being distorted. The runic verse and the carved images are working in tandem to suggest that there is more than one way to read this side of the casket.

Accordingly, alternative readings of this side have been offered, emphasising its Christian aspect over its paganity. Austin Simmons, for instance, sees Christ's nativity in the midst of these images. Look carefully at the tiny, enclosed figure beneath the horse. Here, the 'infant Jesus lies atop the hay in his manger' while 'a shepherd kneels over him with a staff in his left hand'. Now glance again at the rightmost scene. The central figure here is Christ with 'his captors on either side'. Take another look at the leftmost image. The setting is 'hell' and the 'mound-sitting figure is Satan in the form of an ass' whose mouth is 'bound fast with the coils of a snake'.[28] Osborn is another who sees Christian elements. She recognises that the coded runes contained within the runic inscription are 'meant to provoke rather than discourage an alternative reading of the text'. For Osborn, there are three different ways of reading the inscription which can alternatively refer to the far left, the centre or the far right of the carving. This leads to an interpretation of the *harmberga* as a human figure, the 'drinker of woe'. The 'name of the victim, Harmberga, links her (the gender revealed by the following pronoun) to Eve, the original taster of harm or sorrow'.[29] This is one of the 'allegorical' implications of the inscription, which Osborn links to her overall understanding of the casket as a 'syncretistic' artefact, whereby its paganity is converted and transcended. While Osborn is right regarding the possibility of

alternative readings, one need not see a hierarchy. The right side cannot be said to move us from a starting point to a finish. The moment of 'transcendence' (if there is one at all) is endlessly delayed and ultimately denied. The runic verse is inscribed in a way that does not follow the logic of the manuscript page; it is rectangular, and continuous: it asks to be constantly reread, and the more one rereads it, the more its meaning (and the meaning of the carving) shifts back and forth. Nor is it certain that we ought to begin by reading the border-runes. The modern scholar may be more comfortable with image as 'marginalia' but here we have the reverse. We are confronted first and foremost by image – the runes likewise being image as much as word – and, again, imagery does not lead us from beginning to end or from unconverted to converted in any straightforward sense. Rather, the viewer must take everything in at once and be taken in by everything at once. The right side draws us in, overwhelms us, misdirects us. Whatever categories we may bring to it soon become entangled. The warrior faces the monster on the mound; the horse faces the shepherd; the captors face the captive, who faces us. This side of the Franks Casket is less about transcendence than it is about meetings, encounters, confrontations.

All across the Franks Casket we witness its ability to transform what we know about Anglo-Saxon identities. It depicts its various figures in more than one role within space and time so that we cannot read a single figure and the scene they inhabit the same way twice. Take the left half of the front panel. Even if we leave aside what we think we know about this 'story' momentarily, it is evident that a kind of doubling and repeating effect is at work here. Farthest left stands a smith at his anvil, holding a head in a pair of tongs, standing over a decapitated body. Beside the anvil stands a female figure, reaching for a cup. But the figure to her right looks almost identical. Is she not standing beside herself? And what are we to make of the rightmost figure, smaller than the others, who is strangling birds? Birds suggest flight. Who might want to escape this enclosure? I am encouraged to look left again, to try and figure it out. I look at the headless figure on the floor. He or she also looks small. There must be a link. Look at the way the rightmost figure seizes the birds by the neck. Now look again at the severed head and headless corpse. The mutilated in one space turns mutilator in another. Even without bringing a 'missing' story to this enclosed scene, we begin to make sense of what we are seeing by looking back and forth, back and forth, remembering and repeating.

Even with the Wayland story to work with, ambiguity remains. Are we seeing Beaduhild (King Niðhad's daughter) twice? Why are there floral symbols, or runes, to the right and left of the second female figure? Does this indicate a shift in time or a shift in identity? Is this other female actually a Valkyrie? What about the figure strangling birds? The smallness of this figure, which connects it to the headless body, suggests we are seeing one of King Niðhad's sons. Yet Wayland is the one escaping on manmade wings in *Þiðreksaga*. The casket expects us to bring our stories to it, but it is unwilling to follow the logic of a linear narrative. Maybe, therefore, we are meant to see both Beaduhild and a Valkyrie in the second female figure. Maybe we are meant to see Wayland escaping the first time we look but King Niðhad's son strangling birds the second time.

A similar sense of motion and doubling occurs on the left side (see Figure 4). Here, we are in the wilderness again. Trees with visible roots and twisting branches fill every bit of free space. Two figures on the left face right and two figures on the right face left. One wolf lies on its back, while another prowls above it. Two lean, lithe youths are suckled by the lower wolf, their bodies twisted like the trees. As on the right side, different things come together and become entangled. This is also true of time and space, which overlap across this panel. We need not read this as a 'scene'. This is not one place, one moment in time. I see one wolf, not two. A lone wolf is prowling through the wood. The same wolf is lying on its back, feeding the twins. We may put ourselves in the position of the spear-carriers as they witness the event-in-motion. Notice that they watch from both sides, now following the wolf through the trees, now observing as it suckles the young. This encourages the observer to take two, even four, differing views of what is going on. The upside-down runes on the lower border also provoke movement and alternative ways of seeing.

So let us bring in some outside knowledge, as before, and see what the casket does with it. This is the 'Romulus and Remus' panel: the runic inscription tells us so. Yet the carving deviates from the story commonly found in classical sources. Carol Neuman de Vegvar has highlighted some of these anomalies. The twins are shown as 'young adults, possibly bearded, sprawling on the ground beside a recumbent wolf, rather than as infants seated underneath the belly of a standing wolf'. There are four shepherds, whereas normally there are 'at most three'. These shepherds carry 'spears rather than crooks' as they 'kneel in homage' rather

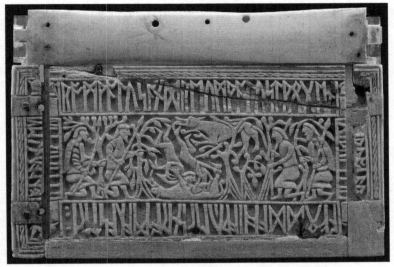

4 Franks Casket, left panel (© The Trustees of the British Museum).

than 'gesturing their surprise or standing by'. Most anomalous, according to Neuman de Vegvar, is the 'second wolf at the top of the panel'.[30] For Becker, such changes take the image further into the realm of pagan Germanic worship. The men with spears are Germanic warriors, by no means Roman shepherds. The two wolves are Woden's famous beasts of battle and the trees evoke the holy grove.[31] Webster, thinking along similar lines, links this, the left side, with the impenetrably pagan right side, since both 'are set in dangerous wilderness, symbolized by the wood'.[32]

For other scholars, the anomalies of this carving serve to Christianise the scene. Simmons sees the four shepherds as 'kneeling' before Romulus, 'here an infant, but one who will someday found Rome as its first king'. They therefore 'represent all the world with its four ends which was made to kneel to the Roman Empire'. They carry spears 'which signify the war which was necessary for Rome to extend its lawful authority over the earth; war which ended with the closing of the gates of Janus and the birth of Christ'.[33] What makes Simmons view the left side in this way? His movements around the casket do. He is thinking back to the right side, with the shepherd kneeling before Christ, giving hay to

the ox; he is recalling the right half of the front panel, where the three wise men are kneeling before the throne with gold, frankincense and myrrh. This is a legitimate way of reading the left side. The casket invites such a reading. Yet it is not the only way. The watching spearmen, two on the left facing right and two on the right facing left, imply that we should come at this scene from both directions. We might start with the right half of the front, the Magi bearing gifts, then move to the right side, seeing Satan and Hell, the Nativity, the Passion, then to the back and the Fall of Jerusalem, and finally to the left side and Rome invested with temporal authority 'in preparation for Christ's universal rule'.[34] Alternatively, we might arrive at this left side straight from the left half of the front. What have we seen there? Brothers in danger. King Niðhad's sons. One beheaded. The other trying desperately to flee. Now what do we see when we engage with the left side of the casket? Kneeling shepherds are suddenly crouching spearmen. They may even be walking or running – if we compare their legs to those in the Titus panel, upper right. These armed warriors encroach on the two brothers. A wolf prowls through a dark, dense wood. It all depends on where we are coming from, where we have been.

The front panel, by virtue of being 'the front' of the chest, might be considered crucial in determining what sort of movement and reading one chooses to take. It has the ability and the power to direct us: to the left, or the right, or else straight to the lid. The first thing we see is a gaping hole where the keyhole should be. There is a runic border which tells a kind of riddle, but one that seems, initially, to be unrelated to the images. The images consist of two 'scenes' depicting Wayland the Smith on the left and the three Magi on the right. A narrow column of interlace neatly separates the left scene from the right scene. It is tempting and, perhaps, reasonable to see some sort of deliberate contrast or comparison at work. But it is harder to know what to do with this contrast. Are the two scenes paired? Should they be viewed together and scrutinised for similarity and overlap? Or are they actually pulling the casket apart? Are they leading the observer, the handler, off in different directions? Once again, it is easy to be lured into categorisation whereby the left is pagan and Germanic while the right is Christian. But, like before, such classification becomes complicated as soon as we begin to move.

Starting with the right half, the Magi scene, is a move that apparently 'baptises' the casket. Is it a monastic product, then?

Is it a reliquary? The three kings are presenting gifts to Christ and Mary. They are offering their valuables to a sort of container: Mary is housed within a pillared and arched structure, while Christ is housed within Mary's womb. In typically riddling manner, the casket is inviting us to guess its function and contents while simultaneously refusing to yield a straightforward answer. Three earthly kings are bringing treasures to a sacred container. Now look at Mary and Christ looking back at us. Their wide eyes are staring out from the whalebone, but also drawing the observer in with their gaze. This sense is heightened by the relief carving. Mary's body emerges from the panel, but the dark space left behind it draws the observer inwards. By this stage, my mind is full of half-formed solutions about what this box contains, what it is for, and the carving is playing on this, luring me inside. To think practically, if I really want to find out what the box holds, I must open the lid; the motion of the Magi scene does not lead me to the lid, however. The three kings and their little bird are moving off to the right. Should I follow them? If I choose to do so, I find myself amid the bewildering right side of the casket. But what is this? The little bird has followed me here. It is flying through the wood, again rightwards. The motion of its flight is taking me towards yet another container or enclosure. Should I recall Christ enclosed within Mary's womb and see the infant Jesus in his manger, watched over by a shepherd? The runic verse in the borders suggests something different altogether. Is this actually a sorrowful burial mound (*hærmberga*) containing a skeleton with grave goods? Have I been led, or misled, into a dead end?

Even if I decide to carry on, to the right, I must move round to the back, then to the left side, and at last I am back inside Wayland's smithy on the front. The ostensibly 'pagan' and the 'Christian' are always meeting across the casket. Since we are back once more in the smithy, we ought to ask where this scene directs us. The two female figures (maybe Beaduhild twice, or Beaduhild and a Valkyrie) are staring to the left, their eyes slightly diverted. Their movement, too, is mostly leftwards. Wayland is facing right. But the real way out of this scene, I think, is up. I am drawn to the small figure strangling birds. As discussed, this figure (whoever it is) wants to escape. Birds suggest flight, and accordingly the four birds look as if they are yearning skywards. If I follow their motion, I am led up onto the lid. This move alters the meaning of the casket in yet another way. If we isolate this, the left half of

the front panel, and follow its progression straight onto the lid, it becomes perfectly plausible to see the archer – labelled Ægili by the runes above his head – as the famous brother of Wayland, Egil. We remember the smithy scene that sent us here, and try to link what we have seen there with what we now see on the lid. If we know the legends associated with Wayland and Egil, we might bring them into play. The casket thus becomes the 'Wayland' casket and suddenly seems a lot less 'Christian'.

And yet to get too caught up in either the left scene or the right one obscures the obvious fact that we must, in the first instance, take the entirety of the front panel in at once: Wayland, Valkyrie, Magi, Mary, Christ, runes, riddle, lock and all. Does this mean that the front panel is united? I do not believe so. The front of the Franks Casket is playful in a contradictory, deceitful way. It is aware of its role as the 'key' to a container. As such, the carved figures stare out at us and draw us in, while others direct us towards the lid. And yet other figures are distracting us and sending us off to the left or the right. Why? From a practical perspective, if you actually had the key to the Franks Casket, it would be all too easy to unlock it, open the lid, and acquire access to the precious contents. The game ends before it begins. But why should it be in the interest of the carved 'ornamentation' to support this accessibility, which renders any sustained engagement with the outer texts and images pointless? They must instead be there to mislead us, divert us, to delay the moment of penetration for as long as possible. The runic riddle around the borders of the front panel is especially complicit in this, since it takes as its subject the materiality (not the inner contents) of the three-dimensional object.

Like the front, the back panel could be described as neat. The challenges it poses are different to those posed by the bewildering right or left sides, but the effects are similar. The border text is especially interesting in this respect. It can be seen, straightaway, that the text looks different to that found in the borders of the front, right and left sides of the casket. The top border is narrower than the borders found elsewhere, so the letter forms have been compacted. As on the front panel, the top border is punctuated by a space; here, the intervening space is occupied by images rather than a lock or any other functional device. This space also prompts a change in script, from Anglo-Saxon runes to the Roman alphabet. The two borders that run down the left and right of this panel are similar to those found elsewhere on the casket, but there

is no lower border on this back panel; instead, we see two three-letter inscriptions in the bottom corners. We can see all of this even before we try to 'read' what we see.

The texts on this back panel therefore present the observer with an immediate, visual signal – indicating that different levels of interpretive competency will now be called into play. As with the separated scenes on the front panel, there is a very visible contrast or comparison at work. The Anglo-Saxon runes could be said to embody a native characteristic, hinting at a long tradition. As the 'distinctively Germanic form of writing, runes made available to English readers something offered to no other European culture: a system of representation that could, in its formal and its functional differences from the Roman alphabet, embody the literacy of a tribal or national vernacular'.[35] This does not mean that reading runes would have come 'naturally' to any given Anglo-Saxon encountering the back of the Franks Casket, for runic inscriptions also 'call attention to the skills of the carver and exhort the reader to interpret symbols accurately'.[36] Being a 'native' Anglo-Saxon does not automatically entail the ability to read runes. It is a difficult skill, which must be learned and maintained. As with any skill, reading runes can be half-learnt, exercised or abandoned, forgotten or erroneously utilised. The Roman alphabet serves to remind one of this. Situated fairly innocuously on an artefact that otherwise displays runic texts, the alphabet is a subtle reminder (lest one become too nonchalant about reading runes) that our engagement with this thing is not an innate or natural process. That is, one does not simply carry the necessary skills to the casket, but the casket is constantly evoking, summoning, forming or reforming those skills for us. The observer recalls what sort of script they can or cannot read by encountering it here, by having to suddenly switch modes, or by failing to do so. If one has the skill to penetrate the runes and alphabet a little further, it becomes evident that there is a switch in language too. Commencing with the left border, and running across the left half of the top border, we read, in Old English:

|| herfegtaþ || titusendgiuþeasu ||

But then, as the right half of the top border moves into the Roman alphabet, the language also moves into Latin:

|| HICFUGIANTHIERUSALIM ||

However, as the text switches back into the runic script down the
right border, the language remains in Latin, albeit an Anglo-Saxon
pronunciation spelling of *habitatores*:

| | afitatores | |[37]

You will note that the switch in language does not exactly
'match' the switch in script. We might expect a simple and con-
sistent pairing of Germanic runes with Old English, and Roman
alphabet with Latin. Of course, the casket is more playful than
this. What does this do to potential readers of the back panel?
Should we assume that all who encountered it were equally con-
fident with both scripts and both languages? On the contrary, the
casket is both informed by and actively able to form varied levels
of interpretive competency. More than one scenario may be imag-
ined. You can read runes but not the alphabet. You can read Latin
but can make no sense of runes. The Roman alphabet looks famil-
iar but you have not mastered Latin. You know Old English but
have not learnt runes. You think you know runes, and the alphabet,
but the sudden switch proves tricky. You are confident with Latin
but the move back into runes, and the alternative pronunciation,
stumps you.

In this way, the casket reminds you of what you already know,
but also tells you what you need to learn if you wish to know it (the
casket) more intimately. It prompts and provokes us. What is more,
such interpretive power – or lack thereof – is linked to notions of
identity. The casket is prompting the beholder to adopt a series of
interrelated roles: literate/illiterate, initiated/uninitiated, secular/
ecclesiastical, Germanic/Roman. Some Anglo-Saxons would have
been able to take on most, if not all, of these identities. Others
would have had more limited access to them. At the same time,
however, the casket is suggesting that these roles are always liable to
change. Far from being stable, these identities can be transformed
over time as interpretive power waxes or wanes. For Webster, the
'unique use of Latin and the Roman alphabet at this point in the
text emphasizes the pictorial message of a new world order'.[38]
I agree that there is an element of transformation at work here, but
do not think that the transformative movement is as fixed as this
implies. The movement – if we are able to make it – is more com-
plex and multivalent than a simple shift from Germanic to Latin
and Roman. It calls on skills that are both visual (seeing runes, rec-
ognising the alphabet) and oral (the syllabic voicing of a rune, the
reciting of Old English or Latin) as well as aural (hearing different

pronunciations). Nor does this movement end with a Roman 'new world order' but turns a corner, shifting into an inventive and challenging combination of runic symbols, Latin language and Anglian pronunciation. Karkov points out that *afitatores*, as a corrupt form of the Latin *habitatores*, written in runes, transforms the inhabitants of Jerusalem 'into a people that is both Roman (language) and "Anglo-Saxon" or "Germanic" (alphabet), yet not quite either'.[39] It is a rectangular, rather than linear, shift; it is a transformation that keeps us in between two states and on the move.

Does this constant movement lead anywhere? As I have already suggested, there may be a case for taking the lid as a 'close' to the Franks Casket. This is mostly determined by its practical function. If opened, the lid promises to reveal the contents – the heart – of the casket. Is this not, after all, what we have been working towards? The extant lid has a fixing for a missing handle. The former function of this handle gives us our first clue as to the double nature of the lid. On the one hand, this handle would have enabled anyone who had already unlocked the front panel (and, remember, there is no need to think that this individual must have been a riddle-solver or rune-knower; they merely possessed a physical key) to more easily lift the lid and peer or reach inside the box. On the other hand, the handle would have been used to carry the casket from one location to another. This is a quite different matter. To carry the casket by the handle, the front needs to remain securely locked, lest the lid suddenly spring open and spill the precious contents. We do not know exactly what sort of travels the Franks Casket would have gone on, but we can safely assume that in the midst of this travelling a secure, rather than accessible, box would have been crucial. So, all at once, and in a very practical sense, the handle hints at accessibility and security, openness and closure.

The carved detail on the lid (arranged around the central disc) supports this contradictory view. It is important to recall, first, that the extant 'lid' under discussion is too small and so it is likely that at least two other constructional components have been lost. As it is, the lid seems frustratingly taciturn. The four sides of the casket have accustomed us to seeing texts and images working in tandem. Here, those border-runes are absent, making the search for meaning harder still. If you look carefully enough, you will see a runic label, discreetly concealed within a fortified structure, above the head of the defending archer. The label reads *ægili*. This has often been understood as a name, identifying this bowman as the brother of Wayland, Egil. Yet, as Simmons has pointed out, we would

expect the name to appear as 'Ægel' or 'Ægil', but are confounded to read the form Ægili, which has an -i appended to the end of the word. For Simmons, 'the form Ægili would be the expected form of an OE dative singular Ægil, though uncontracted; it would yield the meaning "to/for Ægil" '. It is also possible that 'the name was Latinized, and so given a Latinate o-stem genitive singular' so that a 'possessive genitive could make sense here, "of Ægil" '.[40] Either way, this form of the name implies ownership. The casket is a gift for 'Ægil' or an item that belongs to him. The runic label may be an attempt to link the legendary Egil with the real-life owner of the casket, whoever this 'Ægil' might have been.[41] This is all very well for 'Ægil' but sends a stark warning out to the rest of us, identifying us as intruders. This thing does not belong to you. Hands off. Keep out.

Taken along with the images carved on the lid, the warning gathers force. What do we see? There is a great battle unfolding. The panel is crowded with armed and armoured figures. A number of figures on the left are attacking the fortified enclosure to the right. There are at least four attackers and two of them loom larger and taller than the rest. They might be giants or other superhuman beings. The two smaller attackers are distinguished by their coats of mail, and one of them, the leftmost one, looks as if he is treacherously stabbing his giant ally(?) through the back of the skull. The fortress on the right encloses two figures. One is the labelled archer (Egil?) who is shooting arrows at the attackers. The other is usually taken to be a female figure. She has been tentatively identified as Alrun, a Valkyrie.[42] It looks as if she is weaving. The birds and beasts above and below her link this inner sanctum with the one on the back panel, which is likewise surrounded by strange birds and beasts. We cannot know the outcome of this siege, but the attackers are being showered with arrows, one of which has pierced the heart of the figure low and to the left of the circular handle fitting. This, along with the treacherous stab, suggests that they are up against it, while the defended fort and its inner sanctum remain safe and secure. This imagery, then, adds to the 'keep out!' warning implied by the *ægili* label. Osborn's discussion of these runes lends further weight to this reading. For Osborn, the Old English translation of Psalm 90 illuminates the runic label as 'in this verse the word *egle* ("trouble") appears, apparently the same word as the *ægli* and *ægili* on the Franks Casket'. In this sense, the bowman on the lid may mean 'trouble' for the opposition, like a scourge of God. The archer may be interpreted as a symbol for the preacher.

Equally, Osborn recognises that *ægili* could be construed as the casket's owner's name in the genitive in Latin.[43] For me, the overall effect of the lid – as we have it – is to serve as a warning. It promises trouble and death for intruders who try and break in. And so the lid 'closes' the Franks Casket in more ways than one.

Yet for all its riddling the casket does offer us a very open and simple solution as to its nature. There, on the left border of the front panel, in plain view, is our answer:

| | hronæsban | |

Whale's bone, it says. As with the lock and lid, the obvious-ness, the easiness, of this statement stands at odds with the complex and problematic nature of the carved texts and images. This thing *insists* on its basic function and material (it openly declares that it is a whalebone box) but *resists* human mastery (we cannot claim ownership of it or know what was kept inside it). So this talking thing is telling us to engage with it as both whalebone *and* as a chest, something at once organic and crafted, natural and man-made, autonomous and functional. This view of the Franks Casket is echoed by Karkov when she claims that the artefact is 'some-thing that hovers between inanimate object and living being'.[44] In this sense, the casket is asking us to embrace its riddle-like double nature. I will try to heed this call in the next section.

But since I began by considering how previous scholars have moved around the Franks Casket, I should finish with some brief remarks on my own movements. Suffice it to say that they have been random and repetitive. I have not tried to follow a single coherent programme, have not tried to unlock anything. I have instead attempted to create an impression of what it means to move around, and be moved by, to look at, maybe touch, scru-tinise, and be scrutinised by, the casket. At times, my movement from panel to panel has maintained the three-dimensional form of the artefact; at other times I have moved in a more arbitrary man-ner and skipped from front to back, side to side. At times, I have tried to get as close to the thing as one can through words; other times I have interacted with it in a more distanced, virtual way. This reflects my relationship with the Franks Casket in the course of my research. Although I have, on numerous occasions, visited the thing itself in the British Museum,[45] I have also engaged with photographic reproductions and digital images. In this sense, there are many Franks Caskets, demanding a flexible methodology and writing style.

The Franks Casket as assembly

Until now I have been arguing that the enigmatic Franks Casket resists human mastery through continuous movements, back and forth transformations, repetition, misdirection, concealment. But the casket is also a *þing* in the original, Germanic sense of the word: an assembly with the autonomous ability to gather other elements to it. If the Franks Casket can be thought of as an assembly, within what sort of environment would it have carried out this role? Most commonly, the artefact is considered to be of Northumbrian origin and dated to the eighth century. R. I. Page, for instance, dates and locates it thus on philological grounds, while Leslie Webster does so for iconographic reasons.[46] Particularly interesting for my purposes here is Ian Wood's article 'Ripon, Francia and the Franks Casket in the Early Middle Ages', in which he makes a strong case for linking the casket to the milieu of Wilfrid of York's monasteries, finding that this iconographically sophisticated and self-consciously clever artefact is in keeping with the monastic culture of Ripon.[47] Whereas Wood's intention in assigning the Franks Casket to this context is to cast light onto some of the less discussed aspects of Northumbrian culture, mine is more or less the reverse. I wish to ask what the monastic culture of Ripon can reveal about the autonomous ability of the casket to gather other elements to it. What kinds of ideas, images, material goods, bodies and so forth were available within this time and place and how does a whalebone chest draw them into itself?

An illuminating figure, in this regard, is the founder of Ripon, Wilfrid. According to his biographer, Stephen of Ripon, Wilfrid was a Northumbrian nobleman who made his way in the royal court through service in Queen Eanflæd's retinue.[48] Using these royal contacts, Wilfrid was able to travel to Gaul and Rome. On the first such occasion, he accompanied Benedict Biscop. Like Biscop, Wilfrid sought out books, relics and other exotic, cultural goods and brought these back to Northumbria. As Peter Brown puts it, the 'steady drift of books into Britain ensured that fragments of a Mediterranean world ... now came to rest at the far end of Europe' where each book 'opened a window down the centuries'.[49] But more than books was transferred to northern Britain at this time. Wilfrid, for instance, introduced Frankish architectural ideas to Northumbria and may even have brought Gallic masons with him as part of his building programme. Wilfrid also brought the

tonsure of Saint Peter back from his travels, a very Mediterranean hairstyle that 'would distinguish Wilfrid and his eventual followers from the Irish monks of Iona'.[50] In addition, according to Stephen's Life, a Roman archdeacon taught Wilfrid how to calculate the correct date of Easter.[51]

Traditionally, this activity, with the resulting controversy, has been understood as culminating with the famous Synod of Whitby in 664. Michelle Brown warns us that the conflict focused upon this synod was 'not governed by the overly simplistic nationalistic complexion with which it has been imbued in modern scholarship in which "Celtic" opposed "Roman", and "Roman" won'.[52] Nevertheless, we can see the synod as a moment in time when different things met, where the material (i.e. differently styled and adorned bodies) and the immaterial (i.e. ideas about the dating of a festival) came together. It was an assembly. It was, in this sense, a *þing* – a meeting with an issue and an outcome. Although, in all likelihood, the Franks Casket came into being slightly later in time, this Northumbrian environment, and the movement and assemblage that formed it, may shed some light on our whalebone chest, especially if we are linking it to Ripon. But how far can we take this? In what ways is the casket like or unlike assemblies of the less material kind?

Like any meeting or assembly, the casket does bring together a wide range of things that may not have been combined in such a way before. Indeed, I have noted throughout this chapter the extent to which critical praise for this artefact focuses on its eclecticism. Scholars like Vandersall have identified its visual sources as being variously Oriental, Coptic, Merovingian, Celtic, Viking and Northumbrian. Its verbal sources are equally eclectic. Parallels have been drawn between the casket and a number of manuscripts, such as world chronicles and historical compilations which juxtapose scenes from Christian, Jewish, Roman and Germanic histories.[53] Additionally, the casket has literary equivalents in the Old English riddles and wisdom poetry and, like the runic riddles of the Exeter Book, skilfully employs alternative scripts as a means of wordplay.[54] On the Franks Casket, runes work as images, not always confined to the borders but sometimes also embedded in the midst of bodies, beasts, birds and foliage; while in the carving of the panels forms are 'sharply defined, simplified, and isolated like silhouettes' so that figures float freely, ambiguously, like enigmatic signs.[55] Words and images, the visual and the verbal, meet across this box. Factor in the representation of different styles of dress,

architecture, tools and weapons, and we are not far away from the sorts of meetings instigated by Wilfrid and others.

This shows that the Franks Casket took shape within a dynamic environment and that the maker or makers of the casket were drawing on the range of different resources available to them. Yet, even though we recognise the casket as an eclectic artefact, does it really allow us to identify and isolate its sources? As we have seen, attempts to designate one scene as Roman, another as Germanic, one as Christian and another as pagan, soon fail. Furthermore, while its role as an assembly can link the casket to somewhere such as Ripon and to travellers such as Wilfrid, its composite character simultaneously takes it out of place, out of time. Vandersall commented on the casket's singularity in early medieval English art, the deprecation of its artistic merit, the doubts over whether it is 'English' work at all, its resistance to the 'great art' of the Northumbrian renaissance. Ian Wood similarly observes that 'the iconographic scheme of the Franks Casket seems to have no parallel in the Northumbrian products of its own period'.[56]

What is more, the different things brought together by the casket do not float freely. Rather, they converge thickly within and throughout the whalebone. They are forced together into a visible, tangible whole. The casket assembles, but it also crystallises a moment in time. The disparate, fragmented bits and pieces that this artefact has drawn to it are compatible enough for us to recognise the thing as probably Northumbrian, probably eighth century, and yet these bits and pieces have never quite been combined in this way, frozen at one time, so that the thing also remains distinct enough to elude its own context. There is a tension here. For Daston, it is 'precisely the tension between their chimerical composition and their unified gestalt' that makes things talkative. Things that talk 'instantiate novel, previously unthinkable combinations' but 'their thingness lends vivacity and reality to new constellations of experience that break the old moulds'.[57]

The Franks Casket is an eclectic or 'chimerical' composition but it is also a resolutely material artefact made from whale's bone. The talkative thing tells us this itself. The runes on the front panel read as follows:

	fisc flodu		ahofonferg		enberig	
	warþga:sricgrornþærheongreutgiswom					
	hronæsban					

The moment of the whale's death and its transformation into a box of bone is the particular aspect of the Franks Casket that makes it a one-off. While one can point to other artefacts that juxtapose different myths and histories, and can attempt to draw parallels on this basis, there is no other thing that is so self-consciously aware that it once was, still is and always will be *this* whale.

It is the riddling verse, running around the front panel, which highlights the physical origin of the casket. The riddle is set alongside, and punctuated by, the missing central lock. But if this lock once allowed someone access to the contents of the casket, it is the riddle that gives us access to the material body of the thing. The lock is inviting us in; the riddle is drawing is out and around the three-dimensional chest.

R. I. Page translated the verse as follows:

'The fish beat up the sea(s) on to the mountainous cliff. The king of?terror became sad when he swam on to the shingle. Whale's bone.'[58]

There are several points of difficulty in translating this text. I will not discuss these in detail here, except to note the problem of the adjoining words *hrones ban*. How is this phrase linked to the rest of the riddle? It is similar in kind to the Latin *enigmata* by Aldhelm which readily provide their solutions as titles; but similar, also, to a number of the supposedly 'answerless' Exeter Book riddles which offer their solutions in runes that ask to be transliterated. Many scholars, Page included, divide *hrones ban* from the rest of the verse. This leads one to ask whether the phrase should come at the end or at the start of the riddle. Personally, I do not believe we need to choose. It is as it appears on the casket, positioned on the left part of the border, deliberately situated at both the start and end of the rectangular riddle, defying any easy divide between living fish and dead bone, between animate creature and inanimate object. This riddle is not purely intellectual in intention, then, but a key to the tactile, sensual, organic nature of this thing. The riddle on the front invites us, through runes, to reflect on and interact with the thingness of the Franks Casket. Compare this to the way in which the material body of Christ is revealed to onlookers through the mystery (*gerynu*) of the Mass, which is itself a sort of enigma, or riddle.[59]

It is hard for most of us to get to grips with the casket through the glass case that now contains it in the British Museum. Nonetheless, we can take into account the physical processes and

conditions that assembled, disassembled and reassembled it. Each side of the casket is a plate of whalebone and these plates were fixed to corner posts and clamped by metal mounts. How the lid once fitted is largely unknown, though Arthur MacGregor informs us that it 'originally sat on a rebate running around the top edge of the box, secured with a lock on one side'.[60] The extant lid is too small and therefore seems to be missing at least two panels, but the surviving panel has a fixing for a handle in its centre. The front of the chest has a hole for a lock or hasp: the many fixing holes that survive indicate that this lock was renewed on at least one occasion; but the way that the runes and ornament on the front panel avoid the square field around the keyhole shows that the lock was always a feature of the chest.[61]

As we think about how the casket was put together, we also start to take it apart. In this way, we are moving backwards through time. Can we go further still? What sort of thing was the Franks Casket before it began to look and act like a casket? The aptly named 'living history society' that is Regia Anglorum provides us with some useful information on bone-working. For instance, before shaping, polishing and carving a bone plaque, one needs to clean it. To do so, bone 'could be exposed for woodland insects and maggots, or buried for the worms and such to clean it, or even placed in an ants nest'. In a few days 'they will clean off every bit of tendon and fat from the bone'.[62] Such details bring the organic nature of the casket to life for us. Presumably, this process would have likewise heightened the Anglo-Saxon bone-worker's sense that he or she was working with something still living or, at least, undead.

The carving stage would have had a similar effect. Each side of the casket is intricately carved, the runes and images cut with a knife. From the earliest times, 'in a society where pen, ink, paper or parchment were not easily come by but where everyone carried a knife', rune-masters incised their texts in wood, chiselled them on stone, scratched them in metal or cut them in bone.[63] Riddle 60 of the Exeter Book may offer us a glimpse into the cutting process, as the speaking thing describes how the knife's edge cut and carved it in order to send a message. Riddle 26, working along similar lines, has a book tell us about its violent transformation under the knife's sharp edge, which bites and scrapes it. While neither of these riddles can be applied directly to the Franks Casket, they do demonstrate the imaginative awareness, even sympathy, which Anglo-Saxon craftsmen were capable of when carving organic material. It is clear that the cleaning, cutting and carving stages in

the construction of the Franks Casket served to reinforce, if not shape, the life–death obsession that runs across the panels, from the riddle on the whale to the revenge of Wayland and the birth of Christ, from the battles on the lid and back to the burial mound on the right side.

There are other ways in which the materiality of the casket moulds its meaning. There was a long Germanic tradition of cutting runes into bone. Runologists have traditionally claimed that the runic script was developed for the material into which it would be incised – for soft, grained wood, initially, but also for stone and bone, which allowed for forms with more curved lines and rounded loops or bows.[64] And so the whalebone had its own say as to what kind of script and what kind of texts would be carved into it. The linguistic playfulness of the inscriptions on the casket would not have worked so well had those inscriptions not been, for the most part, runic – the cryptic runes on the right side that need to be decoded, for instance, or the runic symbols found within the foliage, disguising as images amongst other images. There is also the fact that, from the start, there was no recognised direction of writing runes. A runic inscription and its letter forms could run from left to right or right to left, or could mix the two.[65] Across the Franks Casket, we can see how the rune-carver revelled in this freedom; the runes run back and forth, up and down, upside down and so on. They form rectangular riddles, and misdirect us in a physical as well as intellectual manner, often inviting us to tilt and turn the box this way and that. There is a 'runic' element to the carved figures, too. Discussing the front panel, Vandersall identifies the style of carving as more evocative than descriptive, where the simple differentiation between foreground and background creates an impression of decorative surface pattern and dark–light contrasts, thereby matching the inscriptions which are carved as raised, rather than incised, letters. The aesthetic result is a 'tendency to treat persons and objects as decorative elements'.[66]

But the size and shape of the bone plates further condenses the texts and images on display. Parts of the whale's jawbone have been used for these plates, and the size of this jawbone would have determined what sort of dimensions the craftsman could work within, again contributing to the evocative nature of the panels. When working with this whalebone throughout these various stages of construction, the makers of the Franks Casket must have been acutely aware that the whale was still having a say in its own transformation.

This, then, takes us all the way back to our living whale. We are led to ask whether the moment of its death, the stranding of the whale, occasioned the construction of the Franks Casket or whether the casket was already conceived, maybe even designed, before the bone became available. The riddle on the front, which has the king of terror swimming onto the shingle, suggests the former. If Ælfric's Colloquy is anything to go by, this beached whale would have been received as a real gift, since actively hunting whales could be a very risky endeavour:

Master: Wylt þu fon sumne hwæl?
Fisherman: Nic!
Master: Forhwi?
Fisherman: Forþam plyhtlic þingc hit ys gefon hwæl. Gebeorhlicre ys me faran to ea mid scype mynan, þænne faran mid manegum scypum on huntunge hranes.
Master: Forhwi swa?
Fisherman: Forþam leofre ys me gefon fisc þæne ic mæge ofslean, þonne fisc, þe na þæt an me ac eac swylce mine geferan mid anum slege he mæg besencean oþþe gecwylman.

[Master: Would you like to catch a whale?
Fisherman: Not me!
Master: Why not?
Fisherman: Because catching whales is a risky thing to do. It is safer for me to go to the river with my boat than to go hunting whales with many boats.
Master: Why so?
Fisherman: Because I prefer to catch a fish that I can kill, rather than a fish that can sink or kill not only me but also my friends with a single blow.][67]

Here, the practical risks posed by the whale blend with the symbolic, diabolical perception of this terrible 'fish'. Harder to obtain than many other materials, but also imbued with a partly supernatural power, it was surely the boon of the whalebone itself that warranted the creation of such a time-consuming, high-status artefact. As Vicki Ellen Szabo points out, 'the material must matter, otherwise its origins would not have merited mention'. One must 'question whether the material would have merited inscription if it had been something more mundane; the archaeological record offers few such examples' and so the inscription on the front 'implies that the material itself is as fantastic as any of the magical iconography

spanning the box'.[68] Indeed, the bones of this 'king of terror' were deemed special enough to be adorned with silver fittings, as well as intricate ornament. Along similar lines, Karkov proposes that the runes chosen for alliteration in the front-panel verse (i.e. *feoh* and *giefa* or 'treasure' and 'gift') could possibly relate to the casket's material as well as its function 'as the whalebone is both treasure and a gift from the sea'.[69] Intriguing parallels between the nature of the Franks Casket and the nature of Fastitocalon in the Exeter Book poem *The Whale* suggest that early medieval ideas about the behaviour of this terrible giant *fisc* in its natural habitat may have played a part in shaping this box of bone. Drawing on the Physiologus tradition, *The Whale* describes how:

Is þæs hiw gelic hreofum stane,
swylce worie bi wædes ofre,
sondbeorgum ymbseald, særinca mæst,
swa þæt wenaþ wægliþende
þæt hy on ealond sum eagum wliten,
ond þonne gehydað heahstefn scipu
to þam unlonde oncyrrapum,
setlaþ sæmearas sundes æt ende,
ond þonne in þæt eglond up gewitað
collenferþe. Ceolas stondað
bi staþe fæste, streame biwunden.
Ðonne gewiciað werigferðe,
faroðlacende, frecnes ne wenað,
on þam ealonde æled weccað,
heahfyr ælað; hæleþ beoþ on wynnum,
reonigmode, ræste geliste.
Þonne gefeleð facnes cræftig
þæt him þa ferend on fæste wuniaþ,
wic weardiað wedres on luste,
ðonne semninga on sealtne wæg
mid þa noþe niþer gewiteþ
garsecges gæst, grund geseceð,
ond þonne in deaðsele drence bifæsteð
scipu mid scealcum. (8–31a)

[Its hue is like rough stone, as if worn down all over by water, sealed around by sandbanks, many reed beds, so that the wave travellers believe that they look on some island with their eyes, and then moor high-prowed ships to that un-land with anchor ropes, settle the sea-horses at the water's edge, and then go up onto that island, proud-hearted. Keels stand fast by the shore, encircled by currents. Worn

out, the seafarers set up camp, unaware of the dangers, and awaken fire on the island, kindle high flames; the heroes are in happiness, weary in spirit, wishing for rest. When, skilful in evil, it feels that the travellers are safely settled on it, guarding their dwelling and delighting in weather, then suddenly the ocean-guest dives downwards with the loot into the salt sea wave, seeking the sea-ground, and confines them in the death-hall by drowning, the sailors with their ships.]

Like the Franks Casket, the whale known as Fastitocalon has a surface layer with the power to mislead the ignorant into misinterpreting its depths for something other than the truth. What we see (an island) is not necessarily what we get (a monstrous whale). Such mistakes can be dangerous, if not fatal. Where the lid of the casket issues a stark warning about what lies beneath, Fastitocalon feels the unwary seafarers (*frecnes ne wenað*) on its back and drags them down into darkness. Once below the surface, there is no way out. The sailors are confined in the watery *deaðsele*.

The devilish craft of the whale (*facnes cræftig*) might have been understood as enduring in its whalebone, the material of the casket. Both the poet of *The Whale* and the maker of the Franks Casket attempt to alleviate this threat and exert verbal power over the monstrous (or even satanic) whale by bestowing a name on it: Fastitocalon in the poem; Gasric on the casket.[70] But, as we have seen in relation to riddles, speaking the right name can be tricky. The runes that name the whale as 'Gasric' on the Franks Casket read retrograde, implying a transformation from the fearsome king of terror (*gasric*) to whale's bone (*hronæsban*). So the whale has (or had) a named identity but the relationship between the name spoken and the thing named changes as the *fisc* shifts between living creature in the sea and bone on the shingle. 'Fastitocalon' is also an unstable kind of name, quite possibly a mistake, a Middle Irish corruption of the Greek 'Aspidochelone', which originally referred to a giant sea turtle, not a whale,[71] suggesting a Babel-like confusion of tongues. Moreover, in *The Whale*, speech and the mouth are associated with trickery, deceit and ultimately entrapment. *The Whale* links the jaws of this sea monster to a devilish allure, an outer temptation which draws mortals into an inescapable inner darkness:

> He hafað oþre gecynd,
> wæterþisa wlonc, wrætlicran gien.
> Þonne hine on holme hungor bysgað
> ond þone aglæcan ætes lysteþ,

ðonne se mereweard muð ontyneð,
wide weleras; cymeð wynsum stenc
of his innoþe, þætte oþre þurh þone,
sæfisca cynn, beswicen weorðaþ,
swimmað sundhwate þær se sweta stenc
ut gewitað. Hi þær in farað
unware weorude, oþþæt se wida ceafl
gefylled bið; þonne færinga
ymbe þa herehuþe hlemmeð togædre
grimme goman. (49b–62)

[He has another nature, the proud water-rusher, yet more wondrous.
When hunger troubles him in the water and the fierce-fighter lusts
after food, then the sea-warden opens his mouth, his wide lips; a
pleasant stench comes out from his innards, so that other kinds of
fish become seduced, swim swiftly to where the sweet stink wafts
out. They fare inside there, the unwary throng, until the wide maw
is full; then suddenly, the grim jaws crash together around that loot.]

Thus, the poet explains, Satan himself ensnares sinners with false
desires. Then hell's gates close like the jaws of the whale. And
human souls are confined in darkness, like the inside of a closed
casket. It is worth recalling here that the Franks Casket is con-
structed from a whale's jawbone. Surely the association between
hellmouth and the whale's maw would not have escaped the maker
of the casket. Yet a casket can open as well as lock up, release as
well as contain, reveal as well as conceal. The Anglo-Saxons knew
the biblical story of Jonah and the Whale, a prefiguring of the
Resurrection of Christ, which suggests that a great gift might
emerge from the darkness:

For as Jonas was in the whale's belly three days and three nights: so
shall the Son of man be in the heart of the earth three days and three
nights. (Matthew 12:40)

All of the lore that accrues around whales illuminates aspects of
the Franks Casket and shows how matter can constrain meaning.
I use the word 'constrain' in a positive sense, however. For the
Franks Casket would not be the enigmatic, intriguing, irritating
thing it is today had it not been made from whalebone.

This bone not only moulds meaning into a distinct whole but
holds it together over time. In addition to having a former life,
the Franks Casket also has an afterlife, spanning the centuries
since its construction. It is a transtemporal artefact. The marks
and scars it carries speak to us; they show how the artefact was

used and reused across the years. An example of such reuse may have occurred within the medieval period. James Robinson of the British Museum believes that while the casket 'was made not as a reliquary but possibly as a box to store a holy text such as a Gospel or the Psalms' it 'appears that it may have been converted into a reliquary in the later Middle Ages when it was linked to the cult of St Julian at Brioude in the Auvergne'. This again comes back to the materiality of the thing since 'its adaptation into a reliquary would have been determined by the fact that, although made of whale bone, it resembles ivory' and ivory, like the flesh of the saints, was 'considered to be incorruptible'.[72]

Reuse of, damage to and disassembly of the casket continued beyond the Middle Ages. As we have it today, the casket is broken and incomplete, from a missing lock and handle to a fragmented lid and an absence of silver fittings and hinges. Some of these wounds are talkative. O. M. Dalton, for instance, examined the structure of the casket and concluded that the removal of the silver fittings would not have led to its disintegration; someone had torn it apart forcibly.[73] When combined with the letter written by Augustus Franks, detailing his discovery of the artefact, the marks and absences start to tell shadowy half-stories. Who used the Franks Casket as a sewing box and why? And what about the young man who tore off its silver fittings to buy a ring? These enigmatic, evocative yet ultimately frustrating legends are in keeping with the overall tone of the casket, which never really tells us everything we wish to know but at the same time refuses to stay silent.

It is indeed a talkative thing: a thing that talks, a thing to talk about, a thing to talk with. Yet the reason that the Franks Casket says so much, both about its former life and its afterlife; the reason that it has been reused and misused again and again; the reason that it has accrued so many names, stories, legends; has attracted so much debate, excited so much speculation, misled us so many times, is precisely because it still speaks, in a very real, a very physical and three-dimensional way, of that unique environment in which it assembled itself ...

> Once circumscribed and concretized, the new thing becomes a magnet for intense interest, a paradox incarnate. It is richly evocative; it is eloquent. Only when the paradox becomes prosaic do things that talk subside into speechlessness.[74]

The Franks Casket is showing no signs of lapsing into silence, not yet. It remains meaningful. It still matters.

Notes

1 See Leslie Webster, 'The Iconographic Programme of the Franks Casket', in Jane Hawkes and Susan Mills (eds), *Northumbria's Golden Age* (Gloucestershire: Sutton, 1999), pp. 227–46, at 227; and Ian Wood, 'Ripon, Francia and the Franks Casket in the Early Middle Ages', *Northern History*, 26 (1990), 1–19, at 1.

2 For a general overview, see James Paz, 'Franks Casket', in Siân Echard and Robert Rouse (eds), *the Wiley-Blackwell Encyclopaedia of British Medieval Literature* (Oxford: Wiley-Blackwell, forthcoming).

3 Wood, 'Ripon, Francia and the Franks Casket in the Early Middle Ages'.

4 Daston (ed.), *Things That Talk*, p. 24.

5 Michel Serres, *Statues: Le Second Livre de Fondations* (Paris: Flammarion, 1987), p. 211. The translation into English is by Steven Connor, available online at www.stevenconnor.com/feelingthings/.

6 This anecdote is recounted in Leslie Webster, *The Franks Casket: British Museum Objects in Focus* (London: British Museum Press, 2012), p. 5. Borges's simultaneous closeness to and distance from Anglo-Saxon literature is evoked by his poem 'To a Saxon Poet', in *Selected Poems*, ed. Coleman, pp. 242–3.

7 Page, *Introduction to English Runes*, p. 173.

8 Ibid., pp. 177–8.

9 Amy L. Vandersall, 'The Date and Provenance of the Franks Casket', *Gesta*, 11:2 (1972), 9–26, at 9.

10 Ibid., pp. 9–12.

11 Ibid., p. 15.

12 Alfred Becker, 'Franks Casket Revisited', *Asterisk*, 12:2 (2003), 84–128, at 84.

13 Ibid.

14 Ibid., pp. 86, 124.

15 Marijane Osborn, 'The Lid as Conclusion of the Syncretic Theme of the Franks Casket', in A. Bammesberger (ed.), *Old English Runes and their Continental Background* (Heidelberg: Winter, 1991), pp. 249–68, at 250.

16 Osborn offers a very useful examination of the meaning of the word *ægili*, linking it to 'trouble' or even 'terror'; I will return to this matter later on.

17 Webster, 'Iconographic Programme', p. 227. Although I have selected this essay as the most suitable, Webster has written extensively on the casket: e.g. Webster, 'Stylistic Aspects of the Franks Casket', in R. Farrell (ed.), *The Vikings* (London: Phillimore, 1982), pp. 20–31; Webster, 'The Franks Casket', in Leslie Webster and Janet Backhouse (eds), *The Making of England: Anglo-Saxon Art and Culture, AD 600–900* (London: British Museum Press, 1991), pp. 101–3. Her 2012 publication for the British Museum's *Objects in Focus* series is written for a more general audience.

18 Ibid., pp. 229–30.

19 Ibid., p. 235.
20 See ibid., pp. 245–6.
21 See Webster, 'Iconographic Programme', pp. 231, 234, 237, 240, 242.
22 Becker, 'Franks Casket Revisited', pp. 85–6.
23 Webster, 'Iconographic Programme', p. 246.
24 Webster, 'Iconographic Programme', p. 241; cf. Vandersall, 'Date and Provenance of the Franks Casket', p. 14.
25 See, for instance, R. W. V. Elliott, *Runes: An Introduction* (Manchester: Manchester University Press, 2nd edn, 1989), pp. 131–3.
26 Page, *Introduction to English Runes*, p. 179.
27 Karkov, *Art of Anglo-Saxon England*, p. 151.
28 Austin Simmons, *The Cipherment of the Franks Casket* (Homeric Society of Texas, 2010), pp. 5, 12, 13, 14. This article has been made available to the public via Oxford University's Woruldhord Project: http://poppy.nsms.ox.ac.uk/woruldhord/contributions/144.
29 Osborn, 'Syncretic Theme of the Franks Casket', pp. 256–8.
30 Carol Neuman de Vegvar, 'The Travelling Twins: Romulus and Remus in Anglo-Saxon England', in Hawkes and Mills (eds), *Northumbria's Golden Age*, pp. 256–67, at 256.
31 Becker, 'Franks Casket Revisited', p. 100.
32 Webster, 'Iconographic Programme', p. 239.
33 Simmons, *Cipherment of the Franks Casket*, p. 10.
34 Ibid.
35 Lerer, *Literacy and Power*, p. 11.
36 Ibid.
37 See further Page, *Introduction to English Runes*, p. 176.
38 Webster, 'Iconographic Programme', p. 239.
39 Karkov, *Art of Anglo-Saxon England*, p. 150.
40 Simmons, *Cipherment of the Franks Casket*, pp. 57–8.
41 Osborn proposes Egil, Abbot of Fulda (817–822) as a candidate, pp. 264–5.
42 See Simmons, *Cipherment of the Franks Casket*, p. 48.
43 Osborn, 'Syncretic Theme of the Franks Casket', pp. 262–4.
44 Karkov, *Art of Anglo-Saxon England*, p. 147.
45 Even referring to the object in the British Museum as 'the thing itself' is misleading. The item on display is fragmented and broken, the right end panel represented by a replica. Furthermore, I have seen the casket in two different contexts within the BM: first, within Europe AD 300–1100 (Room 41); second, within the *Treasures of Heaven* exhibition (23 June to 9 October 2011) where it was surrounded by an array of medieval relics and reliquaries.
46 See Page, *Introduction to English Runes*, pp. 25, 31; Webster, 'Stylistic Aspects of the Franks Casket', pp. 28–30.
47 Wood, 'Franks Casket in the Early Middle Ages', pp. 5–6.

48 Stephen of Ripon, *The Life of Bishop Wilfrid by Eddius Stephanus*, ed. and trans. Bertram Colgrave (Cambridge: Cambridge University Press, 1927).

49 Peter Brown, *The Rise of Western Christendom* (Oxford: Blackwell, 2003), p. 357.

50 Ibid., p. 360.

51 See Stephen of Ripon, *Life of Wilfrid*, chapter 5.

52 Michelle Brown, *The Lindisfarne Gospels: Society, Spirituality and the Scribe* (London: The British Library, 2003), p. 32.

53 For instance: Vandersall, 'Date and Provenance of the Franks Casket', p. 16; Wood, 'Franks Casket in the Early Middle Ages', pp. 7–8.

54 Webster, 'Iconographic Programme', p. 228.

55 Vandersall, 'Date and Provenance of the Franks Casket', p. 16.

56 Wood, 'Franks Casket in the Early Middle Ages', p. 7.

57 Daston (ed.), *Things That Talk*, p. 24.

58 Page, *Introduction to English Runes*, p. 175.

59 Clare A. Lees and Gillian R. Overing look at how the mystery of the Mass and the mystery of the riddle converge in *Double Agents: Women and Clerical Culture in Anglo-Saxon England* (Philadelphia, PA: University of Pennsylvania Press, 2001), pp. 98–100.

60 Arthur MacGregor, *Bone, Antler, Ivory, and Horn: The Technology of Skeletal Materials since the Roman Period* (London: Barnes and Noble, 1985), pp. 202–3.

61 In addition to MacGregor, see Webster, 'The Franks Casket', in Webster and Backhouse (eds), *The Making of England*, p. 101.

62 See www.regia.org/life/bonework.htm.

63 Page, *Introduction to English Runes*, pp. 40–1.

64 Ibid.

65 Ibid., p. 41.

66 Vandersall, 'Date and Provenance of the Franks Casket', p. 13.

67 Text based on Ælfric's *Colloquy*, ed. G. N. Garmonsway (Exeter: University of Exeter Press, rev. edn, 1991). Translation is mine.

68 Vicki Ellen Szabo, 'Bad to the Bone? The Unnatural History of Monstrous Medieval Whales', in *The Heroic Age, A Journal of Early Medieval Northwestern Europe*, 8 (June 2005). Available online at www.heroicage.org/issues/8/szabo.html.

69 Karkov, *Art of Anglo-Saxon England*, p. 149.

70 'Gasric' has conventionally been translated as 'king of terror' but Gaby Waxenberger has proposed that the name means 'the one strong in life or power' (unpublished paper delivered at the thirteenth conference of the International Society of Anglo-Saxonists, July 2009). Quoted in Karkov, *Art of Anglo-Saxon England*, pp. 148–9.

71 Jorge Luis Borges, *The Book of Imaginary Beings* (London: Vintage, 2002), p. 62. See also Michelle C. Hoek, 'Anglo-Saxon Innovation and

the Use of the Senses in the Old English Physiologus Poems', *Studia Neophilologica*, 69:1 (1997), 1–10, at 3.

72 James Robinson, *Finer than Gold: Saints and Relics in the Middle Ages* (London: British Museum Press, 2011), p. 105.

73 O. M. Dalton, *Catalogue of the Ivory Carvings of the Christian Era in the British Museum* (London: British Museum Press, 1909), pp. 27–32.

74 Daston (ed.), *Things That Talk*, p. 24.

4
Assembling and reshaping Christianity in the Lives of St Cuthbert and Lindisfarne Gospels

In the previous chapter on the Franks Casket, I started to think about the way in which a thing might act as an assembly, gathering diverse elements into a distinct whole, and argued that organic whalebone plays an ongoing role, across time, in this assemblage. This chapter begins by moving the focus from an animal body (the whale) to a human (saintly) body. While saints, in early medieval Christian thought, might be understood as special and powerful kinds of human being – closer to God and his angels in the heavenly hierarchy and capable of interceding between the divine kingdom and the fallen world of mankind – they were certainly not abstract otherworldly spirits. Saints were embodied beings, both in life and after death, when they remained physically present and accessible through their relics, whether a bone, a lock of hair, a fingernail, textiles, a preaching cross, a comb, a shoe. As such, their miraculous healing powers could be received by ordinary men, women and children by sight, sound, touch, even smell or taste. Given that they did not simply exist 'up there' in heaven but maintained an embodied presence on earth, early medieval saints came to be associated with very particular places, peoples and landscapes, with built and natural environments, with certain body parts, materials, artefacts, sometimes animals. Of the earliest English saints, St Cuthbert is probably one of, if not the, best known and even today remains inextricably linked to the north-east of the country, especially the Holy Island of Lindisfarne and its flora and fauna.

This chapter looks at how the books, relics and other material things associated with the cult of St Cuthbert reshaped 'universal' Christianity within a distinctly Northumbrian environment in the seventh and early eighth centuries. St Cuthbert has been identified as a post-Whitby figure of reconciliation, preserving the best of the 'Celtic' ascetic tradition while actively promoting a new order more in line with the European mainstream in Northumbria.[1] In

light of this view, I will consider how the saint – both as text, in the hagiographical evidence, and as relic, in the case of the incorrupt corpse – assembles and performs differing elements of Christianity through his body. In the Lives of St Cuthbert, the saintly body of Cuthbert stands in for and localises the universal Christ and thus verifies the 'realness' of God within a particular place. This body must be seen to suffer and endure, felt to heal, and heard to prophesy, in order to substantiate God within the Northumbrian environment. The sort of suffering undergone by Cuthbert mirrors the nonviolent ascetic martyrdom associated with the Irish colour term *glas*, often translated as the colour of 'sky in water' or green, grey, blue. And so the bodily substantiation of God cannot be divorced from environmental features. Human beings – even saintly humans – are not at the centre of a system of nature, but entangled within it.[2] The elemental fluidity of Lindisfarne and the Farne Islands shapes perceptions of the spiritual world and its relation to the temporal.

As well as acting as an assembly, the saintly body is also a thing that crosses the boundaries between life and death, animate and inanimate, organic and artefactual. When St Cuthbert becomes absent in death, the relics associated with his body serve to extend his afterlife and actively carry his presence across time. As material expressions of the pain endured and healed by the saint in life, the relics are what Sherry Turkle would call 'evocative objects'.[3] That is to say, they carry both ideas and emotions, bringing thoughts and feelings together. There is a sensuous intimacy to these things – the comb that derives a venerable quality and the shoes that hold the power to heal a paralysed boy, the linen cincture that cures the nuns, the pectoral cross worn on the body – which enables the inhabitants of Northumbria to not only cope with the loss of their own 'Christ' but to feel at one with an otherwise distant God.

The second section of the chapter focuses in on the Lindisfarne Gospels, dedicated to God and St Cuthbert.[4] Like the Lives, the Lindisfarne Gospels reshape a universal sign (the body of Christ as Cross) into a perceptible thing. Through its artwork, the gospel book assembles eclectic influences to create something distinctly local. The finished 'product' is not the only thing of interest here; I will take into account the process of its making (physical preparation, construction, designing and decorating) and the huge input of local resources: the sheer number of calfskins used to create this monumental work, for instance, as well as the palette used by

the artist, which emulates Mediterranean colours by drawing on exclusively local materials. What is more, the making process of the gospel book offers a glimpse into the divine for the artist–scribe usually assumed to be Eadfrith, who, like Cuthbert, becomes immersed in meditative prayer and feats of spiritual and physical endurance, whilst creating artwork that acts as a series of visual riddles, mysteries to be perceived and penetrated.

This chapter will, on the one hand, analyse things represented within literary texts; but, on the other hand, it will also be examining extant artefacts. In many ways, the textual Lives of St Cuthbert are formulaic in nature, marked by familiar hagiographical elements. Yet the specificity of these texts is located in the 'things' they describe: material items, yes, but also bodies, buildings and environmental features.[5] Such things anchor an otherwise universal Christianity in a certain time and place. More than this, a number of the books, relics, crosses and so on encountered in our texts play an active role in their narratives, displaying agency and altering the human world; they break out of their roles as inert, background objects and become things. It is not always easy to grasp the materiality – the distinctive *thingness* of things – the decorative colours of a book, say, or the fibres of a garment – through textual evidence alone. For this reason, I will also turn to extra-textual evidence. The Lindisfarne Gospels receive special attention, but also Cuthbert's coffin and its treasures, the Codex Amiatinus, the tidal isle of Lindisfarne and other things besides. This raises a further difficulty, in that many of the things described in our texts cannot be matched unproblematically to a corresponding extant, material artefact. Questions often arise over the link between textual and extra-textual counterparts. Does the silk cloth mentioned by Bede actually refer to the kind of garments found within Cuthbert's coffin? Can the empurpled gospel book of St Wilfrid, described by his biographer Stephen of Ripon, be linked to any surviving manuscript? Was the book described by Symeon of Durham as leaping overboard when the community began their wanderings really the Lindisfarne Gospels? While prepared to acknowledge such questions as the chapter progresses, I would also contend that, even where there can be no definitive corroboration, extant artefacts may still *evoke* their textual doppelgängers, summoning forth the materiality of things and recalling times, places and people of the past. These objects have the ability to anchor human memory, sustain relationships and provoke new ideas.[6]

Assembling, reshaping: the Lives of St Cuthbert

The two main hagiographical authorities for the life and miracles of St Cuthbert are a prose Life written by an anonymous monk of Lindisfarne and another, slightly later, prose Life written by Bede. The anonymous Life was completed soon after the translation of the saint's body in 698 and, while influenced by conventional Christian hagiography and following the traditional form and outline of a saint's life, it also draws on local, oral sources and imbues its genre with a freshness by including many details and textures from daily life, along with references to familiar landmarks and historical characters. Its writing style is marked by conciseness and clarity. Bede's later prose Life is more diffuse, filling out the concise account of the anonymous writer, adopting what Bertram Colgrave has called a 'picturesque' style of writing and expanding upon a number of scenes, descriptions and stories. Before composing his prose Life, Bede had also written a metrical *Life of St Cuthbert*. Both of Bede's versions were based upon the earlier anonymous work and both proved very popular, being in constant demand from the eighth century onwards, in England and on the Continent.[7]

These Lives depict St Cuthbert as substantiating, reshaping and localising an otherwise distant Christianity. Julia M. H. Smith has argued that being 'Christian' in the early Middle Ages was not susceptible to a standardised definition. Rather, before *c.*1100, Christianity was organised in ways that were local but nevertheless replicable anywhere:

> In effect, early medieval Christianity was neither centralized nor systematized. Not a single, uniform cultural package to be adopted or rejected as an entity, it comprised a repertoire of beliefs, social practices, and organizational forms that could be adopted and adapted piecemeal. Thus Christianity jumped from one cultural and political context to another, repeatedly mutating and reconstituting itself in ways that preserved its core features. Differently put, a religion with an avowedly universal message managed to localize itself in a multitude of cultural contexts. Pluralisms and possibilities remained the hallmarks of early medieval Christianity – or, better, of early medieval Christianities – and enabled this universal religion to take endlessly varied local forms.[8]

For Smith, traditional narratives of the spread of Christianity do not take adequate account of these local variations. Within an early medieval context, therefore, it was less about 'being' a Christian

than 'doing' Christianity. That is, shaping and living out an idiosyncratic version of Christianity suited to one's own region. Christian belief was a continual, performative process of worship, in which divine patterns were repeatedly iterated in local, temporal spaces; faith was habitually re-enacted.[9]

We began to look at aspects of seventh- and early eighth-century Northumbria in the last chapter through the figure of St Wilfrid, a contemporary, and in many senses rival, of St Cuthbert. Wilfrid exemplifies the importance of movement and assemblage in this phase of the kingdom's development. In *The Rise of Western Christendom*, Peter Brown identifies this process as part of the formation of a 'micro-Christendom' and points to the unusual wealth of Northumbrian kings and aristocracy in the seventh century that made a massive transfer of goods from the Continent to northern Britain possible. This practice can be seen early on with Benedict Biscop, a wealthy Northumbrian nobleman turned monk who was able to move across Europe as a Christian aristocrat, in search of Christian goods, returning to the north-east with not only books but also relics, icons, embroidered silks and experts in Mediterranean styles of chanting, glassware, masonry and so on. This trend continued with men such as Ceolfrith, another aristocrat and successor to Biscop, and with the aforementioned Wilfrid of York, of whom more will be said later in this chapter. The piecemeal transfer of so many cultural goods meant that the seventh century in Britain was an 'exciting age' where each area developed its own distinctive 'micro-Christendom' through the 'skilled deployment of resources' from abroad. Each region was convinced that its own local variant of a common Christian culture was the 'true' one and each believed that it 'mirrored, with satisfactory exactitude, the wider macrocosm of worldwide Christian belief and practice'. The result was the unprecedented rise of a number of 'vibrant and idiosyncratic versions' of 'true' Christianity. Although Brown suggests that these micro-Christendoms took shape all across the British Isles, he singles out the kingdom of Northumbria as 'one area where the creation of conflicting "micro-Christendoms" led to dramatic moments of conflict'.[10]

One way in which St Cuthbert assembled and performed aspects of a universal Christianity within his own micro-Christendom was by adopting and adapting the role of Christ for a local context. The aim of his hagiographers was to reveal that Cuthbert 'showed in his life the marks of Christ crucified and that God had shown his love for that life of discipleship by signs and wonders'.[11]

Accordingly, the anonymous Life depicts the saint in the guise of Christ-as-healer on numerous occasions. This, in itself, may not be unusual in a work of hagiography, but the anonymous monk of Lindisfarne – writing soon after the translation of 698 – pins the specificity of the saintly act down by consistently naming those who are healed. The anonymous writer creates an 'impression of reality' via constant reference to places and people known to his original readers or hearers.[12]

Like Christ in the New Testament, Cuthbert eliminates disease, distress and pain; but he does so for the inhabitants of his own time and place. In Book 2, for example, the anonymous writer tells us how the saint healed a woman 'vexed by a devil' (*a daemonio vexatam*).[13] The woman's husband, named and identified as Hildmer, calls on St Cuthbert for help but does not reveal the true nature of her affliction: 'Iam enim erubescebat illam olim religiosam, tamen a demonio uexatam indicare' [for he was ashamed to declare that a woman once so religious was oppressed by a devil] (II.8). Cuthbert soon displays his prophetic powers and fully reveals the nature of the affliction that the husband had tried to conceal from him, before also exhibiting his healing abilities. It is, in fact, the horse's reins held by the saintly hands that affect the cure: 'mulier quasi de somno surgens uenit in obuiam, et primo tacto freni plene pulsato demone sanitati pristine reddita, ut illa cum gratiarum actione testata est ministrauit illis' [the woman, as if rising from sleep, came to meet them, and at the first touch of the reins, the demon was completely driven away, and, as she thankfully declared, she was restored to her former health and ministered to them]. On another occasion, Cuthbert heals a faithful brother from dysentery. The saint summons the brother, called Walhstod, to his cell, and, as the anonymous Life informs us, 'Ille uero gratanter accedens, primo tactu eius, sicut memorans frequenter cum lacrimis indicare solet, plene omnen grauitatem languoris deseruisse eum' [He gladly consented and at the saint's first touch, as he frequently narrated, recalling the story with tears, the grievous sickness entirely deserted him] (IV.12).

These and other episodes demonstrate the importance of sensory contact. More often than not, it is either the touch of the saint or the touch of something (e.g. the horse's reins) touched by the saint that brings about the healing effect. Where God's sensory contact with humanity is mediated by Jesus in the New Testament, it is mediated by Cuthbert in Northumbria, who takes on the healing role of Christ within his own specific milieu. In her discussion

of body and voice in the Judaeo-Christian scriptures, Elaine
Scarry points out that in the Hebrew scriptures the powerful God
does not have the power of self-substantiation and therefore the
wounded human body becomes the confirmation of God's 'real-
ness'. Man has a body; God has no body. Thus the difference in
power 'depends on this difference in embodiedness'.[14] However,
in the Christian scriptures God does have a body. Scarry asserts
that the human body substantiates God in the New Testament, as
in the Old, but now verification of God comes about via 'sensory
apprehension'. The Christian scriptures are 'the story of the sen-
tient body of God being seen and touched by the sentient body
of man' and so the centrality of the act of witnessing 'cannot be
overstated'.[15] In Anglo-Saxon Northumbria we have a culture
which has adopted these Judaeo-Christian narratives but for which
the body of Christ is no longer perceptible within their own time
and place. Yet it could be made to be so again. The saintly body
of Cuthbert verifies the existence of God and, moreover, does so
within a particular place. This verification is reliant on perception;
the human body becomes the site and perceiver of 'signs' of the
reality and authority of God. Healing can be seen as one source of
this apprehension, since even as 'the Old Testament act of wound-
ing is explicitly presented as a "sign", so the New Testament act
of healing is'.[16]

As well as substantiating God by assuming the role of healer,
Cuthbert must also take on the role of sufferer. The cross on which
Christ suffered is unusual as a weapon since 'its hurt of the body
does not occur in one explosive moment of contact; it is not there
and gone but there against the body for a long time'.[17] In order to
verify the reality of God within Northumbria, Cuthbert's own suf-
fering must resemble this kind of pain, not sudden but long-lasting.
It must also be witnessed. Cuthbert cannot endure in isolation but
must be seen to suffer, even as he was felt to heal, by local men and
women. Thus we have the famous incident at Coldingham monas-
tery, where Cuthbert begins to walk about at night on the seashore,
singing as he keeps vigil:

> Quo conperto, a quodam clerico familie, qui incipiebat occulte de
> longinquo obsequi eum temmptando, scire uolens quomodo uitam
> nocturnam transegeret. Ille uero homo Dei Cuðberht, inobstinata
> mente adpropinquans ad mare usque ad lumbare in mediis flucti-
> bus, iam enim aliquando usque ad ascellas tumultuante et fluctuante
> tinctus est.

> [When a certain cleric of the community found this out, he began
> to follow him from a distance to test him, wishing to know what he
> did with himself at night. But that man of God, approaching the sea
> with mind made resolute, went into the waves up to his loin-cloth;
> and once he was soaked as far as his armpits by the tumultuous and
> stormy sea.] (II.3)

Standing in the freezing North Sea throughout the night is an act
of prolonged suffering.[18] Slow and drawn out, with ice cold waves
against the body for a long time, Cuthbert undergoes a kind of
watery crucifixion. As Christ's suffering on Calvary was witnessed
and narrated in the gospels, Cuthbert's ordeal in Northumbria
does not go unseen or unrecorded: 'clericus uero familiae supra-
dictus in scopulosis locis latens, uisu pauidus et tremebundus, tota
nocte coangustatus prope mortem accederat' [the above-mentioned
cleric of the community lay hidden amid the rocks, frightened and
trembling at the sight and, being in anguish all night long, he came
nigh to death].

The next day, the cleric confesses all and prays for pardon, which
Cuthbert agrees to on condition that the brother vows never to tell
the story so long as he is alive (*numquam te esse quamdiu uixero
narraturum*). Nevertheless, as with Christ, 'the consent to have a
body is the consent to be perceived and the consent to be perceived
is the consent to be described'.[19] The brother keeps his vow and
only tells the story of Cuthbert's endurance after his death. Once
the saintly body cannot be perceived to suffer, and thus substanti-
ate God, it must be described to do so. While the New Testament
describes how Christ was perceived to heal and perceived to suffer,
so too does the anonymous Life describe Cuthbert. Yet in the lat-
ter case the description is not of a universal Saviour, but rather the
local saint of a particular place.

St Cuthbert's suffering is not only witnessed by inhabitants of
Northumbria. It is also intimately connected to the natural fea-
tures of the Northumbrian environment. As with the constant
naming carried out by the anonymous writer, his references to a
familiar landscape serve to root Christianity in a specific place and
time. The Irish influence on Cuthbert's Lives is important here.
While (as we shall see) the cult of Cuthbert looked to many, diverse
sources for inspiration, it was Irish and, specifically, Columban
traditions, which coloured the nature of Cuthbert's interaction
with the land, sea and sky around him. Alan Thacker reminds us
that, in the late seventh century, Lindisfarne was still marked by
its Irish origins and that the anonymous *Life of Cuthbert* 'exhibits

especially close links with Adomnan's *Life of Columba*'. Thacker points to one particularly striking parallel in that 'both authors relate a story in which their hero is spied upon by a suspicious monk while engaged in solitary prayer'.[20] The Columban influence on this incident becomes even more intriguing if we consider the early Irish Church's division of martyrdom into three colours: red, white and *glas*. Here, each colour is linked to a different kind of suffering. It is the last colour – *glas* – that can be most strongly related to the suffering endured by Cuthbert in his Lives.

What did *glas* or *glasmartre* actually signify in the early Irish tradition? Clare Stancliffe carried out a careful investigation of this term and found that *glas* lends itself to the idea of austerity, for 'it has a figurative sense of "fresh, raw, sharp" (of weather), and "harsh" (in a moral sense)'.[21] It was associated with the type of bloodless, lifelong martyrdom developed in the East from the second century on by the likes of Clement of Alexandria, whose essence lay in bearing daily witness to Christ. Stancliffe claims that *glas* martyrdom may be linked in particular to the importance of penitence in the early Irish Church, and to the sort of fearsome penances which we meet in the *De arreis*, such as 'spending the night in water, or on nettles or nutshells, or with a dead body'.[22] The first of these practices obviously takes us once more to Cuthbert's vigil in the freezing sea.

Indeed, the colour term *glas*, and the sort of suffering it called for, was bound up with water and watery rites. Alfred K. Siewers agrees that *glas* is 'the colour of a nonviolent ascetic "martyrdom" involving strict self-discipline' and adds that the term is best translated as 'the colour of sky in water'.[23] Both Stancliffe and Siewers highlight the role of tears in *glas* martyrdom, whereby tears of penance express the element of water in the human body, binding that body to the environment in which it suffers. In the anonymous *Life of Cuthbert*, one often encounters the saint weeping or others weeping before him. When, for instance, Cuthbert is elected to the bishopric of Lindisfarne, we are told that King Ecgfrith and Bishop Tumma come to him in his cell, and lead him away unwillingly, 'lacrimans et flens' [weeping and wailing] (IV.1). The tears demonstrate Cuthbert's reluctance to forsake his solitary life, but they may also be seen as part of *glas* martyrdom, a physical expression of the bond between the ascetic and the island far out to sea, surrounded by deep water, on which he endured hardship.

The term *glas* is not associated with water alone, though: it is a colour adjective used to describe a pale shade of blue (sky in water);

but also to denote green (as of grass or foliage); grey (as of stone, mist or horses); natural-coloured (as of wool); or wan (as of complexion).[24] *Glas* had a range of often environmental related meanings and could describe a combination of natural colours, green, grey and blue, linking land, sea and sky.[25] The elemental fluidity of Lindisfarne and the Farne Islands, where sky and sea, sea and sand, sand, grass and rock, rock, mist and sea, come together and break away, connect and divide, in an ever-shifting blend of green, grey and blue, blue, grey and green, creates a fitting environment for the austere way of life endured by the *glas* martyr.

The Lives draw attention to the role of these natural features in shaping Cuthbert's time as a solitary ascetic. The anonymous writer depicts Lindisfarne as an in-between place, where Cuthbert can make the transition between this world and the other. After his time as a prior at Melrose, Cuthbert, we are told, 'postremo tamen secularem gloriam fugiens clam et occulte abscedens enauigauit' [finally fled from worldly glory and sailed away privately and secretly] (III.1). It is then that Cuthbert is invited by Bishop Eata 'ad hanc insulam nostrum que dicitur Lindisfarnae' [to this island of ours which is called Lindisfarne] where he is able to be both present and absent (*praesens et absens*), carrying out further acts of healing and curing. And so the transitional phase in this saint's life and the mysterious yet predictable retreat-and-return of the tidal isle are intimately intertwined.

In due course, Farne Island offers itself as the stage on which Cuthbert may conduct his feats of eremitic endurance:

> Post plures itaque annos ad insulam quam Farne nominant, undique in medio mari fluctibus circumcinctam, solitariam uitam concupiscens conpetiuit.

> [And so, after some years, desiring a solitary life he went to the island called Farne, which is in the midst of the sea and surrounded on every side by water.] (III.1)

In an analogous passage, Bede emphasises the remoteness of Farne Island in comparison to Lindisfarne:

> Farne dicitur insula medio in mari posita, quae non sicut Lindisfarnensium incolarum regio, bis cotidie accedente aestu oceani, quem reuma uocant Greci, fit insula, bis renudatis abeunte reumate litoribus contigua terrae redditur, sed aliquot milibus passum ab hac semiinsula ad eurum secreta, et hinc altissimo, et inde infinito clauditur oceano.

[There is an island called Farne in the middle of the sea which is not like the Lindisfarne region – for that owing to the flow of the ocean tide, called in Greek "rheuma", twice a day becomes an island and twice a day, when the tide ebbs from the uncovered shores, becomes again contiguous to the land; but it is some miles away to the south-east of this half-island, and is shut in on the landward side by very deep water and on the seaward side by the boundless ocean.] (Chapter XVII)[26]

Water serves here as an exile's desert, severing Cuthbert from the world of men. Farne, this land in the midst of the sea, roofed by grey, leaky sky, the sky reflected in the sea, shapes perceptions of the spiritual, eternal realm and its relation to the physical environment, provoking the solitary ascetic into an embodied interaction with that other world. Cuthbert responds in turn and puts the otherworldly, demonic inhabitants of Farne to flight, before reshaping the natural environment in which he finds himself. According to the anonymous Life, Cuthbert digs down into the earth through hard and stony rock. Then,

Alterum uero cubitum mirabilem desuper cum lapidibus incredibilis magnitudinis nisi scientibus tantum Dei uirtutem in eo esse, et terra commixtis constructum aedificauit, faciens ibi domunculas, de quibus nisi sursum coelum uidere nihil potuit.

[He also built a marvellous wall another cubit above it by placing together and compacting with earth, stones of such great size as none would believe except those who knew that so much of the power of God was in him; therein he made some little dwelling places from which he could see nothing except the heavens above.] (III.1)

The physical and the spiritual, natural and supernatural, human and nonhuman, are continuously overlapping in this scene. Cuthbert, endowed with superhuman strength, physically reshapes the earth and stone in order to make a visual bridge to heaven, directly connecting the local, tangible Farne Island to a universal, intangible God.

Even as Cuthbert's watery crucifixion shows the influence of Adomnan's *Life of St Columba* on the anonymous and subsequent Lives, so too does Cuthbert's solitary battle against demons recall Evagrius' translation of Athanasius' *Life of St Antony*.[27] But, at the same time, Cuthbert's choice of 'desert' retreat – first Lindisfarne, then Farne Island – localises his endurance, his *glas* martyrdom. In his hagiography, Cuthbert's body thus becomes a sort of conduit, channelling diverse Christian practices into the Northumbrian

land, sea and sky; he acts as a witness (martyr) to a distant and universal God in a very distinct environment and, in turn, the natural features of that environment reshape Christianity in their own image.

Although, following the language of the anonymous writer, I have been talking about Cuthbert's 'solitary' retreat and his ere-mitic 'exile' on Lindisfarne and Farne Island, we ought to recall the role of witnessing in substantiating an otherwise invisible God. It is worth noting here that those who witness and perceive Cuthbert within Northumbria are, more often than not, the powerful. For instance, the men and women who benefit from his acts of heal-ing are ecclesiastics or the upper levels of lay society.[28] Power is interlinked with perception and place: Cuthbert heals and those who feel healed perceive God in a particular place; but those who perceive are also those who hold power within that place. Similarly, the one who witnessed Cuthbert's vigil in the seawater was again a cleric of the community (*clerico familie*).

This was also the case when, desiring a solitary life (*solitariam uitam concupiscens*), Cuthbert went to the island called Farne. As we have seen, the anonymous writer describes this place as in the midst of the sea and surrounded on every side by water (*in medio mari fluctibus circumcinctam*). But if water in one sense severs and isolates, it also connects. While the island of Farne is farther out to sea, 'it is closer to the royal fortress – a mere two miles away'.[29] Although it is claimed that Cuthbert made some little dwelling places from which he could see nothing but the heavens above, the saint remains within the view of Bamburgh, the site of Bernician royalty. So, as Cuthbert looks towards the heavens, towards God, those with power look towards Cuthbert. If his austere life on Farne brings the saint closer to God, those who see him must surely see God more closely from and within their own place of power.

Hagiographical writings depict St Cuthbert as assembling and performing diverse elements of Christianity through his body. This was part of a larger political picture. In the previous chapter, I identified the 664 Synod of Whitby as a moment in time when different things, both material and immaterial, came together, making the synod itself another kind of *þing* – a meet-ing with an issue and an outcome. Peter Brown understands the synod as a necessary culmination of the piecemeal transfer and building up of goods that had been going on in Northumbria since at least the time of Benedict Biscop. While Northumbria stretched far to the north into a world dominated, through the

monastery of Iona, by the Christianity of Ireland, its suprem-
acy also reached as far south as the Thames where it absorbed
areas that were exposed to 'Roman' influence. And so, under
King Oswy, the kingdom of Northumbria 'had to face the conse-
quences of its triumphant expansion' and 'risked falling apart'.[30]
The council summoned by Oswy at Whitby in 664 can therefore
be seen as an effort to keep the disparate bits and pieces together.
Indeed, Whitby was not so much a conflict of ideas as a conflict
of contradictory bodies and things. For in an almost totally illit-
erate society, the 'precise nature of visible gestures and the pre-
cise timing of festivals spoke volumes'. The Synod of Whitby
took place in a world fused by externals: hairstyles distinguished
monk from warrior, warrior from farmer; loyalty and status was
demonstrated by personal ornament; the correct dating of Easter
affected the timing of mass baptisms. And so to 'treat external
matters, such as the cutting of one's hair and the day of one's
principal festival, as if they were matters of indifference was to
remove from the entire fabric of profane and ecclesiastical soci-
ety the vital bond of demonstrative loyalty'.[31]

This helps to explain the importance of Cuthbert's percep-
tible sanctity in the hagiography, in which he not only takes and
combines different ideas, beliefs and customs, but uses his body to
show that they can be made to work, visibly and tangibly, within
Northumbria. The time was right for such a demonstration. From
the end of the seventh century onwards, once the dust had started
to settle after Whitby, there were signs of what Michelle Brown
calls 'a new eirenic atmosphere of reconciliation and collaboration
pervading the thought of many of the leading ecclesiastical fig-
ures of Northumbria and Ireland who sought to celebrate their
combined Roman, Eastern and Celtic legacies'.[32] Although, at the
synod itself, King Oswy, convinced by the case argued by Wilfrid,
had opted in favour of the 'Roman' forms of Christendom, more in
keeping with the European mainstream, the situation post-Whitby
played out in a more balanced manner. As the seventh century pro-
gressed, the solution turned out to be a 'constructive compromise'
whereby Lindisfarne and other key Columban houses were allowed
'to retain something of their earlier allegiances while actively pro-
moting the new order in Northumbria'. For Michelle Brown, it is
Cuthbert who emerges in Bede's *Historia* 'as the leading figure in
the process of reconciliation'.[33]

As products of his posthumous cult, the various Cuthbertian
Lives depict the saint performing his important reconciliatory

role while alive. Yet this performance did not end with his death. In fact, it was crucial for the community of Lindisfarne, and for Northumbria in a wider sense, that Cuthbert did not 'die' – or crucial, at least, that his presence remained perceptible. Following Cuthbert's death, the leadership of the Lindisfarne community passed for a brief but divisive period to Wilfrid. Thacker identifies this as a period of anxiety for a large section of the Northumbrian ecclesiastical establishment, since 'hostility to the Wilfridians persisted'.[34] The post-Whitby process of reconciliation was temporarily under strain, as Wilfrid's stridently Romanist vision for the English Church was 'dynamic and outward looking, but not one that took account of the needs and sensitivities of those who might not fully concur'.[35] The inflexible *Romanitas* of the Wilfridians threatened the constructive compromise favoured by most Northumbrian ecclesiastics. We ought to remember that this view of Wilfrid and, conversely, of Cuthbert, is largely inflected through Bede's writing. Thacker acknowledges this, suggesting that Bede did not wholeheartedly approve of Wilfrid and, at the very least, 'disliked the contentiousness which helped to bring divisions upon the church'.[36] Indeed, Lindisfarne and Wearmouth-Jarrow would become closely aligned through the spirit of post-Whitby compromise and reconciliation, and Bede's reworking of the earlier Life must be seen in this context. In particular, his prose Life may be understood as a response to the continued, posthumous threat that Wilfrid and his cult posed to these reconciliatory aspirations. It was, after all, completed at approximately the same time as Stephen's *Life of Wilfrid*, *c*.720.[37]

At the time of writing his prose life of the saint, Bede was more distanced from the lifetime of Cuthbert – both temporally, if we date the Bedan Life to around 720, and spatially, situated as he was in Wearmouth-Jarrow.[38] As such, his account may lack some of the verisimilitude of the earlier Life: Bede 'often deliberately omits the name of a person or place which he thinks may not be familiar to the wider circle of readers for whom his Life was probably intended'.[39] In the stead of this verisimilitude, I would argue that Bede's work is more evocative than that of the anonymous writer – most noticeably in its use of sensory detail.

For a start, the anxiety over the death of Cuthbert and ensuing leadership of Wilfrid sheds some light on Bede's additions to his prose Life. Particularly interesting here is Bede's enlarged and elaborated account of Cuthbert's last days and death. In both the metrical and prose versions, this account 'includes an attempt

to make the figure of Cuthbert the rallying point of the opposi-
tion to the regime installed at Lindisfarne after his death'.[40] In the
prose version, Bede ascribes the prolonged account of Cuthbert's
death to Herefrith, present abbot of Lindisfarne. This first-person
narrative-within-a-narrative provides us with a greater sense of
intimacy, as we hear, verbatim, how Herefrith himself spoke with
Cuthbert in the days and moments leading up to his death. One
such encounter occurs in Chapter XXXIX. Here, Herefrith tells
us how he finds Cuthbert lying in a corner of the oratory and goes
and sits down beside him. This is presented as a close, somewhat
tender, moment, in which the two men sit together in silence for
a time, since the 'weight of affliction' makes it hard for Cuthbert
to talk. This intimate moment soon acquires a more political tone,
with Cuthbert finding the strength to launch into a discourse on
'peace and humility' (*pace et humilitate*) and warn the brethren
'cauendisque eis qui his obluctari quam oblectari mallent' [about
being on our guard against those who would rather fight such
things than delight in them] (XXXIX). Given what we know about
the short, divisive period after Cuthbert's death, it is not difficult
to see what Bede – via Herefrith, via Cuthbert – might be hinting
at in this instance.

However, it is not only Cuthbert's words that Bede lingers over
in his extended account of the saint's last days. Through the per-
sonal recollections of Herefrith, we also feel closer to Cuthbert's
physical presence. In Chapter XXXVIII, Cuthbert's ailing, dying
body loses none of its healing abilities. Herefrith tells us: 'Cunque
increscente languore uideret tempus suae resolutionis instare,
praecepit se in suam mansiunculam atque oratorium referri' [And
when his illness increased and he saw that the time of his depar-
ture was at hand, he commanded that he should be carried back to
his little dwelling place and oratory]. Herefrith and his brethren
do carry the weakening Cuthbert back, even as the community of
Lindisfarne would carry the saintly body with them in the years,
the centuries, after his death. As he is being carried, Cuthbert
catches sight of Wahlstod, the monk suffering from dysentery, and
commands him to stay inside the oratory with him till about the
ninth hour. The presence of Cuthbert's body cures Wahlstod, who
tells his brethren: 'Possum autem tibi rem referre nouam permi-
rabilem, quia ex quo ingrediens illuc tetigi episcopum deducturus
eum ad oratorium, continuo sensi me omni illa longe infirmitatis
molestia carere' [And I can tell you some very wonderful news, for
since I went in there and touched the bishop when about to take

him into the oratory, I forthwith felt that all my affliction and long-standing infirmity had left me].

Bede enigmatically tells us in Chapter XL that, 'Siquidem sepulto uiro Dei tanta aecclesiam illam temptationis aura concussit, ut plures e fratribus loco magis cedere, quam talibus uellent interesse periculis' [After the man of God was buried, so great a blast of trial beat upon the church that many of the brethren chose to depart from the place rather than be in the midst of such dangers]. While the nature of these troubles remains unspecified, they do coincide with the year in which Wilfrid ruled the church of Lindisfarne.[41] Cuthbert's brief absence after death ushers in strife, but, in the prose Life, Bede presents these troubles as ephemeral and, moreover, does not allow Cuthbert's body to move out of focus for long. After only a brief sentence describing the 'storm of trouble' Bede mentions the role of Eadberht in succeeding to the bishopric and quelling the danger. Although Eadberht is praised and promoted here, it is the body of Cuthbert that takes centre stage and is depicted as an object of unity for the community. The chapter concludes with Herefrith recollecting how 'Impositum autem naui uenerabile corpus patris, ad insulam Lindisfarnensium retulimus. Quod magno occurentium agmine, chorisque canentium susceptum est' [We placed the body of the venerable father on the ship, and bore it to the island of Lindisfarne. It was received by a great company who came to meet it and by choirs of singers]. Thus, the saint's body exudes serenity and harmony in opposition to the aforementioned discord.

By lingering for so long over the build up to Cuthbert's death and then drawing our attention to the continuing influence of the body after his passing away, Bede leaves his audience uncertain as to when that moment of 'death' actually occurs. We are told that Cuthbert 'sent forth his spirit to the bliss of heaven' (*intentam supernis laudibus animam ad gaudia regni coelestis emisit*) and yet he does not appear to truly depart in that instant; his body remains present, influential, even active. What is more, eleven years on, the brethren of Lindisfarne find that that body is still perceptible:

> Et aperientes sepulchrum inuenerunt corpus totum quasi adhuc uiueret integrum, et flexibilibus artuum compagibus multo dormienti quam mortuo similius. Sed et uestimenta omnia quibus indutum erat non solum intemerata, uerum etiam prisca nouitate et claritudine miranda parebant. Quod ubi uiderunt, nimio mox timore sunt et tremore perculsi, adeo ut uix aliquid loqui, uix auderent intueri miraculum quod parebat, uix ipsi quid agerent nossent. Extremam autem indumentorum eius partem pro ostendendo

incorruptionis signo tollentes, nam que carni illius proxima aderant
prorsus tangere timebant, festinarunt referre antistiti quod inuener-
ant, qui tum forte in remotiore a monasterio loco refluis undique
maris fluctibus cincto solitarius manebat.

[And opening the sepulchre, they found the body intact and whole,
as if it were still alive, and the joints of the limbs flexible, and much
more like a sleeping than a dead man. Moreover all his garments, in
which he had been clothed, were not only undefiled but seemed to
be perfectly new and wondrously bright. When they saw this, they
were struck with great fear and trembling, so that they hardly dared
to say anything or even look upon the miracle which was revealed,
and scarcely knew what to do. But they took away the outer gar-
ments to show the miracle of his incorruption, for they did not dare
to touch what was nearest the skin; and they hastened to relate to
the bishop what they had found. He happened to be in solitude in a
place remote from the monastery, surrounded on every hand by the
sea at flood tide.] (Chapter XLII)

Eleven years had passed since Wilfrid's divisive leadership, but the
perceptibility of Cuthbert's undecayed body reminds the brethren
that their saintly protector is not an abstract memory but a still-
present entity.

In accordance, Bede's narrative condenses the time that
lapses between Cuthbert's warning against pride and discord
(Chapter XXXIX), the storm of trouble that breaks out after
his burial (Chapter XL) and the finding of the incorrupt body
(Chapter XLII). We can see, from this, how, at 'particular moments
when there is within a society a crisis of belief' (in this case, threat
of schism and doubt over the correct way of doing Christianity)
'the sheer material factualness of the human body will be bor-
rowed to lend that cultural construct the aura of "realness" and
"certainty"'.[42] And so Cuthbert's body remains within view, con-
tinuing to perform its reconciliatory role beyond death. The way in
which Bede describes the body adds further ambiguity over where
life ends and death begins. It looks as if it is 'sleeping' (*dormienti*)
and the limbs are still 'flexible' (*flexibilibus*), imbuing the 'corpse'
with the potential to both awaken and move. In awe of the miracle,
the brethren are initially fearful of perceiving the body – they did
not dare to look or speak, and were afraid to touch anything that
had been next to his skin – for it is perception that will collapse
the distance between their living bodies and the saint's dead body,
creating a temporarily uncanny moment in which something kept
out of sight is revealed once more as strangely familiar.

As well as acting as an assembly, then, Cuthbert's saintly body is also a thing that crosses the boundaries between life and death, animate and inanimate, as well as those between the organic and artefactual, man and manmade. To demonstrate the latter, I would point to the way that Bede's description of the incorrupt body transfers and extends the living power of the corpse onto the clothes in which the saint was buried. Bede says that the vestments were not merely undefiled but crisp and fresh like new and 'wondrously bright' (*claritudine miranda*). It is, indeed, the outer garments that the brethren take with them as a sign of the body's incorruption and yet, as mentioned, they were afraid to touch anything that had been next to the skin – it is almost as if the saint's power is slowly seeping from his bones and spreading outwards to permeate that which is closest (an early indication, perhaps, of the sacred space exuded by the corpse). When the brothers carry the clothes to Eadberht, he kisses them with great affection, as though they were still wrapped around the father's body (*quasi patris adhuc corpori circundata*).

This sets the scene for the final miracles, where things that touched or were touched by St Cuthbert exert their healing power, extending his afterlife and carrying his presence across time. A striking example of this is the incident concerning the boy who, being paralysed in every limb, was healed by Cuthbert's shoes. The anonymous Life tells us how a young paralytic boy (*adolescens paraliticus*) was brought in a wagon from another monastery to the physicians at Lindisfarne. As the doctors try every cure on the boy, he lay with 'pene cunctis membris mortifactis dissolutus' [almost all his limbs mortified and powerless] (IV.17). The doctors have no success, so the boy asks the abbot for the 'calciamenta que circumdederunt pedes sancti martyris Dei incorruptibilis' [shoes which were on the feet of the holy and incorruptible martyr of God]. The boy puts the shoes on his feet that night and rests, and in the morning he rises, miraculously healed, and sings praise to the Lord: 'Surgens in matutinis quod dictu mirum est, Domino laudem stans cantauit, qui prius pene absque lingua nullum membrum mouere potuit' [He arose in the morning and, marvellous to relate, he stood up and sang praise to the Lord, he who before could hardly move any of his members except his tongue].

The anonymous writer reports that this miracle occurred 'only this year' (*in praesenti anno factum est*). Bede, writing in around 720, is remembering and reporting the same event from a slightly greater distance in time. And yet while Bede is more

removed – temporally – from the incident, he once again lingers over the details, carefully describing the workings and the effects of the healing shoes:

Qui consulto abatte attulit calciamenta quae uiri Dei in sepulchro pedes induerant, et ea pedibus dissolutis aegroti circundedit. Siquidem primo a pedibus eum paralisis apprehenderat. Fecit autem hoc noctis initio, cum tempus requiescendi adesset. Statimque ille placidum dimissus in soporem, procedente intempestae noctis silentio coepit alternis palpitare pedibus, ut palam qui uigilabant et uidebant ministri animaduerterent, quia donata per reliquias uiri sancti uirtute medicandi, sanitas optata a planta pedum per caetera membra esset transitura. At ubi consuetum in monasterio nocturnae orationis signum insonuit, excitatus sonitu resedit ipse. Nec mora solidatis interna uirtute neruis artuumque compagibus uniuersis, et dolore fugato sanatum se esse intelligens surrexit, et in gratiarum actionem Domino omne nocturnae siue matutinae psalmodiae tempus stando persoluit.

[And having consulted the abbot, the servant brought the shoes which had been upon the feet of the man of God in the sepulchre and put them upon the nerveless feet of the sick man – for the paralysis had first seized him in the feet. He did this at the beginning of the night when the time for rest had come; immediately the sick man fell into a calm sleep and, as the silence of the dead of night came on, first one and then the other foot began to twitch, so that the servants, who were awake and watching, clearly perceived that the desired restoration had been given by means of the healing powers of the saint's relics, and that it would pass from the soles of his feet throughout his other limbs. And when the accustomed signal for the nightly prayer sounded through the monastery, he was aroused by the sound and sat up. Without delay the sinews and all the joints of his limbs were strengthened with inward power, the pain was banished, and he rose up realising that he had been healed, and spent the whole time of the nightly psalm-singing, or matins, standing up and giving thanks to the Lord.] (XLV)

By providing us with a moment-by-moment account of how the power of the relics starts to work (first one foot twitches, then another) and how the young boy felt (his healed limbs strong and painless) afterwards, Bede paints a still more intimate picture of this scene, so that his audience can almost feel the healing sensation of the shoes for themselves and become sensuously, as well as intellectually, involved.

Relics such as these shoes may be classed as evocative objects, a description which recognises the power of objects in human

lives and underscores the 'inseparability of thought and feeling in our relationship to things'.[43] As material expressions of the pain endured and healed by Cuthbert in life, his relics evoke the saint's persistent power and presence. One can see from the above descriptions of Cuthbert's shoes that there is a sensuous intimacy to these things, which not only enables the inhabitants of Northumbria to cope with the loss of their own 'Christ' but to feel at one with an otherwise distant God. What is more, the efficacy of Cuthbert's relics is not broken by the transition between life and death. In Chapter XXIII of the Bedan prose Life, we are told that 'Neque uero sanitatum miracula per hominem Dei tametsi longe ab hominibus positum fieri cessabant' [Now the miracles of healing wrought by the man of God did not cease although he was far removed from mankind]. This is followed by an account of how a linen cincture (*zonam lineam*) sent by Cuthbert healed Abbess Ælfflæd when she 'girded herself with it' (*succinxit se illa*) before, a few days later, another nun experiencing excruciating head pains is cured when the abbess bound up her head with the cincture (*et hac illi caput circumligare curauit*). Whether Cuthbert is absent geographically or absent in death, his relics work in the same way. These things – the shoes that are worn, the cincture that is bound round the body – evoke the presence of Cuthbert across time and space in order to provoke a physical response which, in turn, leads to belief – the belief that an eternal, universal God is at work in Northumbria.

Once again, however, those who benefit from the healing power of these relics are primarily ecclesiastical and/or aristocratic members of Northumbrian society. The paralytic youth healed by the shoes belonged to another monastery (*de alio monasterio*), while Abbess Ælfflæd, healed by the cincture, was the daughter of King Oswy and presided over the monastery at Whitby, first with her mother Eanflæd, then alone.[44] This high-status healing is both reflected in and shaped by the quality of a number of the Cuthbertian relics themselves. Bede tells us how the garments in which the saint was buried took on his incorruptibility, appearing unfaded and wonderfully bright when the coffin was opened. But we can glean further clues about what these items of clothing might have looked like. Campbell points to an episode in Bede's prose Life (Chapter XXXVII) between Abbess Verca and Cuthbert, in which Cuthbert, preparing for his death, mentioned a *sindonis* that Verca had given him and which his body was to be wrapped in. Campbell explains that it is not entirely clear what

sindonis means,[45] but the fact that Cuthbert said that he would not wear it while he was alive 'suggests that it was valuable and such as a less ascetic man might have worn'. Campbell wonders 'whether this may not be a reference to silk of the kind in which Cuthbert's body was wrapped, though the actual silks found in the coffin seem to be later'.[46]

Thacker supports and builds on this picture of Cuthbert's burial. The enshrinement, he informs us, was 'remarkably opulent' for, despite the saint's asceticism in life, 'in death he was honoured like an emperor'. As well as the silk already mentioned, Cuthbert 'wished to be interred in a stone sarcophagus given by another high ecclesiastic, Abbot Cudda'. The body itself was 'magnificently clothed' and, along with a number of expensive and elaborate vestments, a 'golden fillet adorned the brow of the saint and at his breast hung the famous gold and garnet cross'.[47]

This pectoral cross provides evidence outside of the textual *Lives* for the quality of Cuthbert's relics. The 1827 opening and investigation of the tomb showed that the cross was found among the garments close to the body.[48] Like those garments, then, the cross may have been imbued with a special 'power' because of its nearness to the saintly flesh. But alongside such power we ought to consider the richness and intricacy of the Cuthbert cross itself. Elizabeth Coatsworth describes the cross as 'overdesigned' if anything and, as a result of this, it carries various connotations. For instance, there may be a numerological significance in the twelvefold subdivision of each arm, where twelve stands for the twelve apostles and also for the twelve foundations of the heavenly Jerusalem. The red garnets used for the cross add connotations of martyrdom and the crucifixion and, set against gold, bring to mind the opening imagery of *The Dream of the Rood*, where the cross is at times red with blood, at times geared with gold.[49] Coatsworth also points to the play of crosses within the cross, a design achieved by complex, underlying geometry based upon grids and compass-drawn circles. Interestingly, these design techniques are comparable to manuscript art; in the Lindisfarne Gospels 'the working lines for many of the designs can still be seen'.[50]

So, while the things associated with St Cuthbert extend the healing and substantiating power of his body beyond death, we ought not to overlook the exclusivity of their influence and the richness of their design and display. As the next section develops, we will see that processes of making, investment of time and resources, workmanship and quality, all play an important role in reshaping

universal Christianity. Access to high-status material things can bring one closer to God within Cuthbert's Northumbria; and closeness to God brings one closer to the higher echelons of Northumbrian society.

Assembling, reshaping: the Lindisfarne Gospels

Like the saintly body of Cuthbert, the Lindisfarne Gospels reshape a universal Christianity into a perceptible and distinctly local thing. Again, this reshaping may be understood as part of the formation of a micro-Christendom. Hence, the Lindisfarne Gospels assemble eclectic artistic, scriptural and codicological influences to shape something manifestly local. We witness this assembling and reshaping not only in the illuminated pages of the finished product but through the process of the gospel book's making: its physical preparation, construction, designing and decoration.[51]

One aspect of this process to take into account is the huge input of local resources. While the Lindisfarne Gospels do draw on and bring together foreign methods, ideas and images, their physical construction made exceptional demands on Lindisfarne and its surrounding environs. This can be seen, for example, from the quantity and quality of vellum used. Michelle Brown states that some 'one hundred and fifty large sheets of finely prepared calfskin (vellum) were used in the manufacture of the Lindisfarne Gospels' and that these sheets are 'remarkable for their quality and the relative scarcity of blemishes'.[52] Christopher de Hamel explains that the selection of good skins was a crucial part of parchment-making as 'medieval farm animals probably suffered from diseases and ticks, and these can leave unacceptable flaws on the skin of the flayed animal'.[53] For Brown, the consistent quality of the gospel book's vellum reveals that a great many skins must have been discarded with the implication that 'only younger animals, perhaps yearling calves, were deemed suitable and that there was an extraordinarily large pool of skins from which to select'.[54] Although Lindisfarne's tidal causeway makes the island suitable for animal husbandry – and slaughter – the community also had extensive landholdings, so it is conceivable that other estates and daughter houses would have donated skins to this remarkable endeavour.

The slaughter of young and healthy beasts, the sheer number of skins used, the keeping of the best ones and discarding of the less desirable, all suggests a regional sacrifice for the good of the gospel book. Yet this is not only a sacrifice made by the

human communities of Lindisfarne and its associates, but one that involves the nonhuman inhabitants of Northumbria too. Pointing to the production of medieval manuscripts as a specific example, Ingold reconfigures human acts of making as simply one part in a myriad of transformations involving creatures of every kind, whereby humans very often take over from where nonhumans have left off. Materials such as oak galls, goose feathers or calfskins are produced by animals and plants before being taken up for human use.[55] That Anglo-Saxon book-makers were aware of this side of the sacrifice is reflected in Exeter Book Riddle 26, as an animal skin describes its torturous transformation into a manuscript, its passage from living beast to gold-bright book:

Mec feonda sum feore besnyþede,
woruldstrenga binom. Wætte siþþan,
dyfde on wætre, dyde eft þonan,
sette on sunnan, þær ic swiþe beleas
herum þam þe ic hæfde. Heard mec siþþan
snað seaxses ecg, sindrum begrunden;
fingras feoldan, ond mec fugles wyn
geondsprengde speddropum spyrede geneahhe
ofer brunne brerd. Beamtelge swealg,
streames dæle, stop eft on mec,
siþade sweartlast. Mec siþþan wrah
hæleð hleobordum, hyþe beþenede,
gierede mec mid golde; forþon me gliwedon
wrætlic weorc smiþa, wire bifongen.
Nu þa gereno ond se reada telg
ond þa wuldorgesteald wide mærað
dryhtfolca helm, nales dol wite.
Gif min bearn wera brucan willað,
hy beoð þy gesundran ond þy sigefæstran,
heortum þy hwætran ond þy hygebliþran,
ferþe þy frodran, habbaþ freonda þy ma,
swæsra ond gesibbra, soþra ond godra,
tilra ond getreowra, þa hyra tyr ond ead
estum ycað ond hy arstafum,
lissum bilecgað ond hi lufan fæþmum
fæste clyppað. Frige hwæt ic hatte,
niþum to nytte. Nama min is mære,
hæleþum gifre ond halig sylf.

[An enemy ended my life, took away my worldly strength. Afterwards he dipped me in water, drew me out again, and set me in the sun, where I swiftly lost all the hairs that I had. Then the

cruel knife's edge cut me, scraped me free of stains; fingers folded me and the bird's delight spread lucky droppings across me, often made tracks over the dusky border, swallowed wood dye, a share of the streams, and stepped on me again, travelling with black tracks. After that a man wrapped me with protective boards, covered me with hide, geared me up with gold; thus am I enriched by the wondrous work of smiths, wound about with wire. Now the trappings and the red dye and the glorious setting make the protector of men widely known, not the pains of the foolish. If the children of men make use of me, they will be the safer and the more sure of victory, in their hearts the bolder, and merrier in mind, in spirit the wiser; they would have more friends, dearer and closer, truer and better, more honourable and more loyal, who would gladly increase their glory and greatness and cover them with grace and kindness, clasping them closely with love's embraces. Ask what I am called, a benefit to mankind. My name is renowned, helpful to heroes and holy itself.]

The violence of the process that turns beast into book is certainly not underplayed here – the creature is killed, cut and scraped, folded and stained and bound (1–15). Yet the speaking thing also shows an awareness that its sacrifice has not been in vain. It says that it is 'niþum to nytte' [a benefit to mankind] (27) and 'hæleþum gifre' [helpful to heroes] (28). Indeed, it is difficult not to read this as somehow analogous to saintly or even Christlike self-sacrifice: the animal undergoes a violent passion or martyrdom, imitating the crucifixion of Christ. The references to gold ornamentation in Riddle 26 call to mind something more precious, lavish and richly illuminated than an ordinary manuscript; they evoke an Anglo-Saxon gospel book, perhaps one from the golden age of Northumbrian book production akin to the Lindisfarne Gospels.[56] In this way, the beast that is tortured in the process of becoming a gospel book re-enacts the very contents of its pages: Christ suffering and dying at the hands of his enemies before being resurrected and his story disseminated as the *godspel*.

If we apply the description in Riddle 26 to the many, many calves that yielded up their flesh for the Lindisfarne Gospels, we heighten our understanding of their roles in this enormous, but local, project. From an anthropocentric viewpoint, these Northumbrian animals sacrifice their bodies for Christ, bearing witness (martyrdom) to the Word made (with their) flesh. One might also recall and compare this to St Cuthbert's watery crucifixion, where the sea animals of Northumbria come forth to witness and recognise the suffering of 'Christ' in their own habitat.

The gospel book also makes use of local resources for its decoration. It is often noted that the ornament of the Lindisfarne Gospels reflects the artistic and cultural melting pot of seventh- and eighth-century Northumbria, combining Celtic and Anglo-Saxon styles with Roman, Coptic and Eastern traditions. The manuscript decoration 'mingles the interlacing zoomorphs of Germanic Anglo-Saxon art' with 'the curvilinear patterns traditional to the Celtic art of Ireland and the British west, and the art of the classical tradition, re-introduced to the region through the Church, with its associated language of Christian symbolism'.[57] Yet how was this eclectic visual effect, this blend of familiar and foreign influences, achieved? Picking up on the results of the Raman laser project, which examined the pigments of the Lindisfarne Gospels, Michelle Brown informs us that the maker of the book was 'able convincingly to emulate and even extend the range of colours available to the artists of the Mediterranean during Antiquity and the early Middle Ages using purely local materials'.[58] While this dispels evidence for the presence of lapis lazuli within the manuscript, it does place more emphasis on the skill in experimental chemistry possessed by the gospel book's maker, who must have worked with a restricted range of pigments, drawn from a restricted region. Therefore, as with the vellum that bore this decoration, the process of making once again placed the strain on the surrounding environment – even if the resulting visual display spoke of and to a wider Christian world.

I want to stay with the process of creation, but shift the focus now onto the creator of the Lindisfarne Gospels: the artist–scribe himself. Eadfrith, bishop of Lindisfarne and heir of Cuthbert, from 698 to 721, is identified by Aldred's tenth-century colophon as the 'writer' of the gospel book. The colophon reads: 'Eadfrið biscop/b lindisfearnensis æcclesiæ he ðis boc avrat æt frvma gode 7 sce cvðberhte 7 allum ðæm halgvm. ða. ðe / gimænelice in eolonde sint' [Eadfrith, bishop of the Lindisfarne Church, originally wrote this book, for God and St Cuthbert and for all the saints whose relics are on the island].[59] In an earlier essay entitled 'The Lindisfarne Scriptorium', Brown thought that this attribution might have referred simply to Eadfrith's patronage, since it was 'certainly improbable that he would have found time to undertake the task himself during the busy period of his episcopate'.[60] Yet she later revised this opinion, seeing the 'special dignity' of working on such an important project as an honour bestowed on Eadfrith at a more advanced stage in his ecclesiastical career; it is plausible, then, that

he wrote and illuminated the Lindisfarne Gospels himself around 710–20.[61]

So what was Eadfrith's role in reshaping universal Christianity within the Northumbrian micro-Christendom? How was his body and his perception involved in this process? We have already seen how Cuthbert's feats of physical endurance substantiated the existence of God, but what of similar feats by Eadfrith? If indeed the Lindisfarne Gospels represent the work of this single artist–scribe, as thought likely, then their creation must have involved immense dedication, endurance and pain. It has been described as a 'body-racking, muscle-aching, eye-straining task' made worse by wind and rain and cold.[62] It is possible to compare this with Cuthbert standing in freezing seawater or retreating to an island to battle demons. The role of *miles Christi* was bestowed on the scribe by Cassiodorus, who said that each word written by the monastic scribe was a wound on Satan's body.[63] It is a spiritual struggle, but a physical struggle too. Whereas Cuthbert's endurance is perceived, told, described, rewritten and retold, Eadfrith's endurance manifests itself in the beautiful work of the gospel book, which in turn makes the body of God perceptible and transmits the Word. The labour (and therefore the toil and pain) of Eadfrith is situated within the context of an apostolic mission which had 'reached the farthest ends of the known world ... where a Christian people carried the Word of God still further northwards while showing the old centre, the Mediterranean, that they were no provincial outpost'.[64] Hence the artist–scribe plays a key part in the construction of a micro-Christendom. In his work – which is itself a product of his body, its endurance, ache, coldness, stiffness – wider Christianity is reshaped and made perceptible within a specific time and place.

The Word of God is not only made perceptible as a result of Eadfrith's work but is meditated on as part of the process of its creation. The artwork of the Lindisfarne Gospels can be seen as a series of visual riddles, symbolic representations of spiritual mysteries which must be perceived and penetrated. Even as the scribe brings the Word of God to the edges of the world and makes that edge a new centre, so an illustrated Insular manuscript integrates word and image. Unlike the marginalia of later medieval manuscripts, in the Lindisfarne Gospels images existed not at the edges, but within the sacred Word itself – Word here as both Letter and Logos incarnate.[65] The creation of such visual art, amalgamated as it is with the Word, is a form of meditative prayer, or *ruminatio*. The cross-carpet pages of the Lindisfarne Gospels have been

compared to prayer labyrinths.[66] The initial pages serve a similar function, whereby the X, P and I of the chi-rho page stand for a name (the initial letters of Christ) but also a symbol and a body (the X as a cross; the intersecting P and I as a haloed figure).[67]

When the maker 'loses' himself in this complexity during painting he meditates on the Word by penetrating the name and body of Christ, delving ever deeper, following loops and knots and laces with his eyes, with his hand, forming birds and beasts and many smaller crosses as their bodies intersect; maybe he also masticates and digests the letters as he illustrates them, memorising and uttering aloud, until letters become words which reveal the Word. Even as the artist–scribe creates, his creation starts to take on a life of its own, shaping the shaper – as a Northumbrian Christian – in return.

In the process of its creation, the gospel book stares back at Eadfrith and offers him a special glimpse into the divine from his scriptorium on the island of Lindisfarne. Of course, the results of that process would have been received by a wider Northumbrian audience. The Latin text of the gospels tells the story of a universal saviour, Christ, but each gospel is preceded by an evangelist portrait page, a decorated cross-carpet page, and an initial page. The carpet pages deserve special attention, for I would argue that, where the Latin text communicates the universality of Christ, these pages serve to make a widespread Christian symbol – the cross – particular to the place of their creation, by visually referencing the absent body of Christ in a Northumbrian artistic and cultural context. Indeed, the cross was becoming 'a key sign for the Northumbrians' in the seventh and eighth centuries, and the account of Oswald's erection of a wooden cross at Heavenfield, as recounted by Bede, may be 'an illustration of a burgeoning Northumbrian interest in the idea of the cross'.[68] The carpet pages of the Lindisfarne Gospels may well be linked to the early stages of this interest.

How, then, do the carpet pages particularise the cross? For a start, one can see that the crosses are comprised of intertwined birds and beasts. In one sense, these animals recall early Christian inhabited vine scrolls in which all of creation feeds on the true vine, the tree of life. This, of course, is the cross depicted as a universal Christian symbol. But there are local attributes here, also. Any visitor to the Northumbrian coast and its islands 'can hardly fail to be aware of the richness of wildlife of the region' and, while Eadfrith is likely to have seen and been inspired by a Mediterranean

model, the birds of the Lindisfarne Gospels 'clearly have characteristics with which he himself felt at home'.[69] Although the birds may not be 'naturalistic' in the modern sense, they are nonetheless familiar to the Northumbrian environment. The paired birds and hounds on the Mark carpet page may serve a similar function to the beasts depicted at the feet of Christ on the Ruthwell and Bewcastle monuments, whereby the Saviour is recognised by the beasts.[70] Parallels may be drawn, therefore, between such iconography and the scene discussed above in the anonymous *Life of St Cuthbert*, when the sea animals (identified as *lutraeae* or 'otters' by Bede) minister to the saint, washing and warming his feet. The involvement of animals credible in a Northumbrian setting and the persistently popular view of Cuthbert as a friend to otters, seals and eider ducks reinforces the idiosyncrasy of this scene.[71] Just as we have, in the Lindisfarne Gospels, beasts and birds with a hint of the Northumbrian about them recognising Christ (as cross), so too Cuthbert, a Northumbrian saint, is recognised (as Christ-like) by the animals of that land. Additionally, the role of the beasts in recognising Christ takes us back to the process of making a gospel book from animal bodies. These nonhuman inhabitants of Northumbria are drawn towards the Saviour in their land, but at the same time their presence – as vellum, as literary and artistic figures – localises that universal Saviour.

The effect of the carpet pages, with their interlace design and paradoxical patterns, is also reminiscent of Germanic metalwork, and the texture of the interwoven colours calls to mind rich eastern silks, so that the crosses display both wealth and power. Certainly the carpet pages, with their emulation of raised glass bosses, remind one of the metalwork processional crosses used in an Insular milieu; but their zoomorphs and step and fret patterns also resemble the Sutton Hoo shoulder clasps.[72] Riddle 26 evinces the visible connections between metalwork and manuscript adornment, when the gospel book explains: 'forþon me gliwedon / wrætlic weorc smiþa, wire bifongen' [thus am I enriched by the wondrous work of smiths, wound about with wire] (13b–14). The possible transfer of technique between smith and illuminator itself lends the Lindisfarne Gospels a kind of mysterious power when one considers the status of the smith in Germanic legend, attested to by the appearance of the mythic Wayland on the Franks Casket and his mention in *Beowulf*, in which the hero's mail coat is said to be 'Welandes geweorc' (455). Although Anglo-Saxon smiths could often be viewed as liminal figures who possessed magical

powers of transformation and practised a closed and hidden art, Christianity gradually directed the skills of someone like Billfrith, who contributed his talents in metalworking to the adornment of the Lindisfarne Gospels, towards the service of the Church.[73]

The status of the metalworker is transferred onto the wearer. Personal ornament as a display of wealth and power was intensely important to a nobleman of Anglo-Saxon England, who might wear on his person the value of a considerable estate.[74] It was not only secular rulers, either: a fact confirmed by the *sindonis* in which Cuthbert's body was to be wrapped after death. The patterns and colours of the carpet pages can be compared to 'the sort of elaborate, exotic embroidered silks and woven braids of eastern manufacture in which the incorrupt remains of St Cuthbert were reverently wrapped'.[75] As such, the crosses of the Lindisfarne Gospels can be said to 'wear' power and wealth. This power is thereby transferred to the body of Christ, as cross, but nevertheless remains intricately bound up with the upper levels of Northumbrian society and the kind of ornament they chose to adorn their own bodies with.

Access to high-status material things can bring one closer to God within Northumbria; and closeness to God brings one closer to the higher echelons of Northumbrian society. This is clearly demonstrated by the display of the cross-carpet pages. It is not difficult to detect an element of gift exchange from such display. We need not think of such giving and receiving in purely earthbound terms; the custom could also be projected into the realm of the supernatural, as wealth and treasure was bestowed on God, Christ and the saints. In this manner, economic capital (i.e. gold, silver, gems, silks) could be converted into symbolic capital (i.e. divine approval). As Julia Smith puts it, 'In the early Middle Ages, material wealth and political power had flowed along channels that were secular, sacred, or both simultaneously'. In this world 'where resources were hard-won but easily dissipated, their possession was one of the defining characteristics of the religious and lay elite' who 'used their wealth to display their status; uphold and reinforce their honour; establish and strengthen their ties to lord, rulers, and the saints in heaven'.[76] The wealth worn by the carpet pages of the gospel book, then, not only reflects the power of the Northumbrian elite but reveals the power of Christ, the power of God, who, upon receipt of Northumbrian riches, bestows approval and symbolic capital on the gift-givers. Of course, it was only the Northumbrian elite – ecclesiastical and aristocratic – who were in a position to lavish such wealth on God, and receive His favour, in the first place.

Therefore, even as the Lindisfarne Gospels reshape Christianity for Northumbria by clothing the cross in regional ornament, they limit accessibility to that Christianity, creating a restricted micro-Christendom in which only those who possess material wealth may fully partake.

This is in keeping with the Lindisfarne Gospels' status as an inspirational but relatively inaccessible focal point.[77] We may think back to Eadfrith's privileged position as creator of the manuscript art, how he was able to meditate on the labyrinthine play of crosses within crosses while writing and painting their pages, and compare this to the less available display of the gospel book once it had left the scriptorium, for the Lindisfarne Gospels themselves 'may not have been available for detailed study to many, even if visible as a source of inspiration at the shrine and on the altar on special feast days'.[78] Thus, the reshaped Christianity depicted in the Lindisfarne Gospels is limited even further. Who had the power to perceive the book and who had the power to read, interpret and penetrate it? There are multiple issues to consider here. For one, who could actually get close enough to the gospel book to view it? We know that, throughout its afterlife, St Cuthbert's body had the ability to draw pilgrims from far and wide but that, at the same time, the Cuthbertian community controlled access to said body from the seventh to the twelfth century and beyond.[79] Would the custodians of the Lindisfarne Gospels have exercised a similar authority, deciding who could and could not approach its pages? Even if someone did find themselves within viewing distance of the book, would they have had the requisite literacy to read its Latin text? We may again look to the Cuthbertian cult more generally for clues. Latin *vitae* produced in England, for instance, were less assured of an audience than in somewhere like pre-Carolingian Gaul and 'must have been less accessible, comprehensible perhaps only to the educated clergy and a few unusually learned princes and nobles' with a more restricted appeal to ordinary pilgrims.[80]

However, while the Lindisfarne Gospels may have been read by very few, they did display a visual power. Even if it could not always be read, the Word of God could still be seen. Hawkes highlights the manner in which the decorated pages (the evangelist portraits, the cross-carpet pages and the initial pages) present complex visual commentaries on the succeeding Latin text. These pages speak in a visual language, in a 'vernacular artistic language' that 'combines with other visual traditions to serve a symbolic function that draws out the relevance of its setting'. By replicating the way

that 'Germanic and Celtic metalwork presents paradoxical patterns, forcing the viewer to contemplate the forms to understand them, the artist has articulated the value of the Word in a traditional manner, transforming the painted page into the something that both represents and is the subject of the Gospel'.[81] This draws on a different sort of literacy: a visual literacy, bound up with the vernacular arts. And yet, while this visual dimension does particularise the gospels, I would hesitate to say that such artwork widens the book's audience; the effect may be quite the opposite. We have already seen how the carpet pages speak predominantly to those in possession of material wealth, narrowing participation. But the visual language of the gospels speaks even more directly, to an even more specific section of the Northumbrian elite. That is, it speaks to those members of the Northumbrian political and ecclesiastical establishment who supported and rallied to Cuthbert and his cult, as opposed to the Wilfridian camp.

Throughout this chapter, I have repeatedly pointed to the role of Wilfrid and his followers in offering an alternative view of what Northumbrian Christianity could look like. The cult of Wilfrid was undoubtedly a rival to that of Cuthbert, both acting as foci for opposing parties in politico-ecclesiastical conflict.[82] So, how did those in opposition to the Cuthbertian party shape their own, idiosyncratic version of a wider Christianity? In Chapter XVII of the *Life of Wilfrid*, his biographer, Stephen of Ripon, gives us a tantalising glimpse of what a rival gospel book might have looked like, describing letters of purest gold on empurpled parchment and a golden case set with precious gems.[83] While the Lindisfarne Gospels are still with us, as an existing artefact, we can be less certain about the appearance of the Wilfridian Gospels, as alluded to in this passage. One can, however, compare them with the eighth-century Canterbury Codex Aureus, now in Stockholm, which displays purple pages with gold crosses embedded in the text. A still more apt comparison may be found with the Codex Amiatinus, which is closer in time and location to the Wilfridian Gospels. Folios 4r. and 4v. of Amiatinus were written in a yellow pigment, orpiment, on purple-stained vellum, corresponding to Stephen's description of Wilfrid's book.[84] Both the Lindisfarne Gospels and the Codex Amiatinus are Northumbrian manuscripts, produced at about the same time. Yet their difference in appearance demonstrates that versions of Christianity could vary not only from region to region but also within each region. Both Lindisfarne and Amiatinus are Northumbrian things, but they speak of and to

different Northumbrias, of and to conflicting micro-Christendoms. The gold lettering on purple pages described in the *Life of Wilfrid* is in keeping with his Romanising interests during his brief leadership of Lindisfarne. Such decoration offers a striking contrast to the zoomorphic interlace and Germanic metalwork effects evident in the Lindisfarne Gospels. And so the textual allusion to Wilfrid's Gospels, and the extant parallels, encourage us to recognise that, although the Lindisfarne Gospels are distinctly Northumbrian, they are a restricted and restricting version of Northumbria. Wilfrid's Gospels show that, even within the higher echelons of society, other Northumbrias could and did exist, with the capability of producing different kinds of material things.

A portable assembly: the relics of St Cuthbert across time

Following Viking raids on the island in 875, the bodily remains and associated relics of St Cuthbert would not only accompany the Lindisfarne community on its wanderings around northern England but actively dictate the course of their travels – as when St Cuthbert's gospel book leapt overboard before the community could cross to Ireland, redirecting them, and then emerging miraculously undamaged by the water, its pages incorrupt, like the body of the saint. What was more, the persistent presence of the saint's corpse helped to ease the uprooting of the community from Lindisfarne by gathering other things – body parts and artefacts that evoked memories of the past – into its sacred space. Indeed, the saint's coffin would come to house an assemblage of disparate relics, both human and nonhuman, from a gospel book and pectoral cross to the head of King Oswald and the bones of Bede. Across space and time, the body continued to act as a portable assembly, with the magnetic ability to draw the living towards it – pilgrims in search of healing and felons in need of sanctuary, priests offering worship and kings seeking favour – while also acting as a sort of force field, barring and excluding others – notably, women were later excluded from this sacred space in twelfth-century Durham.

For it was in Durham that the community of Cuthbert would finally cease their wanderings and establish a new home. And it was in Durham, in 1104, as the new Anglo-Norman cathedral was being built, that the monks would open the coffin up once more, inspect the body of St Cuthbert, and find it to be incorrupt, looking as if asleep, giving off sweet smells, the bones solid, the flesh soft, the limbs still bendy. On the one hand, the tangible realness

of the body allowed those monks to reach backwards through time and perceive the historic seventh-century past. On the other hand, the incorruptible body, by dint of not displaying the passage of time, allowed multiple temporalities to coexist. Perpetually poised between life and death, activity and slumber, St Cuthbert could carry the past into the present – his still incorrupt corpse forever fixed in a former time yet, quite literally, flexible enough to endure into the future.

Notes

1 Michelle Brown, *The Lindisfarne Gospels*, pp. 34–5. The 'Celtic' tradition refers to the Irish-oriented Columban monasticism that combined spiritual retreat with pastoral outreach, first established at Lindisfarne under Bishop Aidan; the 'new order' opted for by King Oswy at Whitby sought a more unified English Church displaying greater conformity to Rome.

2 Michel Serres, *The Natural Contract*, trans. Elizabeth MacArthur and William Paulson (Ann Arbor: University of Michigan Press, 2001). See also Vin Nardizzi, 'Remembering Premodern Environs', in Jeffrey Jerome Cohen and Julian Yates (eds), *Object Oriented Environs* (Earth: Punctum Books, 2016), pp. 179–83.

3 Sherry Turkle (ed.), *Evocative Objects: Things We Think With* (Cambridge, MA: MIT Press, 2007).

4 For a general overview, see James Paz, 'Lindisfarne Gospels', in Siân Echard and Robert Rouse (eds), *Wiley-Blackwell Encyclopaedia of British Medieval Literature* (Oxford: Wiley-Blackwell, forthcoming).

5 I follow Ingold by refusing to make a sharp division between landscape and artefacts. See Ingold, *Being Alive*, pp. 20–2. He also insists here that the human body partakes of the material world, along with all the diverse forms of animal, plant, fungal and bacterial life.

6 Turkle (ed.), *Evocative Objects*, pp. 3–10.

7 For further discussion of the historical contexts and the relationship between the *Lives of St Cuthbert* in form and content, see B. Colgrave (ed. and trans.), *Two Lives of Cuthbert* (Cambridge: Cambridge University Press, 1940), pp. 1–5.

8 Julia M. H. Smith, *Europe after Rome: A New Cultural History 500–1000* (Oxford: Oxford University Press, 2005), pp. 223–4.

9 Clare A. Lees makes this point in *Tradition and Belief: Religious Writing in Late Anglo-Saxon England* (Minneapolis, MN: University of Minnesota Press, 1999), especially ch. 4.

10 Brown, *Rise of Western Christendom*, pp. 355–9.

11 Benedicta Ward, SLG, 'The Spirituality of St Cuthbert', in Gerald Bonner, David Rollason and Clare Stancliffe (eds), *St Cuthbert,*

His Cult and Community (Woodbridge: Boydell and Brewer, 1989), pp. 65–76, at 65.

12 Colgrave (ed.), *Two Lives of Cuthbert*, p. 4.

13 References to the anonymous *Life* are taken from Colgrave (ed.), *Two Lives of Cuthbert*, pp. 59–139.

14 Elaine Scarry, *The Body in Pain* (Oxford: Oxford University Press, 1985), pp. 200, 209.

15 Ibid., p. 212.

16 Ibid., p. 213.

17 Ibid.

18 The anonymous *Life* does not actually refer to the freezing coldness of the North Sea, other than to say that the sea animals warmed the saint's feet with their breath. Yet this coldness may be easily evoked for the modern reader; I invite you to visit the north-east coast of Britain.

19 Scarry, *The Body in Pain*, p. 217.

20 Alan Thacker, 'Lindisfarne and the Origins of the Cult of St Cuthbert', in Bonner, Rollason and Stancliffe (eds), *St Cuthbert, His Cult and Community*, pp. 103–22, at 112.

21 Clare Stancliffe, 'Red, White and Blue Martyrdom', in Dorothy Whitelock, Rosamond McKitterick and David Dumville (eds), *Ireland in Early Mediaeval Europe: Studies in Memory of Kathleen Hughes* (Cambridge: Cambridge University Press, 1982), pp. 21–46, at 29.

22 Ibid., p. 41.

23 Alfred K. Siewers, *Strange Beauty: Ecocritical Approaches to Early Medieval Landscape* (New York: Palgrave, 2009), p. 97.

24 Stancliffe, 'Red, White and Blue Martyrdom', p. 28.

25 Siewers, *Strange Beauty*, p. 97.

26 References to Bede's prose *Life of St Cuthbert* are taken from Colgrave (ed.), *Two Lives of Cuthbert*, pp. 141–307.

27 The anonymous writer of the first *Life* was indeed influenced by Evagrius' translation of Athanasius' *Life of St Antony*; see Colgrave's introduction to the *Two Lives*, p. 11.

28 David W. Rollason, *Saints and Relics in Anglo-Saxon England* (Oxford: Blackwell, 1989), p. 97.

29 Clare A. Lees and Gillian R. Overing (eds), *A Place to Believe in: Locating Medieval Landscapes* (University Park, PA: Penn State University Press, 2006), p. 19.

30 Brown, *Rise of Western Christendom*, pp. 359–60.

31 Ibid., pp. 360–1.

32 Brown, *The Lindisfarne Gospels*, p. 34.

33 Ibid.

34 Thacker, 'Lindisfarne and the Origins of the Cult of St Cuthbert', p. 119.

35 Brown, *Lindisfarne Gospels*, p. 34.

36 Thacker, 'Lindisfarne and the Origins of the Cult of St Cuthbert', p. 121.

37 See Thacker, 'Origins of the Cult of St Cuthbert', p. 119, and Brown, *Lindisfarne Gospels*, pp. 64–5.

38 For dating see Walter Berschin, 'Opus deliberatum ac perfectum: Why Did the Venerable Bede Write a Second Prose Life of St Cuthbert?', in Bonner, Rollason and Stancliffe (eds), *St Cuthbert, His Cult and Community*, pp. 95–102, at 95.

39 Colgrave (ed.), *Two Lives of Cuthbert*, p. 4.

40 Thacker, 'Lindisfarne and the Origins of the Cult of St Cuthbert', p. 120.

41 Ibid.

42 Scarry, *The Body in Pain*, p. 14.

43 Turkle (ed.), *Evocative Objects*, pp. 5–10.

44 See Bede, *Ecclesiastical History*, III.24, IV.26, ed. Colgrave and Mynors.

45 J. F. Webb, in his translation of Bede, renders it simply as 'cloth'; but according to Campbell it is sometimes translated as 'muslin'.

46 J. Campbell, 'Elements in the Background to the Life of St Cuthbert and his Early Cult', in Bonner, Rollason and Stancliffe (eds), *St Cuthbert, His Cult and Community*, pp. 3–19, at 17.

47 Thacker, 'Lindisfarne and the Origins of the Cult of St Cuthbert', p. 105.

48 See Dr James Raine's description in *St Cuthbert, with an Account of the State in which his Remains were found upon the Opening of his Tomb in Durham Cathedral, in the year 1827* (Durham, 1828), p. 211.

49 Elizabeth Coatsworth, 'The Pectoral Cross and Portable Altar from the Tomb of St Cuthbert', in Bonner, Rollason and Stancliffe (eds), *St Cuthbert, His Cult and Community*, pp. 287–301, at 295, 296.

50 Ibid., p. 293.

51 To view the illuminated pages of the Lindisfarne Gospels in detail, visit www.bl.uk/onlinegallery/features/lindisfarne/ttp.html.

52 Brown, *Lindisfarne Gospels*, p. 200.

53 Christopher de Hamel, *Medieval Craftsmen: Scribes and Illuminators* (London: British Museum Press, 1992), p. 8.

54 Brown, *Lindisfarne Gospels*, p. 201.

55 Ingold, *Being Alive*, pp. 24–6.

56 Niles proposes that 'gospel book' is a more apt and precise solution to this riddle than 'book' or 'bible' in *Old English Enigmatic Poems*, pp. 117–19.

57 Description by Jane Hawkes, 'The Lindisfarne Gospels', in Tim Ayers (ed.), *The History of British Art: 600–1600* (London: Tate Publishing, 2008), pp. 198–9.

58 Brown, *Lindisfarne Gospels*, pp. 280–1. Details of the Raman laser project are provided in the appendix, pp. 430–51.

59 Aldred's colophon may be viewed via the British Library's online gallery at www.bl.uk/onlinegallery/ttp/lindisfarne/accessible/pages31and32. html. Transcription and translation provided in Brown, *Lindisfarne Gospels*, pp. 102–4.

60 Michelle Brown, 'The Lindisfarne Scriptorium from the Late Seventh to the Early Ninth Century', in Bonner, Rollason and Stancliffe (eds), *St Cuthbert, His Cult and Community*, pp. 151–63, at 154.

61 Brown, *The Lindisfarne Gospels*, pp. 106–9.

62 Ibid., p. 4.

63 Cassiodorus, *De institutione divinarum litterarum*, ch. 30; see A. Fridh (ed.), *Magni Aurelii Cassiodori variarum libri XII*, Corpus Christianorum Series Latina 96 (Turnhout: Brepolis, 1973).

64 Brown, *The Lindisfarne Gospels*, p. 8.

65 See Michael Camille, *Image on the Edge: The Margins of Medieval Art* (London: Reaktion, 1992), p. 18.

66 Brown, *The Lindisfarne Gospels*, p. 324.

67 See www.bl.uk/onlinegallery/ttp/lindisfarne/accessible/pages11and12. html.

68 Orton and Wood with Lees, *Fragments of History*, p. 172; and see also Bede, *Ecclesiastical History*, III.2, ed. Colgrave and Mynors.

69 Janet Backhouse, 'Birds, Beasts and Initials in Lindisfarne's Gospel Books', in Bonner, Rollason and Stancliffe (eds), *St Cuthbert, His Cult and Community*, pp. 166–7.

70 See Brown, *The Lindisfarne Gospels*, p. 328.

71 As discussed by Janet Backhouse in 'Birds, Beasts and Initials', p. 169.

72 See Hawkes, 'The Lindisfarne Gospels', p. 198.

73 David A. Hinton, 'Anglo-Saxon Smiths and Myths', *Bulletin of the John Rylands Library*, 80:1 (1998), 3–22, at 17.

74 J. Campbell, 'Elements in the Background to the Life of St Cuthbert and his Early Cult', p. 9.

75 Brown, *The Lindisfarne Gospels*, p. 307.

76 Smith, *Europe after Rome*, pp. 213–14.

77 Brown, *The Lindisfarne Gospels*, p. 383.

78 Ibid., p. 380.

79 See David Hall, 'The Sanctuary of St Cuthbert', in Bonner, Rollason and Stancliffe (eds), *St Cuthbert, His Cult and Community*, pp. 425, 426, 436.

80 Thacker, 'Origins of the Cult of St Cuthbert', p. 109.

81 Hawkes, 'The Lindisfarne Gospels', p. 199.

82 Rollason, *Saints and Relics*, p. 113.

83 See Stephen of Ripon, *Life of Wilfrid*, ch. XVII.

84 Richard Marsden provides a description of Codex Amiatinus in *The Text of the Old Testament in Anglo-Saxon England* (Cambridge: Cambridge University Press, 1995), pp. 108–23.

5

The Dream of the Rood and the Ruthwell monument: Fragility, brokenness and failure

In this fifth and final chapter, I want to pay attention to the other side of assemblage – that is, the way that things break up and break away. The poem (or poems) usually referred to as *The Dream of the Rood* is a fragile thing that has been, and in a sense asks to be, broken apart and pieced back together time and again. It is not a coherent whole, in any of its forms, but an elusive assortment – at once breakage and assemblage – that invites us to participate in its ongoing process of becoming.

I will start by closely analysing the poem as it exists in the Vercelli Book manuscript, carrying out a reading of the text in light of thing theory, looking at how the various things represented in the poem (tree, beam, beacon, gallows, rood, body) transform one another, but how they also shift and shape the human 'dreamer' as he speaks his vision. I will acknowledge the riddle-like nature of this poem yet contend that this is nevertheless a riddle without a solution. This point is crucial because it is their resistance to objectification that imbues these items with thing-power. They will not be resolved and therefore dissolved, but go on breaking, failing, merging, re-emerging and reanimating themselves. Although we are dealing with marred or disused materials here (an uprooted tree, a stained cross, a discarded gallows, a bloodied, buried body) these things are associated through their fragile but changeable nature; they gain an agency beyond their original 'usefulness' and form a vibrant, self-altering assemblage.

In discussing the 'agency of assemblages' Bennett has highlighted the fact that in any congregation or meshwork there is a 'friction and violence between parts' so that assemblages are 'living, throbbing confederations that are able to function despite the persistent presence of energies that confound them from within'.[1] As such, when looking at how things are assembled in a poem like *The Dream*, we need to attend not only to the way in which the bits

and pieces come together but to how they suffer wounding, damage, breakage, but then seek new encounters to creatively compensate for these alterations. A fragile tree is torn from its roots, but instead of dying gains voice and agency as the killer of Christ; the body of Christ becomes lifeless but the blood of his death unites flesh and wood, human and rood, and gives both broken, disused things a new vibrancy. Human beings are entangled with this kind of thingness and so the dreamer is afflicted and altered by the things he sees, hears and speaks, and is ultimately rendered an inert but talking thing – spiritually and verbally active but physically passive and dependent. While the dreamer becomes a voice-bearer (OE *reordberend*), speech is not the means by which human subjects master objects in this poem. Rather, it is voice that links the human and nonhuman participants in this assembly together. Speech is like the connective tissue that binds one thing to another. Thus, the dreamer does not solve the riddle by speaking it but becomes part of it, does not name the 'Cross' with his voice but is united with the multivalent *treow-beam-gealga-rod* as part of an assemblage.

The second part of the chapter will explore the connections, and tensions, between a late tenth-century manuscript poem and a rune-inscribed stone sculpture from the eighth century: *The Dream of the Rood* and the Ruthwell monument. It has been difficult to keep these two things together in a sustained and meaningful way and yet it has been almost impossible to break them apart. As much as they have been drawn to each other across time and space, they have repeatedly asserted their own individual thingness. The fragility, brokenness and failure that runs through this meeting offers another, more thematic, way of understanding the relation between *The Dream of the Rood* and the runic poem on the Ruthwell monument. Acknowledging their resistance to straightforward unification gives us a way of speaking about the two together without forcing them to be the same – providing a means of talking about these things without eroding their autonomy. What kind of encounter does the Ruthwell monument offer us and how is this experience like or unlike that offered by *The Dream* in the Vercelli Book manuscript? Following the work of Fred Orton, I will argue that the Ruthwell monument is a thing of tension and paradox, at once beautiful and ugly, balanced and broken, fragile and enduring.[2] What I would add is the observation that sometimes this paradoxical quality results from the intentions of the monument's makers, but sometimes it is accidental; and most of the time we are witnessing a collaboration, or maybe tussle, between human

and nonhuman forces. The agency of this monument comes from its resistance to human knowledge. It makes us think it is a certain kind of thing only to then break or fail to act as that thing. Part of this thing-power comes from the very *stoniness* of the monument: although stone may seem still, silent and solid to human observers, this material actually has a vibrancy of its own, a life story that has shaped and will shape our experience of that which we call the Ruthwell monument. As the stone moves and changes across the ages, will it one day cease to function as a monument, let alone a cross, altogether? And will it not break further and further away from the manuscript poem until no one can remember why these two things were put together in the first place?

The things in the Vercelli Book

It has long been acknowledged that *The Dream of the Rood* draws on the style and language of riddling found elsewhere in Old English literature. Michael Swanton, who produced an authoritative edition of the poem in 1970, was one of many critics to point out that a literary precedent for this mode 'existed in the popular type of Anglo-Saxon riddle in which an enigmatic object is made to describe itself in oblique terms, sometimes telling its history'.[3] More recently, Patrick Murphy notes how the language of riddling overlaps with the language of dreaming in the poem, pointing to the wonders of dreams, their shifting images and paradoxes, and their traditional need for riddle-like interpretation. Interestingly, Murphy argues that riddles, dreams and other literary forms closely associated with them in medieval manuscripts (like proverbs and fables) embody a 'sense of failure' insofar as their moral resolutions often fail to satisfy us. There is a friction between proposition and solution, and the unknown never completely fits into the known.[4]

Indeed, in Chapter 2, I demonstrated the logic of *not* always answering or solving the identities of the speakers in Old English riddles. To name the thing is to objectify it and rob it of its enigmatic power. There is more to a riddle than its solution; a thing always exceeds the name we give it. The same contention applies to *The Dream of the Rood*. While the poem may invite us to find a theological truth among its visual and verbal layers, this is not the same as asking us to name and identify a single object. We need not even read the text against the grain here, for unlike some of the Exeter Book riddles, *The Dream* does not at any stage tell us to say what it is called. I especially want to avoid the notion

that the answer to this riddle is: the Cross. As I will show, there is no monolithic 'Cross' standing behind or beneath the alternating *treow-beam-gealga-rod*. Rather, we are at once dealing with one shapeshifting thing and with many different things criss-crossing into one another. What these things have in common is their fragility, their brokenness. And, as a result of this fragile brokenness, they hold a creative and transformative potential. The human body, and voice, is enmeshed in this process of breakage and alteration. Therefore, the things in *The Dream* have the power to shift and shape that which we call 'human'.

The poem is riddle-like from the outset, with the first twenty-seven lines depicting the dreamer's vision of some mysterious sight that is continuously altering its appearance. This passage does not lead us to any resolution but moves back and forth, back and forth, presenting us with a meshwork of things breaking open, spilling over and bleeding into other things. In the midst of this, the dreamer also receives glimpses of body parts, emphasising the fact that human beings are also caught up in this process. Drawing upon the third-person descriptive riddling mode, and the common riddle formula *ic seah*, the dreamer opens by exclaiming:

> Þuhte me þæt ic gesawe syllicre treow
> on lyft lædan, leohte bewunden,
> beama beorhtost.

> [It seemed to me that I saw a wondrous tree, raised into the air, wound round with light, the brightest of beams] (4–6a)[5]

What is more, 'Eall þæt beacen wæs / begoten mid golde' [that beacon was all drenched with gold] (6–7). *Begoten*, past participle of *begeotan* ('to pour over' or 'to sprinkle, anoint, drench, cover'), has the sense of water or even blood and evokes images of bodily fluids.[6] To drench or cover with gold seems better suited to the adornment of a relic than a mere tree or beam. Yet this tree is also a *beacen*, a word which has retained in modern English its double sense of flaming brand and abstract sign, suggesting both materiality and immateriality. Along with the dreamer, we are gazing at a 'sigebeam' [victory-beam] (13) and are reminded 'ne wæs ðær huru fracodes gealga' [that was no felon's gallows] (10). Of course, the denial itself evokes images of human suffering and death – of a wooden beam on which bodies become corpses, where animate subject is transformed into inanimate object. In these lines, then, the sight seen by the dreamer is multivalent: a tree soaked with gold, a beam which is not a gallows, burning wood and shining symbol.

These things are also a human body. The dreamer says that 'Gimmas stodon / fægere æt foldan sceatum, swylce þær fife wæron / uppe on þam eaxlegespanne' [Gems stood beautifully at the corners of the earth, even as there were five upon the shoulder-span] (7–9). The symbolic, universal aspect of this 'beam' is once more depicted here, as it extends across the world and quarters the universe and is beheld by 'halige gastas, / men ofer moldan, and eall þeos mære gesceaft' [holy spirits, men over the earth, and all this fair creation] (11–12). This abstract quality is juxtaposed with a physical dimension. The word used for the crossbeam is *eaxlegespanne*, where *eaxle-* means 'shoulder', a word echoed later on with 'bæron me þær beornas on eaxlum' [the warriors bore me there upon their shoulders] (32). This line not only reveals that the *treow* is cross-shaped but that it has shoulders like the *beornas* that once carried it to the mound of Calvary, while the embodied Christ himself is later described as 'se beorn' (42). The five gems that adorn the crossbeam symbolise the five wounds of Christ and again connect wooden beam with fleshy body. The blood that flows from its right side ('hit ærest ongan swætan on þa swiðran healfe') (19–20) further identifies this thing as a body, while OE *swætan* could be translated as both 'to bleed' and 'to sweat' and has a dual quality as both blood and water, with simultaneous connotations of battle and baptism, death and life, whereby 'the Church, symbol-ized by the water of baptism and the blood of the Eucharist, was born from the wound in Christ's right side'.[7]

Visually, there are little clues in this opening passage that what-ever the dreamer was gazing at had a cross-shape and cross-like qualities. Yet the image does not remain still long enough to be fixed in this way. To the contrary, what is most striking about this vision, and what gives the thing its ongoing transformative power, is its fragility, its woundedness and dyingness. The dreamer says 'Hwæðre ic þurh þæt gold ongytan meahte / earmra ærgewin, þæt hit ærest ongan / swætan on þa swiðran healfe' [Yet I could per-ceive through that gold the ancient strife of wretched ones, when it first began to bleed on the right side] (18–20). It is the gush-ing battle-sweat, that blend of blood and water, which hints at a long history and suggests that this thing has the ability to move and change through time. The word *ærgewin* ('former struggle' or 'ancient strife') conveys a sense of ancientness and yet the dreamer only sees and recognises this bygone event as the thing *ærest* began to bleed on the right side. Even as the tree or beam seems about to perish in the here and now, it paradoxically displays its ability to

span vast leaps of time and to carry the ancient strife of the past into the present. Rather than signalling its uselessness or obsolescence, the damage done to this thing endows it with the power to continuously alter itself into something new and beautiful: 'hwilum hit wæs mid wætan bestemed, / beswyled mid swates gange, hwilum mid since gegyrwed' [at times it was wet with moisture, soaked with flowing sweat, at times adorned with treasure] (22–3).

The thing or things seen by the dreamer cannot be objectified verbally, either. That the Cross is not the answer to what we are seeing and hearing, that the various fragile, breaking and changing things we encounter cannot be dissolved into this solitary object, is borne out by the fact that the poem does not, at any point, use the Latin term *crux*, or the Old English equivalent *cruc* (sign or shape of the cross). While *crux/cruc* is verbally absent from the text, we do have references to the *rod*. Given that *The Dream of the Rood* was the title bestowed on the poem in the nineteenth century, we may assume that the earliest scholars of this text privileged *rod* as the primary object with which this piece is concerned. But *rod* is not mentioned until line 44 of the Old English poem, after the thing has already been called a *treow, beam, sigebeam, gealga, beacen*; and it will go on to be called, and to call itself, these names again. The fact that the word *rod* is mentioned at all indicates that *rod* is not the sole solution to this riddle. Rather than comparing *The Dream* to those Exeter Book riddles that ask us to say what they are called, we might be better off comparing it to, say, Riddle 47, which announces itself as both a *moððe* and *wyrm* outright, not asking us to solve it but to reflect on its role and how we, as human readers, relate to it. Another apt parallel is Riddle 30a, which can be solved with a single word (OE *beam*) but whose spoken solution embraces everything from tree to log to ship to rood, underscoring the difficulty of trying to capture things within a verbal cage. Similar processes are at play in *The Dream*. We, like the dreamer, cannot satisfactorily name, know or control what we are seeing and hearing and speaking. What is our task, then?

In her work on the political ecology of things, Bennett asks a set of questions that are pertinent here: What method could possibly be appropriate for the task of speaking a word for vibrant matter? How to describe without thereby erasing the independence of things? How to acknowledge the obscure but ubiquitous intensity of impersonal affect? For Bennett, what is needed is a 'cultivated, patient, sensory attentiveness to nonhuman forces operating outside and inside the human body'. Indeed, without 'proficiency

in this countercultural kind of perceiving, the world appears as if it consists only of active human subjects who confront passive objects'. It is our task to defy this kind of action-oriented perception and allow ourselves to be caught up in things and their effects.[8] Such an approach need not be 'applied' to *The Dream of the Rood*. It appears to be there already, embedded in the poem. The opening passage invites us to look and listen attentively to the transformations affected by fragile things and to reflect on our own, human, enmeshment with those transformations. The role we adopt as readers is one of patient, partially passive, perceptiveness, and the dreamer who mediates this poem for us sets an example. By the close of the initial passage, he is lying down and looking on as the *fuse beacen* (that is, 'eager' or 'lively' beacon) shimmers and shifts its shape: 'Hwæðre ic þær licgende lange hwile / beheold hreowcearig hælendes treow' [However, lying there a long while, I beheld, sorrowful in spirit, the saviour's tree] (24–5). While the thing dynamically affects change within itself, and within the human body, the dreamer simply watches and waits – a far cry from the human agent who actively organises and categorises objects. The dreamer says that he remained lying there for a long while 'oððæt ic gehyrde þæt hit hleoðrode' [until I heard that it spoke] (26). How to speak a word for things, to describe them without erasing their independence? In *The Dream*, this works the other way around. Things speak a word for us. We are not being asked to say what the thing is called at the close of this riddle-like section, but to lie back and hear it speak. Once more the dreamer shows the way, not so much speaking for things, but allowing the *wudu selesta* to possess his voice and speak through him. In the written, poetic form taken by *The Dream*, we do appear to receive the tree's words via the voice of the dreamer. Yet whereas modern editions have a habit of separating lines 28–121 out with quotation marks, the Vercelli Book manuscript does not follow this convention, furthering the sense that two voices (human and nonhuman) are merging into one here, making it difficult to frame or contain one within the other.

Now the poem shifts from the third-person descriptive mode of riddling ('ic seah', 'ic gefrægn') to the first-person mode ('ic eom', 'ic wæs'). When the *wudu selesta* does begin to talk, it moves into a more historical, narrative style than that of the opening shapeshifting vision. Nonetheless, the story told by the talking tree is similarly one in which a series of fragile things break, suffer, die, but then come together and reinvigorate one another – even if this

occurs in a more sequential and linear manner than in the previous passage. Accordingly, the first event that the tree relates is a violent cutting off of life:

> Þæt wæs geara iu, (ic þæt gyta geman)
> þæt ic wæs aheawen holtes on ende,
> astyred of stefne minum. (28–30a)

[That was a long time ago (I remember it yet) when I was hewn down at the wood's edge, removed from my roots]

Here, the speaker is hacked down at the end of the wood and borne away from its forest home. The living tree is thereby turned into an inanimate beam of wood. Paradoxically, however, it is in this very moment that the tree is imbued with new life and the ability to become something else.

The tree claims that it was 'aheawen holtes on ende'. According to the TDOE entry for *aheawan*, the verb was used by Old English writers to describe the cutting down of trees, the cutting up of wood, but also the cutting or hacking off of body parts and the cutting down of entire nations. While these acts of 'cutting' imply pain or even death, a tree that is cut near the roots (i.e. coppiced) remains alive – in the same way that a person deprived of a limb can remain alive – and responds by growing new shoots. The memory of this experience seems not to belong to the living stump left behind, but to the timber that is carried away from the copse's edge and transformed into a gallows. In line 30, the speaker recalls how it was 'astyred of stefne minum'. This is usually translated into modern English as 'removed from my roots' or similar. Yet there is another way in which line 30 may be translated and interpreted, in keeping with my argument that the tree actually gains renewed life and vibrancy in its moment of suffering and death. OE *stefn* can be translated as 'root' or 'stem' but the same word also means 'voice' or 'sound uttered by the mouth'. We already know that the poet responsible for *The Dream* has a tendency to play with homophones: the word for tree (*treow*) in line 4, for example, may recall *treow*: 'truth', 'faith' or 'pledge'. There is good reason to think that another pun is at work in line 30. We read or speak *stefn* as 'roots' but might also hear 'voice' and reflect on the thing's ability to talk. After all, it is the tree itself speaking these lines. With this in mind, it does not necessarily work to translate the line as 'removed from' or 'deprived of my voice'. *Astyred* is the past participle of *astirian*, which may be translated as to 'remove' but, alternatively, as to

'move', 'stir', 'rouse' or 'excite'. A different translation of lines 28–
30 can be offered:

> Þæt wæs geara iu, (ic þæt gyta geman)
> þæt ic wæs aheawen holtes on ende,
> astyred of stefne minum. (28–30a)

[That was a long time ago (I remember it yet) when I was hewn
down at the wood's edge, stirred up in my speech]

And so, while these lines initially seem to be a simple descrip-
tion of the tree's violent separation from its roots in the forest, the
poem is evidently hinting at another consequence of this action,
one perhaps unintended by the *feondas* who have carried out this
attack: for even as the living tree is cut down, it suddenly finds its
voice; its speech has been stirred or roused. Destruction, damage,
even death, can make things talkative in this poem.

In becoming something else, the living-tree-turned-dead-beam
does not only gain a voice but a renewed agency and even auton-
omy. At first, the speaker plays the role of inert object, remaining
passive while its enemies seize it, carry it, set it down, fasten it in
place and simply manhandle it:

> Genaman me ðær strange feondas,
> geworhton him þær to wæfersyne, heton me heora wergas hebban.
> Bæron me ðær beornas on eaxlum, oððæt hie me on beorg asetton,
> gefæstnodon me þær feondas genoge. (30b–33a)

[Strong enemies seized me there, made me into a spectacle, com-
manded me to raise up criminals. Men carried me there on their
shoulders, until they set me down on a hill. The many fiends fas-
tened me there.]

On a formal level, this section is quite different to the series of
rapid, short half-line units of the opening vision, where different
images were contrasted, progressing swiftly from paradox to para-
dox. Conversely, lines 30–3 are hypermetric, deploying extra syl-
lables to widen the gaps between the alliterative *w*, *b* and *f* sounds
and introduce a slower, broader, more reflective tone as the tree
starts to speak, imbuing that nonhuman voice with the dignity and
gravity of one who has witnessed something remarkable long ago.

However, as the tree watches the *frean mancynnes* hasten towards
it, the verse quickens once more and the speaker suddenly takes on
a form of thing-power, abruptly developing autonomy, the voli-
tion and determination to obey Christ, stand firm and not kill

the 'fiends' despite a full awareness that it could, if it wanted, do exactly that:

Þær ic þa ne dorste ofer dryhtnes word
bugan oððe berstan, þa ic bifian geseah
eorðan sceatas. Ealle ic mihte
feondas gefyllan, hwæðre ic fæste stod. (35–8)

[There, I dared not, against the lord's word, bow down or break, when I saw earth's surfaces shake. I might have flattened the fiends entirely, yet I stood fast.]

Like many of the speaking objects found across Anglo-Saxon literature and material culture, the nonhuman voice creates a 'passive yet powerful' impression upon us, possessing a wondrous agency that is active and potent but also in keeping with its own properties as an artefact.[9] It is as if the thing has had a moment of epiphany, realising that by no longer functioning as a growing tree it can now assume a new role and act as a deadly weapon – or choose not to. As well as triggering talkativeness, the brokenness of this thing has become the source of its new potency.

The gallows expresses its new found willpower and potential to cause harm, but alongside the young hero (*geong hæleð*) who is hastening, stripping himself off, climbing or mounting, clasping and so on, the thing does come across as rather rigid. And yet what may begin as an ontological contrast soon turns into a union, a merging of human and nonhuman, active body and inactive artefact, as the two beings fuse together. This union is initiated by Christ, who embraces the speaking gallows, causing it to tremble: 'Bifode ic þa me se beorn ymbclypte' [I shook when the warrior embraced me] (42). The gallows relates how it dared not fall to the earth and this is followed by line 44a, in which the *gealga* is transformed, raised up as the *rod*. As mentioned, this is the first time that the word *rod* is used in the text. Nevertheless, this is clearly not the ultimate answer, or resolution, to the poem; the *rod* is simply another incarnation of the same speaker, who has shifted from *treow* to *gealga* to *rod*. By merging with the lively body of Christ, the speaker can re-emerge as yet another kind of thing. In this moment of togetherness, that active and animate body pours its life force into the rood, so that by line 44b there is a sudden change in roles. It is now the rood that is acting, the rood doing the moving, the rood that physically lifts or heaves up the body of a powerful, but now inert, king: 'Rod wæs ic aræred. Ahof ic ricne

cyning, / heofona hlaford' [I was raised as a rood. I lifted a mighty king, the lord of heaven] (44–5a).

It is a striking image of wounding and breakage that reinforces the fusion between wood and flesh: 'Þurhdrifan hi me mid deorcan næglum; on me syndon þa dolg gesiene, / opene inwidhlemmas' [They drove dark nails through me; the scars can still be seen on me, gaping evil gashes] (46–7). The speaking rood itself recognises that this is the action, this driving through of dark nails, this opening up of holes or wounds, which actually has the adverse effect of connecting or assembling one thing with another; for here the rood shifts from the first-person singular ('ic' and 'me') to the dual pronoun ('unc'). Indeed, in line 48 the speaker is at pains to emphasise and intensify this moment of togetherness: 'Bysmeredon hie unc butu ætgædere' [They degraded us both together]. The body of Christ, which had been so animated moments before, is lifeless. Yet, as it departs, the wounded, battered, bloodied corpse leaves traces of its death behind on the rood. 'On me syndon þa dolg gesiene, opene inwidhlemmas' the talking thing says in line 46b, and then in 48: 'Eall ic wæs mid blode bestemed, / begoten of þæs guman sidan, siððan he hæfde his gast onsended' [I was entirely wet with blood, pouring out from the man's side, after he had sent forth his spirit]. Both statements serve to remind us of the lively, vibrant thing of the opening vision, showing that signs of fragility and death have become signs of renewed agency, of a thing that still shifts and shimmers and speaks in the here and now of the poem.

Where the first use of the OE word *rod* (44) in the poem signified the merging of gallows and body, wood and flesh, and thus the re-emergence of a new kind of thing, the second use of the word (line 56) underscores the inertia of the broken and defeated corpse:

> Geseah ic weruda god
> þearle þenian. Þystro hæfdon
> bewrigen mid wolcnum wealdendes hræw,
> scirne sciman, sceadu forð eode,
> wann under wolcnum. Weop eal gesceaft,
> cwiððon cyninges fyll. Crist wæs on rode. (51b–56)

[I saw the god of hosts terribly tortured. Darkness had covered the king's corpse, clearly shining, with clouds. A shadow went forth, dim under the sky. All creation wept, cried for the king's fall. Christ was on the cross.]

The simple line 'Crist wæs on rode' testifies to the gallows' success-ful slaying of its lord, but it also heralds the instant when the *geong hæleð* or *ricne cyning* is no longer a human body and has instead merged with and morphed into the *rod*. In the next lines, we are told how the lifeless *limwerigne* corpse is taken down from the gal-lows. All heat and energy and blood flow has fled from it: 'Hræw colode, / fæger feorgbold' [The corpse cooled, the fair life-house] (72–3). The speaking thing goes on to relate its burial and resur-rection in a very succinct three lines: 'Bedealf us man on deopan seaþe. Hwæðre me þær dryhtnes þegnas, / freondas gefrunon, / gyredon me golde ond seolfre' [They buried us in a deep pit. But the lord's friends and retainers found out where I was, adorned me with gold and silver] (75–7). Curiously, no mention is made here of Christ's physical resurrection. His animate-body-turned-inanimate-corpse simply vanishes from the poem at this point and it is instead the rood that is dug up and decked out in gold and silver. And so, although the embodied Christ comes across as active – hyperactive, perhaps – when he first appears on the scene, the actions of that body are all crowded into a mere eleven lines (33–43) before it is abruptly deprived of its animacy. From lines 44 to 72, the corpse is predominantly described in passive terms, as it is raised, mocked, tortured, taken down, laid down, buried – and then it cools and vanishes from sight and sound. This has the effect of making embodied human life seem swift and short: we are excessively animate and active for a time; but only for a brief, transient time when compared to the enduring lifespan of other things in this poem.

Several breaks in time do occur throughout *The Dream*. It opens with what must have been a relatively recent event: the *swefna cyst* that came to the dreamer in the middle of the night. Although recounted in the past tense ('Þuhte me þæt ic gesawe ...') the dream is recent enough for the dreamer to be able to recall its visual and verbal content very clearly, so that it remains within the bounds of living human memory. Yet when the speaking tree takes over, it leaps back into the much more distant, historical past ('Þæt wæs geara iu ...'). The series of events that the tree goes on to relate are again within the bounds of memory ('ic þæt gyta geman ...'). This is no longer human memory, however, but nonhuman memory. Towards the end of its speech, the talking thing brings us fur-ther forward in time, to the day when *dryhtnes þegnas* uncovered it and adorned it with gold and silver (75–7). Another break in time occurs straight afterwards, when the rood addresses the dreamer in

the present tense: 'Nu ðu miht gehyran, hæleð min se leofa' [Now you might understand, my beloved hero] (78). Pasternack points out that all the sentences between 78 and 121 'make connections – either typological ones between historical events, analogical ones between historical event and Judgement Day or between contemporary man and Judgement Day, or tropological ones between historical event and contemporary man'.[10] It is the nonhuman, speaking thing making these connections (line 121 is where its speech finishes). It is the nonhuman tree-gallows-rood whose lifespan and perspective is stretchy and spacious enough to encompass the distant past, the present and the far future; the listening human is unable to make such vast temporal leaps without its help.

Human voices and bodies fade in and out of the poem's fractured time frames. The dreamer speaks within the present of the poem, relating his vision in the opening and expressing hope for eternal life towards the end; but when the poem details distant historical events, it is the voice of the tree that does the remembering and narrating. Christ is embodied in human form in that historical past, but only makes an appearance in the present of the poem through the shapeshifting beam that has absorbed and now displays aspects of his human body within itself. On the other hand, the nonhuman speaking thing is capable of crossing temporal boundaries. In its endurance, it is both a variety of different things (breaking, dying, merging and re-emerging) and yet the same thing with the same voice, memory and sentience. This may lead us to recall Exeter Book Riddle 74, in which a single thing is mysteriously able to change from young girl to grey-haired woman to warrior but somehow remain itself *on ane tid*. As we have seen, the speaking thing in *The Dream* does not only alter itself in order to endure but embroils humans – who would otherwise fail to overcome their temporal rootedness – in this process. By verbally possessing the dreamer in order to speak about its history, the rood carries the human voice back into the past. By visually displaying the body parts of Christ in its own wounds and stains, the rood conveys the human body forward into the present and future.

Even as breakage in its form and functionality enables the thing to alter and revivify itself, these breaks in time allow it to defy a single state of being. This is why the dreamer cannot pin down, in words, exactly what it is he perceives. True, the poem contains allusions to cross shapes. These occur visually, in the opening section, and verbally, in the chiasmatic patterns which underlie the sequence of scenes narrated by the rood.[11] Yet

the thing seen and the thing that speaks eludes and exceeds its cross-like quality. It stretches across space and stretches across time to embrace its former and future existence as tree, gallows, beam, beacon, rood, body and more. Similarly, one effect of the hypermetric lines is to slow down and stretch out the verse within time.[12] This again creates an excess of meaning as well as expanding – one might say momentarily breaking – the carefully designed chiasmus, presenting us with something that goes beyond a cross shape.

As a result, the dreamer cannot really know, cannot really resolve, whatever he sees, hears and speaks – and he cannot and does not name it as a cross, or the Cross. The human dreamer does not, therefore, master the things around him through language but becomes enmeshed with them. Rather than reaching a resolution as the poem progresses, this human being is shifted and shaped by things, so that he himself is ultimately rendered an inanimate but talking thing – spiritually and verbally active but physically passive. He cannot hope to master things with a single word; talking things master him, bringing him into their riddle.

For a start, the poem suggests that the human body of the dreamer can criss-cross between discrete categories, highlighting not only the bodiliness of things but the thingness of the body. The lines 'Syllic wæs se sigebeam ond ic synnum fah, / forwunded mid wommum' [Splendid was the victory-beam and I stained by sins, wounded with stains] (13–14) may be read as the dreamer recognising a moral contrast between himself and this noblest of trees, where the latter is splendid (*syllic*) and he is hateful because of sin. Yet as a statement it has a visual or material dimension to it, as well as a moral one, and thus visually connects – as well as contrasts – the body of the dreamer with the sight of the rood. Even as the rood 'wendan wædum and bleom' [changed its colours and coverings] (22) and is at times 'mid wætan bestemed' [with wetness/blood bedewed], at times 'mid since gegyrwed' [bedecked with treasure] (22–3), so too the dreamer describes himself as at once wounded and brightly adorned, hateful but alluring to behold. *Wommum* is translated by Ó Carragáin as both (with) 'sins' and (with) 'stains'.[13] In Bosworth-Toller *wamm* is glossed as 'a spot, mark, blot, stain'. Just as the sins of the past (*earmra ærgewin*) are displayed visually on the rood's bloody, sweaty body, the sins of the present that afflict the dreamer are there to be seen as 'stains' or 'marks' on the skin.

The OE word *fah* is likewise key in seeing the body of the dreamer as thinglike. *Fah* can mean hostile or guilty but also

decorated, gleaming or brightly coloured. It is used elsewhere, in *Genesis B*, to describe the serpent that tempted Eve as 'fah wyrm' (899). Here, the snake is something shining and beautiful yet also deceitful and dangerous. In *The Wanderer* it describes a 'weal wundrum heah wyrmlicum fah' [wall wondrously high, adorned with serpentine patterns] (98) and in *Beowulf* the hall Heorot is 'fættum fahne' [gleaming with gold ornaments] (716). When applied to the dreamer, the word therefore makes him sinful and guilty but also adorned and shining like an engraved wall, gilded hall or bejewelled cross or column. We are invited not only to hear of his sinful state but to see his wounds/adornments in the same way that we look at the Saviour's tree. Like the rood, the dreamer is an object to be seen as much as a subject to be heard. In this poem, then, the shapeshifting thing impresses its own appearance, as well as voice, upon a human body. The dreamer responds to the vision of the *sigebeam* and only senses and expresses his own moral and physical condition in relation to it. That thing is wounded; I am wounded. It is adorned; I am adorned. It is a voice-bearer; I am a voice-bearer.

The dreamer is not simply shaped by the thing in terms of what he looks and feels like, either, but as the poem unfolds he is physically shifted by it too. The human dreamer is positively inert compared to the things he perceives and he comes to rely on the rood to fetch and carry him. The dreamer may be talkative and opens the poem by declaring his intention to speak, but then he swiftly fades out of focus and proceeds to relate the lively, shapeshifting actions of the tree as it towers, shimmers, changes its coverings, sweats, bleeds and so on. Towards the end of this opening passage, the dreamer reminds us that he is still here, but that he has been lying down and passively watching and listening to the thing's performance (24–6). Starting with the moment when the tree starts to talk ('Ongan þa word sprecan wudu selesta ...') the poem breaks from the subject–verb syntactic pattern with which it opened to introduce a verb-initial pattern for the rood's narrative.[14] Such a word order emphasises action but places less emphasis on whom or what is acting. Sometimes things are done to the gallows ('Genaman me ðær strange feondas') while at other times things are done by the rood ('Ahof ic ricne cyning') and still other times things are deliberately not done by it ('Hyldan me ne dorste'). Yet throughout this passage the thing remains involved and at the forefront of what is unfolding – unlike the sleeping dreamer who merely observes things happening from a spatial and temporal distance.

In the closing sections of *The Dream* (122–end) the dreamer becomes verbally active once again, expressing his reaction to the words of the speaking thing. Uplifted by the story of the rood, he is also spiritually active by this point. That is, he describes himself as praying before the beam ('Gebæd ic me þa to þan beame') and uses a variety of phrases to explain how his mind, heart and spirit are yearning for heavenly things: 'Wæs modsefa / afysed on forðwege' [My mind was urged on the way forth] (124–5) and 'Is me nu lifes hyht / þæt ic þone sigebeam secan mote' [It is now my life's hope that I might seek the victory-beam] (126–7). And yet, while the dreamer may yearn and seek with his spirit, he remains as physically immobile as he was in the opening – and, more than this, he expresses a physical dependence on the rood to one day raise him into heaven:

> ond ic wene me
> daga gehwylce hwænne me dryhtnes rod,
> þe ic her on eorðan ær sceawode,
> on þysson lænan life gefetige
> ond me þonne gebringe þær is blis mycel,
> dream on heofonum, þær is dryhtnes folc
> geseted to symle, þær is singal blis,
> ond me þonne asette þær ic syþþan mot
> wunian on wuldre, well mid þam halgum
> dreames brucan. (135b–144a)

[and each day I hope for the moment when the lord's rood, which I saw before here on earth, may fetch me from this fleeting life and bring me to where there is great bliss, joy in heaven, where the lord's people are placed at the feast, where there is ongoing delight, and set me down there, where I might afterwards dwell in glory and justly enjoy bliss with the holy ones.]

In this passage, a series of verbs grant agency to the thing rather than to the human being: *dryhtnes rod* will 'fetch' (*gefetige*) and 'bring' (*gebringe*) and 'set down' (*asette*) the dreamer where there is bliss among the holy ones.

The dreamer is hardly a masterful human subject at the outset, but, as the poem progresses, he loses still more of his subjectivity and becomes increasingly like an object. The talking thing commands him, and all humankind, to become treasure-bearing objects when it states that, 'Ne þearf ðær þonne ænig anforht wesan / þe him ær in breostum bereð beacna selest' [There need be none who are fearful among those who bear the best of beacons in

their breasts beforehand] (117–18). The image has both an outer dimension (recalling a pectoral cross worn on the breast, perhaps) and an inner one (some precious treasure mysteriously concealed within a chest), and makes me think not of human subjectivity but of other objects that survive from Anglo-Saxon culture, such as the pectoral cross of St Cuthbert or the Franks Casket. Even more forcefully, the rood commands humans to become voice-bearing objects: 'Nu ic þe hate, hæleð min se leofa, / þæt ðu þas gesyhðe secge mannum, / onwreoh wordum þæt hit is wuldres beam ...' [Now I command, my beloved hero, that you speak this vision to mankind, and reveal with words that it is the tree of glory ...] (95–7). Again, I am reminded of extant Anglo-Saxon artefacts, of the numerous inscribed objects (helmets, jewels, brooches, crosses) which sometimes speak of their makers, owners or masters but whose voices also granted them life and a 'vestige of subjectivity'.[15]

In *The Dream*, voice is an attribute that flows freely across the subject and object binary and enmeshes human with nonhuman, body with object, things with other things. Even as the tree had to be stirred up in its voice by being removed from its roots, the talkative potential of humans also needs to be roused. Voice is connected to sight, and through seeing, speaking and hearing the dreamer moves from sleep to wakefulness, from death to life. It is sight that initially distinguishes the dreamer from the rest of humankind, for while they lay at rest in the middle of the night, he envisions the best of dreams. Yet this is a vision not only to be seen but spoken and heard. 'Hwæt' as a conventional exclamation commands the attention, both aural and visual, of the audience. The rest of humankind against whom the dreamer is contrasted are said to be 'reordberend' [voice-bearers] (3). What is implied is that we, as audience and as humans, may 'bear' voices within our bodies but that the transformative potential of these voices remains unused while we lie asleep. The dreamer, on the contrary, has his eyes wide open and the wakefulness of his dream vision is contrasted with the sleep of the inanimate, insensible voice-bearers around him, whose eyes, ears and mouths remain closed to the spiritual truth. Ó Carragáin informs us that 'the liturgy made it clear that, even during sleep, divine grace could bring the heart to deeper wakefulness, so that sleep could be a true vigil, a time of spiritual growth'.[16] While his eyes are open, the dreamer at first looks on in silent awe – but paradoxically speaks his silent awe, for the poem itself is the fulfilment of his potential as a voice-bearer. The dreamer is challenged to imitate and become a thing that talks,

and the voice in which he fulfils this challenge ultimately merges with that of the talking tree as the latter narrates the story of the crucifixion for a significant portion of the poem. What is more, although the poem ostensibly shifts back into the 'human' voice of the dreamer from line 122 onwards, traces of his verbal individuality actually fade away as the poem comes to a close. Around line 147, the dreamer suddenly substitutes the personal *ic* with an *us*. The *us* functions as (indirect) object rather than subject and introduces an impersonal, repetitive tone to the final lines of the poem. The individual persona of the dreamer finally breaks away, but the entirety of humankind is now brought into the poem, each of us included as a voice-bearer (*reordberend*) who may spread the word about the wonders we have seen and heard.

Poetry, textuality, materiality

Until now, I have been reading a 156-line Old English poem known as *The Dream of the Rood*. This version of the text is found in the Vercelli Book manuscript, across folios 104–6, and has been dated to the second half of the tenth century, probably copied down *c.*970 by one scribe, possibly at St Augustine's, Canterbury. The book gets its name because it has survived, not in Canterbury, but in the cathedral library at Vercelli, Italy. A piece of northern Italian chant, scribbled onto a page of the manuscript, shows that the book was already at Vercelli by around 1000–1100 AD and, since Vercelli was on one of the pilgrim routes on the way to Rome, the Anglo-Saxon manuscript may have been brought along by a group of English pilgrims, perhaps given as a gift to the church.[17]

The Dream of the Rood is a curious title invented by scholars who first studied and published the poem in the early nineteenth century. The text could as easily have been called *A Vision of the Cross* or *The Riddle of the Tree*. There is no title in the Vercelli Book itself. The poem opens abruptly near the top of folio 104v. and starts with a plain H to introduce the opening word, *Hwæt*. The folio is damaged by a water stain in the outer margin and by reagent at the bottom of the page. Like all Old English poetry, *The Dream* is laid out in long continuous lines.

Pasternack has pointed to the differences between discrete Old English poems such as *The Dream of the Rood* as they are presented to us in modern editions – with titles, in units marked and defined by rhythm and alliteration, with current conventions of punctuation – and what she calls the 'verse sequences' found in

Anglo-Saxon manuscripts, which are not constructed of fixed dimensions or content but which 'act' as poems when certain conditions suggest their coherence. Pasternack contends that this verse 'operates without the author function' and so 'opens itself to another poet, a reader, a scribe or manuscript compiler remaking it'. These verse sequences are 'constructions that another can reconstruct, much as the Anglo-Saxons used Old Roman stones to construct new churches'.[18]

As one of the four main codices in which the bulk of surviving Old English poetry is found, the Vercelli Book asks us to assemble a poem in what is an open process and in which the 'poem' is never quite completed. Indeed, the Vercelli Book may even contain fragments of poems embedded within its highly poetic prose homilies, visually undifferentiated by the Anglo-Saxon custom of writing both poetry and prose in long lines across the page and yet audibly there for the making – before failing to act as poetry and breaking off into prose again.[19] We can say, therefore, that this process of poem-making and poem-breaking is partly accidental, whereby the reader can easily skip or miss parts, spill over from poetry into prose, prose into poetry, or from one poem into another, linking and breaking sections depending on what he or she finds on the manuscript page and how he or she responds to it.

That the Vercelli Book engenders acts of finding, making, breaking and remaking is embodied by the Cynewulfian runes that are integrated into some of its texts. On folio 54r. of the Vercelli Book a request for prayers incorporates the name CYNEWULF in runes. Immediately prior to this, the reader is told: 'Her mæg findan foreþances gleaw, se ðe hine lysteð leoðgiddunga, hwa þas fitte fegde' [Here the wise fore-thinker, he who delights in the singing of lays, may find who fixed together this song] (*Fates of the Apostles*, 96–8). Thus, we as readers are invited to solve this riddle by 'finding' the one who found and 'fixed together' this song. The straightforward solution is: Cynewulf. But the OE word *fegan* is defined as to join, unite, bind, fit or fix.[20] The 'I' who is revealed to be Cynewulf found and bound or fixed together this visible song. This same 'I' invites us to find him and fix together his name from the scattered runes. That is to say, Cynewulf asks us as readers to recognise ourselves in him. Like Cynewulf, we as readers are finders and fixers. The wise, fore-thinking person will surely discover that the one who found and fixed together 'this song' is not only Cynewulf but also herself or himself. The song is not something original in us, but we can remake its meaning in a collaborative act.

The invitation to recreate Cynewulf by finding him, working out
the meaning of each rune and uniting them or fixing them together
is analogous to our active involvement in the making and break-
ing and remaking of poems in the Vercelli Book, whereby we link
together verse sequences and work out their connections.

This collaborative act involves both human and nonhuman par-
ticipants. The physical condition of the Vercelli Book manuscript,
and the processes by which it came to that condition, similarly
shape the reader's response to its texts. The manuscript consists
of 135 parchment leaves, with the sheets normally arranged so
that the hair side is outside. Hair and flesh sides are not always
easy to distinguish. The parchment itself is 'yellowish, smooth,
and somewhat transparent' but holes and faults in the parchment
affect the written space on various folios.[21] These elements of fra-
gility, damage and defect are especially interesting. Sarah Kay has
linked the violent processes (flaying, scraping, stretching, drying,
stitching, folding) inflicted on the dead animal during the making
of parchment manuscripts to the forms of torture endured by the
protagonists of many of the texts written on them, contending that
the skin of the medieval manuscript could sometimes double as
the reader's own skin, having an uncanny effect on her or him, and
undermining the categorical demarcation between human beings
and other animals.[22] Folio 98r. of the Vercelli Book shows stitching
where a gash or cut made in the flaying may have opened up and
been mended, and folios 64r. and 56r. show unstitched worm holes,
while 63r. shows treelike veins which were the result of blood in
the skin when the animal died. These are but a few examples of
the many marks on the manuscript. When readers of the Vercelli
Book encountered such blemishes would they have thought of
the bruised and battered body of Christ or the bloody and sweat-
drenched rood? If so, they may well have felt a more tangible and
immediate connection with these thinglike bodies, these bodylike
things, linking them to the stained, veined, torn and stitched skin
before them: skin which served as a voice-bearer for the word.

It is well known that echoes and traces of *The Dream of the
Rood* (or some song or story resembling it) can be found elsewhere
in Anglo-Saxon material culture, beyond the manuscript page.
The Brussels Cross is often studied alongside *The Dream of Rood*
because its verse inscription includes lines matching some of those
found in the poem. Badly damaged and with its once jewelled
front missing, it takes the form of a large piece of cross-shaped
wood covered with a silver plate. Across the arms, a craftsman has

inscribed his name in large Latin letters: 'Drahmal me worhte' [Drahmal made me]. An inscription around the edges reads: 'Rod is min nama; geo ic ricne cyning bær byfigynde, blod bestemed' [Rood is my name. Trembling once, I bore a powerful king, made wet with blood]. These lines roughly correspond to lines 44 and 48 in *The Dream of the Rood*, stripping the riddling vision and historical narrative of that poem down to its bare essentials and omitting any reference to a dreamer figure. This is followed by a common form of dedication: 'þas rod het Æþmær wyrican and Aðelwold hys beroþo[r] Criste to lofe for Ælfrices saule hyra beroþor' [Æthlmær and Athelwold, his brother, ordered this rood to be made so as to praise Christ for the soul of Ælfric, their brother]. The cross speaks in both the first person and the third, meaning that the epigraphic voice emerges from the material form of the cross yet also seems able to stand apart from its own speech, memory and identity.

In early medieval England, then, a 'poem' can manifest itself in different material forms with different functions. This raises important questions. When and how does a poem become a poem in this period? How do different material things invite different kinds of interaction and interpretation? *The Dream of the Rood*, in its multiple forms, presents us with a speaking 'I' which implicitly refers to itself as a tree, or as a gallows, or as a rood, or as a body. But who or what does this 'I' actually belong to? How is the perceived identity of the speaker altered by media, materials, substance, shape and size? It is one thing to imaginatively engage with a literary dream vision, in which a tree speaks from the pages of a manuscript; it is another thing to hold or kiss a silver and bejewelled cross that claims it once carried the king of heaven; it is another thing again to be confronted with a huge stone monument, speaking as if it were living wood, or a wounded body ...

The thing in Ruthwell

The complicated relationship between *The Dream of the Rood* and the runic poem on the Ruthwell monument is a riddle that has intrigued Anglo-Saxonists for a long time. What to make of the connection between a late tenth-century manuscript poem and a rune-inscribed stone sculpture from the eighth century? It has been difficult to keep these two things together in a sustained and meaningful way. It has been almost impossible to break them apart. As much as they have been drawn to each other across time and space, they have repeatedly asserted their own individual thingness.

Their assembly or meeting has been characterised by friction as well as agreement. It is tricky, therefore, to account for the connection between these two different things. The best explanation may be that 'each makes use of a conventional, probably primarily spoken topos that was widely available as a resource in Anglo-Saxon culture for some considerable time'.[23] Here again, voice acts as a connective glue linking two things that should not function together and yet somehow, sometimes, do. A disjointed poem in a manuscript that is out of place; a demolished, reassembled, mismatched monument; fragmented words that sound similar but do not look alike: it might be that the fragility, brokenness and failure that runs through this meeting offers another, more thematic, way of understanding the relation between the dream vision in the Vercelli Book and the Ruthwell monument. Acknowledging their resistance to straightforward unification (their thing-power) gives us a way of speaking about the two together without forcing them to be the same – providing a means of talking about these things without eroding their autonomy.

The 'spoken topos' which provides the only perceptible link between the Vercelli Book poem and the Ruthwell runes does not amount to much: when the runic inscriptions on the monument are transliterated, transcribed and thus transformed into something resembling a poem, they correspond to less than eighteen lines of the 156-line *Dream of the Rood*.[24] More importantly, and more obviously, these runes are but a part of a three-dimensional stone monument and they partake in its other features, such as inhabited vine scroll, biblical scenes, Latin inscriptions and so on. Unlike the poem in the Vercelli Book, our experience of the Ruthwell monument is only partially 'poetic'. This point has been made recently by Orton, Wood and Lees, who remind us that while *The Dream* signals its genre, beginning and ending according to conventional expectations of Old English poetry, utilising figuration, dream vision, frame narratives, the '*sententiae* inscribed on the Ruthwell monument, by contrast, do not announce that they are structured in the form of a poem or as parts of a poem' and 'might be best understood as a hybrid genre'.[25] Even if our experience of the Ruthwell runes is a poetic one, it is poetry that breaks off as we start to move our bodies around the four-sided column. Usually, Anglo-Saxon poetry is located on the manuscript page, in a two-dimensional not a three-dimensional space, and 'we can be invited to walk around a poem only in a metaphorical sense'.[26]

What sort of encounter does the Ruthwell monument offer us, then? How is this experience like or unlike that offered by *The Dream* in the Vercelli Book? Above all, I understand the Ruthwell monument as a thing of tension and paradox. This view has been borne out by my own personal experience of it but also by an examination of its documented history, the written record of which started with a note made in 1599 when Reginald Bainbrigg visited the church of Ruthwell and saw *something* there.[27] For me and for many of those who have engaged with and talked about the monument across time, the thing is at once beautiful *and* ugly, balanced *and* broken, fragile *and* enduring. Sometimes this paradoxical quality results from the intentions of the monument's makers (it is multilingual and multi-scripted, it is stone that speaks as if it were living wood); sometimes it is accidental and thingly (the mismatched colour of the stones, the fading runes, the possible shedding of its paint); but most of the time we are witnessing a collaboration, or maybe tussle, between human and nonhuman forces. The agency of this monument comes from its resistance to human knowledge. It makes us think it is a certain kind of thing (tree? beam? rood? wood? flesh? stone? column? cross?) only to then break or fail to act as that thing. This tension, this contradictory character, will inform the way I write about the Ruthwell monument in the pages to follow.

We should start with movement since this is one of the key ways in which one engages with the monument, distinguishing it from the manuscript page. This three-dimensional, four-sided work of stone sculpture has the power to keep human bodies on the move. As part of this kinetic process, it also keeps us guessing. Acts of seeing and then not seeing, speaking and then not speaking, touching and not touching, knowing and not knowing are bound up with this riddle-like game. Voices and images manifest themselves before our senses only to break off again as we turn a corner, asking us to piece disparate parts of the monument together as we move around it. This object has the ability to humble human subjects. It plays on our uncertainty and forces us to confront the fragility of human memory, the smallness and vulnerability of our bodies, the limits and failures of knowledge gained through the senses. We may think back to the dreamer's inability to really know what it is he is envisioning in *The Dream*; but whereas he was lying down while the thing moved and changed and remembered and talked, the reverse is true in the case of the Ruthwell monument, which asks its human viewers to move while it stands still.

The first sort of motion that the monument expects from us is *movement around*. What is it that we perceive as we do so? One of the primary functions of the monument was to 'invoke a metonymic vision of the Crucifixion arrived at through an understanding of its texts and its images of figures and animals who touch, hold or consume the body of Christ in its multiple forms'.[28] There is no opening 'Hwæt' here to tell us where to begin our walk around the monument, but wherever we come from, wherever we go, we meet versions of Christ. On the original north side we see vine scroll (see Figures 5 and 6). This could be the first thing to catch our eye as it fills the centre of this narrow side. The vine scroll is inhabited by birds and beasts who are feeding on bunches of grapes, thus invoking the ancient Middle Eastern concept of the Tree of Life and calling forth eucharistic associations whereby all creation feeds on the true vine and is incorporated into the body of Christ and the universal Christian Church. Surrounding this vine scroll are a series of runic inscriptions, which appear to be describing an almighty god (*god almeittig*) and powerful king (*riicnæ kyninc*) in the third person. Yet we are also presented with a first-person speaker (*ic*) here, who is raising that king but daring not to bow or tilt before being drenched with blood poured from the man's side. The speaking voice seems to belong to the masculine gallows and yet this gallows is paradoxically referring to itself in the third person (*þa he walde on galgu gistiga*).

The original east side, one of two broad sides, depicts a faded Crucifixion scene on the base. Above this, we see a depiction of the Annunciation, featuring the Archangel Gabriel greeting the Virgin Mary; above, we find Christ healing a blind man; above again, Mary Magdalene is washing Christ's feet with her tears and drying them with the hair of her head; at the top, Elizabeth is embracing the pregnant Mary. Latin inscriptions, in the Roman alphabet, identify each of these scenes – as they do on the opposite west face. The body of Christ is present (but not necessarily visible) all the way from top to bottom of this side. This is a very different version of that body, however, from the one that we encountered on the narrow side.

Moving around to the original south side, we are once more faced with vine scroll surrounded by runes. This time, the voice unlocked by penetrating the mystery of the runes announces that 'krist wæs on rodi'. As before, even though it refers to itself in the third person, this voice may belong – or at least partially belong – to

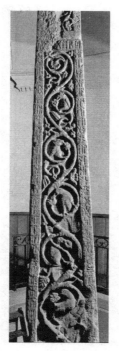

5 The Ruthwell monument, north (now east) side, upper and lower
stones: vine scroll and runic inscription (© Corpus of Anglo-Saxon Stone
Sculpture, photographer T. Middlemass).

the feminine *rod*, who claims to have been an eyewitness to the
events it recounts (*ic þæt al biheald*).

Finally, if we choose to finish here, one comes to the original
west face of the column. The base is too worn to identify accur-
ately, but may have been a Nativity scene. Above, we can see a
somewhat faint image of Mary, seated on an ass, holding the Christ
child in the flight into or out of Egypt; above that two male figures,
Paul and Anthony, break a loaf of bread in the desert, evoking the
edible body of Christ; then there is the adult Christ being recog-
nised by two beasts, crossing their paws; and at the top, John the
Baptist holds or points to the body of the Agnus Dei.

Thus, as we move around the monument we soon become aware
that we are moving around a body, amongst other things. That
body is both physical and symbolic, present and absent, literal and

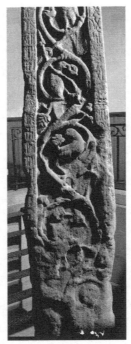

6 The Ruthwell monument, north (now east) side, lower stone: vine scroll and runic inscription (© Corpus of Anglo-Saxon Stone Sculpture, photographer T. Middlemass).

mysterious; we can see it, here and there, but must also read it and speak it. The body is broken into bits. On one side, its blood pours forth or drenches us; elsewhere, it is being eaten as fruit or as bread; it is adult in one space but a child in another; unborn within the womb, but then on the verge of death. It is our role, as we move around, to piece these broken bits together. In doing so, we may reach a *deeper* understanding of what the body of Christ means and yet the *surface* of the column prevents us from forming a complete picture – something is always breaking away, something always eludes us. Movement around a four-sided column entails forget-fulness as much as remembrance; and not seeing or not touching or not speaking is a continuous part of this experience. Stand before the east face of the column. Can you remember what is on the west face? It will depend on how much you have committed to memory.

It will depend on the extent to which your memory fails you. Yet, even if you have an eidetic memory, remembering an image is not the same as seeing or touching it in the here and now – eyes detecting shape and colour, flesh feeling stone. When you are looking at eucharistic scenes, you are simultaneously not looking at baptismal ones; when viewing vine scroll, you are not seeing a human body; when reading and speaking the voice of masculine gallows, you are not reading or speaking as the feminine rood. Even as the Ruthwell monument presents the body of Christ to us, it conceals aspects of that body; it is able to keep body parts out of reach, out of memory. We may, in theory, take as much time as we want with this monument, but space is limited.

The other sort of motion that the monument expects from us is *movement up and down*. This is, of course, interconnected with movement around – we are free to pause in our walk from one side of the column to another in order to tilt our heads back or kneel down or simply move our eyes from top to bottom. This type of movement is particularly relevant to our reading of the runes on the narrow sides. On the original north side, for instance, as you read the runes down the right-hand border, you are moving your eyes down the shaft of the column but you are also performing a bowing movement with your body. What is more, the lowermost runes that you read on this right border are *ur* and *gar* or *u* and *g*. This has been reconstructed as the word *buga* in the sentence 'buga ic ni dorstæ'. Hence, as we make a bowing movement with our bodies we read the word 'bow' (*buga*). Something similar occurs on the narrow south side, where the final two runes down the right hand border are *hægl* and *ac* or *h* and *a*. This is thought to be a fragment of the word *hnag* in the sentence 'hnag ic þam secgum til handa'. Again, the word we read as we bow down to read it is 'bow' or 'bend' (*hnag*). The Ruthwell monument is thus an object that not only has the authority to move the human subjects that stand before it, but to humble them.

Even as it humbles us, bringing us low, the monument can raise us high. On the north narrow side, we move our gaze from the runes on the lower right border to those on the upper left border; and there we see the phrase: '[ahof] ic riicnæ kyninc'. As we read how a gallows raised a powerful king – or perhaps speak and adopt the 'I' ourselves – we move our body from a bent or bowed position to tilt our heads back and strain our necks. As we perform these up and down movements, it is hard not to become aware of our own bodies within space. Whereas our walk around the monument

made us aware that we were moving around a body, this bowing and stretching, crouching, kneeling, lifting, straining, forces us to confront the fragility of our own human bodies. Our movements around the column concealed space from us, emphasising the limits of human knowledge, while our movements up and down emphasise the physical limitations of the human body.

Finally, the monument wants us to *move across* it. For example, if we wish to read the runes on either of the two narrow sides in full, we must move our eyes across the top border, then down the right border, back up to the top of the left border and down. That is to say, we must make cross shapes with our eyes. As we make this movement, we are at the same time reading or speaking about a gallows, or a rood, while also taking in the inhabited vine scroll imagery that flows up, down, across and in loops and knots, partly distracting us from the runes, partly enhancing their meaning. As such, we may glimpse cross shapes but these half-crosses are always merging with other kinds of things.

There is, of course, another cross shape on the Ruthwell monument as it stands today. Whether you are tracing the upward flow of the vine scroll on the narrow sides, or viewing the series of figural images on the broad sides upwards from the base of the shaft, your eyes will eventually alight on the crosshead. Yet can we really perceive this cross? Within the parish church in Ruthwell, the monument stands at about six metres high. If you stand back from it, you can view the crosshead from a distance. But how is one meant to see and read its images, let alone its fragmentary inscriptions? If you stand close to the monument, the central column seems to rise into the air like a 'syllicre treow on lyft lædan' but then you must strain your eyes, neck and back even more to try and view the crosshead above you. How can we hope to touch it? Either way, this cross shape is only partially glimpsed. It remains impenetrable, out of reach, always slightly beyond human senses and our means of knowing it. Nor should we forget that this cross-head is a nineteenth-century addition to the monument, designed by Henry Duncan in 1823 to replace a 'lost' cross. It is, further-more, mistakenly reversed. It is a cross that does not quite fit; a cross out of place. This monument allows us to move across it and to half glimpse cross shapes and yet it ultimately fails to be a cross – eluding any attempts to identify and categorise it in this way.

All in all, the Ruthwell monument moves the viewer while continuously hiding something from us. The different kinds of

movements it asks for (around, up and down, across) hint at but evade different ways of identifying this thing. The monument continuously makes those who engage with it aware that it might be one thing (tree? food? body?) but is also always some other thing slightly out of our grasp (rood? cross?). Although the monument invites human bodies to interact with it, it forces us to confront the fragilities of our bodies as we try but repeatedly fail to see, speak, touch and know.

This public sculpture was almost certainly made for a monastic community who, perhaps individually but more probably collectively, may have interacted with the monument in the close-up, multisensory, multilingual and mobile manner I have explored above. Yet this imposing work of stone sculpture can be experienced from a distance too – a significant attribute, given that it was originally erected outdoors.[29] For whom would the monumental aspect of this work have been the most important part of it? Alongside the religious, monastic audience of the Ruthwell monument, we must take into account its other audience: the British who were still living in the Solway region in the early Middle Ages. The kingdom of Rheged was an important component part of early Northumbria, though there are difficulties in pinpointing exactly when and where this kingdom existed: Rheged is mentioned in a number of British sources, yet, perhaps unsurprisingly, the name does not appear in Bede or the early ninth-century *Historia Brittonum*. The location of the kingdom and its importance is open to debate, depending on how much credence is given to the evidence of early Welsh poetry. Nevertheless, the place names of present-day Dumfriesshire point to a significant population that continued to distinguish itself from the incoming Anglians, and so the pre-Anglian history of the Solway region should be taken into account when discussing the Ruthwell monument.[30] Orton, Wood and Lees highlight that fact that even a British person literate in the Latin alphabet and language is unlikely to have been able to read the Old English runes on the narrow sides of the monument.[31] Karkov has similarly picked up on the inability of the British population to decipher all the inscriptions on the monument, and the alternative meanings that this could have created for that group.[32] In both of these studies, the authors come to the logical conclusion that, to the British, the Ruthwell monument might have functioned as a symbol of aggression, an intimidating and imposing thing assembled and forcibly inserted into the land, its display of distinctly Anglian runes an affront to the British.

Even though the British of the Solway region had been domi-
nated by the incoming Anglo-Saxons, does this mean that this
group was excluded from engaging with the Ruthwell monument?
We have seen how even an intimate interaction with this monu-
ment entailed elements of obscurity, concealment and unknowing.
Can runes still speak without being read and unlocked? What do
they speak of? They might suggest violence, given that runes were
designed to be cut, carved or scratched into the bodies of things
dead and not dead.[33] They could also speak of permanence, the
irremovable. What does the stubborn muteness of this monument
signify? What about the bluntness of its sheer size and stability?
Power? Control? Arrogance? While the British may have been kept
away from the monument – whether because of physical distance
or lack of literary and interpretative power – there is more than one
way to 'read' this thing. While it goes against scholarly tendencies,
we need not privilege the detail or intricacy of this monument at
all. What if the highly visible nature of this beacon was its primary
function? This column, probably painted in technicolour, per-
haps decorated to resemble precious metalwork, must have had the
power to dazzle and intimidate onlookers from far away. For the
British, this immoveable pillar may well have evoked the brightly
and boldly adorned bodies of those Anglo-Saxon warriors who
had seized control of their region. A striking and colourful, but
aggressive and alien, thing inserted into the land can communicate
loud and clear even before one scrutinises its iconography. And
the British would have seen something very different to what we
see today – not an old, broken, obscure, fading thing but maybe a
metallic and painted, shining and glittering shaft, shockingly new,
unambiguous in its message and confident of its own durability, as
capable of keeping human viewers away as it was of drawing them
towards it.[34] This is another of the Ruthwell monument's para-
doxical qualities, then. Stillness, solidity and stability could be as
crucial as movement to the way it was experienced.

Indeed, the monument plays on the tensions and contrasts cre-
ated by its own materiality. It simultaneously presents itself to us
as unyielding *and* emotional, fragile *and* enduring. As noted, the
north side of the column is inscribed with the voice of a masculine
galgu which describes a scene of wounding and death as it is 'miþ
blodi bist[e]mi[d]' [drenched with blood] begotten from Christ's
right side. If we move around to the original south side, however,
a transformation occurs and the inscribed voice now belongs to a
feminine *rod*. As well as shifting gender, the wood has undergone

a change from death-bearing gallows to life-bearing rood. This
change is catalysed by the body of Christ, now hanging from the
gallows, now rising on the rood. It is a change that stirs both the
voice of the wood and its emotional life as it relates how 'saræ ic
wæs miþ sorgum gidræfid' [I was sorely afflicted with sorrows].
This emotional response, expressed in a feminine voice, links the
wood with another human body, that of the sorrowing Mary.[35]
In one dynamic movement from north to south, we have speech,
transformation and emotion. But who or what is doing the talking
here? The possibilities are somewhat confusing and contradictory.
For a start, some lines are in the third person (e.g. 'geredæ hinæ
god almeittig þa hewalde on galgu gistiga' and 'krist wæs on rodi')
while others are in the first person (e.g. 'hælda ic ni dorstæ' and
'saræ ic wæs ...'). An effect of the third-person voice is to distance
the human who reads it. So should we speak it? Neither is it clear
who owns the first-person voice and who should speak it. Am I the
'I' or is it the 'I'? Can the human who performs and speaks the
'I' for a moment and then moves on claim ownership of it? This
could be interpreted as an imposition. Can a man speak the rood?
Can a woman speak the gallows? Does the voice really belong to the
absent wood of the historical cross? Alternatively, it might belong
to the solidly present stone that bears the voice and will still bear
it long after talkative men and women have fallen silent. This is
one way of comprehending it, to be sure. The stone is perform-
ing as some other thing: a lifeless yet enduring material paradoxi-
cally speaking as if it were fragile yet lively; a hard, blunt substance
recalling its emotional suffering.

From an anthropocentric perspective, the nature of stone
seems to be at odds with this vibrant moment of transformation
and emotion. Why would stone speak as if it were a rood or a
body? Would not the wood of a tree that once grew greenly in
the forest, or the bone of a once sentient and lively animal, have
worked better? I would suggest that we should, in fact, reflect on
the tension created here and the effects of that tension. Just as
we encounter the body of Christ as we walk around the monu-
ment, the voices that speak from the two narrow sides evoke the
transformative power of the Saviour and His crucifixion. The
apparent inanimacy and immutability of the stone emphasises
this power, this miraculous ability to turn death into life. Stone
is the limit case here. Stone stretches that transformative power
to the point of failure. It works because it almost does not work.
How can stone, of all things, talk and change and feel? This point

is accentuated when one thinks about those missing medieval elements of the modern monument – colourful paint and metallic effects, possibly, but maybe also a relic of the True Cross contained within the hole at the centre of the Annunciation panel.[36] If so, this dead stone would have borne the body, as well as the voice, of living wood; and in turn that living wood would have vitalised the stone. Such additions, when set against inert stone, would have intensified the contrast between fragility and endurance, sentience and insentience, life and death, facilitating the imaginative change undergone by those who interacted with the Ruthwell monument, deepening their understanding of what Christ's sacrifice truly meant.

The runes, too, play a part in this process. Those on the narrow sides of the monument are difficult to read, in more ways than one. They stand in contrast to the Latin inscriptions on the broad sides, which are written in an impersonal voice in the third person and set out in a straightforward manner so that 'any literate religious man or woman would have had little trouble either reading them or understanding their meaning'.[37] The runes are a different matter, trickier and more complex. On a monument that also displays Roman and Greek alphabets, this runic lettering seems to draw attention to itself as a different sort of script, one that carried arcane and archaic associations even for the Anglo-Saxons who cut and carved it. The rune masters who engraved these symbols into wood or bone or stone were elevated and celebrated for their singular skilfulness, their talent carrying connotations of literacy, mastery and maybe even magic.[38] Interpreting runes was no easy feat, either. Even if you had committed their shapes and names and sounds to memory, the runic characters on the Ruthwell monument are generally smaller and less distinct than those of the Roman alphabet on the broad sides. What is more, while the language of the runes is vernacular Old English, it is a poetic kind of language and this 'poem' is broken up by the corners of the column. The British would have been unable to decode these runes, but many members of an Anglo-Saxon audience would have likewise found their interpretive skills tested by them.

The various difficulties of the runes force us to stop, hesitate, look, speak, perhaps stutter, misread, mispronounce, try once more, fail, try another time, pause, wait, look closer, deeper, reach out ... Whatever we do, it is hard to simply pass the runes by. They create a break in our movements around or across or up and down and slow down time while we attempt to perceive them. All the

while, we are gazing on stone, maybe touching it, and recognising its thingness, even as we are slowly reading or hearing or speaking the voice of a living tree-gallows-rood. Again, a contrast is brought forth. There is, on the one hand, a 'poetic coherence' to the runic inscriptions, and this 'patterning of language, which is not obvious unless the runes are read aloud (and thus formalised), seems to have some relation of association with the structure of the inhabited plant-scroll, its rhythm, the way it moves to the left and the right, and marks those moves with different forms of flora and fauna'.[39] But this is only the case when the runes are read aloud without difficulty or failure. On the other hand, we have a hesitancy which is linked to the problematic visual appearance of the runes. This does not flow upwards and downwards, side to side, with the flora and fauna of the vine scroll, but instead dwells on the slowness, stubbornness and depth of stone. As is well known, the OE word *run* connoted more than runic characters or inscriptions; it could also mean mystery, secret or whispered counsel.[40] Both medieval and modern audiences sense that the runes are mysteries to be penetrated, that the runic characters are hiding something within or beneath themselves; and in order to access this *something* we do not flow with vine scroll but delve deeper into the stone. Whereas (most of) the runes on the Franks Casket were carved in relief, and thus emerged from the darkness of the bone box, the runes on the Ruthwell monument are incised, retreating into the material from which the column has been constructed.

We may experience an imaginative change as we take on, and maybe hear others take on, the voices inscribed on the Ruthwell monument. Yet at the same time that we try to penetrate the runic mysteries, we are confronted by inexorable stone. This further confounds human attempts to identify this monument as one thing or another, slowing down time and forcing us to instead ruminate on the tension between fragility and endurance, with the nonhuman actors in this collaborative performance shaping our conception of what it means to transform and be transformed.

The potency of this effect has changed across the ages as the Ruthwell monument has shifted from painted pillar to dull, faded column. We do not really know what the monument looked like in the early Middle Ages but we can be sure that it looked different to the way it looks now. As Jane Hawkes points out, even the application of paint could highlight details and make them easier to decipher and yet in that act 'definition is imposed and defined; by applying colour, decisions concerning the meaning

and the presentation of that meaning, are implemented'.[41] For an early medieval viewer, the Ruthwell runes may have been sharper, clearer and simpler to see and to read. Today, however, those runes are fragmented, worn away, lost. In the eighth century, the stoniness of the column could have been overlooked more easily; today, we cannot fail to recognise and acknowledge it. Painted texts and images have returned to stone carvings. Gradually, as time goes by, the stone is reasserting its thingness ...

And so, when writing about the Ruthwell monument in our time, one has a duty to talk with and about the lithic. As shown in Chapter 2, stone may not be as solid, as stark, as still, as enduring as humans tend to assume. Jeffrey Jerome Cohen has recently challenged some of these cultural truths by exploring the life of stone and following its matter energy. Cohen recognises that 'Durability is the reason we short-lived humans construct walls, pyramids and memorials by use of quarries. Stone seems an uncomplicated material, instantly and bluntly knowable.' There is something very real about the 'comforting solidity' of stone and this 'reality' is not infinitely pliable, so that we cannot, for instance, 'squeeze water from a rock because we "socially construct" the lithic as aqueous'. However, the permanence of stone is also a quality that humans desire from it, representing some ability or power we wish for ourselves. This does not, however, 'mean that stones are so immobile that they will not reveal their fluid tendencies when viewed in a nonhuman historical frame'. Cohen is attempting to be both scientific ('from a deep history perspective all stone moves and changes') and attentive to the insights of medieval writers, for whom inanimate stones were rather alien.[42] He refers to high medieval lapidaries, such as that of Marbode of Rennes, to make this point; but there is also evidence within Old English texts for the animacy and agency of stone.

Andreas (another Vercelli Book poem) has St Andrew encounter a stone column: 'He be wealle geseah wundrum fæste / under sælwage sweras unlytle, / stapulas standan storme bedrifene, / eald enta geweorc' [He saw by a wall, firmly fixed, standing under the side of the building, some great columns, storm-beaten pillars, the old work of giants] (1492–5). Whereas in line 87 of *The Wanderer* the old work of giants is said to stand idle ('eald enta geweorc idlu stodon'), St Andrew speaks to the stone and expects it to respond. The saint 'wið anne þæra, / mihtig ond modrof, mæðel gehede, / wis, wundrum gleaw, word stunde ahof' [mighty and bold-minded, held a meeting with one there, wise and clear-sighted, at once raised a word] (1495–7). He addresses the stone in the second person and

commands it to listen to the counsel of God: 'Geher ðu, marman-
stan, meotudes rædum' [You, marble stone, hear the measurer's
counsel!] (1498). Once the *marmanstan* has heard what Andrew has
to say it does indeed react. And so this ancient work, this dead
thing of bygone days, springs into life: 'Næs þa wordlatu wihte
þon mare, / þæt se stan togan. Stream ut aweoll, / fleow ofer foldan;
famige walcan / mid ærdæge eorðan þehton, / myclade mereflod'
[There was not then a whit more time wasted on words before the
stone split open. A stream welled out and flowed over the fields.
Foamy billows drenched the earth by dawn, and the torrent grew
greater] (1522–6). This passage suggests that Anglo-Saxon writers
grasped something about stone – its potential for both permanence
and action, endurance and liveliness – that new materialists and
ecotheorists are now exploring afresh.

When we learn how to recognise it, then, the life story of stone
(its deep history, how humans found, formed, sculpted, inscribed
it, how we broke it, intentionally or accidentally, how it broke itself,
how it endured for spaces of time yet refused to stay the same,
transformed itself, returned to its former self) has, does and will
shape our experience of the Ruthwell monument. Yes, the stoni-
ness of this column has allowed it to endure across the ages while
other, timber monuments have long since rotted away. But that
does not mean that this work of stone has stayed the same across
time. That thing in the church at Ruthwell is habitually referred
to as a cross, whether a 'high cross' or 'preaching cross'. In one
sense, the monument is indeed a cross; but within its stony being
it also contains that latency and excess that is characteristic of all
things. This thing is both more and less than a cross; it remem-
bers its deep past and anticipates its distant future. Although the
Ruthwell monument was never a 'living' creature like the whale of
the Franks Casket, it does carry traces of a vibrant former life that
had nothing to do with Christian crosses. This former life carries
us outside of religious categories such as Christian and pagan, or
minute historical divisions between, say, the medieval and modern,
and into the realm of vast geological time frames, all the way back
to the Carboniferous age. The pale pinkish-grey lower stone of
the monument is a quartz-rich, medium-grained, mica-free, not
obviously lamented sandstone; the pale red upper stone is also a
quartz-rich, medium-grained sandstone, but is less well sorted
compared to the lower stone and its reddened hue is due to the
introduction of iron oxide that coated the grains at the moment
when they were cemented and compacted together. Both stones

are likely to be Carboniferous sandstone of the Northumberland–
Solway Basin.[43] As well as demonstrating that the stone monument
in Ruthwell had an autonomous life outside of the historical narra-
tives in which we try to embed it, elements of its deeper past also
affect the way that we respond to this thing as a work of art. For
instance, the uniformity of grain sizes of the lower stone identify
it as a 'prime piece of building stone' and an 'excellent stone for
sculpture'.[44] Just as the whale and its bone shaped the look and feel
of the Franks Casket, the kind of stone that offered itself to Anglo-
Saxon builders, sculptors and carvers in the Solway region at once
restricted and enabled the art they could produce.

Some of us, sometimes, will experience the Ruthwell monument
as a fine, visually and verbally pleasing artefact, a well-designed and
well-executed work of art, which has retained its ability to move us.
But it is now thought likely that the monument had more than one
moment of production. It first took its monumental – as opposed
to rocky, amorphous – shape in the eighth century, but was pos-
sibly augmented in the ninth century or later. Material and picto-
rial inconsistencies between the upper and lower stones, as well as
deviations between the inscriptions, may be taken for evidence of
at least two historically and culturally different communities and
moments of production.[45] As such, the Ruthwell monument 'was
always and remains today a monument in process'.[46] The processes
endured and provoked by the Ruthwell monument complicate
its artistic appeal, however. We must concede that the monument
we see today is surely less balanced and symmetrical than it once
was, after Scottish Reformers toppled it and smashed it up in
1642 following the issuing of the *Act anent Idolatrous Monuments
in Ruthwell*. In truth, the terms 'toppling' and 'smashing' may
sound overly dramatic in comparison to what really went on, for
it seems that Gavin Young (minister at Ruthwell from 1617 to
1671) 'demolished' the monument with 'no more and no less dam-
age than he could get away with'. In any case, this act did alter the
Ruthwell monument irreversibly, did break it, unbalance it, spoil
its symmetry. Although the 'toppling' of the monument might not
have been as violent and vehement an act as is casually assumed,
it was, nonetheless, an act of iconoclasm that changed the column
from one thing to another. The term 'iconoclasm' cannot account
for everything that went on in and around 1642, but its connota-
tions of breaking or destroying images are pertinent here – for this
was one of the steps that helped transform the pillar from a series
of (perhaps painted and coloured) texts and images to blocks of

bare stone. In defacing its 'idolatrous' images, Young also brought out its latent stoniness.

The life of this stone thing did not end here, though. As with the things in *The Dream of the Rood*, this 'death' eventually reinvigorated and reinvented it. It lay broken in two, suddenly fragile and a far cry from the imposing pillar that had spoken of Anglian dominance and British subjugation, in Murray's Quire, before the massive lower stone was brought out of the quire in the eighteenth century and left lying in the garden of the manse near the church. It was in the late eighteenth and early nineteenth century that the Reverend Henry Duncan reassembled the monument in the form we see it today. In 1802 he brought the lower stone and surviving fragments of the upper stone together and erected them in the garden of the manse. In 1823, unable to find the 'missing' transom, Duncan commissioned a local mason to make a replacement. In this reconstruction, Duncan mistakenly placed the fragment above the transom, the apex of the cross, the wrong way round. Did this turn the Ruthwell monument into an artistic failure? For Ó Carragáin, 'apart from this small error, Duncan convincingly reconstructed the cross: a remarkable achievement' for which he 'deserves the gratitude of every student of the Ruthwell Cross'.[47] For Orton, Wood and Lees, the 'Ruthwell Cross' as we see it is 'an inelegant thing' and what passes as reconstruction 'is actually an awkward mixture of five carved and inscribed Anglo-Saxon stones and six vulgar blocks of convenience from the nineteenth century (one of which is no more than a wedge) cemented together with crude pointing that here and there serves as modelling'.[48] Ó Carragáin focuses on the meticulousness of the nineteenth-century transom designed and commissioned by Duncan, praising it as a fine work of art in itself, whereas Orton, Wood and Lees are keen to draw our attention to the vulgar blocks and mere wedges of the reconstruction, half suggesting that such mundane, unadorned materials do not belong in an artwork.

Thus, the post-medieval life of the stone monument altered what modern scholars can think and say about the quality of its production, too. What use is it, then? What is the Ruthwell monument for and what does it do? For Tilghman:

> If we are to fold the logic of the riddles into our thinking, the Ruthwell Cross speaks *either* of its virtual existence as the Cross *and* of the sand, the rock, the chisels, the paint, the rituals, the destruction, the excavation, the renovation, and, yes, the scholarly fetishization that make up its being.[49]

The existing monument does tell us a good deal about early medieval Northumbria. Some of the messages it delivers from that place of the past are no doubt what its makers intended (the mystery of the body of Christ, the narrative of the Crucifixion) and so we can say that they chose the right material, in stone, to convey those ideas to a distant future. Some of what the monument says about the Solway region in the early Middle Ages may not be exactly what those makers intended but is what modern historians want to know (regarding relations between Anglo-Saxons and British, for instance). The monument also carries stories from beyond its initial moments of production (stories about the Scottish Reformation or about nineteenth-century antiquarianism).

Yet something else is going on, as well; some thingly, stony story that we struggle to grasp and cannot control has been slowly emerging over time. Any original gesso and colourful paint that might have covered the monument has now flaked away, revealing the mismatched hues of the lower and upper stone, discarding human attempts to obscure the former life of this thing and instead displaying another sort of narrative, about the process of its making: the quarrying and building and sculpting that went on before it could be called 'finished'. The runes are fading or lost altogether, making it ever more difficult to connect the Ruthwell verses to the *Dream of the Rood* and yet forcing us to become more reliant on the later poem if we wish to read the monument. Across the centuries, decoration has fallen from the stone while inscribed words have retreated into it. It is as if this thing of stone is at once discarding and absorbing the human messages that have clung onto it. It is enduring but progressively failing to convey meaning as human beings intended.[50] This is partly the fault of humans (the conditions we kept the monument in, our alternating acts of destruction and preservation) and partly nonhuman defiance (stone will only put up with so much before it sheds its adornments, before it fades and crumbles when exposed to weather and contact and time). We may wish to make the most of this fragility, brokenness and failure, for the 'bare stone seen by the modern viewer is, in effect, a text that allows for ambiguity that can be exploited by the modern iconographer' and when 'reading such stone it is possible to read all the details, and to read them as having potentially equal significance' so that all readings are simultaneously possible.[51] But for how long will this attractive ambiguity last? For how much longer will humans be able to exploit it? When will the damaged stone retreat into utter nonsense? The stone is withdrawing from us all the time.

It seems to want to return to that rocky amorphousness that has more to say about prehistory than history, about a prehuman past prior to columns and crosses. Will the stone cease to function as a monument altogether? And will it not break further and further away from the manuscript poem until no one can remember why these two things were put together in the first place?

Notes

1 Bennett, *Vibrant Matter*, pp. 23–4.
2 See Fred Orton, 'Rethinking the Ruthwell and Bewcastle Monuments: Some Strictures on Similarity; Some Questions of History', in Catherine E. Karkov and Fred Orton (eds), *Theorizing Anglo-Saxon Stone Sculpture* (Morgantown: West Virginia University Press, 2003), pp. 65–92, at 87.
3 Swanton, *English Poetry before Chaucer*, p. 105. A more extensive discussion can be found in Peter Orton, 'The Technique of Object-Personification in *The Dream of the Rood* and a Comparison with the Old English Riddles', *Leeds Studies in English*, 11 (1980), 1–15.
4 Murphy, *Unriddling the Exeter Riddles*, pp. 36–7.
5 References to the text are taken from George P. Krapp (ed.), *The Vercelli Book*, ASPR 2 (London: Routledge, 1932). Translations are mine.
6 TDOE.
7 Ó Carragáin, *Ritual and the Rood*, pp. 326–7.
8 Bennett, *Vibrant Matter*, pp. xiii–xv.
9 Ramey, 'Writing Speaks', p. 348.
10 Carol Braun Pasternack, 'Stylistic Disjunctions in *The Dream of the Rood*', *Anglo-Saxon England*, 13 (1984), 167–86, at 179.
11 See Pasternack, 'Stylistic Disjunctions', p. 177.
12 Lines 8–10; 20–3; 30–4; 39; 40b–43; 46–9; 59–70 of *The Dream* are all hypermetric.
13 Ó Carragáin, *Ritual and the Rood*, p. 328.
14 Pasternack, 'Stylistic Disjunctions', p. 172.
15 See Karkov, *Art of Anglo-Saxon England*, pp. 153–65.
16 Ó Carragáin, *Ritual and the Rood*, p. 328.
17 Details and references to the Vercelli Book are taken from the following facsimile: Celia Sisam (ed.), *The Vercelli Book: A Late Tenth-Century Manuscript Containing Prose and Verse, Vercelli Biblioteca capitolare CXVII* (Copenhagen: Rosenkilde and Bagger, 1976). A concise overview is also provided by Elaine Treharne, 'Manuscript Sources of Old English Poetry', in Gale Owen-Crocker (ed.), *Working with Anglo-Saxon Manuscripts* (Exeter: University of Exeter Press, 2009), pp. 89–111.
18 Pasternack, *Textuality of Old English Poetry*, pp. 1–8, 148.

19 See Charles D. Wright, 'More Old English Poetry in Vercelli Homily XXI', in Elaine M. Treharne, Susan Rosser and D. G. Scragg (eds), *Early Medieval Texts and Interpretations: Studies Presented to Donald G. Scragg* (Tempe: Arizona Center for Medieval and Renaissance Studies, 2002), pp. 245–62.

20 TDOE.

21 See the physical description in Sisam, *The Vercelli Book*, pp. 17–18.

22 Sarah Kay, 'Original Skin: Flaying, Reading, and Thinking in the Legend of Saint Bartholomew and Other Works', *Journal of Medieval and Early Modern Studies*, 36:1 (2006), 35–74; and Sarah Kay, 'Legible Skins: Animals and the Ethic of Medieval Reading', *Postmedieval*, 2:1 (2011), 13–32.

23 Orton and Wood with Lees, *Fragments of History*, p. 167.

24 This is not exactly a 'word-for-word' correspondence; but the Ruthwell runes do sound similar to lines 39–49 and 56–64 of *The Dream of the Rood*.

25 Orton and Wood with Lees, *Fragments of History*, p. 166.

26 Ibid., p. 146.

27 See Bainbrigg's note, British Library MS Cotton Julius VI, folio 352, first published by R. I. Page, 'An Early Drawing of the Ruthwell Cross', *Medieval Archaeology*, 3 (1959), 285–8.

28 Karkov, *Art of Anglo-Saxon England*, p. 138.

29 Orton and Wood with Lees, *Fragments of History*, p. 55.

30 Ibid., pp. 121–4.

31 Ibid., p. 124.

32 Karkov, *Art of Anglo-Saxon England*, p. 145.

33 For the various ways of cutting runes, see Page, *Introduction to English Runes*, pp. 40–1; for the association between cutting, writing and violence, see Frantzen, 'Writing the Unreadable *Beowulf*'.

34 This reading of the monument is informed by some of Jane Hawkes's observations in 'Reading Stone', in Karkov and Orton (eds), *Theorizing Anglo-Saxon Stone Sculpture*, pp. 5–30.

35 Karkov, 'Naming and Renaming', in Karkov and Orton (eds), *Theorizing Anglo-Saxon Stone Sculpture*, p. 46.

36 See Karkov, *Art of Anglo-Saxon England*, p. 145.

37 Ibid., p. 144.

38 Page, *Introduction to English Runes*, pp. 115–16.

39 Orton and Wood with Lees, *Fragments of History*, p. 147.

40 The etymology of the word 'rune' in Old English, Old Norse and related Germanic languages is discussed by Martin Findell, *Runes* (London: British Museum Press, 2014), pp. 8–9.

41 Hawkes, 'Reading Stone', p. 28. In 1999–2000 the Manchester Museum, University of Manchester, recoloured a cast of the Ruthwell monument drawing on evidence surviving from other sculptures, manuscript illuminations and metalwork. Images of this coloured cast

can be viewed online at http://poppy.nsms.ox.ac.uk/woruldhord/con-
tributions/369.

42 Cohen, 'Stories of Stone', 56–63. Cohen revisits these arguments in
his book *Stone: An Ecology of the Inhuman*.

43 See Orton and Wood with Lees, *Fragments of History*, pp. 40–1.

44 Ibid.

45 See Orton, 'Rethinking the Ruthwell and Bewcastle Monuments', in
Karkov and Orton (eds), *Theorizing Anglo-Saxon Stone Sculpture*,
pp. 65–92. See also Orton and Wood with Lees, *Fragments of History*,
pp. 40–7.

46 Karkov, 'Naming and Renaming', p. 35.

47 Ó Carragáin, *Ritual and the Rood*, pp. 17, 19.

48 Orton and Wood with Lees, *Fragments of History*, p. 39.

49 Tilghman, 'On the Enigmatic Nature of Things', p. 34.

50 Cf. Ingold, *Being Alive*, pp. 26–7.

51 Hawkes, 'Reading Stone', pp. 27–8.

Afterword: Old things with new things to say

This book has shown that things could talk in diverse ways in Anglo-Saxon culture and the interpretations of literary and material artefacts presented in this study illustrate the validity of 'thing theory' as a critical focus for our understanding of this period. My aim has been to offer a model of how we can record, reflect on, amplify and interact with nonhuman voices without distorting them. Instead of looking through the early medieval things treated in this study, as if they are windows into a distant time and place, I have demonstrated how swords, ships, pens, boxes, books, bodies, trees, crosses, columns and so on mesh meaning with matter and with acts of making and breaking. These things do not simply carry human voices across the ages but change them, sometimes reshaping or even subverting the messages intended by their original makers. By assembling words, ideas, bodies, materials and technologies together into a distinct whole, a *þing* develops a means of communicating independent of, but not entirely divorced from, the human voice. The concept of voice emerges from Anglo-Saxon culture as an attribute that is not simply imposed upon nonhumans but which inheres in their ways of existing and being in the world. Taken together, these five chapters have established that, in Anglo-Saxon England, humans at once used and relied on things to carry their voices. Early medieval patrons, craftsmen, owners, handlers and viewers did not talk over or about or for things, but talked *with* things. This was a human–nonhuman dialogue, a dialogue that did not end in 1066 but which has continued in the afterlives of Anglo-Saxon texts and artefacts and in the scholarship that has circled those lives. At the same time, this is not a conversation that can be easily contained by human discourse; when we talk with things, *something* always has eluded, and always will elude us. The fact that Anglo-Saxon writers and craftsmen so often employed riddling forms or enigmatic language balances an attempt to speak

and listen to things with a tacit recognition that these nonhuman *wihtu* often elude, defy and withdraw from us.

What are the outcomes of this study of thingness and what directions might further work take? What possibilities are opened up by continuing to connect thing theory with medieval studies and what problems could arise? By progressing from issues of time and change, to movement and assemblage, and, finally, breakage and failure, this book highlights both the potentiality and difficulty of taking a project such as this forward. While the final part of this book looked at how *things* break, how they fail to do what humans want them to do, the brokenness and failure of *theory* should not escape our attention either. Key theoretical concepts – agency, autonomy, subjectivity, objectivity, self, other, voice, body, age, gender, genre – have all been put under strain. These concepts have all played their part in the various branches of critical theory since the latter half of the twentieth century, but by applying them to things, mere things, we take such concepts to the limit of their meaning – that is, we stretch them almost to breaking point.

This is especially true when applying theory to early medieval things, where the gaps in our knowledge of this period prevent us from fully knowing our objects of study, making it difficult to say with absolute certainty how this thing was made, or what that thing was made from, or for whom it was made, or what it was made for, how it functioned, how it might function now, if at all. By claiming animacy or agency, vibrancy or voice, on behalf of things that, from a commonsensical human perspective, seem so inanimate and inert, so still and silent, we not only gain a new understanding of the things themselves but are forced to rethink the concepts we apply to them. This has implications for further, theoretically informed work in medieval studies. For instance, critics in the field of gender studies might be provoked into asking new questions about how women and men assert agency in medieval literature and culture; while those applying postcolonial theories to the Middle Ages might develop new takes on the voice of the subaltern in parallel with ideas about the voice or voicelessness of things; and proponents of critical animal theory may find rich areas of overlap in the treatment of nonhuman animals and the treatment of nonhuman artefacts (or indeed artefacts that used to be, or in some sense still are, animals) in the medieval world.

There is also a risk inherent in this sort of work; a risk that, once stretched to breaking point, these theoretical concepts may no longer work for us as they once did. In the face of such failure, how

should critics and scholars respond? Can we adopt new approaches? I have suggested throughout this book that the time we take to get to know things – and the time taken by things to reveal themselves to us – is of central importance. In the midst of an information age, driven by revolutions in digital technologies, knowledge can be created and shared rapidly, global communication made possible in a heartbeat, networks expanded beyond all comprehension. Such advances facilitate very fast styles of learning and teaching – from the immediate reproduction of images to the use of social media in classrooms – but they can also lead to reassessments of the merits of slower forms of scholarship and pedagogy. Our understanding of the 'voice' or 'agency' or 'otherness' of things will inevitably be shaped by the relative speed or slowness of our encounters with them. Multiple two-dimensional digital images, which can be summoned up, switched between and compared simultaneously, or computer programmes that speed up the processes of creation and decay, will provide us with very different concepts of activity and autonomy, life and death, speech and silence, than, say, prolonged or repetitive looking at an artefact in a museum, or a transcription made by eye and hand. Ongoing discussions of how we practise scholarship in the digital age, and the ways in which these practices enhance or obscure the lives of nonhumans, offer one way of taking theories of medieval things forward.[1]

Underlying the idea of a 'slow scholarship' is the rising challenge to the frantic pace of contemporary academia. In *The Slow Professor* (2016), Maggie Berg and Barbara K. Seeber argue that 'approaching our professional practice from a perspective influenced by the Slow movement has the potential to disrupt the corporate ethos of speed'. More than a simple matter of slowing down, this manifesto is fundamentally an issue of agency. Slow Professors act with purpose, taking the time for deliberation, reflection and dialogue, and cultivating emotional and intellectual resilience.[2] There is an overlap, then, between the 'agonizingly slow' time that it takes for us to trace, follow, recognise and record the agency of things that at first seem stubbornly inert to our senses, and the kinds of agency we might need to cultivate as Slow Professors working in a fast-paced age.[3] Like thing-power, this agency becomes a form of resistance, the ability to impede or redirect forces, changing our relationship with temporality by decelerating or even being still or silent and refusing to act.

The age in which we live and work also raises the question of what the things left behind by the distant, early medieval past

still mean today, in our own time, especially when academics are increasingly being asked to consider (and defend) the impact and relevance of our work. New materialists such as Coole and Frost have highlighted the pressing concerns that 'accompany the scientific and technological advances predicated on new scientific models of matter and, in particular, of living matter'. In addressing these concerns, we 'unavoidably find ourselves having to think in new ways about the nature of matter and the matter of nature; about the elements of life, the resilience of the planet, and the distinctiveness of the human'.[4] But what does this mean for critically and theoretically engaged medievalists? As I have made clear throughout this book, recent trends in thing theory – especially those taken up by medievalists – have drawn heavily upon Latour's controversial argument that the dividing line between human subjects and nonhuman objects was more porous prior to the seventeenth century, meaning that medieval animals and objects were endowed with an autonomy that was largely misrecognised in the wake of Enlightenment empiricism. As we move forward, this and similar claims need to be weighed carefully against the fact that medieval cultures, even early medieval cultures like that of the Anglo-Saxons, did possess scientific ways of knowing – they contemplated the nature of the world, observed natural phenomena and tried to fit their observations into models of how the universe worked.[5] I would argue that there is value in taking a long view and re-examining older, premodern models of how human beings studied and interacted with the rest of the nonhuman world because, from this vantage point, we might ask questions that address imperative environmental, geopolitical and technological challenges. If the boundary between human and nonhuman is more fluid, how can a 'scientific' observation and analysis of nature take place? Must human subjects always remain completely detached from, and in control of, nonhuman objects in order to 'know' them? Might we develop a more nuanced understanding of *scientia* – one that would help us to grasp pre-Enlightenment modes of cognition? Such research would not only be concerned with understanding the past; it also connects with important twenty-first-century concerns about how we, as humans, use and abuse the nonhuman world in our pursuit of knowledge and technological advancement.[6]

Nonhuman things embroiled in ongoing processes of creation or alteration, things that may be fragile or broken, accidental or malfunctioning things, things with a life and a voice independent of

their human makers or owners – things of the talkative kind challenge what we can say about them, what we can call them or classify them as. They challenge our very ways and means of knowing the world, the universe. One way forward is to take our cue from the riddles, which speak about a multitude of things – from the littlest bookworm to the light of the sun and moon – in a poetic language that tries to capture something of the beauty inherent in the fragility, life, death and revival of things while, at the same time, allowing for ambiguity and elusiveness. Indeed, I have shown in this book that Old English literary voices shape our conceptions of Anglo-Saxon things; in turn, these voices assume the shape of the things onto which they have been inscribed. It is this shape or half-shape, hovering between the shape of the speaking subject and that of the object speaking back, a shape always in the midst, however fast or slow, of reshaping, that provokes a response in us – that stirs our speech. We sense that there is something not yet dead, not yet still, not yet silent, not yet past, and this sense makes us talk – makes us want to talk – with Anglo-Saxon things.

Notes

1 Some of these practices were discussed and debated in the two panels on 'Slow Scholarship in the Digital Age' at the Leeds International Medieval Congress, 2014. I am grateful to Catherine Karkov for organising these panels and inviting me to participate.

2 Maggie Berg and Barbara K. Seeber, *The Slow Professor* (Toronto: University of Toronto Press, 2016), p. 11.

3 Bruno Latour describes the process of 'slowciology' in *Reassembling the Social: An Introduction to Actor-Network Theory* (Oxford: Oxford University Press, 2005). See also Lowell Duckert, 'Speaking Stones, John Muir, and a Slower (Non)Humanities', in Jeffrey Jerome Cohen (ed.), *Animal, Vegetable, Mineral: Ethics and Objects* (Washington, DC: Oliphaunt Books, 2012), pp. 273–9.

4 Coole and Frost, *New Materialisms*, p. 6.

5 For an accessible overview of Anglo-Saxon science, see R. M. Liuzza, 'In Measure, and Number, and Weight: Writing Science', in Clare A. Lees (ed.), *The Cambridge History of Early Medieval English Literature* (Cambridge: Cambridge University Press, 2012), pp. 475–98.

6 I have started to address some of these research questions in my own scholarship of late. See, for example, James Paz, 'Magic that Works: Performing *Scientia* in the Old English Metrical Charms and Poetic Dialogues of Solomon and Saturn', *Journal of Medieval and Early Modern Studies*, 45:2 (Spring 2015), 219–43.

Bibliography

Primary sources

Ælfric of Eynsham, *Colloquy*, ed. G. N. Garmonsway (Exeter: University of Exeter Press, rev. edn, 1991).

Ælfric of Eynsham, 'Life of St Edmund', in *Ælfric's Lives of Saints*, ed. W. W. Skeat, vol. 2 (Oxford: Oxford University Press, 1966), pp. 318–20.

Aldhelm, *The Poetic Works*, ed. and trans. Michael Lapidge and James L. Rosier (Cambridge: D. S. Brewer, 1985).

Alexander, Michael (trans.), *Beowulf: A Verse Translation* (Harmondsworth: Penguin, 1973).

Asser, *Life of King Alfred*, ed. William Henry Stevenson (Oxford: Clarendon Press, 1959).

Barnhart, Robert K., et al. (eds), *The Chambers Dictionary of Etymology* (London: Chambers, 1999).

Bede, *Ecclesiastical History of the English People*, ed. Bertram Colgrave and R. A. B. Mynors (Oxford: Oxford University Press, 1969).

Bede, *Ecclesiastical History of the English People*, ed. Judith McClure and Roger Collins (Oxford: Oxford University Press, 1994).

Borges, Jorge Luis, *The Book of Imaginary Beings* (London: Vintage, 2002).

Borges, Jorge Luis, *Selected Poems*, ed. Alexander Coleman (London: Penguin, 1999).

Byrhtferth of Ramsey, *Enchiridion*, ed. and trans. Peter S. Baker and Michael Lapidge (Oxford: Oxford University Press, 1995).

Cameron, Angus, Ashley Crandell Amos, Antonette diPaolo Healey et al. (eds), *The Toronto Dictionary of Old English Corpus in Electronic Form* (Toronto: 1981–).

Chickering, Howell D. (trans.), *Beowulf: A Dual-Language Edition* (New York: Anchor, 2006).

Colgrave B. (ed. and trans.), *Two Lives of Cuthbert* (Cambridge: Cambridge University Press, 1940).

Cook, Robert (ed. and trans.), *Njal's Saga* (London: Penguin Classics, 2001).

Crossley-Holland, Kevin (trans.), *The Exeter Book Riddles* (London: Enitharmon, 1978).

Delanty, Greg, and Michael Matto (eds), *The Word Exchange: Anglo-Saxon Poems in Translation* (London: W. W. Norton and Co., 2011).

Doane, A. N. (ed.), *Genesis A: A New Edition* (Madison: University of Wisconsin Press, 1978).

Doane, A. N. (ed.), *The Saxon Genesis: An Edition of the West Saxon Genesis B and the Old Saxon Vatican Genesis* (Madison: University of Wisconsin Press, 1991).

Fulk, R. D., Robert E. Bjork and John D. Niles (eds), *Klaeber's Beowulf and the Fight at Finnsburg,* 4th edn (Toronto: University of Toronto Press, 2008).

Heaney, Seamus (trans.), *Beowulf: A Bilingual Edition* (London: Faber and Faber, 1999).

Isidore, *Etymologies*, ed. W. M. Lindsay (Oxford: Oxford University Press, 1911).

Juster, A. M. (trans.), *Saint Aldhelm's Riddles* (Toronto: University of Toronto Press, 2015).

Ker, N. R. (ed.), *The Pastoral Care* (Copenhagen: Rosenkilde and Bagger, 1956).

Krapp, George P. (ed.), *The Vercelli Book*, ASPR 2 (London: Routledge, 1932).

Muir, Bernard J. (ed.), *The Exeter Anthology of Old English Poetry: An Edition of Exeter Dean and Chapter MS 3501* (Exeter: University of Exeter Press, 1994).

Onions, C. T., et al. (eds), *The Oxford Dictionary of English Etymology* (Oxford: Oxford University Press, 1966).

Prosopography of Anglo-Saxon England, www.pase.ac.uk.

Ringler, Dick (trans.), *Beowulf: A New Translation for Oral Delivery* (Indianapolis: Hackett, 2007).

Sisam, Celia (ed.), *The Vercelli Book: A Late Tenth-Century Manuscript Containing Prose and Verse, Vercelli Biblioteca capitolare CXVII* (Copenhagen: Rosenkilde and Bagger, 1976).

St Augustine, *The City of God against the Pagans*, trans. William H. Green (Cambridge, MA: Harvard University Press, 1972).

St Augustine, *Confessions*, ed. James J. O'Donnell (Oxford: Oxford University Press, 1992).

St Augustine, *De doctrina christiana*, ed. and trans. R. P. H. Green (Oxford: Clarendon Press, 1995).

Stephen of Ripon, *The Life of Bishop Wilfrid by Eddius Stephanus*, ed. and trans. Bertram Colgrave (Cambridge: Cambridge University Press, 1927).

Toller, Thomas Northcote, *An Anglo-Saxon Dictionary: Based on the Manuscript Collections of Joseph Bosworth Supplement, by T. Northcote Toller* (Oxford: Clarendon Press, 1972).

Whitelock, Dorothy (ed.), *Sweet's Anglo-Saxon Reader* (Oxford: Oxford University Press, 1967).

Williamson, Craig (ed. and trans.), *Beowulf and Other Old English Poems* (Philadelphia, PA: University of Pennsylvania Press, 2011).

Williamson, Craig (ed. and trans.), *A Feast of Creatures: Anglo-Saxon Riddle-Songs* (Philadelphia, PA: University of Pennsylvania Press, 2011).

Williamson, Craig (ed. and trans.), *The Old English Riddles of the Exeter Book* (Chapel Hill: University of North Carolina Press, 1977).

Wordsworth, William, 'Preface to *Lyrical Ballads*', in *William Wordsworth: The Major Works*, ed. Stephen Gill (Oxford: Oxford University Press, 2008), pp. 595–615.

Secondary sources

Acker, Paul, 'Horror and the Maternal in *Beowulf*', *PMLA*, 121 (2006), 702–16.

Alfano, Christine, 'The Issue of Feminine Monstrosity: A Reevaluation of Grendel's Mother', *Comitatus*, 23 (1992), 1–16.

Amodio, Mark C., *Writing the Oral Tradition: Oral Poetics and Literate Culture in Medieval England* (Notre Dame: University of Notre Dame Press, 2004).

Appadurai, Arjun (ed.), *The Social Life of Things: Commodities in Cultural Perspective* (Cambridge: Cambridge University Press, 1986).

Becker, Alfred, 'Franks Casket Revisited', *Asterisk*, 12:2 (2003), 84–128.

Bennett, Jane, *Vibrant Matter: A Political Ecology of Things* (Durham: Duke University Press, 2010).

Berg, Maggie, and Barbara K. Seeber, *The Slow Professor* (Toronto: University of Toronto Press, 2016).

Bitterli, Dieter, *Say What I Am Called: The Old English Riddles of the Exeter Book and the Anglo-Latin Riddle Tradition* (Toronto: University of Toronto Press, 2009).

Blackwell, Mark (ed.), *The Secret Life of Things: Animals, Objects and It-Narratives in Eighteenth-Century England* (Lewisburg, PA: Bucknell University Press, 2007).

Bogost, Ian, *Alien Phenomenology, or, What It's Like to Be a Thing* (Minneapolis: University of Minnesota Press, 2012).

Bonjour, Adrien, 'Grendel's Dam and the Composition of *Beowulf*', *English Studies*, 30 (1949), 113–24.

Bonner, Gerald, David Rollason and Clare Stancliffe (eds), *St Cuthbert, His Cult and Community* (Woodbridge: Boydell and Brewer, 1989).

Brantley, Jessica, 'Material Culture', in Marion Turner (ed.), *A Handbook of Middle English Studies* (Oxford: Wiley-Blackwell), pp. 187–206.

Bredehoft, Thomas A., 'First-Person Inscriptions and Literacy in Anglo-Saxon England', *ASSAH*, 9 (1996), 103–10.

Brown, Bill, *A Sense of Things: The Object Matter of American Literature* (Chicago: University of Chicago Press, 2003).

Brown, Bill (ed.), *Things* (Chicago: University of Chicago Press, 2004).

Brown, Bill, 'Thing Theory', *Critical Inquiry*, 28:1 (Autumn 2001), 1–22.

Brown, Michelle, *The Lindisfarne Gospels: Society, Spirituality and the Scribe* (London: The British Library, 2003).

Brown, Peter, *The Rise of Western Christendom* (Oxford: Blackwell, 2003).

Bryant, Levi, *The Democracy of Objects* (Ann Arbor: Open Humanities Press, 2011).

Bryant, Levi, Nick Srnicek and Graham Harman (eds), *The Speculative Turn: Continental Materialism and Realism* (Melbourne: re.press, 2011).

Camille, Michael, *Image on the Edge: The Margins of Medieval Art* (London: Reaktion, 1992).

Candlin, Fiona, and Raiford Guins (eds), *The Object Reader* (London: Routledge, 2009).

Caple, Chris, *Objects: Reluctant Witnesses to the Past* (London: Routledge, 2006).

Chance, Jane, 'The Structural Unity of *Beowulf*: The Problem of Grendel's Mother', in Helen Damico and Alexandra Hennessey (eds), *New Readings on Women in Old English Literature* (Bloomington: Indiana University Press, 1990), pp. 248–61.

Cohen, Jeffrey Jerome (ed.), *Animal, Vegetable, Mineral: Ethics and Objects* (Washington, DC: Oliphaunt Books, 2012).

Cohen, Jeffrey Jerome, *Stone: An Ecology of the Inhuman* (Minneapolis: University of Minnesota Press, May 2015).

Cohen, Jeffrey Jerome, 'Stories of Stone', *Postmedieval*, 1:2 (Spring/ Summer 2010), 56–63.

Cohen, Jeffrey Jerome, and Julian Yates (eds), *Object Oriented Environs* (Earth: Punctum Books, 2016).

Coole, Diana, and Samantha Frost (eds), *New Materialisms: Ontology, Agency and Politics* (Durham: Duke University Press, 2010).

Craig, G., 'Alfred the Great: A Diagnosis', *Journal of the Royal Society of Medicine*, 84 (May 1991), 303–5.

Dailey, Patricia, 'Riddles, Wonder and Responsiveness in Anglo-Saxon Literature', in Clare A. Lees (ed.), *The Cambridge History of Early Medieval English Literature* (Cambridge: Cambridge University Press, 2012), pp. 451–72.

Dale, Corinne, 'Suffering, Servitude, Power: Eco-Critical and Eco-Theological Readings of the Exeter Book Riddles' (unpublished doctoral thesis, Royal Holloway, University of London, 2015).

Dalton, O. M., *Catalogue of the Ivory Carvings of the Christian Era in the British Museum* (London: British Museum Press, 1909).

Damico, Helen, 'The Valkyrie Reflex in Old English Literature', in Helen Damico and Alexandra Hennessey Olsen (eds), *New Readings on Women in Old English Literature* (Bloomington: Indiana University Press, 1990), pp. 176–89.

Daston, Lorraine, *Biographies of Scientific Objects* (Chicago: University of Chicago Press, 2000).

Daston, Lorraine (ed.), *Things that Talk: Object Lessons from Art and Science* (New York: Zone Books, 2004).

Daston, Lorraine, and Greg Mitman (eds), *Thinking with Animals: New Perspectives on Anthropomorphism* (New York: Columbia University Press, 2005).

De Grazia, Margreta, Maureen Quilligan and Peter Stallybrass (eds), *Subject and Object in Renaissance Culture* (Cambridge: Cambridge University Press, 1996).

De Hamel, Christopher, *Medieval Craftsmen: Scribes and Illuminators* (London: British Museum Press, 1992).

Deleuze, Gilles, and Félix Guattari, *A Thousand Plateaus*, trans. B. Massumi (London: Continuum, 2004).

Dietrich, Franz Eduard, 'Die Rathsel des Exeterbuchs: Wurdigung, Losung und Herstellung', *ZfdA*, 11 (1859), 448–90.

Donoghue, Daniel, 'An *Anser* for Exeter Book Riddle 74', in Peter S. Baker and Nicholas Howe (eds), *Words and Works: Studies in Medieval English Language and Literature in Honour of Fred C. Robinson* (Toronto: University of Toronto Press, 1998), pp. 45–58.

Earl, James W., 'Violence and Non-Violence in Anglo-Saxon England: Ælfric's "Passion of St. Edmund"', *Philological Quarterly*, 78 (1999), 125–49.

Elliott, R. W. V., *Runes: An Introduction,* 2nd edn (Manchester: Manchester University Press, 1989).

Findell, Martin, *Runes* (London: British Museum Press, 2014).

Foley, John Miles, 'How Genres Leak in Traditional Verse', in Mark C. Amodio and Katherine O'Brien O'Keeffe (eds), *Unlocking the Wordhord: Anglo-Saxon Studies in Memory of Edward B. Irving Jr.* (Toronto: University of Toronto Press, 2003), pp. 79–80.

Foys, Martin K., 'Media', in Jacqueline A. Stodnick and Renée R. Trilling (eds), *A Handbook to Anglo-Saxon Studies* (Oxford: Wiley-Blackwell, 2012), pp. 133–48.

Foys, Martin K., *Virtually Anglo-Saxon: Old Media, New Media, and Early Medieval Studies in the Late Age of Print* (Gainsville: University Press of Florida, 2007).

Frank, Roberta, 'The Unbearable Lightness of Being a Philologist', *JEGP*, 96 (1997), 486–513.

Frantzen, Allen J., 'Writing the Unreadable *Beowulf*', in Eileen A. Joy and Mary K. Ramsey (eds), *The Postmodern Beowulf: A Critical Casebook* (Morgantown: West Virginia University Press, 2006), pp. 91–129.

Geary, Patrick, 'Sacred Commodities: The Circulation of Medieval Relics', in Arjun Appadurai (ed.), *The Social Life of Things: Commodities in Cultural Perspective* (Cambridge: Cambridge University Press, 1986), pp. 169–91.

Griffith, Mark, 'Exeter Book Riddle 74 *Ac* "Oak" and *Bat* "Boat"', *Notes and Queries*, 55 (2008), 393–6.

Griffiths, Bill, *Aspects of Anglo-Saxon Magic* (Frithgarth: Anglo-Saxon Books, 1996).

Harbus, Antonina, '*Exeter Book Riddle 39* Reconsidered', *SN*, 70 (1998), 139–48.

Harman, Graham, 'The Theory of Objects in Heidegger and Whitehead', in *Towards Speculative Realism: Essays and Lectures* (Winchester: Zero Books, 2010), pp. 22–43.

Harman, Graham, *Tool-Being: Heidegger and the Metaphysics of Objects* (Chicago: Open Court, 2002).

Hawkes, Jane, 'The Lindisfarne Gospels', in Tim Ayers (ed.), *The History of British Art: 600–1600* (London: Tate Publishing, 2008), pp. 198–9.

Hawkes, Jane, 'Sacraments in Stone: The Mysteries of Christ in Anglo-Saxon Sculpture', in Martin Carver (ed.), *The Cross Goes North: Processes of Conversion in Northern Europe, AD 300–1300* (Suffolk: York Medieval Press, 2003), pp. 351–70.

Heidegger, Martin, *Poetry, Language, Thought*, trans. A. Hofstadter (London: Harper, 1971).

Heidegger, Martin, *What Is a Thing?* trans. W. B. Barton Jr. and Vera Deutsch (Chicago: Henry Regnery, 1970).

Hinton, David A., 'Anglo-Saxon Smiths and Myths', *Bulletin of the John Rylands Library*, 80:1 (1998), 3–22.

Hodder, Ian, *Entangled: An Archaeology of the Relationships between Humans and Things* (Oxford: Wiley-Blackwell, 2012).

Hodder, Ian, 'Human–Thing Entanglement: Towards an Integrated Archaeological Perspective', *Journal of the Royal Anthropological Institute*, 17 (2011), 154–77.

Hoek, Michelle C., 'Anglo-Saxon Innovation and the Use of the Senses in the Old English Physiologus Poems', *Studia Neophilologica*, 69:1 (1997), 1–10.

Holsinger, Bruce, 'Object-Oriented Mythography', *Minnesota Review*, 80 (2013), 119–30.

Holsinger, Bruce, 'Of Pigs and Parchment: Medieval Studies and the Coming of the Animal', *PMLA*, 124 (2009), 616–23.

Holthausen, Ferdinand, 'Anglosaxonica Minora', *Beiblatt zur Anglia*, 36 (1925), 219–20.

Horner, Shari, *The Discourse of Enclosure: Representing Women in Old English Literature* (New York: SUNY Press, 2001).

Howe, Nicholas, 'The Cultural Construction of Reading in Anglo-Saxon England', in Jonathan Boyarin (ed.), *The Ethnography of Reading* (Berkley, CA: University of California Press, 1993), pp. 58–79.

Ingham, Patricia Clare, 'Introductory Note: Premodern Things', *Exemplaria*, 22:2 (2010), 97–8.

Ingold, Tim, *Being Alive: Essays on Movement, Knowledge and Description* (London: Routledge, 2011).

Ingold, Tim, *Making: Anthropology, Archaelogy, Art and Architecture* (London: Routledge, 2013).

Jager, Eric, 'Speech and the Chest in Old English Poetry: Orality or Pectorality?', *Speculum*, 65:4 (1990), 845–59.

Joy, Eileen A., and Mary K. Ramsey (eds), *The Postmodern Beowulf: A Critical Casebook* (Morgantown: West Virginia University Press, 2006).

Karkov, Catherine E., *The Art of Anglo-Saxon England* (Woodbridge: Boydell Press, 2011).

Karkov, Catherine E., and Fred Orton (eds), *Theorizing Anglo-Saxon Stone Sculpture* (Morgantown: West Virginia University Press, 2003).

Kay, Sarah, 'Legible Skins: Animals and the Ethics of Medieval Reading', *Postmedieval: A Journal of Medieval Cultural Studies*, 2:1 (2011), 13–32.

Kay, Sarah 'Original Skin: Flaying, Reading, and Thinking in the Legend of Saint Bartholomew and Other Works', *Journal of Medieval and Early Modern Studies*, 36:1 (2006), 35–74.

Keefer, Sarah Larratt, ' "Either/And" as "Style" in Anglo-Saxon Christian Poetry', in Catherine E. Karkov and George Hardin Brown (eds), *Anglo-Saxon Styles* (Albany, NY: State University of New York Press, 2003), pp. 179–200.

Kennedy, Christopher B., 'Old English Riddle No. 39', *ELN*, 13 (1975), 81–5.

Kiernan, Kevin, 'Grendel's Heroic Mother', *In Geardagum*, 6 (1984), 13–33.

Klein, Thomas, 'Of Water and the Spirit: Metaphorical Focus in Exeter Book Riddle 74', *Review of English Studies*, 66:273 (2014), 1–19.

Kuhn, Sherman M., 'Old English Aglæca-Middle Irish Oclach', in Irmengard Rauch and Gerald F. Carr (eds), *Linguistic Method: Essays in Honour of Herbert Penzl* (The Hague: Mouton, 1979), pp. 213–30.

Latour, Bruno, *Reassembling the Social: An Introduction to Actor-Network Theory* (Oxford: Oxford University Press, 2005).

Latour, Bruno, *We Have Never Been Modern*, trans. Catherine Porter (Cambridge, MA: Harvard University Press, 1993).

Lees, Clare A. (ed.), *The Cambridge History of Early Medieval English Literature* (Cambridge: Cambridge University Press, 2012).

Lees, Clare A., *Tradition and Belief: Religious Writing in Late Anglo-Saxon England* (Minneapolis, MN: University of Minnesota Press, 1999).

Lees, Clare A., and Gillian R. Overing, *Double Agents: Women and Clerical Culture in Anglo-Saxon England* (Philadelphia, PA: University of Pennsylvania Press, 2001).

Lees, Clare A., and Gillian R. Overing (eds), *A Place to Believe In: Locating Medieval Landscapes* (University Park, PA: Penn State University Press, 2006).

Lerer, Seth, *Literacy and Power in Anglo-Saxon Literature* (Lincoln: University of Nebraska Press, 1991).

Liebermann, Felix, *The National Assembly in the Anglo-Saxon Period* (New York: Franklin, 1961).

Lightsey, Scott, *Manmade Marvels in Medieval Culture and Literature* (New York: Palgrave, 2007).

Liuzza, R. M., 'In Measure, and Number, and Weight: Writing Science', in Clare A. Lees (ed.), *The Cambridge History of Early Medieval English Literature* (Cambridge: Cambridge University Press, 2012), pp. 475–98.

Lockett, Leslie, 'The Role of Grendel's Arm in Feud, Law, and the Narrative Strategy of *Beowulf*, in Katherine O'Brien O'Keeffe and Andy Orchard (eds), *Latin Learning and English Lore: Studies in Anglo-Saxon Literature for Michael Lapidge* (Toronto: University of Toronto Press, 2005), pp. 368–88.

MacGregor, Arthur, *Bone, Antler, Ivory, and Horn: The Technology of Skeletal Materials since the Roman Period* (London: Barnes and Noble, 1985).

Marsden, Richard, *The Text of the Old Testament in Anglo-Saxon England* (Cambridge: Cambridge University Press, 1995).

Morton, Timothy, *Hyperobjects: Philosophy and Ecology after the End of the World* (Minneapolis: University of Minnesota Press, 2013).

Miller, Daniel, *The Comfort of Things* (Cambridge: Polity Press, 2008).

Miller, Daniel (ed.), *Materiality* (Durham: Duke University Press, 2005).

Murphy, Patrick J., *Unriddling the Exeter Riddles* (University Park, PA: Pennsylvania State University Press, 2011), pp. 19–20.

Neuman de Vegvar, Carol, 'The Travelling Twins: Romulus and Remus in Anglo-Saxon England', in Jane Hawkes and Susan Mills (eds), *Northumbria's Golden Age* (Gloucestershire: Sutton, 1999), pp. 256–67.

Neville, Jennifer, *Representations of the Natural World in Old English Poetry* (Cambridge: Cambridge University Press, 2006).

Niles, John D., *Old English Enigmatic Poems and the Play of the Texts* (Turnhout: Brepolis, 2006).

Niles, John D., 'Ring Composition and the Structure of *Beowulf*, *PMLA*, 94:5 (1979), 924–35.

O' Brien O' Keeffe, Katherine, *Visible Song: Transitional Literacy in Old English Verse* (Cambridge: Cambridge University Press, 1990).

Ó Carragáin, Éamonn, *Ritual and the Rood: Liturgical Images and the Old English Poems of the Dream of the Rood Tradition* (London: British Library, 2005).

Olsen, Alexandra, 'The Aglæca and the Law', *American Notes and Queries*, 20 (1982), 66–8.

Olsen, Bjornar, *In Defense of Things: Archaeology and the Ontology of Objects* (Plymouth: AltaMira, 2010).

Orchard, Andy, 'Enigma Variations: The Anglo-Saxon Riddle-Tradition', in Katherine O'Brien O'Keeffe and Andy Orchard (eds), *Latin Learning*

and English Lore: Studies in Anglo-Saxon Literature for Michael Lapidge (Toronto: University of Toronto Press, 2005), pp. 284–304.

Orchard, Andy, *Pride and Prodigies: Studies in the Monsters of the Beowulf-Manuscript* (Cambridge: D. S. Brewer, 1995).

Orton, Fred, and Ian Wood with Clare A. Lees, *Fragments of History: Rethinking the Ruthwell and Bewcastle Monuments* (Manchester: Manchester University Press, 2007).

Orton, Peter, 'The Speaker in *The Husband's Message*', *Leeds Studies in English*, 12 (1981), 43–56.

Orton, Peter, 'The Technique of Object-Personification in *The Dream of the Rood* and a Comparison with the Old English Riddles', *Leeds Studies in English*, 11 (1980), 1–15.

Osborn, Marijane, 'The Lid as Conclusion of the Syncretic Theme of the Franks Casket', in A. Bammesberger (ed.), *Old English Runes and their Continental Background* (Heidelberg: Winter, 1991), pp. 249–68.

Overing, Gillian R., '*Beowulf* on Gender', *New Medieval Literatures*, 12 (2010), 1–22.

Overing, Gillian R., *Language, Sign, and Gender in "Beowulf"* (Carbondale: Southern Illinois University Press, 1990).

Page, R. I., 'An Early Drawing of the Ruthwell Cross', *Medieval Archaeology*, 3 (1959), 285–8.

Page, R. I., *An Introduction to English Runes*, 2nd edn (Woodbridge: Boydell Press, 1999).

Page, R. I., *Runes and Runic Inscriptions* (Woodbridge: Boydell Press, 1995).

Pasternack, Carol Braun, 'Stylistic Disjunctions in *The Dream of the Rood*', *Anglo-Saxon England*, 13 (1984), 167–86.

Pasternack, Carol Braun, *The Textuality of Old English Poetry* (Cambridge: Cambridge University Press, 1995).

Paz, James, 'Æschere's Head, Grendel's Mother and the Sword that Isn't a Sword: Unreadable Things in *Beowulf*', *Exemplaria*, 25:3 (2013), 231–51.

Paz, James, 'Franks Casket', in Siân Echard and Robert Rouse (eds), *Wiley-Blackwell Encyclopaedia of British Medieval Literature* (Oxford: Wiley-Blackwell, forthcoming).

Paz, James, 'Lindisfarne Gospels', in Siân Echard and Robert Rouse (eds), *Wiley-Blackwell Encyclopaedia of British Medieval Literature* (Oxford: Wiley-Blackwell, forthcoming).

Paz, James, 'Magic that Works: Performing *Scientia* in the Old English Metrical Charms and Poetic Dialogues of Solomon and Saturn', *Journal of Medieval and Early Modern Studies*, 45:2 (Spring 2015), 219–43.

Pratt, David, 'Persuasion and Invention at the Court of King Alfred the Great', in Catherine Cubitt (ed.), *Court Culture in the Early Middle Ages* (Turnhout: Brepols, 2003), pp. 189–222.

Price, Helen, 'Human and NonHuman in Anglo-Saxon and British Postwar Poetry: Reshaping Literary Ecology' (unpublished doctoral thesis, University of Leeds, 2013).

Ramey, Peter, 'Writing Speaks: Oral Poetics and Writing Technology in the Exeter Book Riddles', *Philological Quarterly*, 92:3 (2013), 335–56.

Robertson, Kellie, 'Medieval Materialism: A Manifesto', *Exemplaria*, 22:2 (2010), 99–118.

Robertson, Kellie, 'Medieval Things: Materiality, Historicism, and the Premodern Object', *Literature Compass*, 5:6 (2008), 1060–80.

Robinson, James, *Finer than Gold: Saints and Relics in the Middle Ages* (London: British Museum Press, 2011).

Rollason, David W., *Saints and Relics in Anglo-Saxon England* (Oxford: Blackwell, 1989).

Salvador-Bello, Mercedes, *Isidorean Perceptions of Order: The Exeter Book Riddles and Medieval Latin Enigmata* (Morgantown: West Virginia University Press, 2015).

Schlauch, Margaret, 'The "Dream of the Rood" as Prosopopoeia', in P. W. Long (ed.), *Essays and Studies in Honour of Carleton Brown* (New York: New York University Press, 1940), pp. 23–34.

Serres, Michel, *The Natural Contract*, trans. Elizabeth MacArthur and William Paulson (Ann Arbor: University of Michigan Press, 2001).

Serres, Michel, *Statues: Le Second Livre de Fondations* (Paris: Flammarion, 1987).

Siewers, Alfred K., *Strange Beauty: Ecocritical Approaches to Early Medieval Landscape* (New York: Palgrave, 2009).

Smith, Julia M. H., *Europe after Rome: A New Cultural History 500–1000* (Oxford: Oxford University Press, 2005).

Stancliffe, Clare, 'Red, White and Blue Martyrdom', in Dorothy Whitelock, Rosamond McKitterick and David Dumville (eds), *Ireland in Early Mediaeval Europe: Studies in Memory of Kathleen Hughes* (Cambridge: Cambridge University Press, 1982), pp. 21–46.

Steel, Karl, *How to Make a Human: Animals and Violence in the Middle Ages* (Columbus: Ohio State University Press, 2011).

Stock, Brian, *Listening for the Text: On the Uses of the Past* (Baltimore: Johns Hopkins University Press, 1990).

Swanton, Michael, *English Poetry before Chaucer* (Exeter: University of Exeter Press, 2002).

Szabo, Vicki Ellen, 'Bad to the Bone? The Unnatural History of Monstrous Medieval Whales', in *The Heroic Age*, 8 (2005), www.hero-icage.org/issues/8/szabo.html.

Tiffany, Daniel, 'Lyric Substance: On Riddles, Materialism, and Poetic Obscurity', *Critical Inquiry*, 28:1 (Autumn 2001), 72–98.

Tilghman, Benjamin C., 'On the Enigmatic Nature of Things in Anglo-Saxon Art', *Different Visions: A Journal of New Perspectives*

on Medieval Art, 4 (Jan 2014), http://differentvisions.org/
on-the-enigmatic-nature-of-things-in-anglo-saxon-art.

Tilley, Christopher, *The Materiality of Stone: Explorations in Landscape Phenomenology* (Oxford: Berghahn, 2004).

Tolkien, J. R. R., '*Beowulf*: The Monsters and the Critics', in Lewis E. Nicholson (ed.), *An Anthology of Beowulf Criticism* (Notre Dame: University of Notre Dame Press, 1963).

Trautmann, Moritz (ed.), *Die altenglischen Ratsel (die Ratsel des Exeterbuchs)* (Heidelberg: C. Winter, 1915).

Treharne, Elaine, 'Manuscript Sources of Old English Poetry', in Gale Owen-Crocker (ed.), *Working with Anglo-Saxon Manuscripts* (Exeter: University of Exeter Press, 2009), pp. 89–111.

Trilling, Renée R., 'Beyond Abjection: The Problem with Grendel's Mother Again', *Parergon*, 24:1 (2007), 1–20.

Tupper, Jr., Frederick, 'Anglo-Saxon Dæg-Mæl', *PMLA*, 10:2 (1885), 111–241.

Tupper, Jr., Frederick, 'Solutions of the Exeter Book Riddles', *Modern Language Notes*, 21:4 (1906), 97–105.

Turkle, Sherry (ed.), *Evocative Objects: Things We Think with* (Cambridge, MA: MIT Press, 2007).

Vandersall, Amy L., 'The Date and Provenance of the Franks Casket', *Gesta*, 11:2 (1972), 9–26.

Vaught, Jacqueline, '*Beowulf*: The Fight at the Centre', *Allegorica*, 5 (1980), 125–37.

Walz, John A., 'Notes on the Anglo-Saxon Riddles', *Harvard Studies and Notes in Philology and Literature*, 5 (1896), 261–8.

Webster, Leslie, '*Aedificia Nova*: Treasures of Alfred's Reign', in Timothy Reuter (ed.), *Alfred the Great* (Aldershot: Ashgate Publishing, 2003), pp. 79–103.

Webster, Leslie, 'Archaeology and *Beowulf*', in Bruce Mitchell and Fred C. Robinson (eds), *Beowulf: An Edition* (Oxford: Blackwell, 1998), pp. 183–94.

Webster, Leslie, *The Franks Casket: British Museum Objects in Focus* (London: British Museum Press, 2012).

Webster, Leslie, 'The Franks Casket', in Leslie Webster and Janet Backhouse (eds), *The Making of England: Anglo-Saxon Art and Culture, AD 600–900* (London: British Museum Press, 1991), pp. 101–3.

Webster, Leslie, 'The Iconographic Programme of the Franks Casket', in Jane Hawkes and Susan Mills (eds), *Northumbria's Golden Age* (Gloucestershire: Sutton, 1999), pp. 227–46.

Webster, Leslie, 'Stylistic Aspects of the Franks Casket', in R. Farrell (ed.), *The Vikings* (London: Phillimore, 1982), pp. 20–31.

Whitman, F. H., *Old English Riddles* (Ottawa: Canadian Federation for the Humanities, 1982).

Wood, Ian, 'Ripon, Francia and the Franks Casket in the Early Middle Ages', *Northern History*, 26 (1990), 1–19.

Wright, Charles D., 'More Old English Poetry in Vercelli Homily XXI', in Elaine M. Treharne, Susan Rosser and D. G. Scragg (eds), *Early Medieval Texts and Interpretations: Studies Presented to Donald G. Scragg* (Tempe: Arizona Center for Medieval and Renaissance Studies, 2002), pp. 245–62.

Yates, Julian, *Error, Misuse, Failure: Object Lessons from the English Renaissance* (Minneapolis, MN: University of Minnesota Press, 2003).

Index

Note: page numbers in *italic* refer to illustrations.
Note: an 'n' after a page reference indicates the endnote number.

actor-network theory 30n.16, 220n.3
Ædwen's brooch 11, 22
Ælfric
 Colloquy 130
 Life of St Edmund 43
Æschere 34–44, 50, 53, 56
æstels 24s
Aldhelm 72–3, 76–7, 78, 87, 88,
 96n.54, 127
 Enigma IX ('diamond') 76–7
 Enigma XVI ('cuttlefish') 78
 Enigma XXIV ('dragon-stone') 77
 Enigma XXX ('alphabet') 88
 Enigma LII ('candle') 72–3
 Enigma LIX ('pen') 87
Alfred the Great 42, 70–2,
 94n.26, 94n.30
 candle clock 70–2, 94n.26
 Preface to the Pastoral Care 42
Alfred Jewel 24
Althing (Icelandic national
 parliament) 8
Andreas 1, 208–9
animals 5, 20, 63–8, 80, 84–8,
 126–33, 160–2, 165–6,
 194, 217
 see also birds; fish
anthropocentrism 5, 59, 162, 205
anthropomorphism 59, 82, 92n.2
archaeology 4, 23, 50
Asser
 Life of King Alfred 70–2

Augustine of Hippo, St
 Confessions 67
 De civitate Dei 71
 De doctrina Christiana 65

beasts *see* animals
Bede
 De temporum ratione 69
 *Ecclesiastical History (Historia
 ecclesiastica)* 18, 66, 151
 Life of St Cuthbert (metrical)
 142, 152–3
 Life of St Cuthbert (prose) 142,
 148, 152–60
Benedict Biscop 101, 124, 143, 150
Beowulf 8–9, 10–11, 12, 18, 34–56,
 64, 166
 see also Æschere; Grendel;
 Grendel's mother; Hrothgar
Bewcastle monument 73–7
birds 10, 78, 84–8, 99, 113, 114,
 117, 165–6
bodies
 animal bodies 5, 20, 80, 96n.54,
 126–33, 160–2, 194
 body of Christ *see* Christ
 body in pain 144–6, 164
 saintly bodies 43, 139–60, 170–1
 severed hands 42
 severed heads 12, 41–4, 50, 113, 170
 and things 61–3, 72–3, 78–83
 see also relics

Borges, Jorge Luis 1, 29, 102
 Book of Imaginary Beings 132,
 137n.71
 'Things' 1
brooches 11, 22
Brussels Cross 18, 194–5
Byrhtferth of Ramsey
 Enchiridion 69, 74

Cædmon 18, 20
candle clock *see* Alfred the Great
candles 68, 70–3
Christ 74, 99, 112, 115, 116–17,
 127, 133, 143–6, 162,
 165–7, 179, 183–7,
 198–201, 205–6
Columba, St 146–7
craft 12, 47, 90–1, 128
crosses 12–13, 18, 145, 159, 164–70,
 175–213 *passim*
cryptography 53, 103, 110, 129
Cuthbert, St 139–60, 163, 164, 166,
 167, 168, 169, 170–1

Dream of the Rood, The 1, 13, 18, 21,
 92n.1, 159, 175–95, 196, 212
dream visions 5, 20–1, 191, 195
 dreams and riddles 177

Eadfrith, bishop of
 Lindisfarne 163–5
Edmund, St 43
enigmas *see* Aldhelm; Symphosius
environment 139, 141, 146–50,
 160–3, 165–6, 171n.5
epigraphy 22–6, 195
Exeter Book *see* manuscripts
Exeter Book riddles
 Riddle 5 ('shield') 20
 Riddle 7 ('swan') 84–7
 Riddle 12 ('ox and leather')
 96n.54
 Riddle 14 ('horn') 22
 Riddle 20 ('sword') 10
 Riddle 24 ('magpie') 10
 Riddle 25 ('onion') 10, 22
 Riddle 26 ('gospel book') 20, 128,
 161–2, 166

Riddle 30a ('tree') 180
Riddle 39 (solution uncertain) 1,
 61–8, 70
Riddle 44 ('key and lock') 12
Riddle 47 ('book moth') 10, 180
Riddle 51 ('pen and
 fingers') 42, 87
Riddle 60 ('reed') 88–92, 128
Riddle 74 (solution uncertain)
 78–83, 187
Riddle 85 ('fish and river') 64–8

feathers 86–8
fish 64–8, 130–3
Franks Casket 2, 15, 23, 98–134,
 99, 111, 115, 166, 191, 207,
 209, 210

gallows 1, 178, 180, 182, 184, 186,
 198, 201, 205
gender 27, 39–41, 80–3, 204–5, 217
Genesis A 72
Genesis B 72, 189
genre 13–17, 19–20, 33n.54, 59–61,
 195, 196
 dream vision 5, 20–1, 177, 191,
 195, 196
 elegy 19–20, 33n.54
 hagiography 142, 144
 riddle 13–17, 19–20, 33n.54,
 59–61, 177
glas martyrdom 140, 147–8
gospel books 20, 107, 160–70
Grendel 8–9, 12, 36, 38, 39,
 42, 55, 64
Grendel's mother 34–56 *passim*

Hrothgar 34–9, 41–5, 48–9, 51–6
Husband's Message, The 1, 18,
 33n.54, 89–91

ice 79
Isidore of Seville
 Etymologies (Etymologiae) 85

Life of St Columba (Adomnan) 146–7
Life of St Cuthbert (anonymous)
 142–52, 156, 166

Life of St Cuthbert (Bede) 142,
 148, 152–60
Life of St Edmund (Ælfric) 43
Lindisfarne 139–71 *passim*
Lindisfarne Gospels *see*
 manuscripts
literacy 15–16, 18–19, 24–5, 44,
 119–20, 168–9, 206
see also oral tradition;
 riddles; runes

Magi 99, 116–18
Manchester runic ring 11
manuscripts
 Exeter, Cathedral, Dean and
 Chapter 3501 (Exeter Book) 1,
 32n.48, 89
 Florence, Biblioteca Medicea
 Laurenziana, Amiatinus I
 (Codex Amiatinus) 169
 London, British Library, Cotton
 Nero D. iv. (Lindisfarne
 Gospels) 160–70
 London, British Library, Cotton
 Vitellius A. xv. (*Beowulf*
 manuscript) 18
 Stockholm, Royal Library, MS A.
 135 (Codex Aureus) 169
 Vercelli, Biblioteca Capitolare
 CXVII (Vercelli Book) 1, 181,
 192–4, 196
materiality 4, 13–14, 22, 24, 59,
 60–1, 75–7, 129, 141,
 192–5, 204
 materials versus materiality 4,
 13–14, 76, 77
Maxims I 9, 44
monstrosity 34, 35, 39–40, 45, 53,
 55, 56, 131–3
mystery 38, 100, 103, 108, 198, 207
 mystery (*gerynu*) of the Mass
 127

naming 6, 14, 16–17, 24, 36–7, 39,
 46, 48, 50, 80–2, 85–6, 132,
 177, 188, 193
new materialism 4, 17, 219
 see also thing theory

objectification 9, 16
object-oriented ontology *see*
 thing theory
ontology 4, 13, 14, 19–20, 30n.16,
 45, 184
oral tradition 18–19, 38, 44, 84, 196

paradox 16, 67, 134, 177, 197–8
parchment 5, 18, 20, 42, 128, 160–2,
 169, 194
parliament of things 7
paronomasia 14
pectorality *see* speech
prosopopoeia 14, 15, 22, 59,
 83, 92n.1

Regia Anglorum 128
relics 70, 88, 124, 143, 157–9, 163,
 170–1, 206
riddles 5–6, 12, 13–17, 18, 19–20, 22,
 35, 37, 38, 41, 42, 59–92 *passim*
 99, 102–3, 106–7, 125, 127, 128,
 161–2, 164, 166, 177–8, 180,
 187, 211, 220
 act of solving 15–17, 22, 38, 64,
 78–82, 127, 177, 180
 generic devices 14–15
 see also Aldhelm; Exeter Book rid-
 dles; genre; runes
rings 11, 23, 55
Romulus and Remus 98, 106,
 114–16
Ruin, The 12, 76
runes
 in *Beowulf* 34–5, 37–8, 49, 53–4
 cutting runes 128, 129
 on the Franks Casket 98–134 *passim*
 relationship between *run* and
 ræd 37–8
 in Riddle 60 and *The Husband's
 Message* 88–9
 and riddles 14, 15–16, 37–8, 41
 run as mystery or secret counsel
 37–8, 127, 207
 on the Ruthwell monument
 195–213 *passim*
Ruthwell monument 2, 15, 18, 23,
 73, 166, 195–213, *199, 200*

Seafarer, The 19, 21, 22, 65, 85
seax of Beagnoth 2
skin 2, 5, 20, 88, 155–6, 160–2,
 188, 194
 see also parchment
slowness 27, 66, 68, 73, 146, 180,
 183, 188, 206–7, 212, 218
slow scholarship 218
soul and body 64
speech
 and the chest (pectorality)
 83–4, 86
 and divine inspiration 20–1
 speaking objects 5, 11, 17–26,
 59–92 *passim* 184
 speaking subjects 17–19
 speech-bearers 18, 21, 176,
 191, 192
Staffordshire Hoard 50
 gold hilt plate *51*
stone 73–7, 197, 205–13
subjectivity 17–21, 45, 190–1
substance 13–14, 60–1, 76
sundials 73–7
swords 10, 14, 44–56 *passim*
 hilts 45, 46, 50–6, *51*
 names and naming of 46, 48, 52
symbols 12–13, 164–5, 178–9
Symphosius 64

temporality *see* time
Thames silver fitting 23, 25–6
þing 7–9, 124
 see also Althing
thing theory
 assemblage 6–7, 26, 134, 175
 breakage and failure of things 45

evocative objects 140, 157–8
hyperobjects 4, 62
latency and excess of things 3, 6
object-oriented ontology 3–4
obscurity of things 13–14, 16, 45,
 60–1, 81, 180
obsolescence 55
thing-power 4, 26, 45
things that talk 16, 101, 126
things versus objects 3, 9, 25, 80
vibrant materialism 59, 180
see also actor-network theory; new
 materialism; parliament of things
time 7, 48–9, 55–6, 59–92 *passim*
 179–80, 186–8, 208–13
 passim 218
 see also slowness
treasure 10–12, 50, 84, 86, 131,
 167, 190–1
trees 80, 165, 178–92, 198

Vercelli Book *see* manuscripts
voice *see* speech

Wanderer, The 19–21, 65, 85,
 189, 208
water 63–8, 79, 81, 146–50, 178, 179
Wayland the Smith 98, 104, 113–14,
 116–18, 121, 166–7
Whale, The 131–3
whalebone 2, 15, 98–101,
 123, 126–34
Wife's Lament, The 19, 22
wiht 9–10, 61, 63
wonder 12, 14, 81, 177
wood 1, 2, 129, 182, 197, 204–6
writing tools 87–92, 161